Dawn of the 21st Century

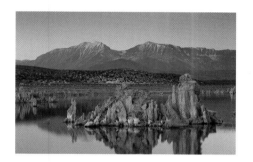

THE MILLENNIUM PHOTO PROJECT

Published in the year 2000 by:
Smashing Books!
London - Toronto - Christchurch
E-mail: books@smashing.com
Project web site: www.millenniumphoto.com

For information on ordering additional copies of this title, framed prints of individual photos or to enquire about bulk purchase for corporate gifts, promotions etc., please contact the publisher above or visit the project web site.

Edited by: Alx Klive & David Kilgour
Designed by: Alx Klive & Andrew Smith
Cover Photos: Keith Nolan, Jeffrey Camarati, Johann Van Tonder

Printed in Canada

Canadian Cataloging in Publication Data

Klive, Alx, 1970 -
Dawn of the 21st Century: The Millennium Photo Project

ISBN 0-9687958-0-3

1. Millennium celebrations (Year 2000) — Pictorial works. I. Klive, Alx, 1970 -

D857.D39 2000 394.2 C00-901387-3

10 9 8 7 6 5 4 3 2 1

First Edition

Contents

⭐ Denotes Judges' Award photo

Introduction

Where were you on the first day of the new millennium? How were you on that day. Were you rich, were you comfortable, were you poor...? Did it affect you. Did it give you a tingle of excitement to realise that you and everybody else in the world, were crossing from one thousand years... to the next?

Maybe your day was like any other. Whatever your circumstances, whatever your feelings, that night and day was truly different. It will be remembered, recalled, held up as a defining moment, for all the years to come.

This book is the culmination of a global project that was two years in the making and involved thousands of people around the world. It began with an idea, the idea of documenting through photographs a day in the life of our planet – not just any day, but the twenty-four hours encompassing New Year's Eve 2000.

In April of 1999, a small group of friends joined with me to launch a web site inviting photographers around the world to become involved in the Millennium Photo Project. Soon, a group of volunteers working in different countries, were translating the site into other languages and helping to spread the word among the photography enthusiast community. In January of 2000, entries began arriving at the project offices in Toronto. Soon after, a panel of judges narrowed thousands of entries down to the selection of 500 photos that you find presented here today.

It is solely due to the hard work and dedication of this group of (not so) ordinary people, who met one another on the Internet, that this amazing collection of photographs became possible. I believe this is the first time such a massive international effort to document history (and to make a book!), has been made in such a grassroots community style fashion. A truly exciting and empowering use of the Internet.

A founding principle of the project was that it be open to anyone. Most of the photographs in this book -- more than two-thirds in fact -- were taken by non-professionals. For many, it is their first time being published. All of them chose to spend the end of one century and the dawn of a new, taking photographs for the project. Indeed their own stories are as varied and fascinating as the images they bring to you. Sahir Raza, for instance, is a thirteen-year-old from Delhi, India, who braved a terrible fever to take his picture of a young child collecting firewood. Liz Larrabee is a seventy-five-year-old grandmother of nine, who spent her New Year's Eve documenting the homeless on the streets of Sarasota, Florida, USA.

Though we knew many photographers would choose to focus on the moment of midnight, we hoped that they would also cover every other aspect of life in those pivotal twenty-four hours, and we were amply rewarded by a dizzying variety of subjects, styles, and approaches. Gradually themes began to emerge, and for the purposes of the book we decided to arrange the photographs thematically rather than chronologically. The themes should speak for themselves.

Please enjoy this book and treasure it. A lot of effort went into making it, and its success means a lot to many people. Please tell your friends if you enjoy it and keep it somewhere safe for your grandkids. If you'd like to learn more about the project, how it came about and the photographers who made it happen, please visit the project web site at www.millenniumphoto.com.

Thank you to everyone involved.

Alx Klive, Project Founder
Toronto, Canada
October 17th 2000

Antici

pation

Photographers begin shooting at noon. Many of the images they capture are of New Year's Eve preparations: the harvesting, sale, and cooking of food for elaborate feasts; last-minute rehearsals by musicians, dancers, and other artists who will perform in the evening; the decorating of places both public and private; people dressing up and others getting made up. But some prefer simply to quietly watch the last sunset of the millennium, before the evening's festivities begin...

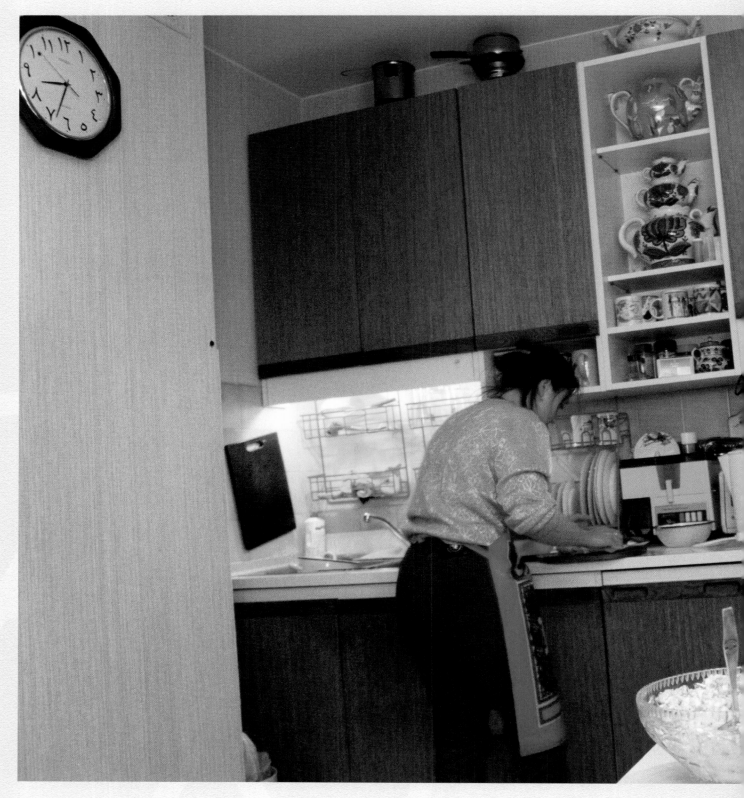

8

8:33PM MOSCOW, RUSSIA
A young couple prepare the
evening meal. A Cyrillic clock on
the wall counts down the hours to
midnight. IVAN KURIMOY

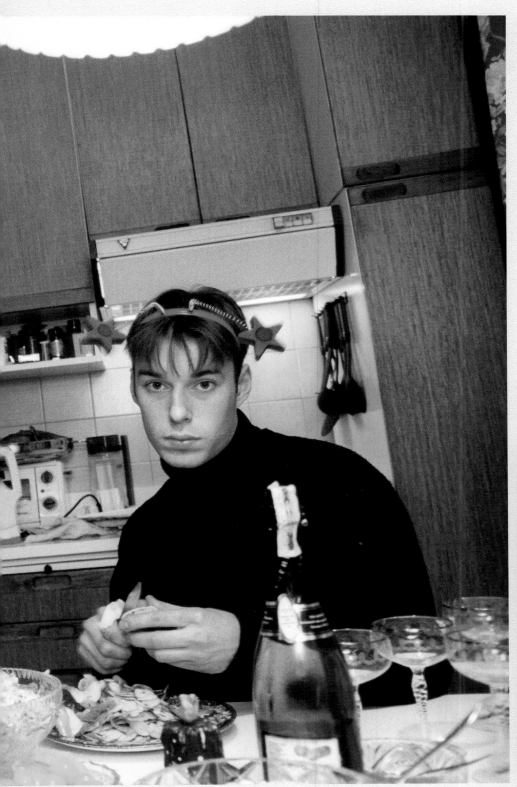

6PM STAFFORDSHIRE, ENGLAND
Filling out a lottery ticket for the last draw
of the century. IAN HOMER

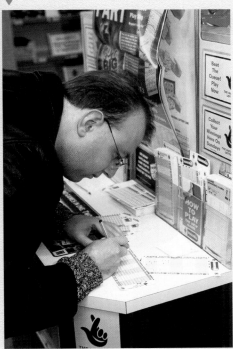

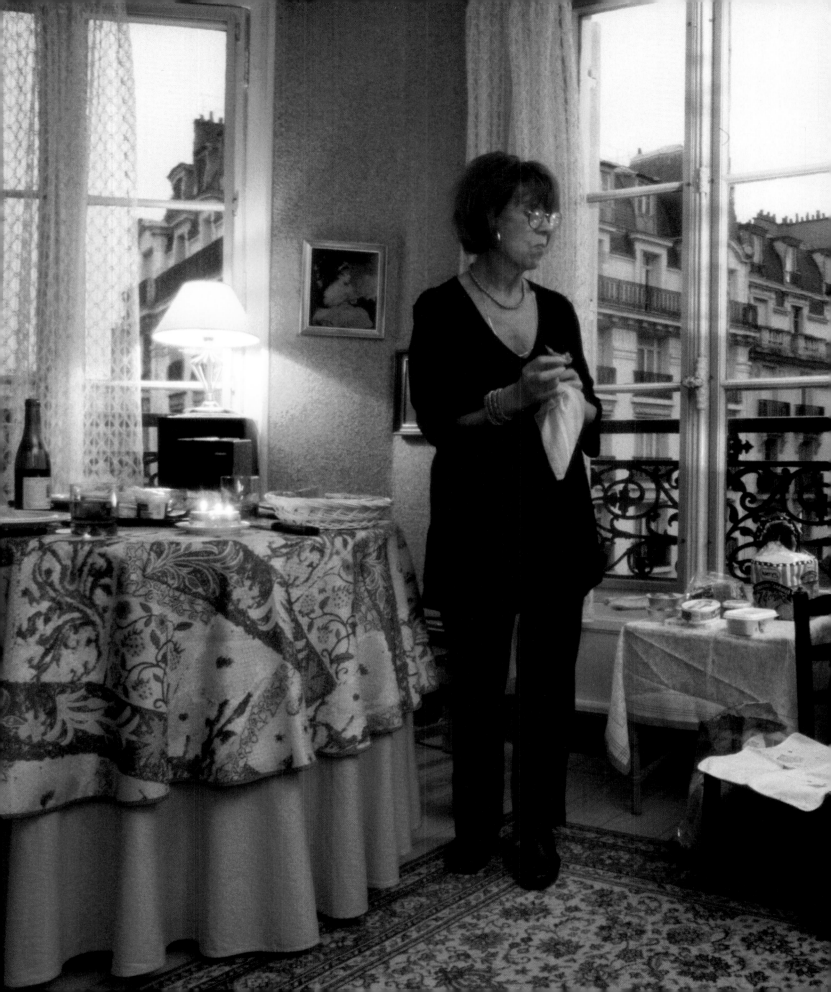

4:15PM PARIS, FRANCE
Mademoiselle Lopez prepares her New Year's Eve meal while watching millennium celebrations in Peking from the comfort of her Paris apartment.
MORTEN BENDIKSEN

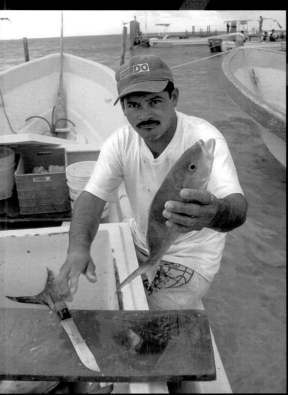

12:05PM ISLA MUJERES, MEXICO
A fisherman's catch destined for one of the local restaurants. STANLEY PATZ

▶ **3:30PM NEW DELHI, INDIA**
A boy collects wood for fuel,
oblivious to the approaching
millennium. SAHIR RAZA

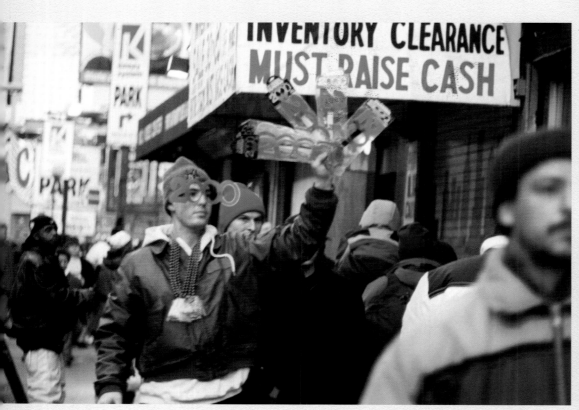

▲
4:30PM NEW YORK CITY, USA
A street vendor hawks the last of
his millennium merchandise near
Times Square. KIMBERLEY WADSWORTH

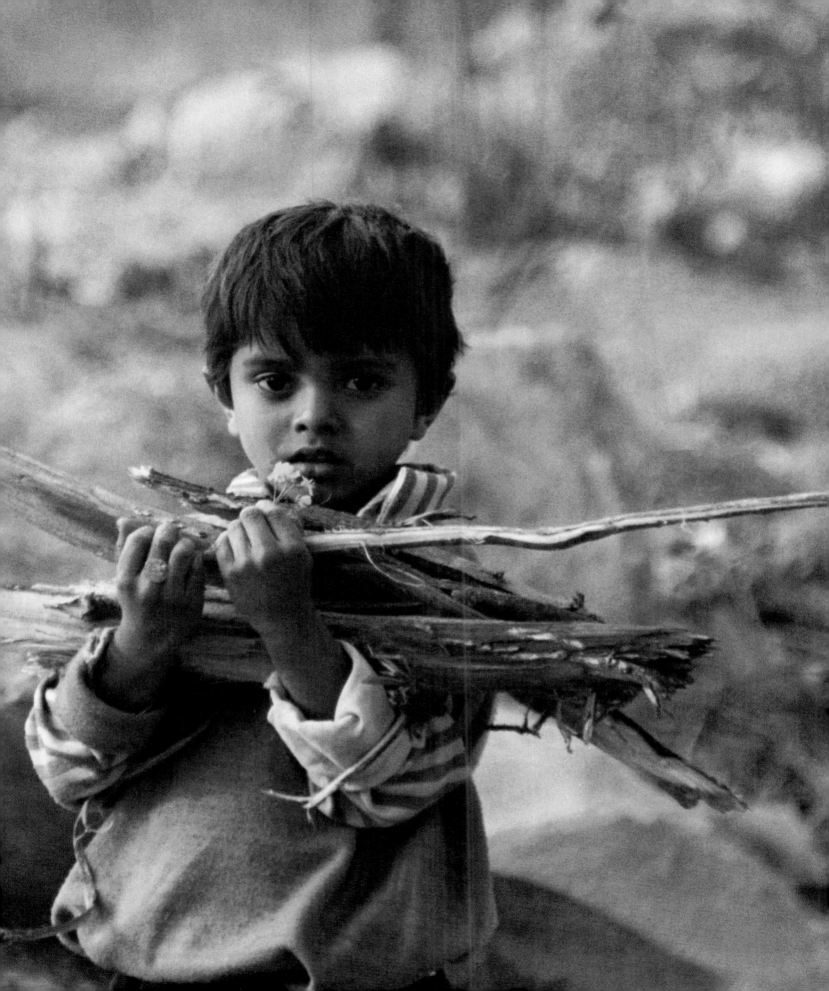

5PM NELSPRUIT, SOUTH AFRICA
Setting up for a concert, two
young roadies make last-minute
repairs to the lighting system.
RICHARD WILSON

14

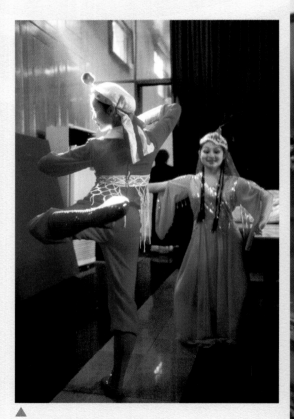

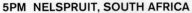
3:45PM WUHAN, CHINA
Students from the University of Central China
rehearse their performance one last time.
YIHUANG HUANG

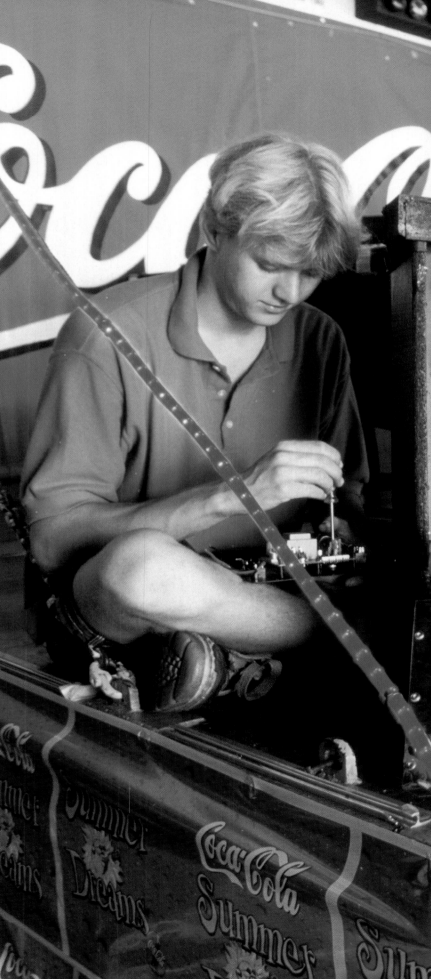

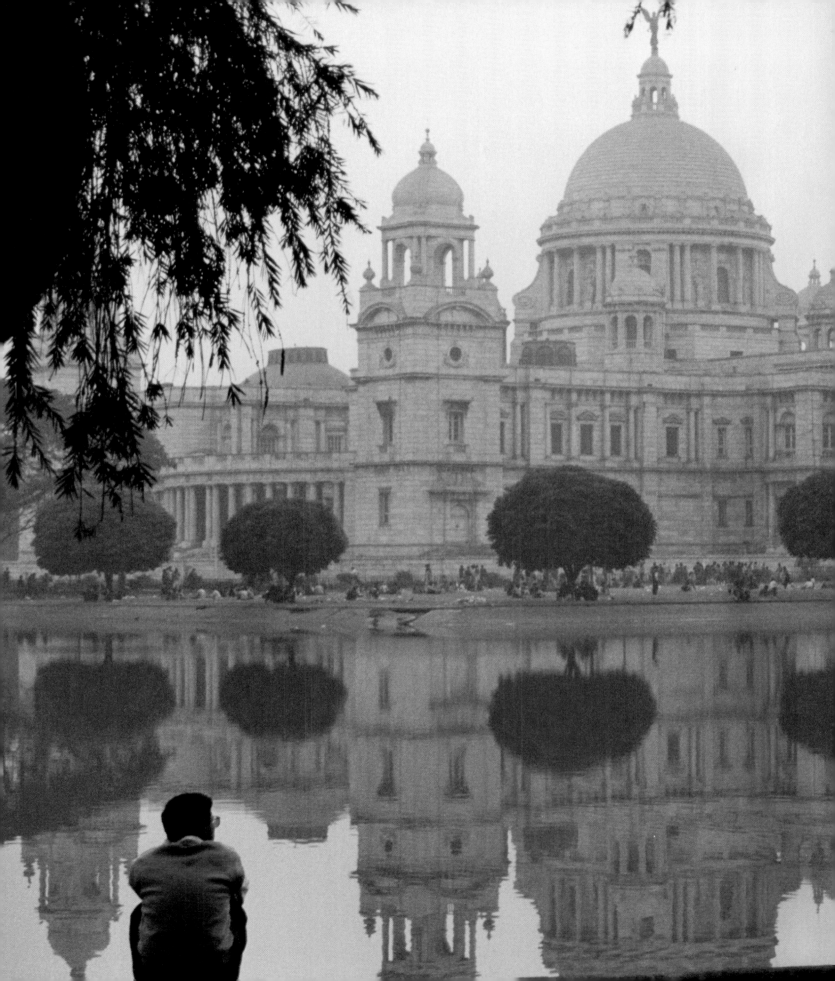

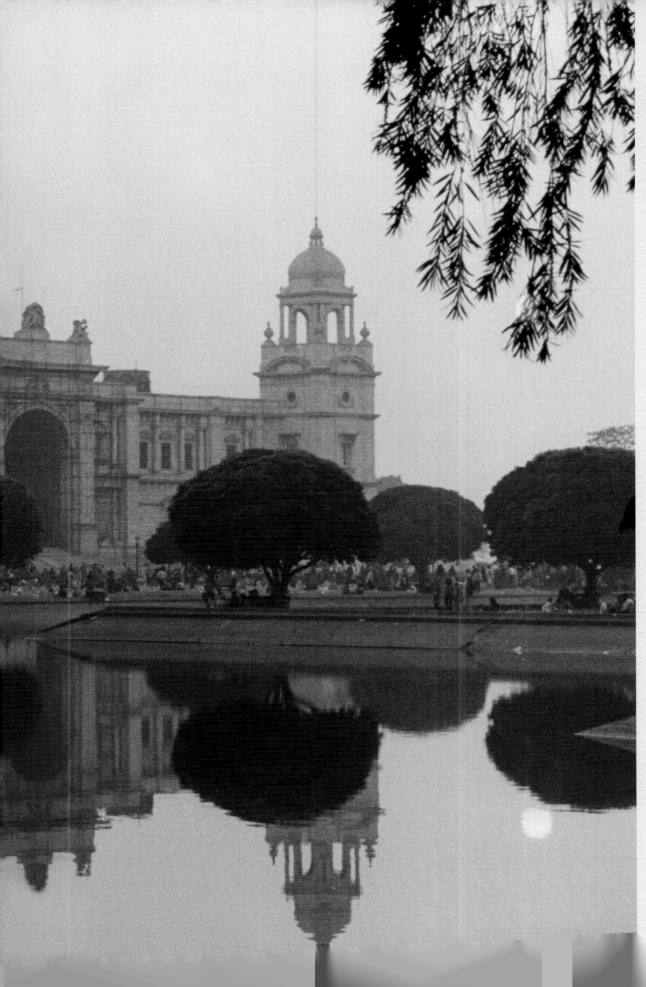

4:45PM CALCUTTA, INDIA
This man escaped the crowds at the Victoria Monument to take in the last sunset of the century.
VALAPPIL RADHAKRISHNAN

17

▲
11:45PM CALGARY, CANADA
Last-minute preparations before stepping
out at the Palace Nightclub. CONNIE SPYKER

2:45PM KOWLOON, HONG KONG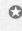
More than 4,000 bottles of
champagne await guests at the Regent's
Ball, a highlight of the social calendar.
PALANI MOHAN

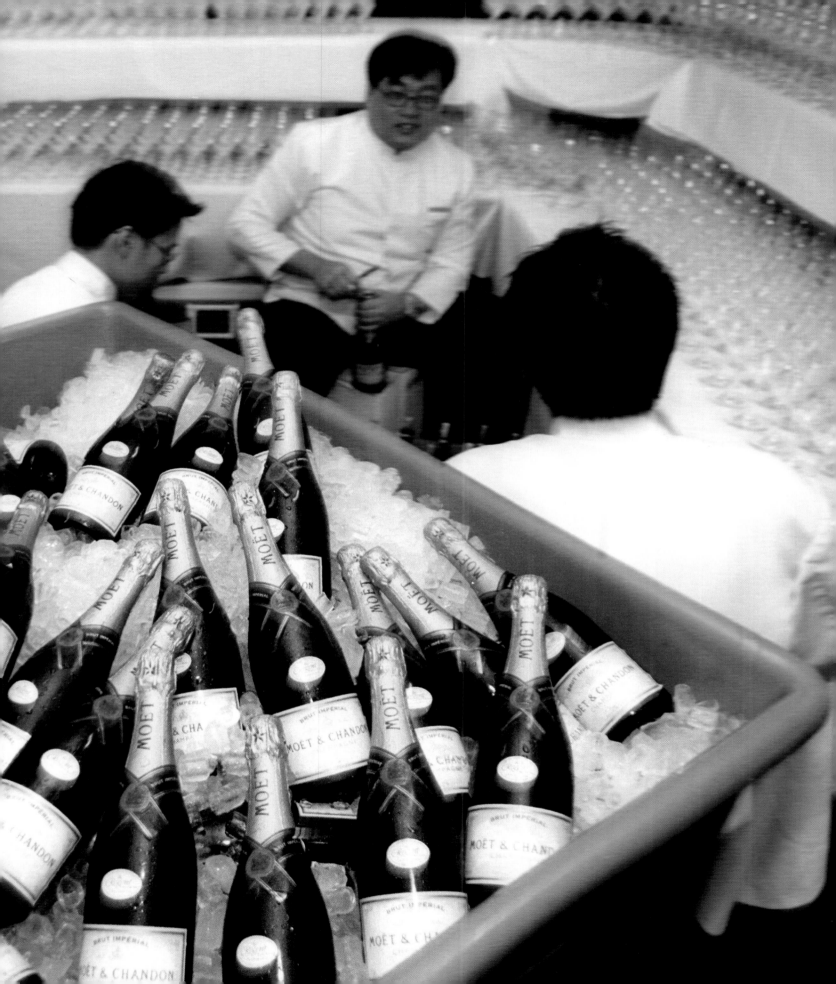

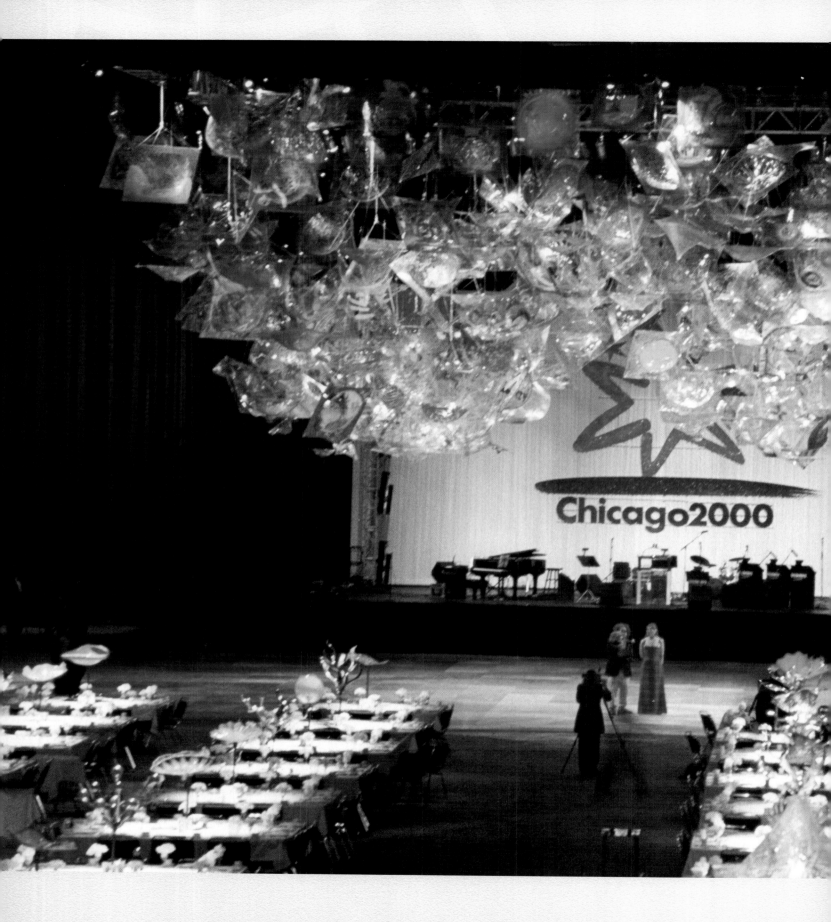

7:45PM CHICAGO, USA
The Mayor invited two guests from
every country in the world to attend
this gala event. KAREN HIRSCH

⭐ **1:30PM CALCUTTA, INDIA**
A child worker puts the finishing touches on
cut-out signs for a millennium celebration.
SUGATO CHATTOPADHYAY

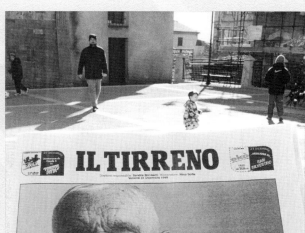

3:30PM IRVINE, CALIFORNIA, USA
Having to deal with constantly changing
weather, a slide operator inflates his ride
for the third time. MARY MULFORD

2PM MAGLIANO, ITALY
The photographer holds up the day's newspaper
at the edge of the central square.
ELIO LOMBARDO / NEWS PHOTO: OLIVIERO TOSCANI

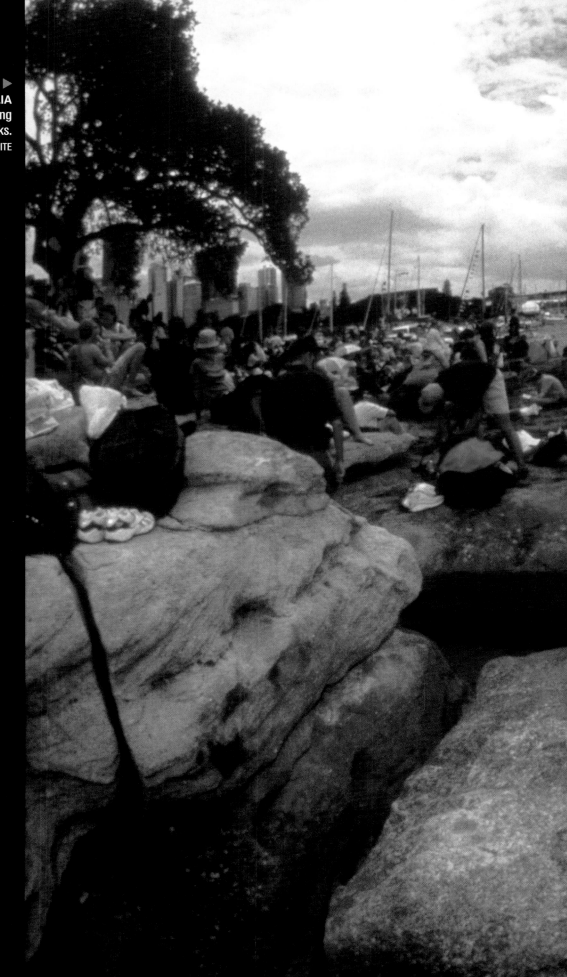

2:30PM SYDNEY, AUSTRALIA
Prime viewing spots meant a long
wait for the midnight fireworks.
CLIFFORD WHITE

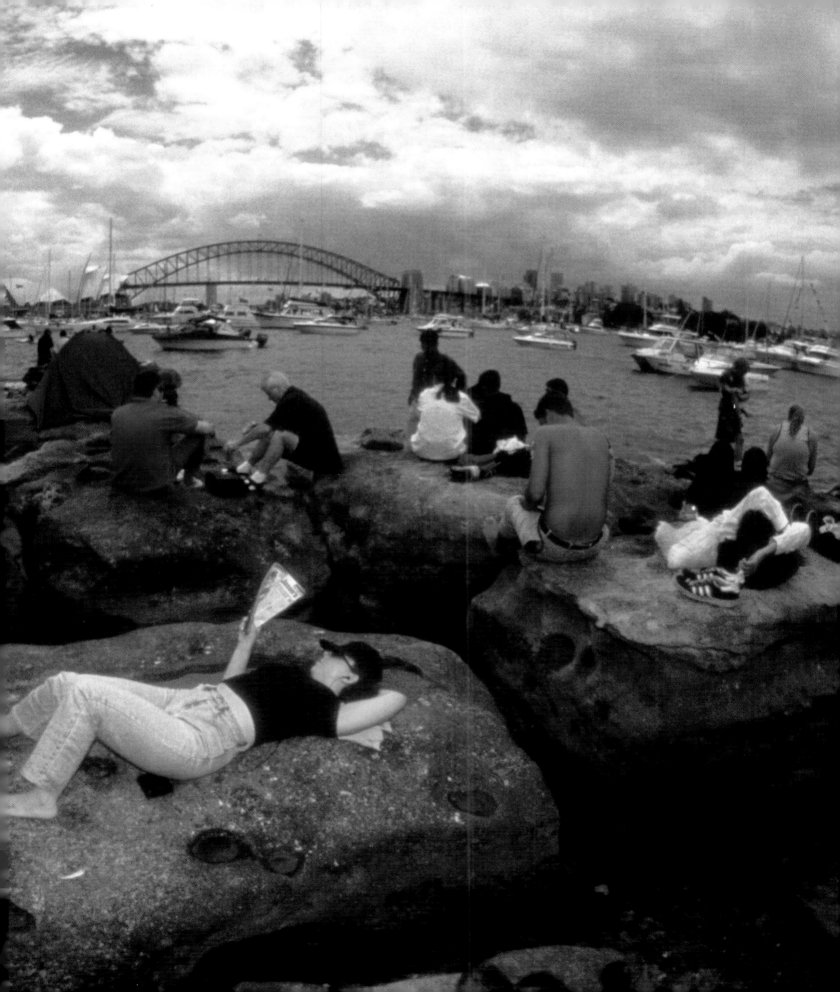

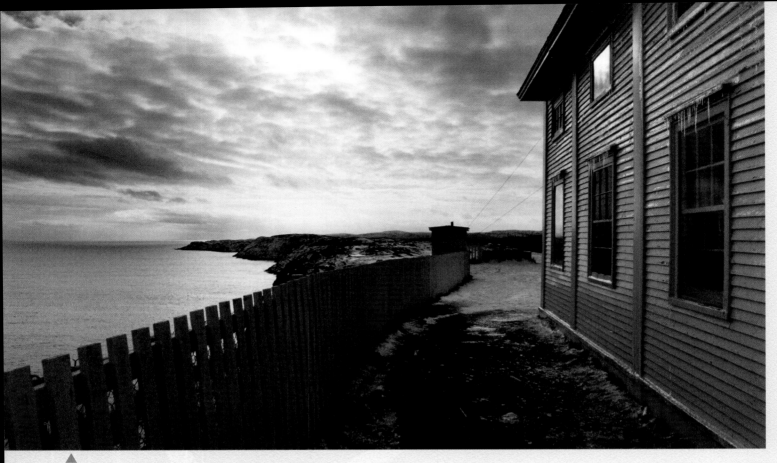

★ **2:30PM CAPE SPEAR, NEWFOUNDLAND, CANADA**
Mid-afternoon light reflected in the windows of the
lighthouse. CHARLES DUFOUR

5:20PM PRAIA DA ROCHA, PORTUGAL
Boats moored at sunset in the Algarve. RICARDO MARTIUS

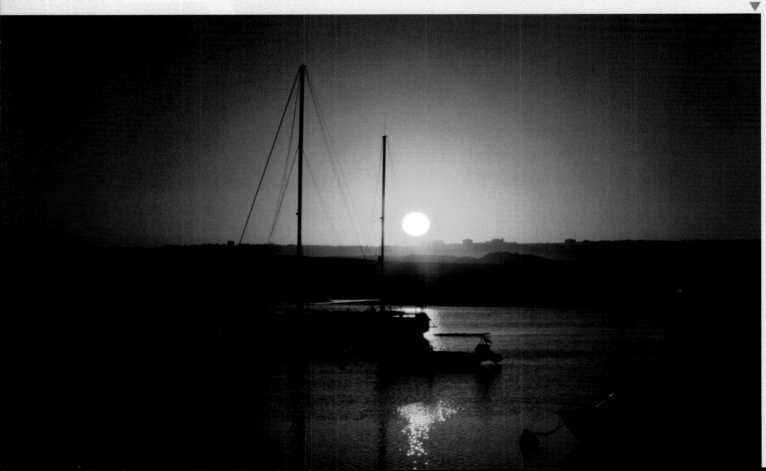

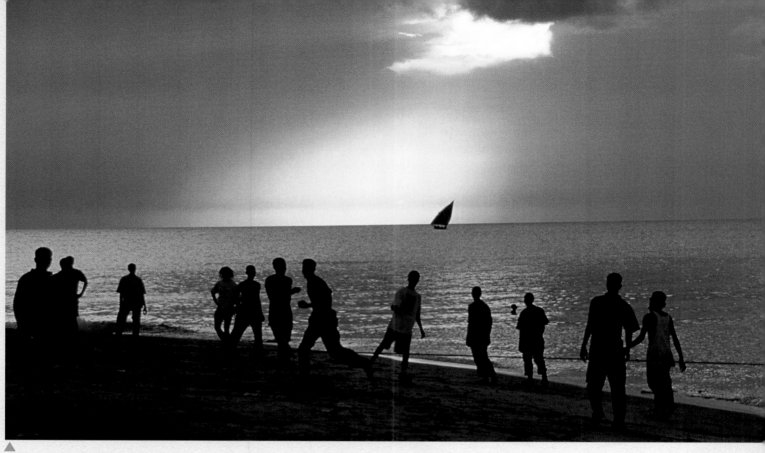

▲
6PM ZANZIBAR, TANZANIA
Young men play soccer on the beach. JAMES STEJSKAL

8:10PM GREATER CAPE TOWN, SOUTH AFRICA
The Kommetjie lighthouse. RYCHERDE WALTERS
▼

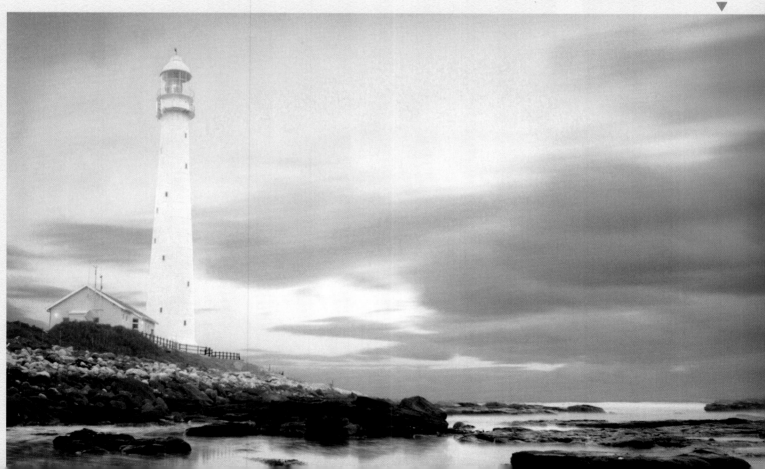

Getting

There

People use every possible conveyance on land, air, and water to reach their destinations. For some, the journey – on foot, by sled, by boat – is just as important as the arrival.

One photographer sets up an elaborate shot to convey the idea of a "time machine" travelling into the new millennium.

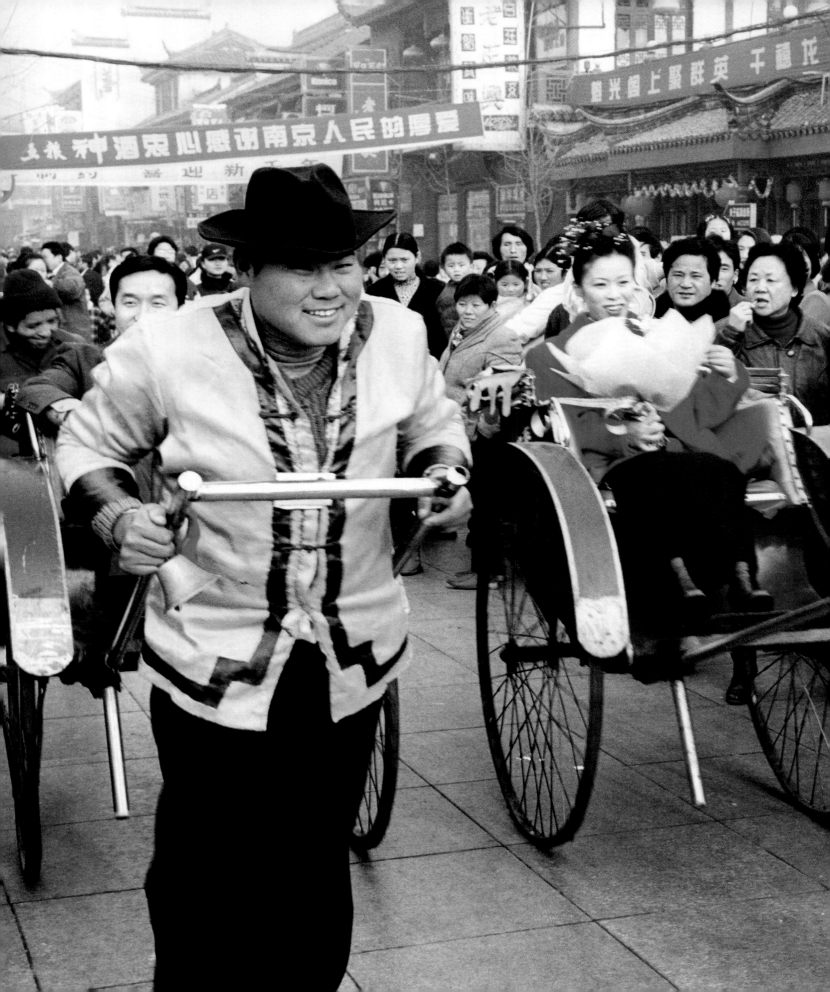

◀ **4PM NANJING, CHINA**
A wedding couple en route to
their reception.
ZHIHANG WANG

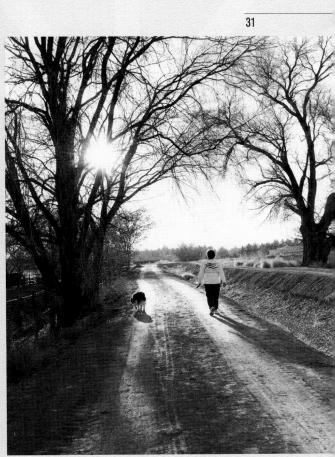

▲ **5PM LAS CRUCES, USA**
A late afternoon stroll with the family dog.
LINDA MONTOYA

▶
12:25PM PONDYCHERRY, INDIA
Friends take a well-deserved break
from their motorbike journey
between Chennai and Pitchavaram.
RAJMOHAN V. PAI

32

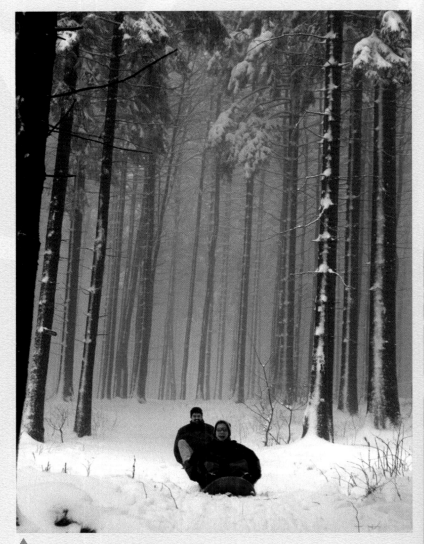

▲
1PM INSELSBERG, GERMANY
Sledding through the forest.
FRAUKE SCHOLZ

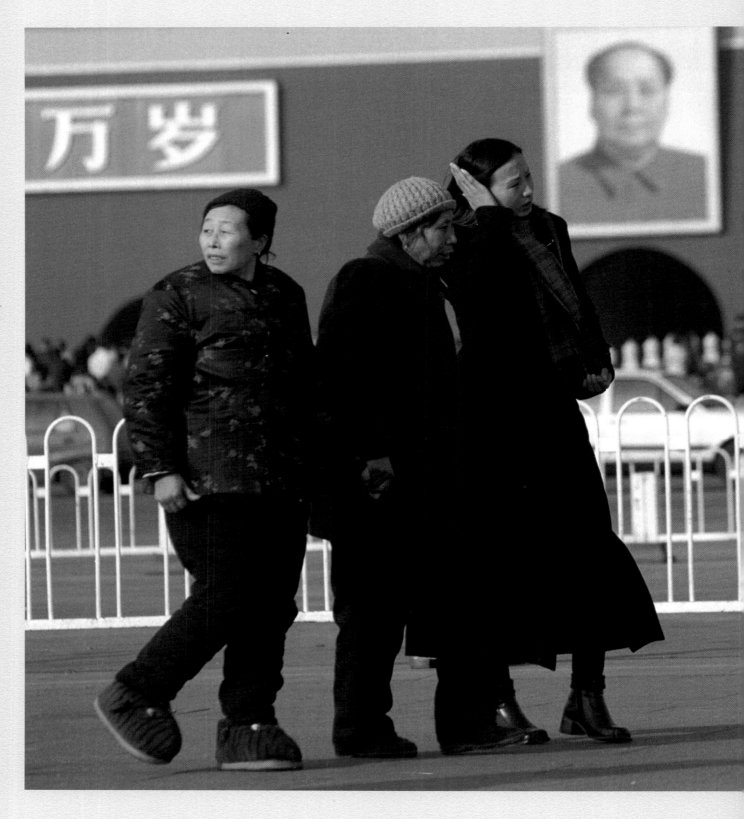

◄

2:20PM BEIJING, CHINA
Three generations walk
across Tiananmen Square.
JAMES HUANG ZENG

▲
3PM MADRID, SPAIN
It's mid-afternoon and these friends
are already celebrating in Plaza Mayor.
JUAN FERRERO

▶

(NEXT PAGE) 6:10PM KOWLOON, HONG KONG
A traditional sampan motors across the harbour at
sunset. PALANI MOHAN

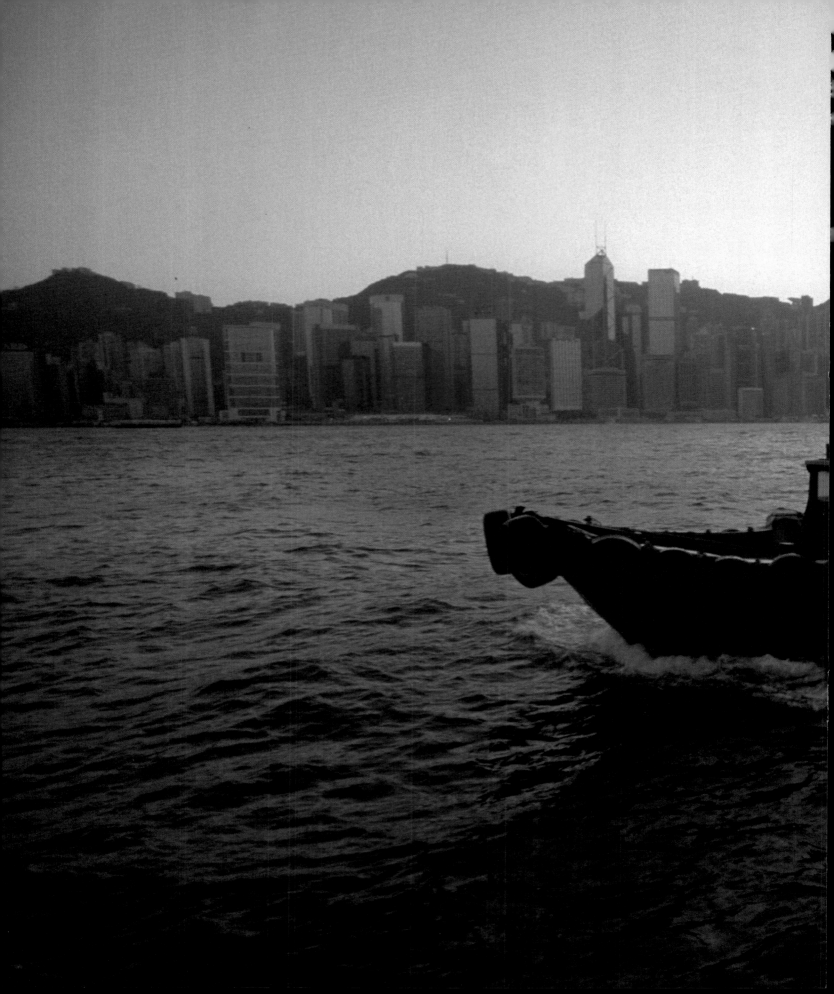

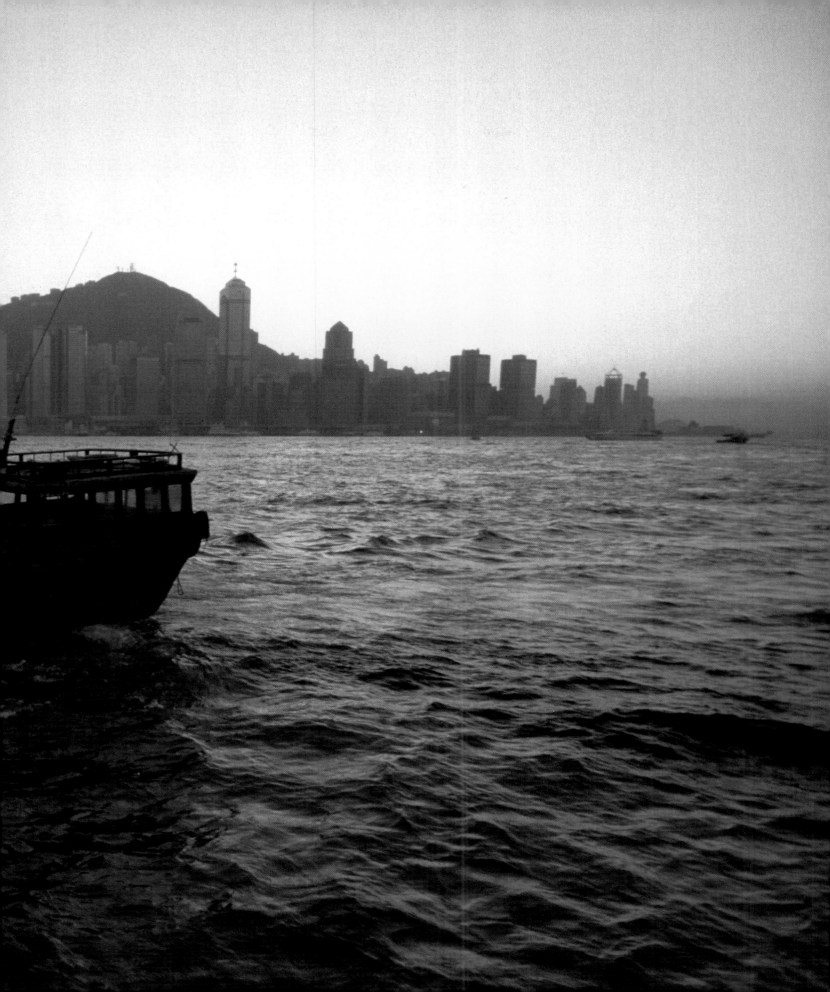

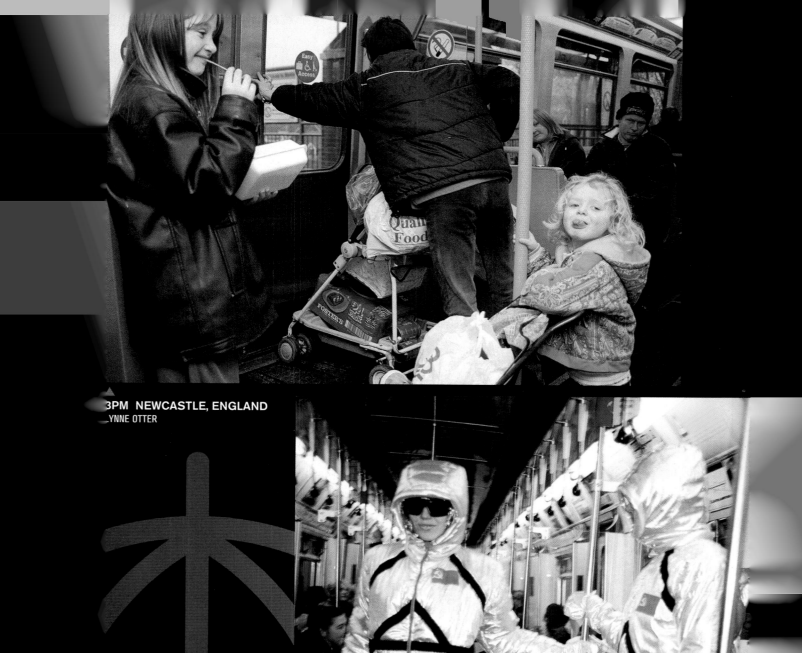

3PM NEWCASTLE, ENGLAND
LYNNE OTTER

2PM LONDON, ENGLAND
MICHELLE STORM

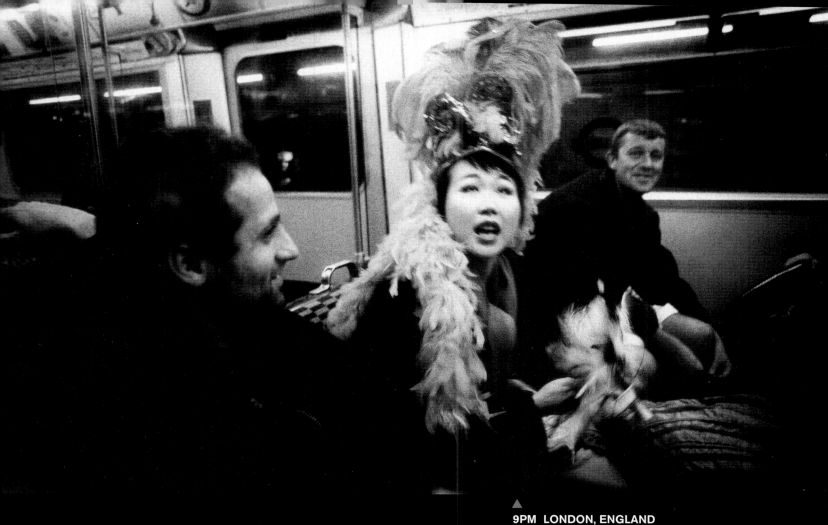

▲
9PM LONDON, ENGLAND
ANDREA MOSSO

◄
★ **10PM LONDON, ENGLAND**
ANDREA MOSSO

►
(NEXT PAGE) 4:20PM CARRICK-ON- ★
SHANNON, COUNTY LEITRIM, IRELAND
After the River Shannon rose to its highest
level in the century, a man tries to get to his
motor cruiser. KEITH NOLAN

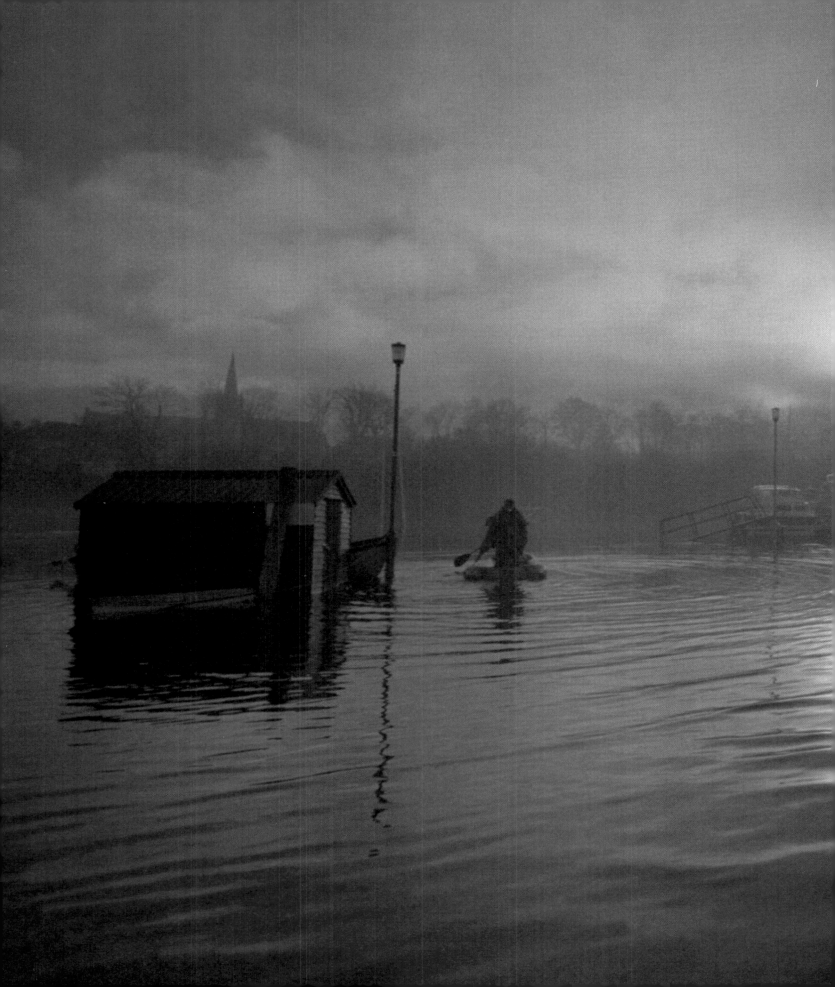

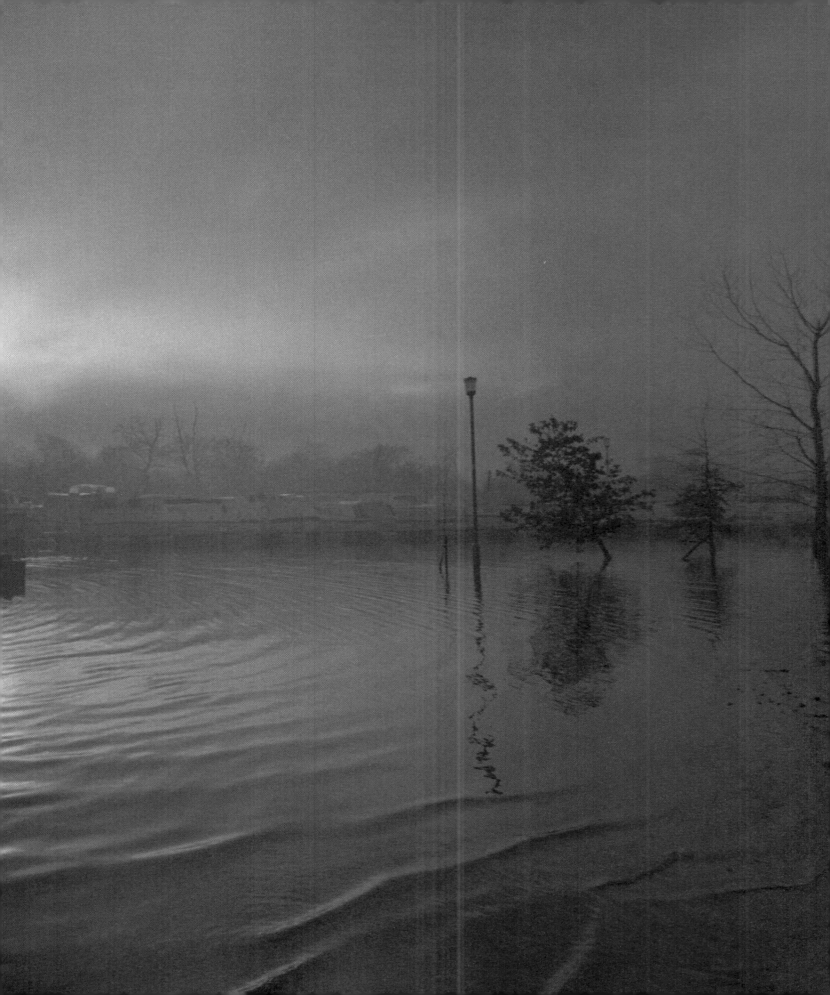

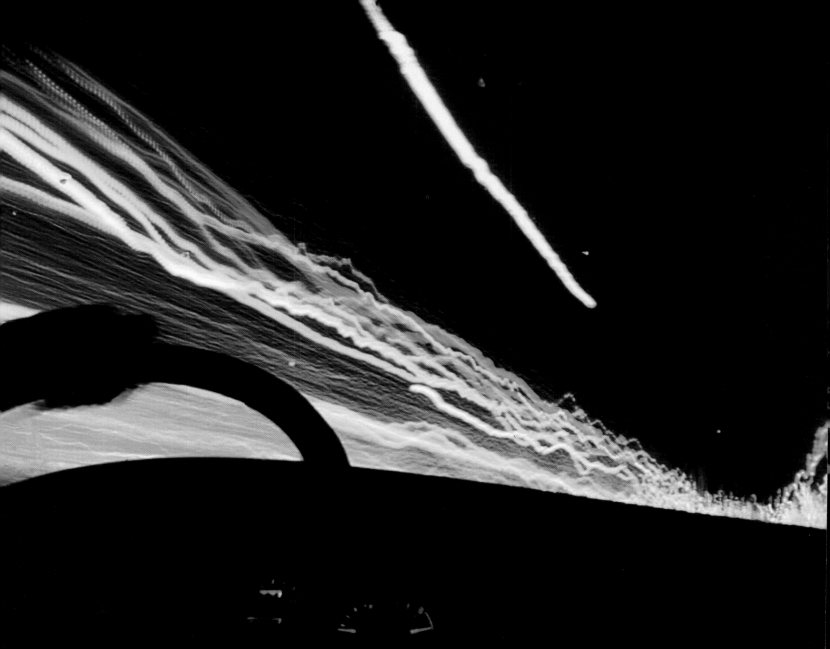

7PM PETERBOROUGH, ONTARIO, CANADA
On his way to a party, the photographer set up a tripod in the back seat of his car and took this picture to represent a "time machine" hurtling into the new millennium.
RANDY ROMANO

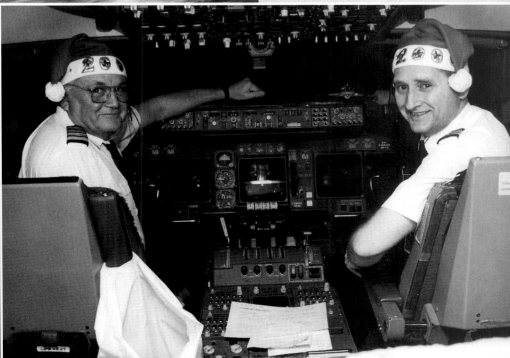

9PM OVER HONG KONG
These pilots spent five days over New Year's away from loved ones, but were determined to make the most of it.
EVE HENRY

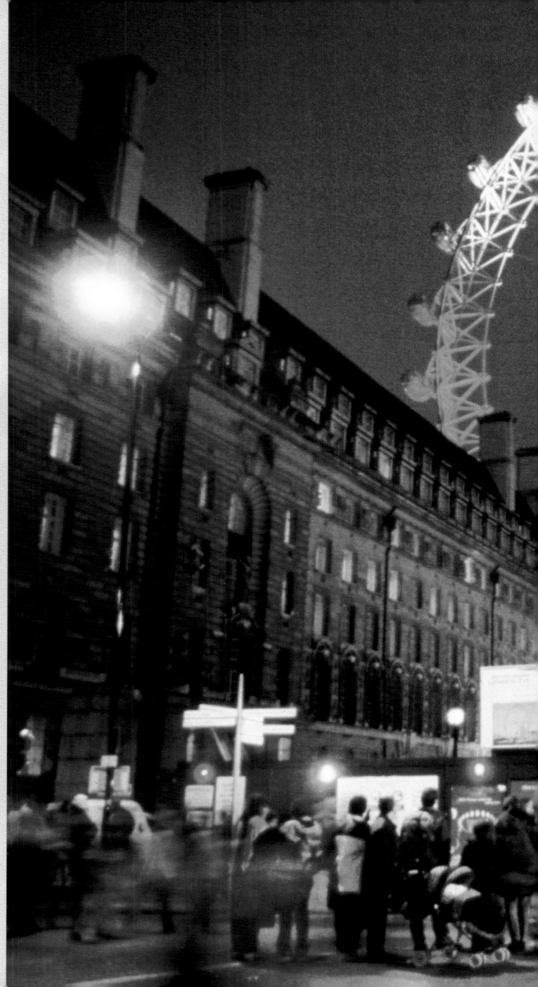

► **6:30PM LONDON, ENGLAND**
Rush hour in front of the Millennium
Wheel near Waterloo station.
NICK TSINONIS

44

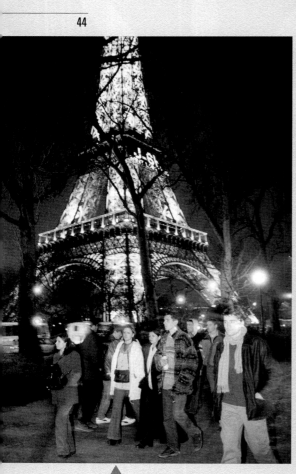

▲
7PM PARIS, FRANCE
Police cordons around the Eiffel
Tower make getting to the party a
little difficult. CLARENCE CHAN

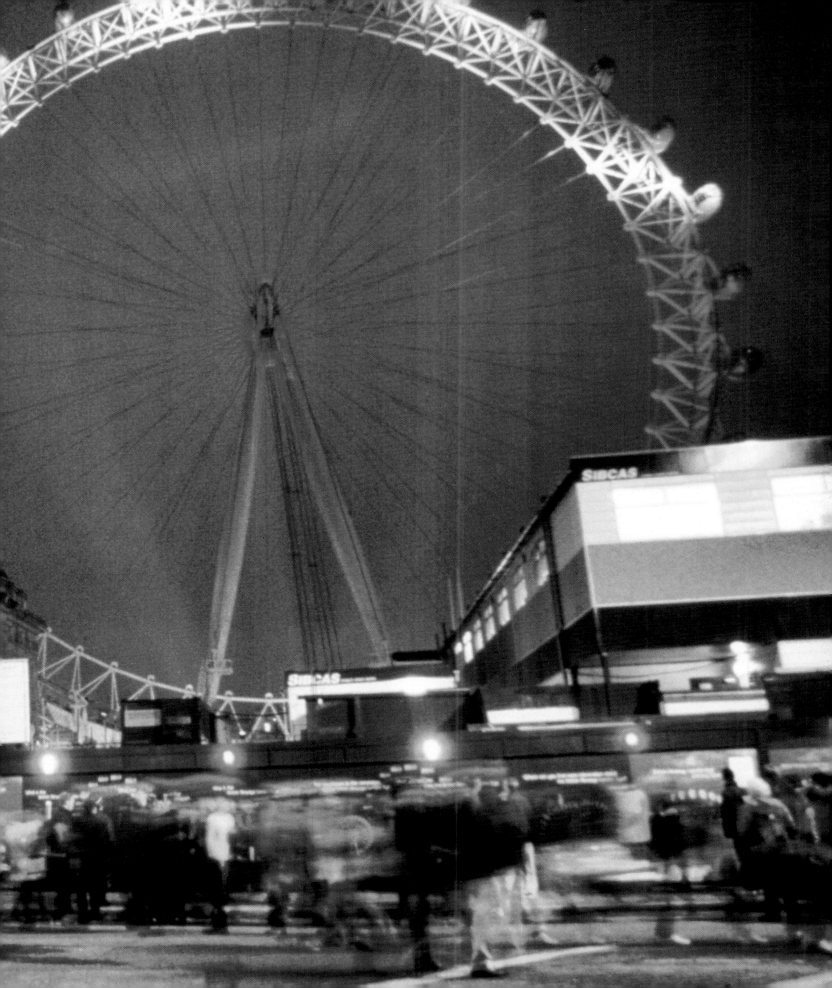

Reunit
and not

ed

In train stations and airports, on piers, in their own homes, families, friends, and lovers come together everywhere. Most plan to spend the evening at parties and official events. In Florida, three women who swore twenty years ago to spend this New Year's Eve together keep their promise.

Some choose to be alone – whether at home or in the middle of the Kalahari. But for beggars, the homeless, the poor, and the friendless, the night is a lonely vigil.

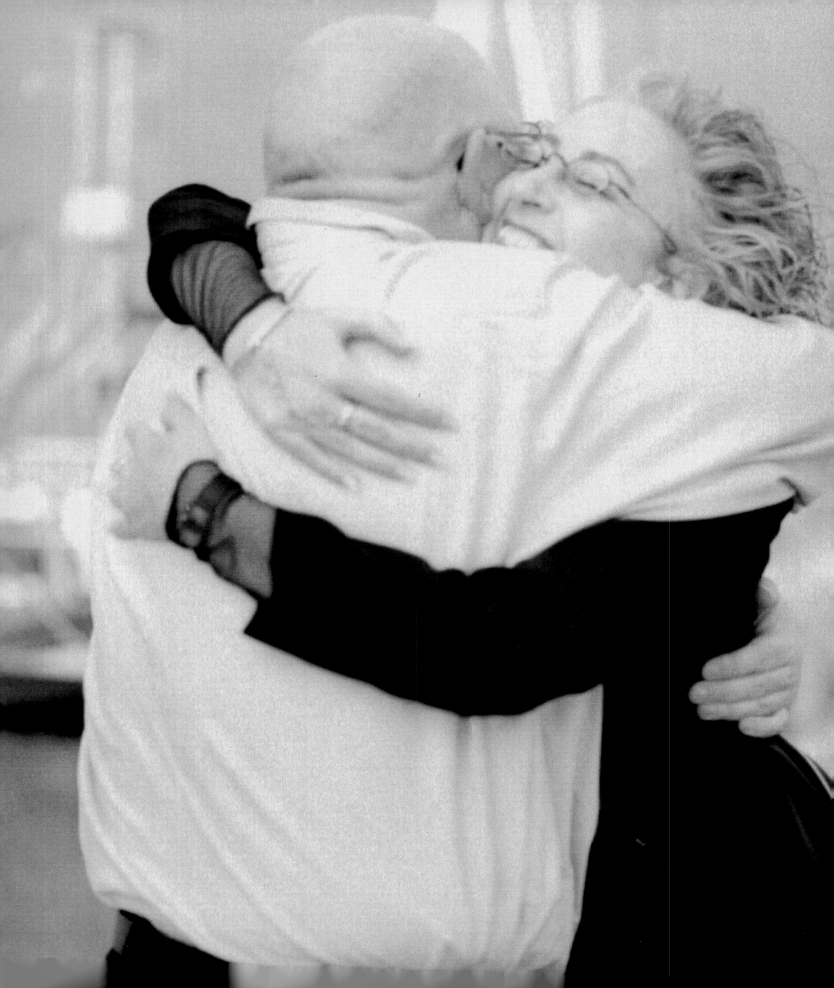

▲

7PM MELBOURNE, AUSTRALIA
Two old friends, Peter and Caroline,
meet by chance on Pier 35. DEE BOND

49

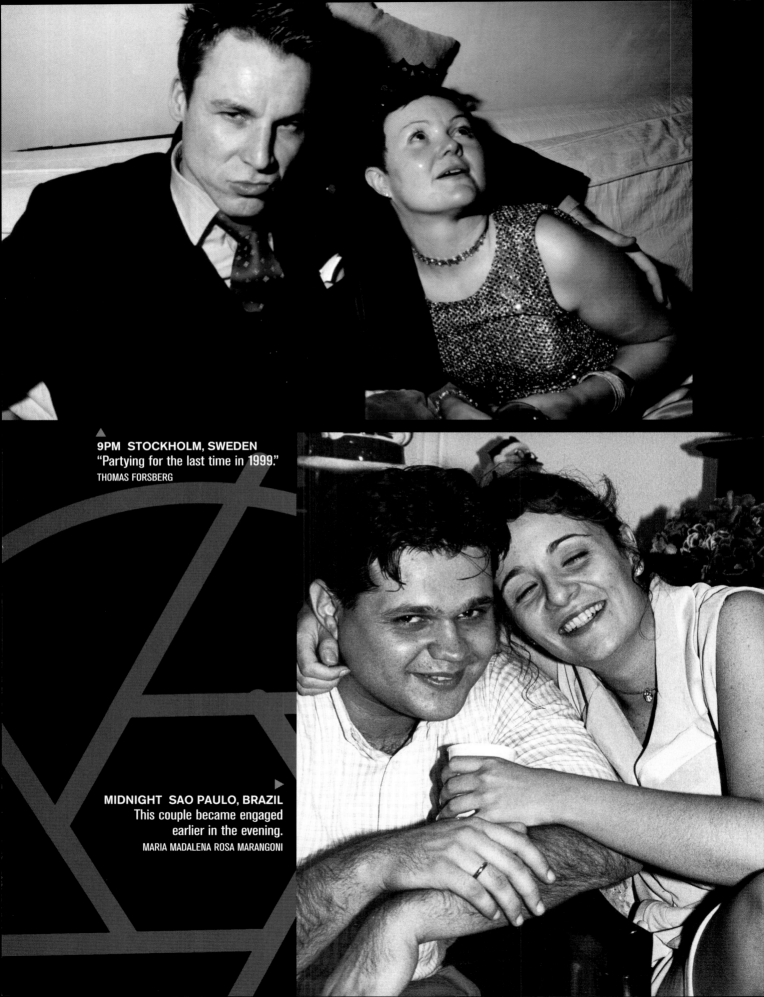

9PM STOCKHOLM, SWEDEN
"Partying for the last time in 1999."
THOMAS FORSBERG

MIDNIGHT SAO PAULO, BRAZIL
This couple became engaged
earlier in the evening.
MARIA MADALENA ROSA MARANGONI

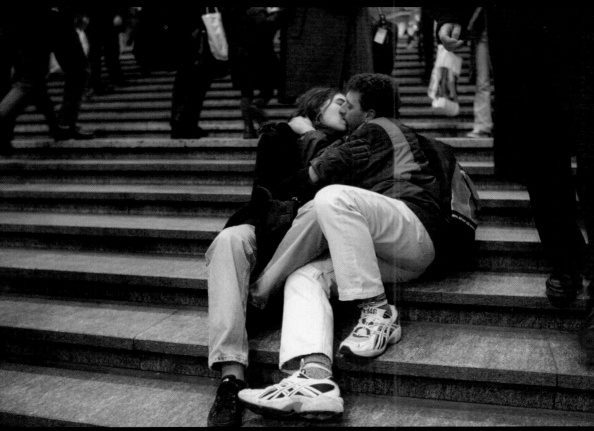

★ **3PM BRUSSELS, BELGIUM**
Following a long train journey from Italy, husband and wife
are reunited on the steps of Central Station. JOCK FISTICK

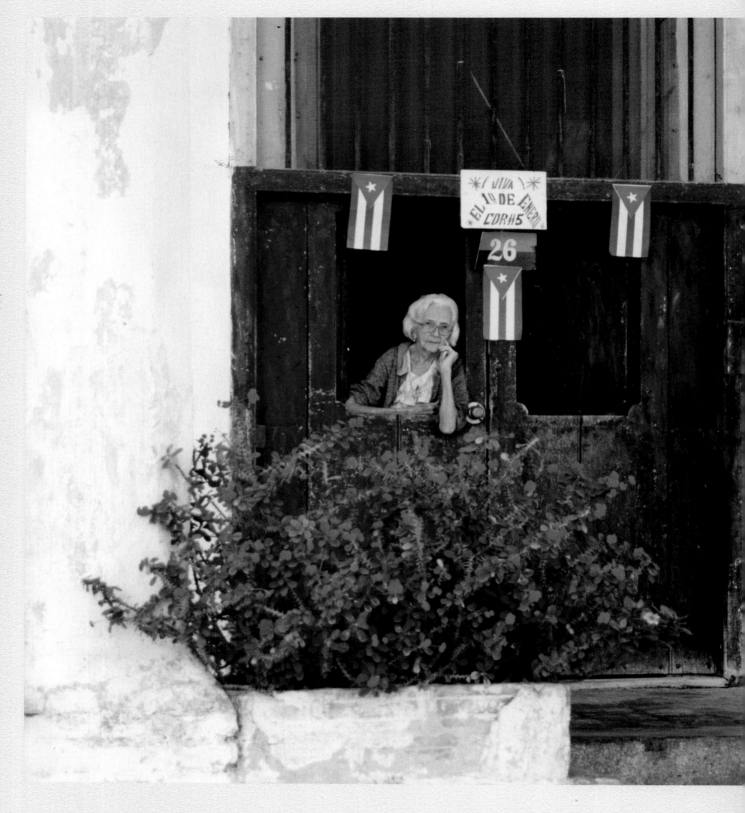

5PM CONSOLACION DEL SUR, CUBA
An old woman watches the world from her front door.
MARTIN BRAVO AGUIRRE

53

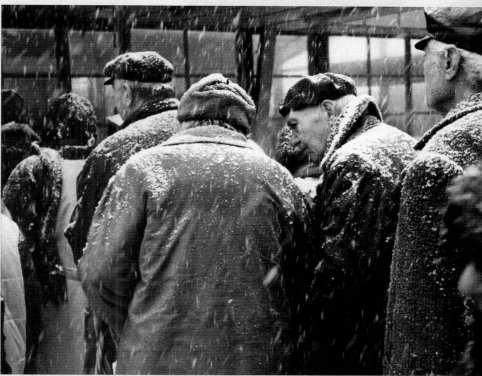
2:30PM SOFIA, BULGARIA
Catching up on news while shopping for the
evening meal. NIKOLAY GEORGIEV

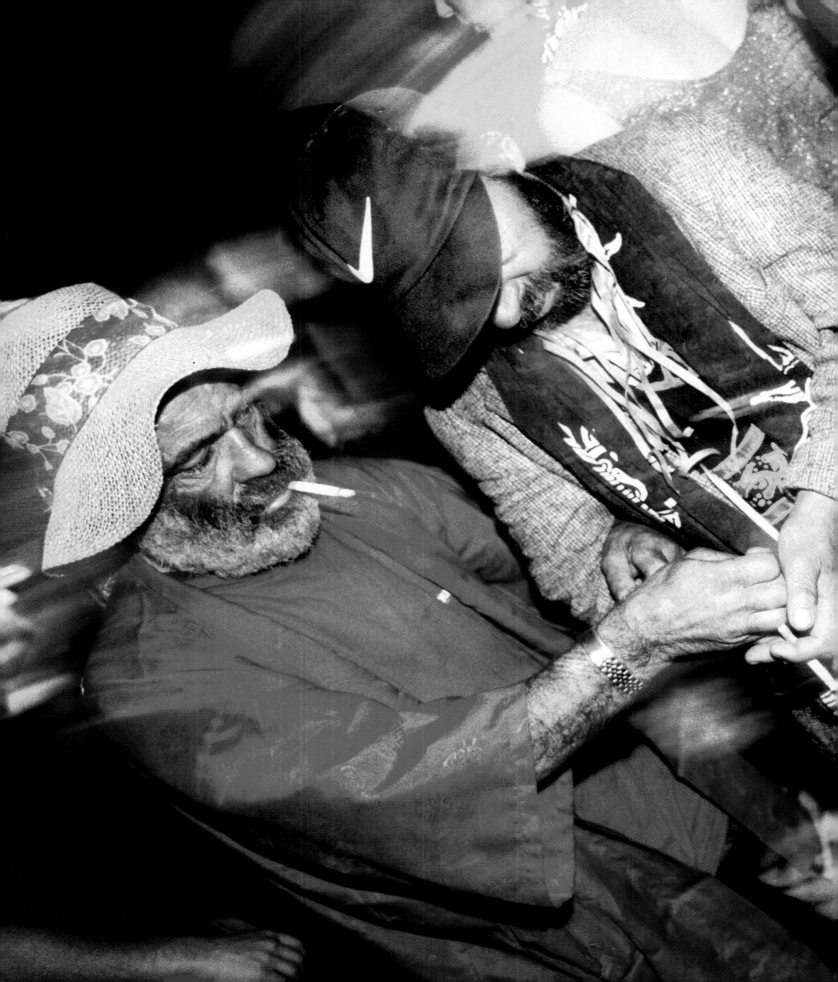

1PM TENERIFE, CANARY ISLANDS
Street entertainers count their takings after
working the crowds on the boardwalk.
PAULINA HOLMGREN

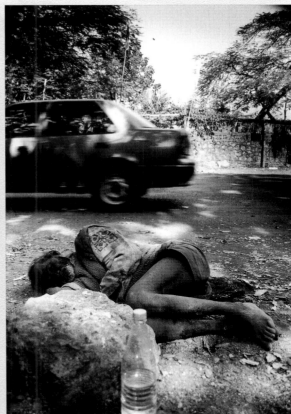

10:50AM BOMBAY, INDIA
The photographer writes that
"In some spheres of life there is no choice."
ISHIKA MOHAN

1999 - 2000

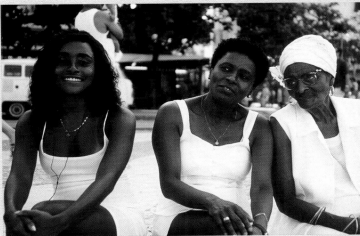

5PM RIO DE JANEIRO, BRAZIL
Wearing the white traditionally worn
in Rio on New Year's Eve, daughter,
mother, and grandmother wait for the
fireworks on Copacabana Beach.
LIANA BITTENCOURT

57

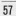

12:10AM MIDLOTHIAN, VIRGINIA, USA
These neighbours took this photograph to
commemorate their evening together watching
the millennium sweep across the globe on
television. MARSHA POLIER GROSSMAN

11:30PM WEST PALM BEACH, FLORIDA, USA
Twenty years ago, the photographer and her two
best friends promised to celebrate the millennium
together "no matter what." KELLY FULTON

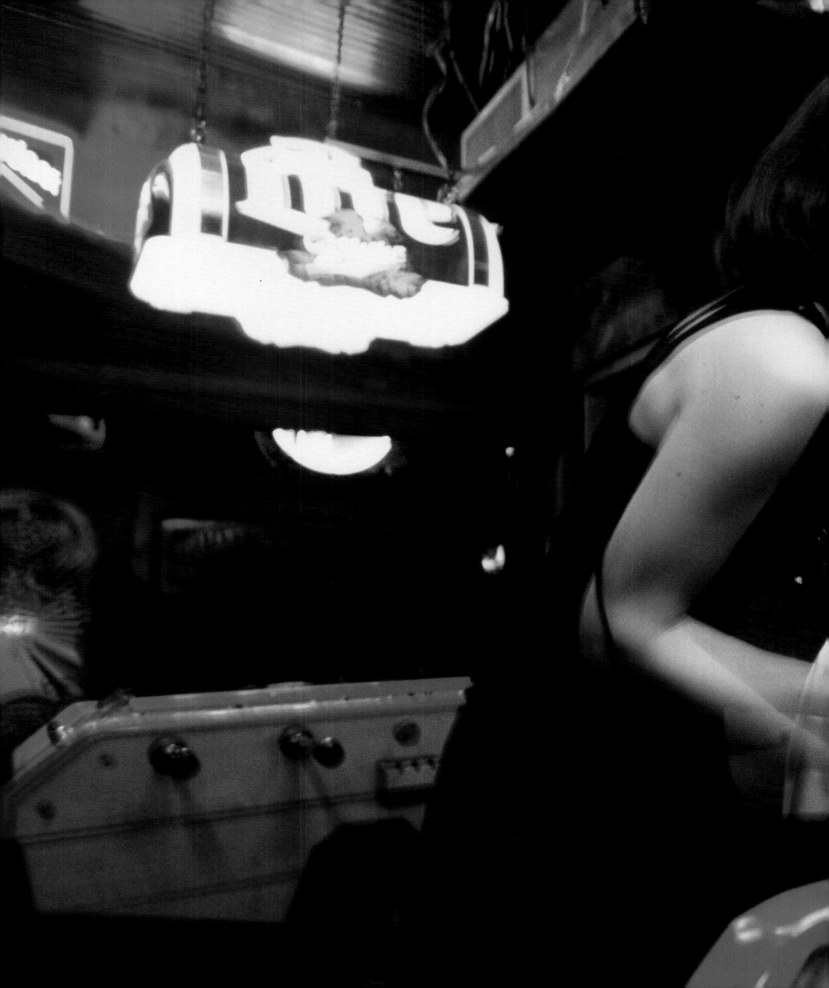

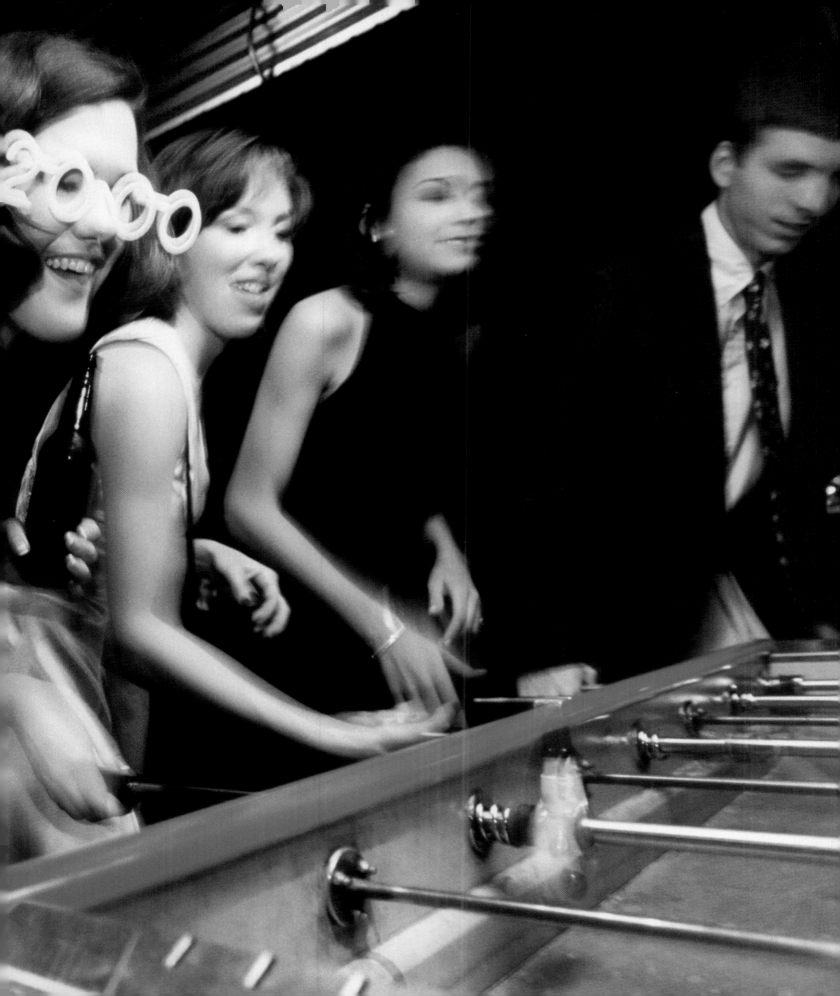

◄

(PRECEDING PAGE) 11:40PM CHAPEL HILL, NORTH CAROLINA, USA
Three former college roommates reunite to celebrate New Year's and play
foozeball at 23 Steps, a bar in Chapel Hill.
JEFFREY CAMARATI

10:30AM BOLIVAR, TENNESSEE, USA
The new year doesn't change much for
this old man. FRANCES BOYD
▼

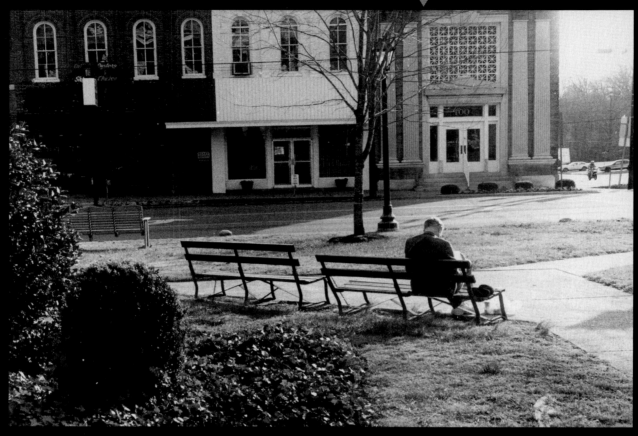

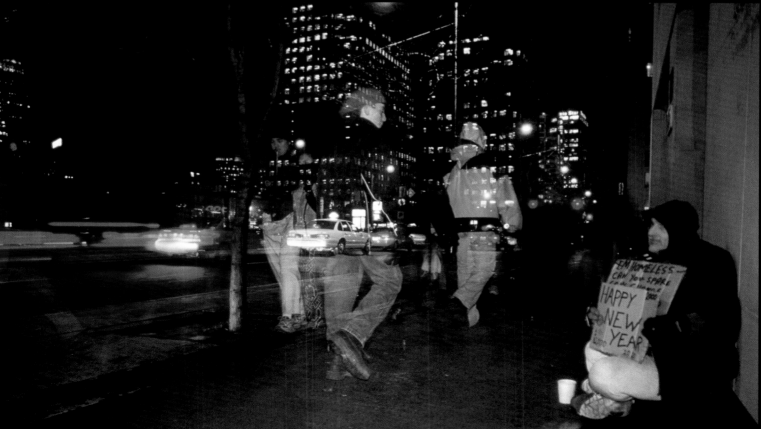

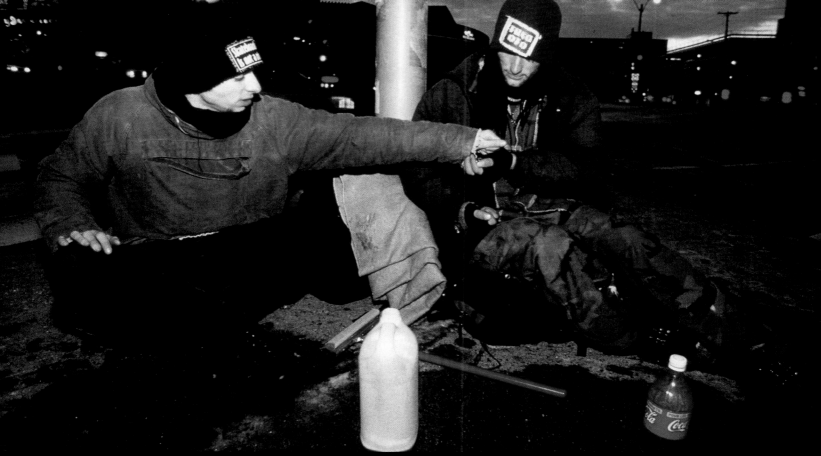

4:35PM HALIFAX, CANADA
Shaun and Philippe are trying to earn enough from washing car windows to buy tickets to an all-night rave party.
JAMES DIKAIOS

9:03PM TORONTO, CANADA
The photographer writes: "This beggar is invisible to passers-by, but in this picture, it is they who are invisible."
JOHN APOSTOL

3PM DHAKA, BANGLADESH
For the slum dwellers of Dhaka, New Year's Eve is just another day, filled with the routines of finding work as day labourers, and gathering waste paper to fuel the fire. DIRK FRANS

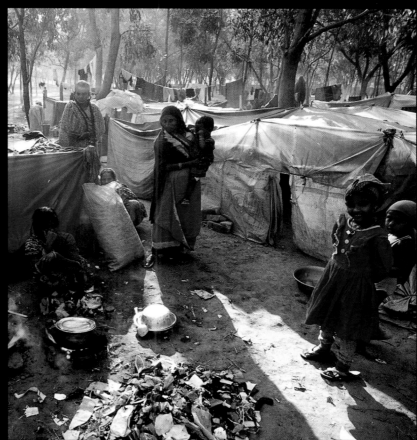

(NEXT PAGE) 7:30PM CARTAGO, COSTA RICA
Locals wait to phone friends and relatives.
MARCO SABORIO

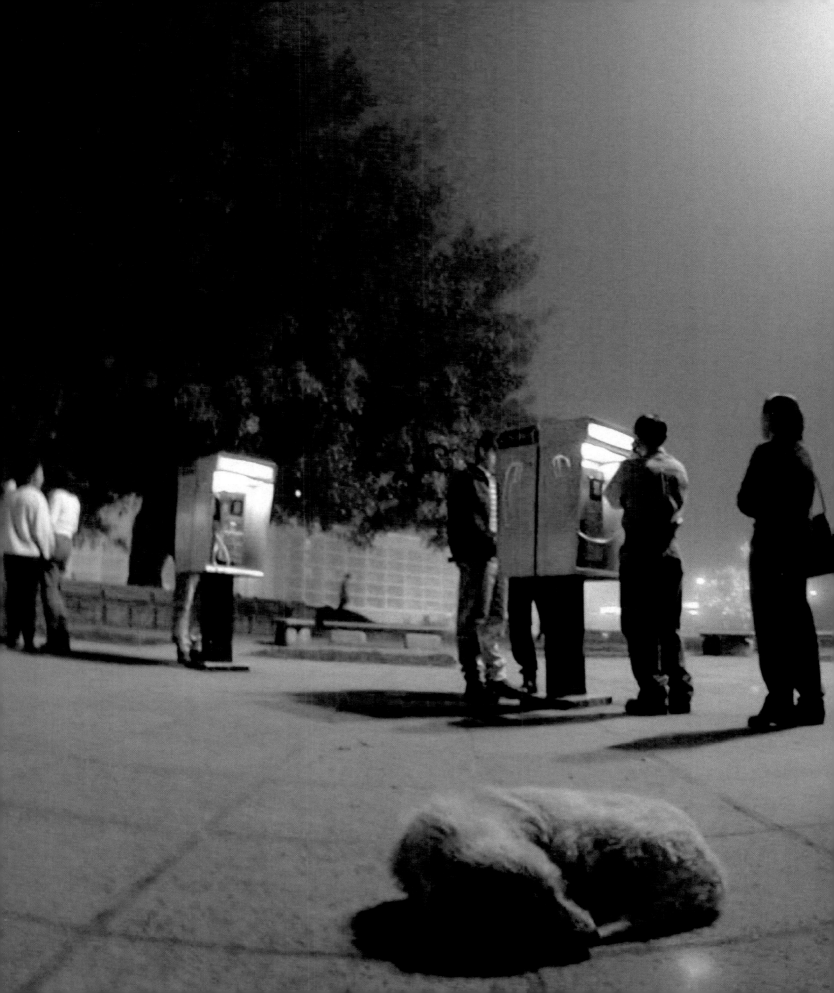

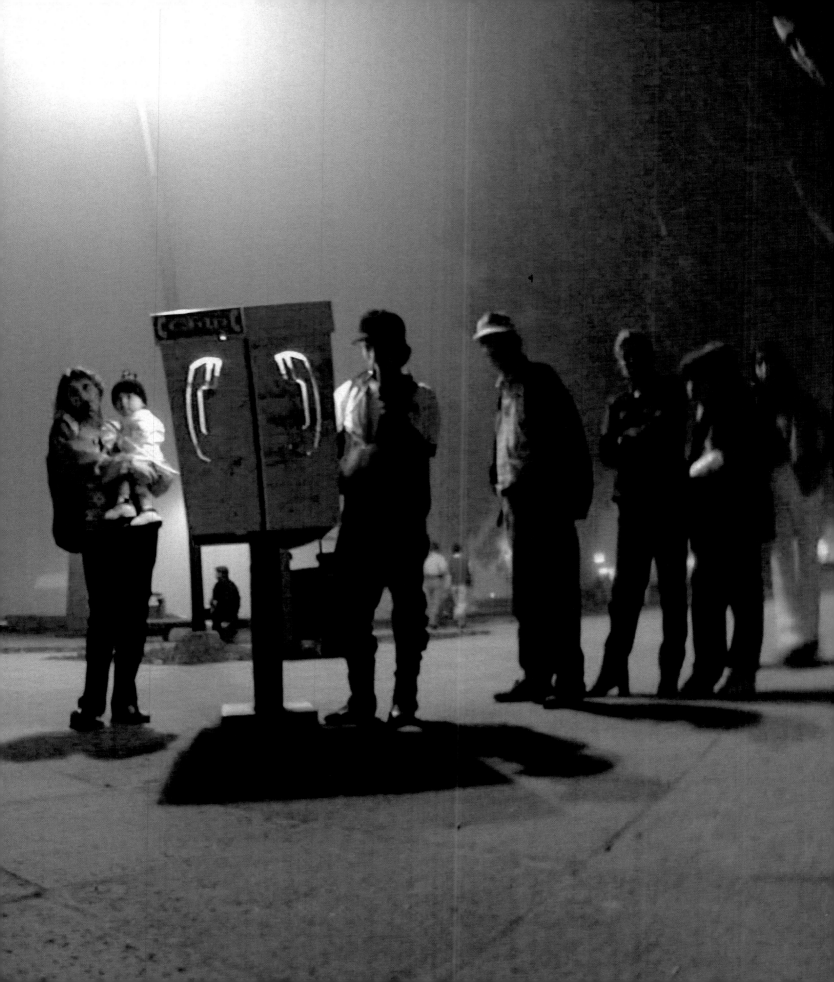

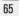
11:30AM ISLAND OF JOST VAN DYKE, BRITISH VIRGIN ISLANDS
Twenty-two friends planned this get-together in 1997. All of them, plus their guide, made it. RICHARD CASS

12:30PM WAPENGO, AUSTRALIA
Kim, Isabel, and Ramone joined thirty friends who gathered from all over Australia at a "bush block" (campground) to welcome the New Year.
AMANDA DALGLEISH

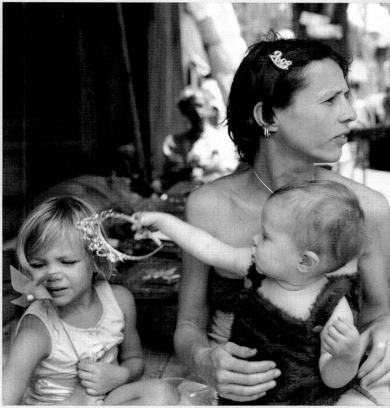

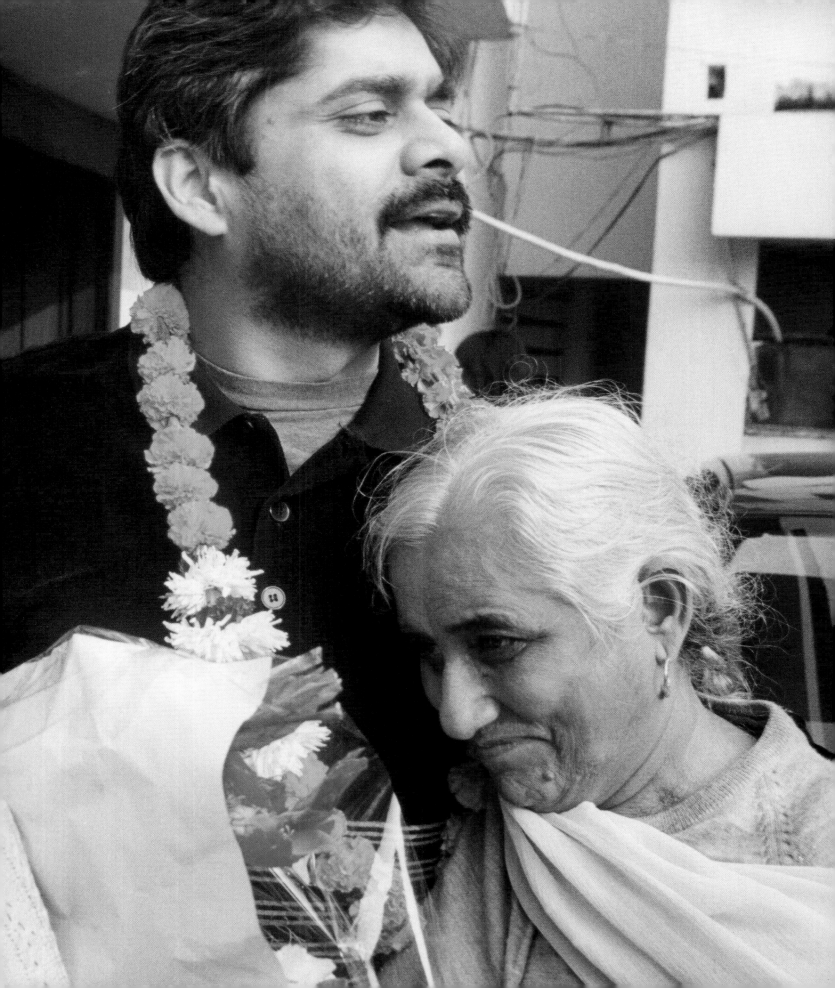

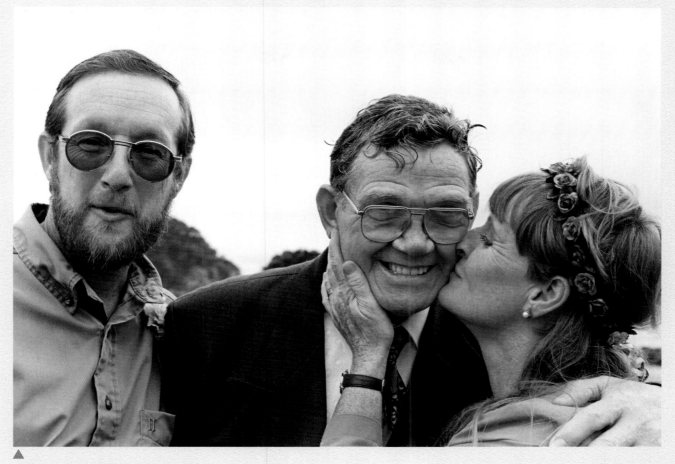

8:30AM TAURANGA, NEW ZEALAND
Hazel McKay kisses her father following his arrival from the UK for her marriage to Angus McKay (on left).
The couple were married once before but divorced five years ago. Twelve months ago they met in
Zimbabwe, rekindled their love, and decided to remarry in their old home town of Tauranga. JOHN PETERSON

10AM NEW DELHI, INDIA
The immense relief is tangible as this man returns
home safe after being held hostage aboard the
hijacked Indian Airlines Flight C814. VINAYAK PRABHU

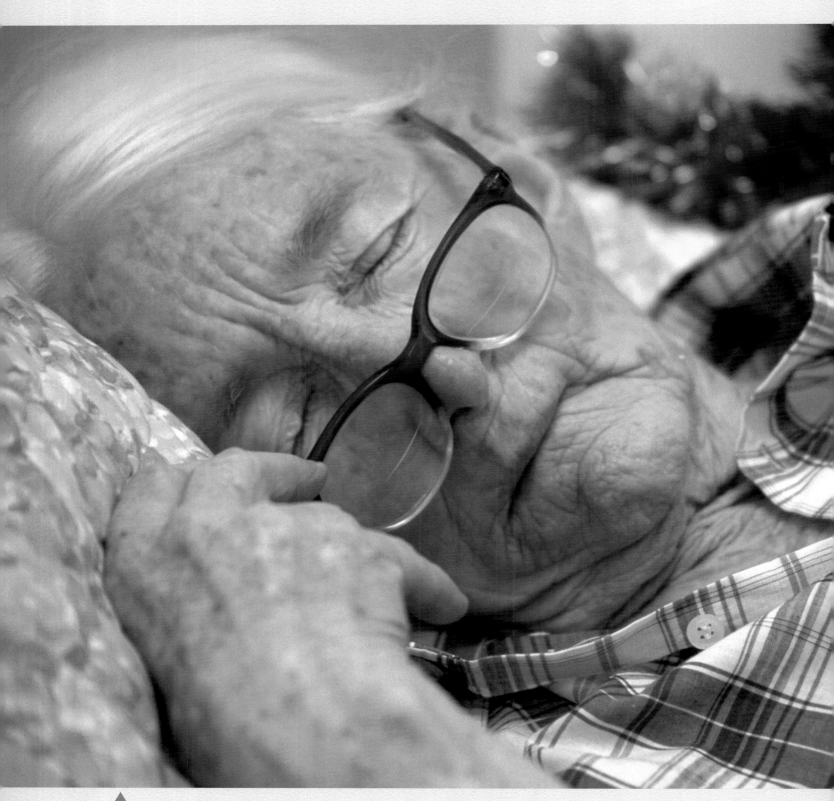

▲
9:30PM NELSPRUIT, SOUTH AFRICA
Peggy eases her way out of the old millennium and into
the new at a retirement village in Nelspruit. RICHARD WILSON

3:30AM ELKTON, MARYLAND, USA
An emergency X-ray has come back
negative, and this woman can now
return home with her daughter.
HENRY FARKAS

11:30AM SALTHILL, GALWAY, IRELAND
After a ten-year absence, the photographer
returned to visit her aunt and uncle at their
bed and breakfast in Galway – "the best
New Year's Day I have ever had!" CIARA O'SHEA

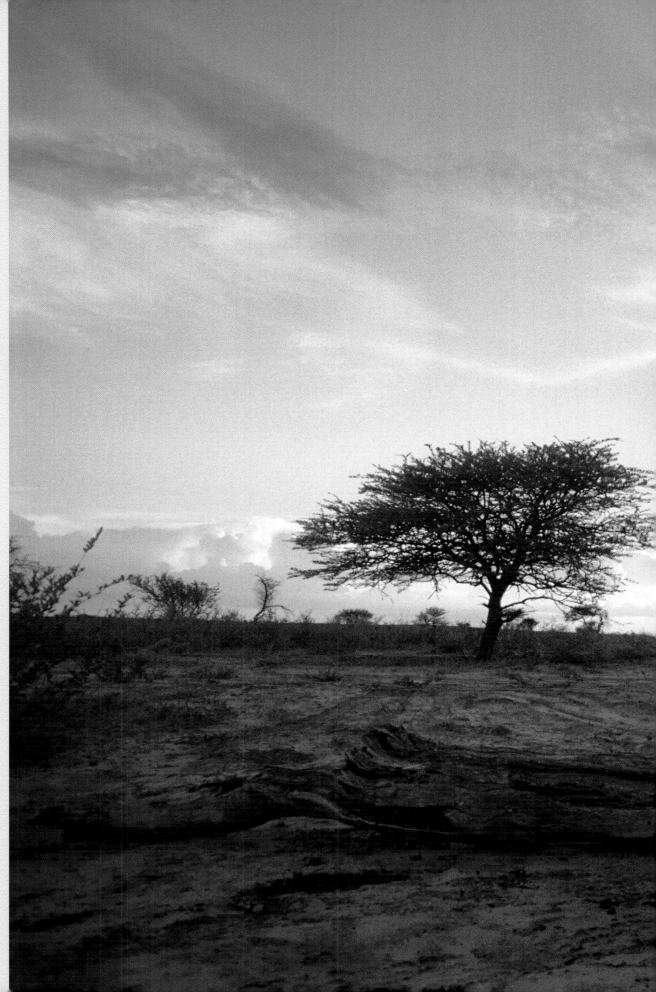

▶
4PM CENTRAL KALAHARI GAME RESERVE, BOTSWANA The photographer chose to spend New Year's Eve in the Kalahari Desert because it was "the most serene place I could imagine."
KATHARINE SCHÄFLI

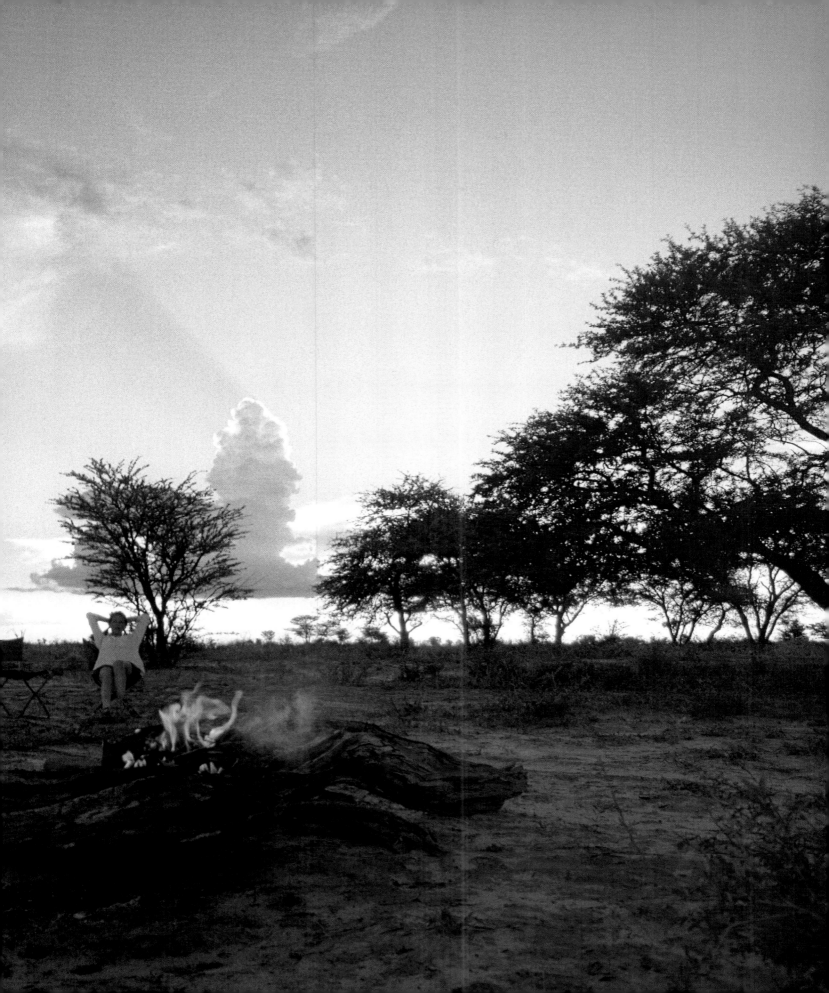

Work

ing

For some, New Year's Eve is just another working shift. Others – hotel and restaurant workers among them – help prepare for elaborate parties and meals.

Behind the scenes, nurses, doctors, paramedics, firemen, and policemen gear up for a busy night. And in the most anticlimactic run-up to the new millennium, experts around the world stand ready to avert the dreaded "Y2K" breakdown of computer systems.

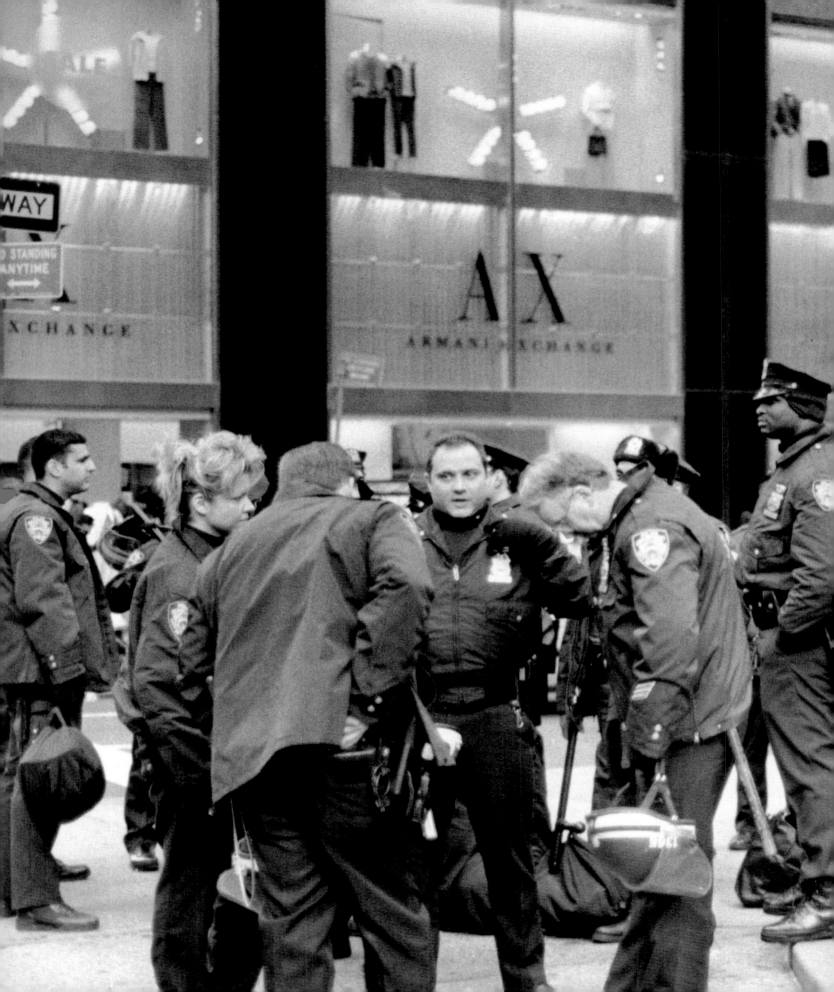

◀ **4PM NEW YORK CITY, USA**
Some of the eight thousand police on duty to handle the two million people expected in and around Times Square. REBECA BARROSO

▶

(NEXT PAGE) 6PM BLOOMINGTON, MINNESOTA, USA
Northwest Airlines employees monitor flights around the world, prepared to assist pilots in case of emergency.
TOM MERCHANT

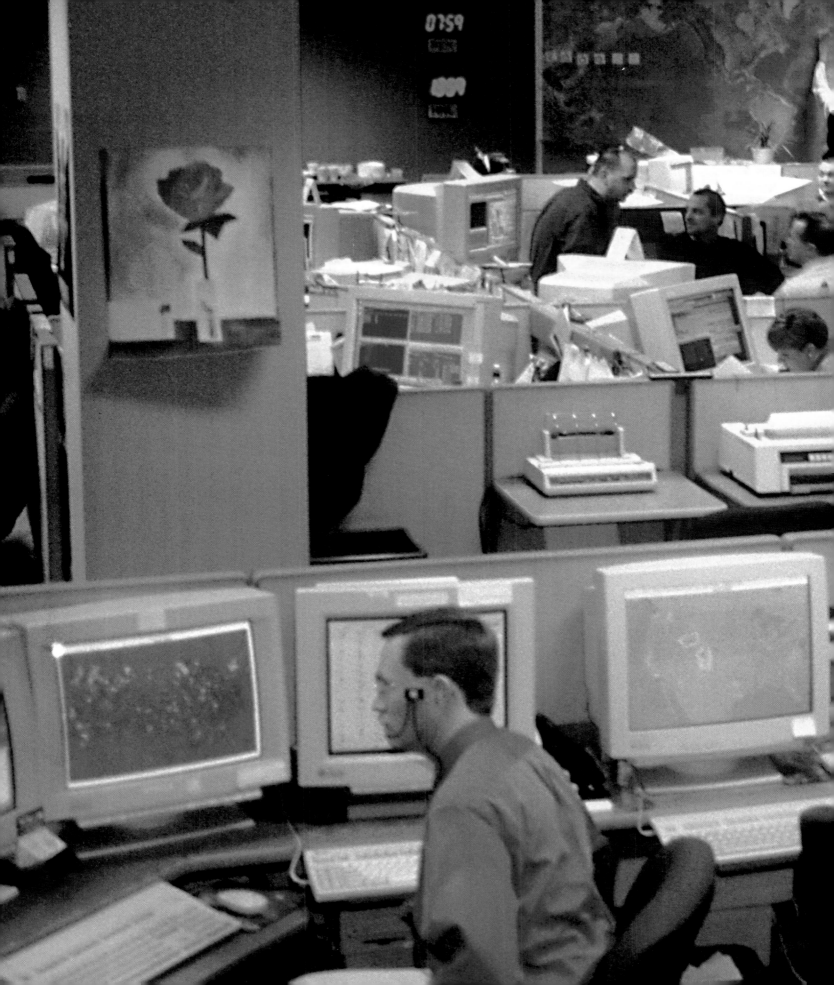

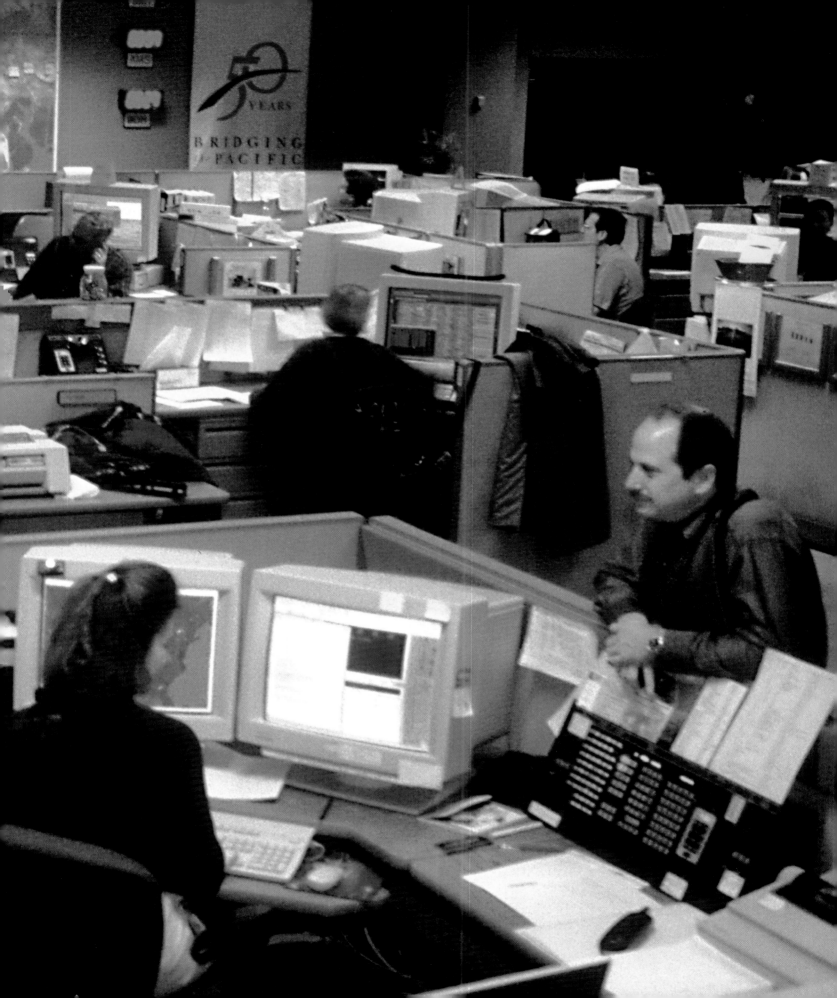

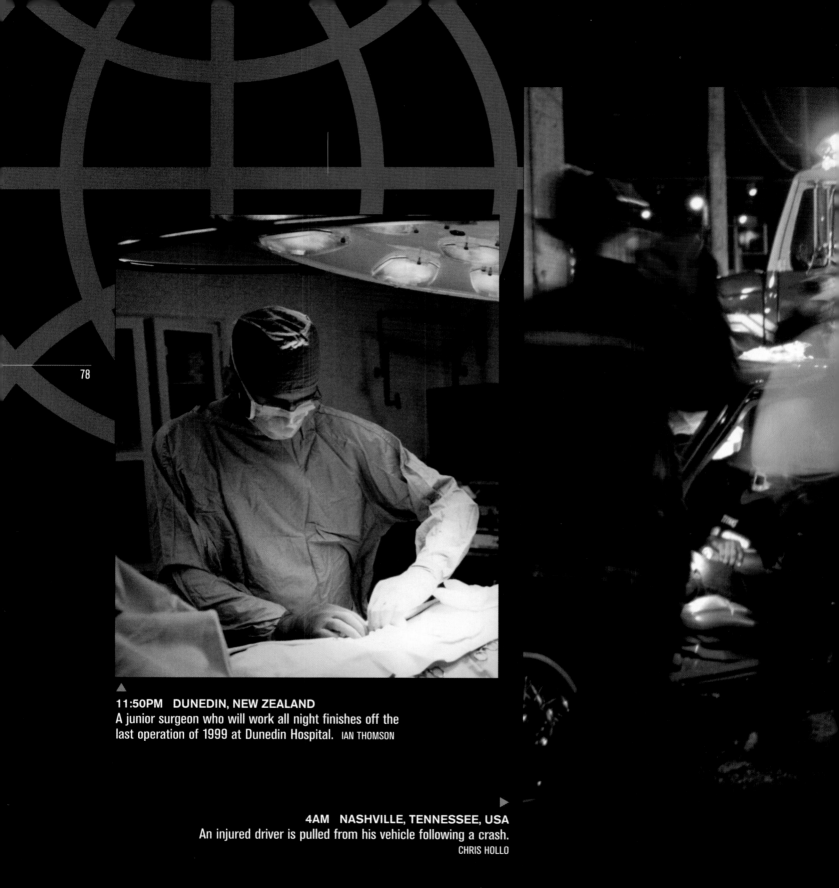

11:50PM DUNEDIN, NEW ZEALAND
A junior surgeon who will work all night finishes off the
last operation of 1999 at Dunedin Hospital. IAN THOMSON

4AM NASHVILLE, TENNESSEE, USA
An injured driver is pulled from his vehicle following a crash.
CHRIS HOLLO

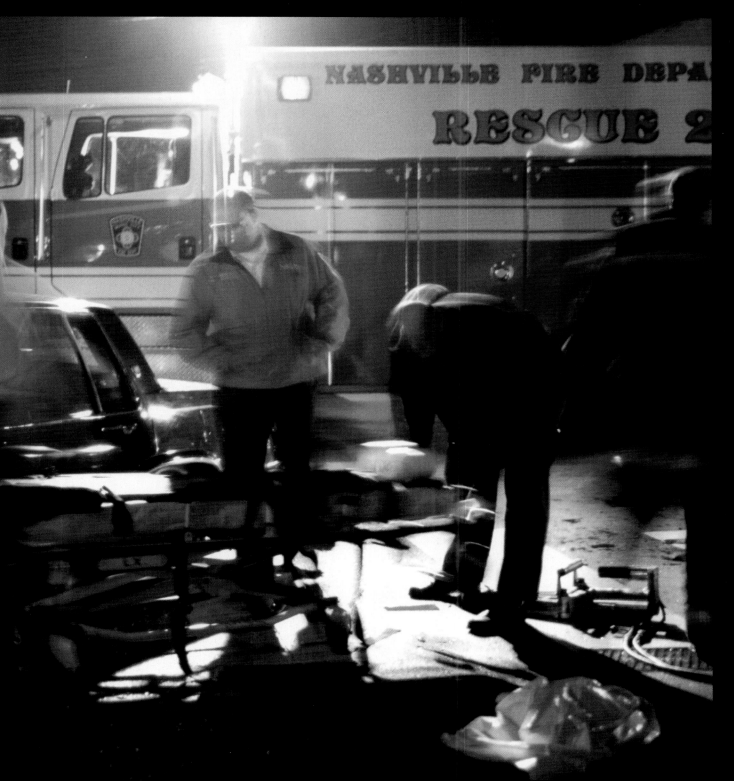

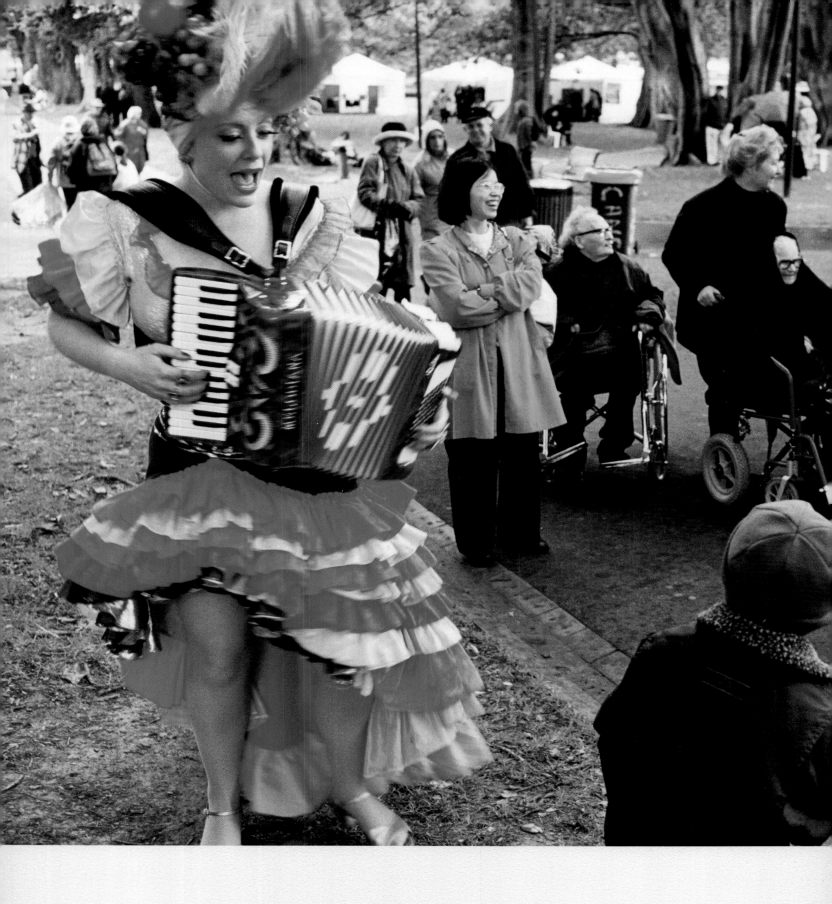

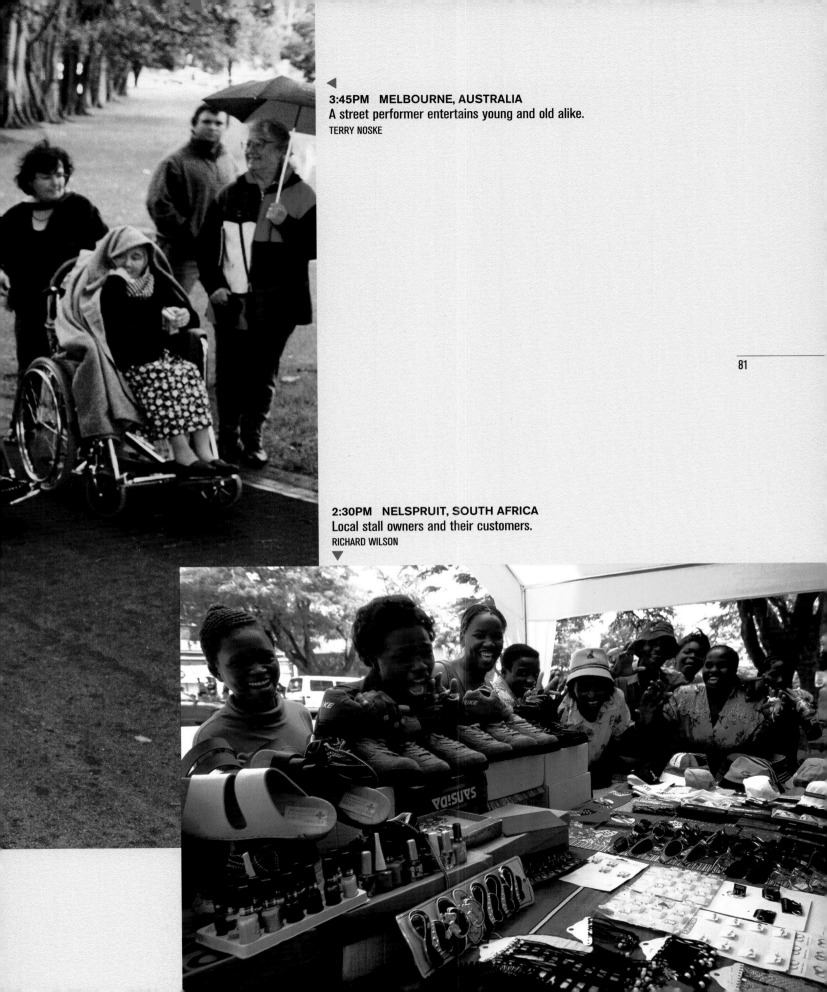

3:45PM MELBOURNE, AUSTRALIA
A street performer entertains young and old alike.
TERRY NOSKE

81

2:30PM NELSPRUIT, SOUTH AFRICA
Local stall owners and their customers.
RICHARD WILSON

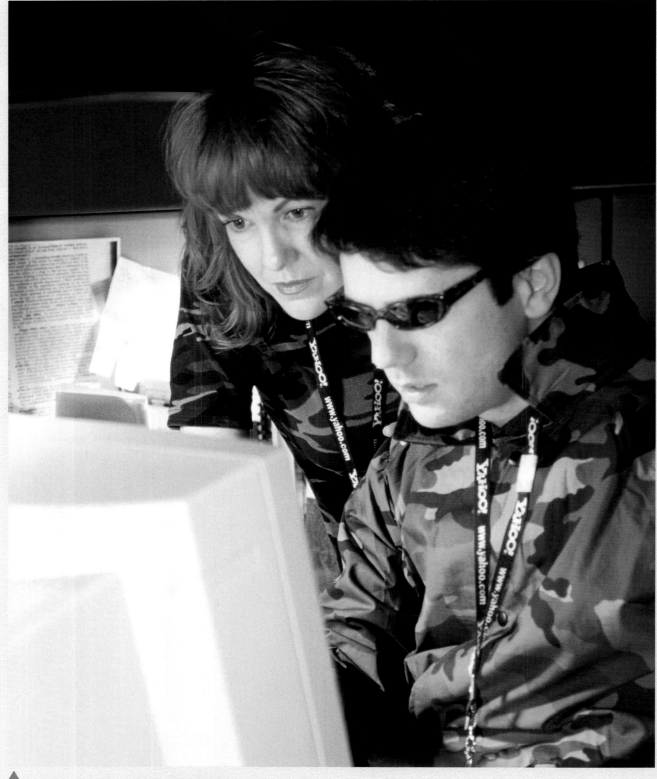

▲
7:15PM SILICON VALLEY, CALIFORNIA, USA
Technical support staff at Yahoo! stand by,
ready to wage war on any killer Y2K bugs.
BRAD PERKS

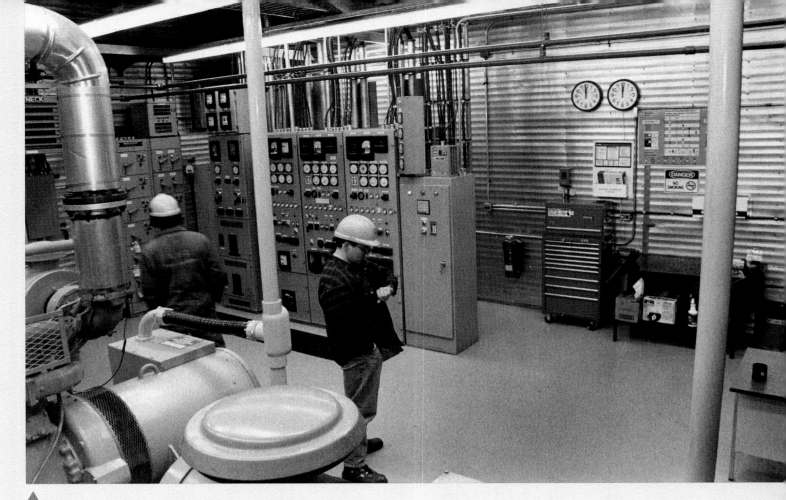

▲

11:59PM TSIIGEHCHIC, NORTH WEST TERRITORIES, CANADA
Seeing in the New Year at an electricity generating plant. GILAD KATZ

◄

5:50PM SUZHOU, CHINA
Serving early dinner in a local restaurant. XIAOJUN YANG

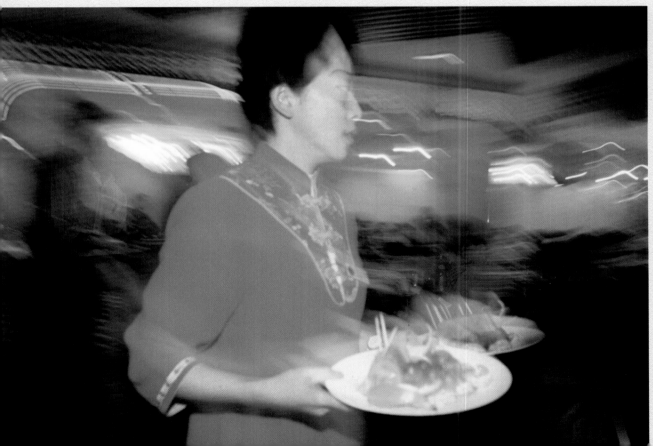

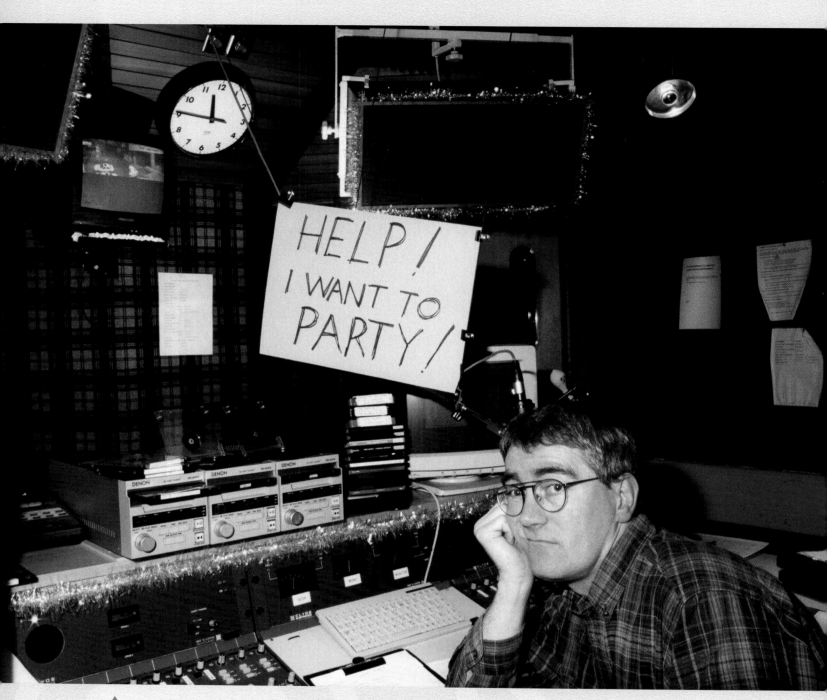

▲
23:46PM DUNDEE, SCOTLAND
Working the midnight shift at Tay FM Studio 2.
WARD MCGAUGHRIN

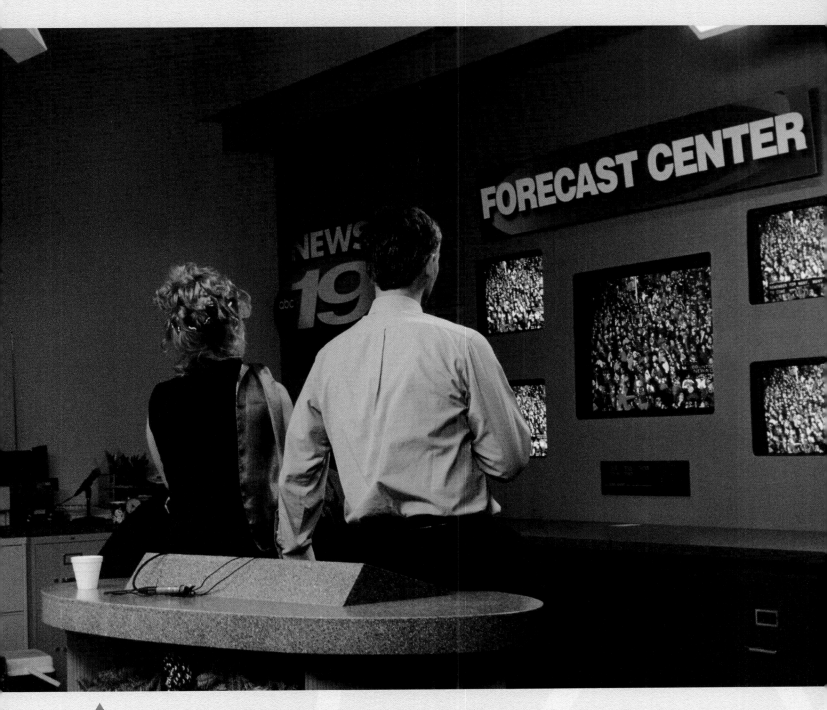

★ **11PM LA CROSSE, WISCONSIN, USA**
The local TV station's chief meteorologist and his wife watch millennium celebrations around the globe.
The screens are usually tuned to different weather feeds. JAMIE POWERS

(NEXT PAGE) 4PM XINHUI, CHINA ★
A 'Duck Steward' feeds three thousand
ducks their last meal of the millennium.
SHANJI ZHAO

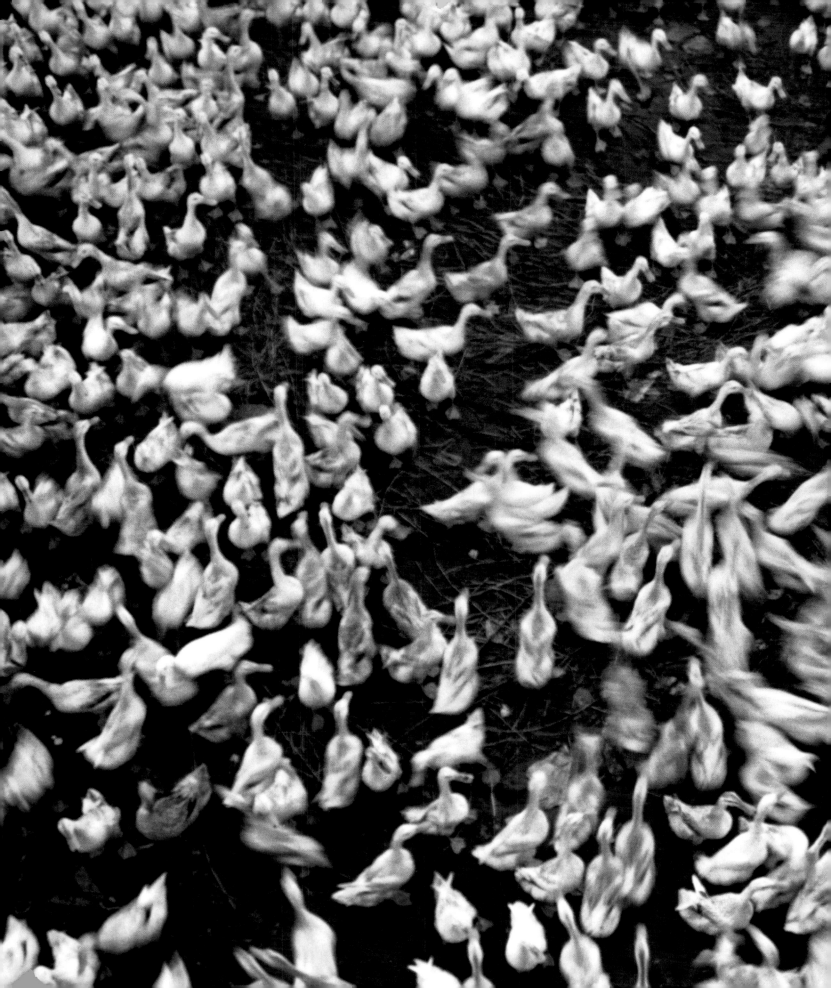

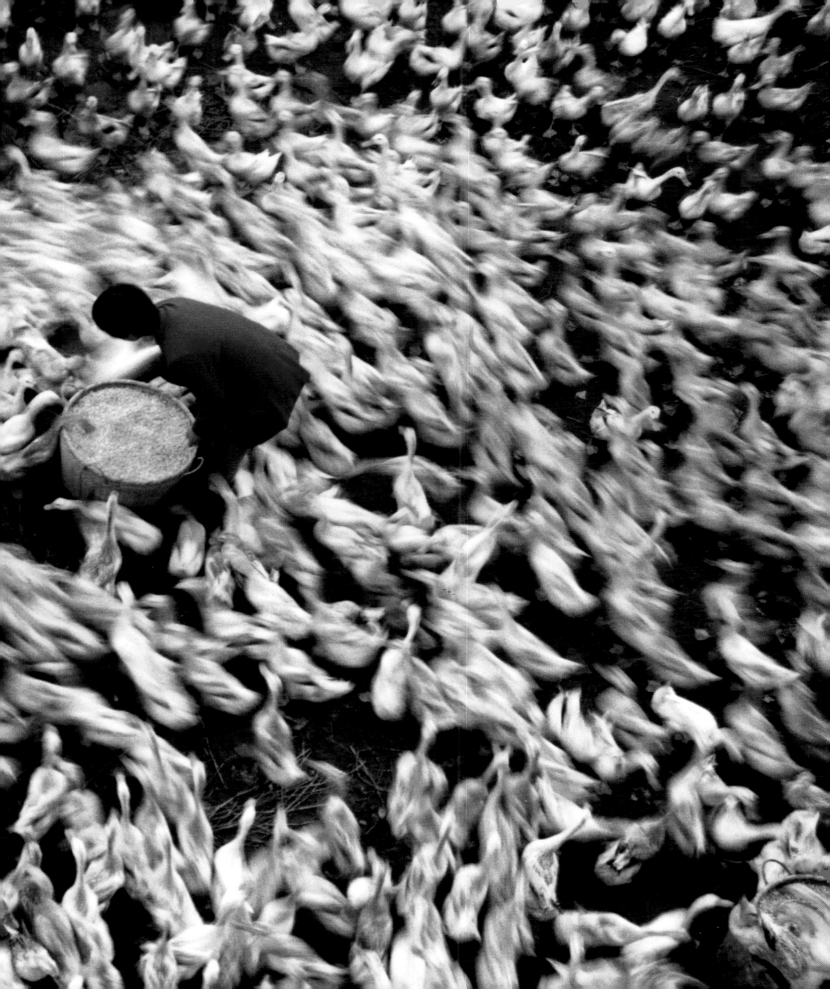

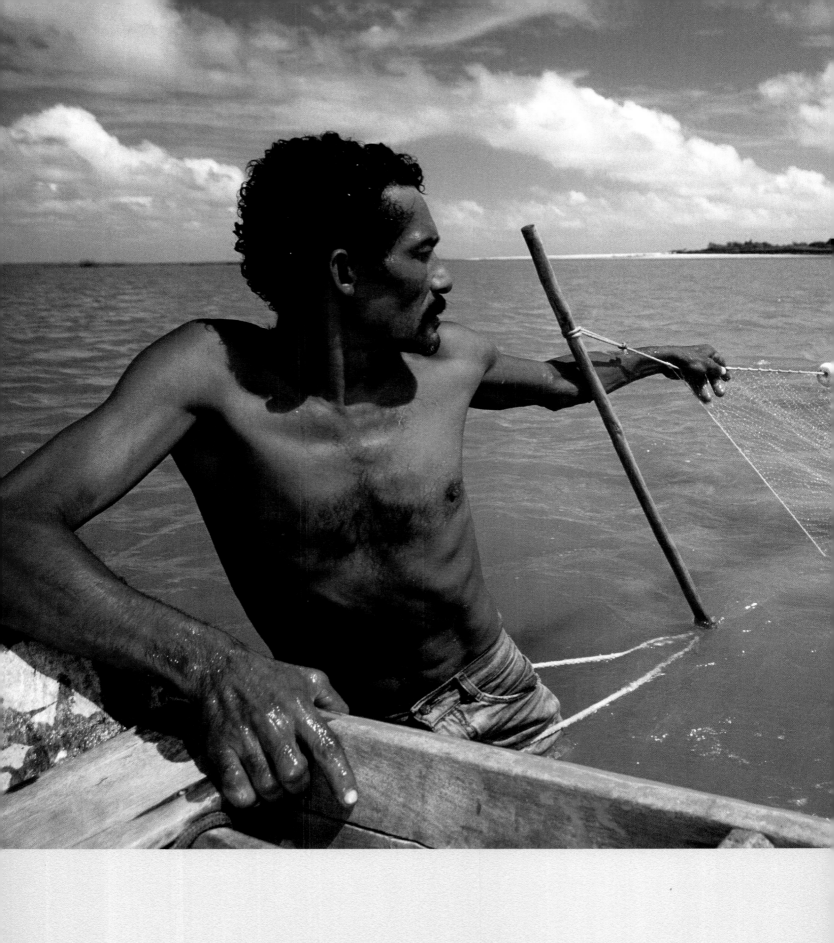

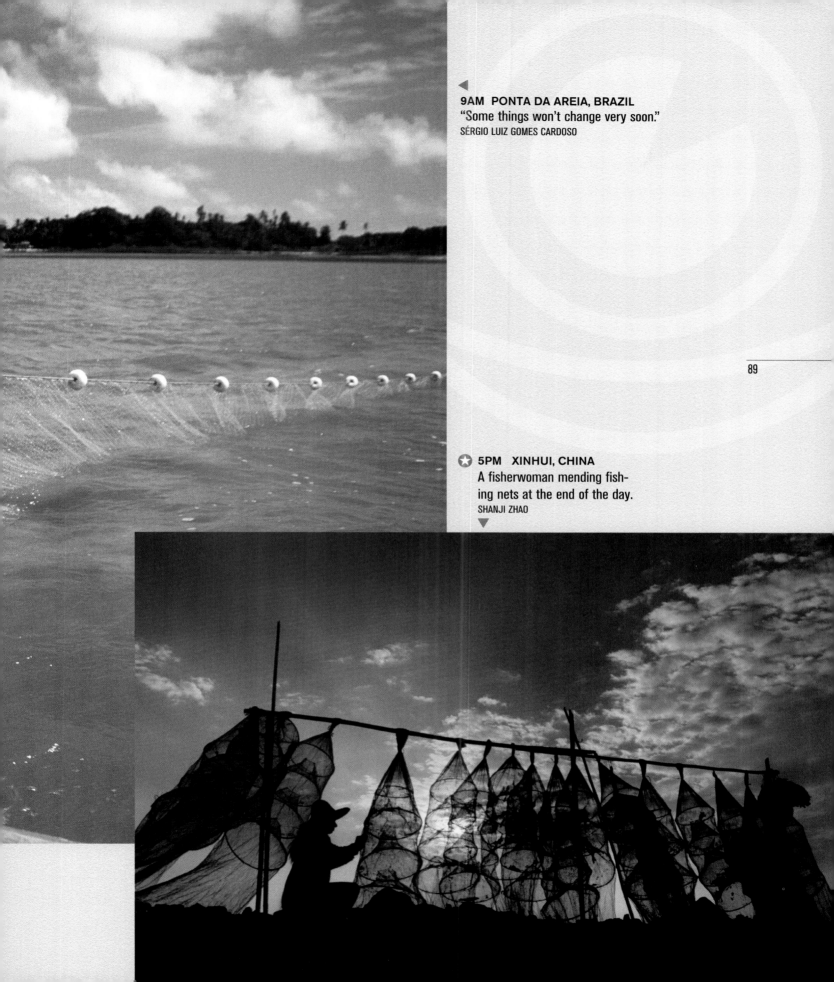

9AM PONTA DA AREIA, BRAZIL
"Some things won't change very soon."
SÉRGIO LUIZ GOMES CARDOSO

89

5PM XINHUI, CHINA
A fisherwoman mending fishing nets at the end of the day.
SHANJI ZHAO

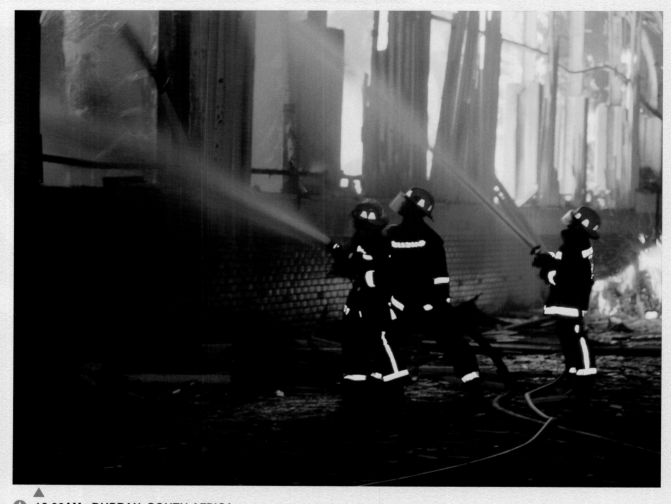

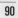 **12:20AM DURBAN, SOUTH AFRICA**
It took five hours to extinguish this huge blaze at a paper warehouse, thought to have been started by a stray firework.
EMANUEL MARIA

6PM PHOENIX, ARIZONA, USA
People worried about power outages stocked up on propane, as this service station attendant points out.
MARK J. PHILLIPS

▲
3AM FORT COLLINS, COLORADO, USA
In this college town, even the students have gone home, and
there's nothing for the police to do but return to the station.
RICHARD MIODONSKI

▶
2AM NASHVILLE, TENNESSEE, USA
Two policemen write up an injury report
for a homeless man. CHRIS HOLLO

Events

Around the globe, the usual big parties are under way, but some special events have been in the planning for years. Elaborate parades and even mass weddings are held. In public squares and stadiums, huge crowds begin to congregate.

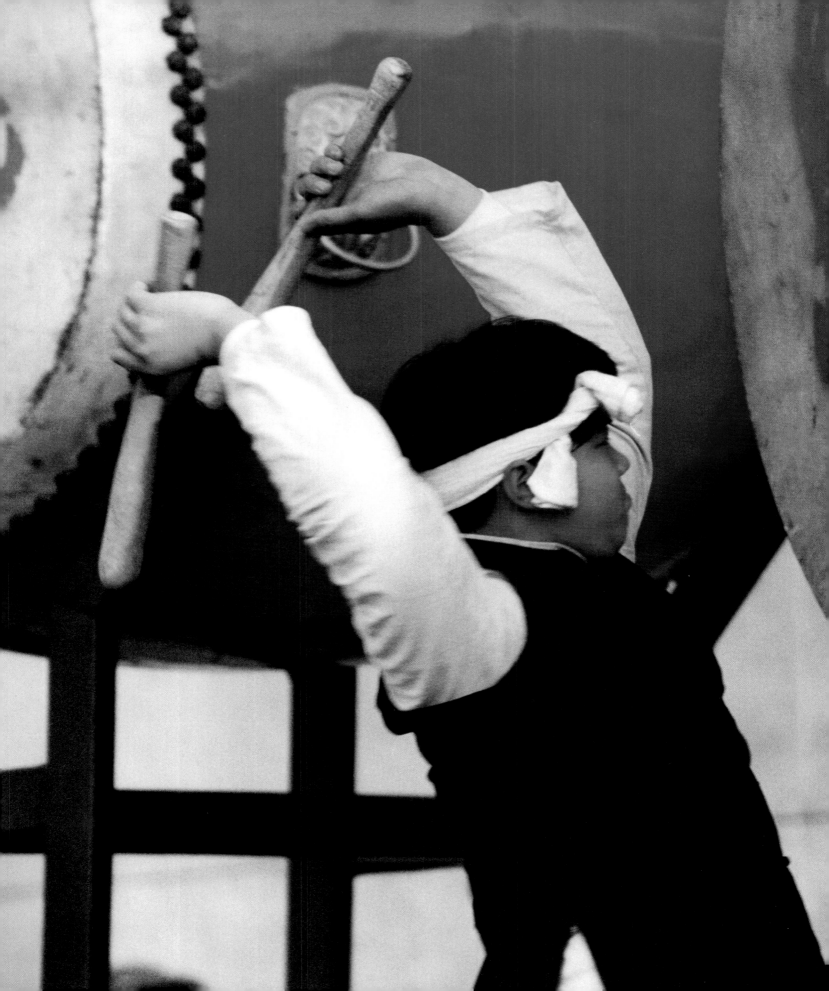

◄
3PM HANGZHOU, CHINA
Drummers perform in Wushan Square – a traditional
way of greeting the New Year in China.
XU JIAN

▲
6:45PM SALFORD QUAYS, MANCHESTER, ENGLAND
The much anticipated lighting of the lanterns is part of the
parade of lights at Salford Quays. DIANA MARTIN

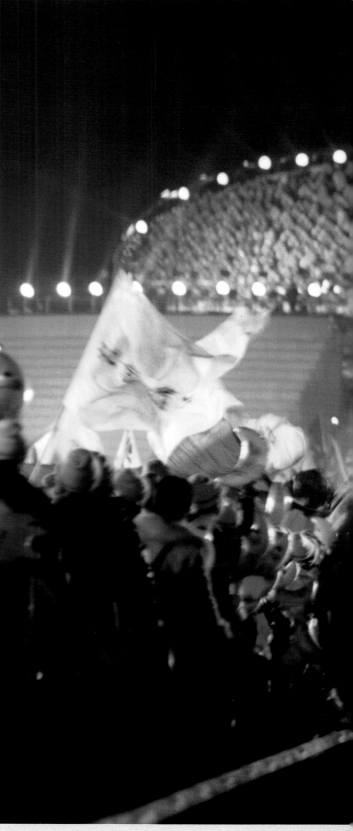

▶ 11:10PM BEIJING, CHINA
A dance performance under
way as midnight nears.
JAMES HUANG ZENG

98

▲
2AM BARROW, ALASKA, USA
Games of endurance are a New Year's tradition among the Inupiat
Inuit in Alaska. Eli Kagak winner of "Four Men Carry" succeeded
by walking one and-a-half times around a basketball court like
this. LUCIANA WHITAKER-AIKINS

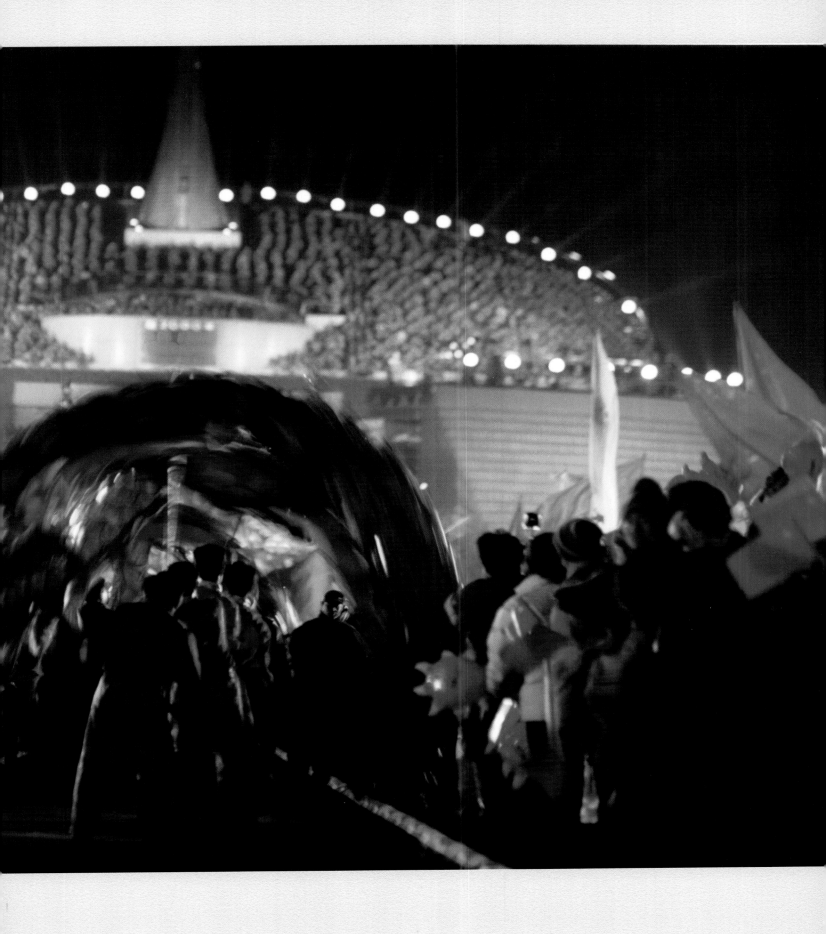

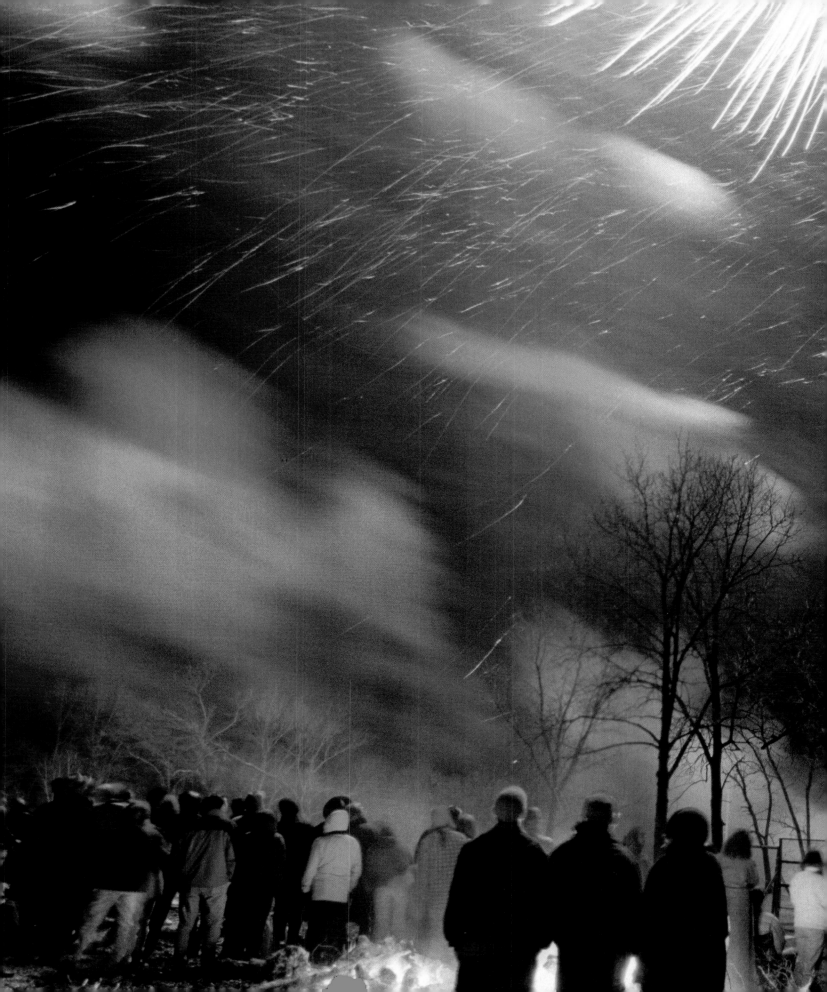

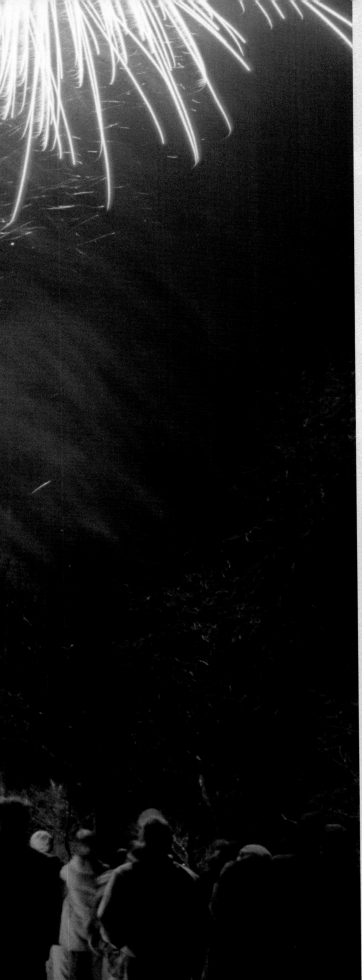

11PM RIVER JUNCTION, IOWA, USA
A fireworks display near midnight.
JONATHAN SABIN

101

9:30PM REYKJAVIK, ICELAND
Local residents enjoy a bonfire and sparklers.
EINAR OLI EINARSSON

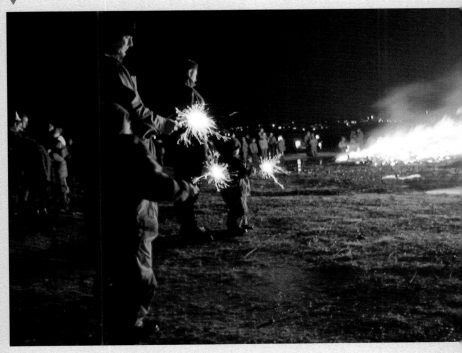

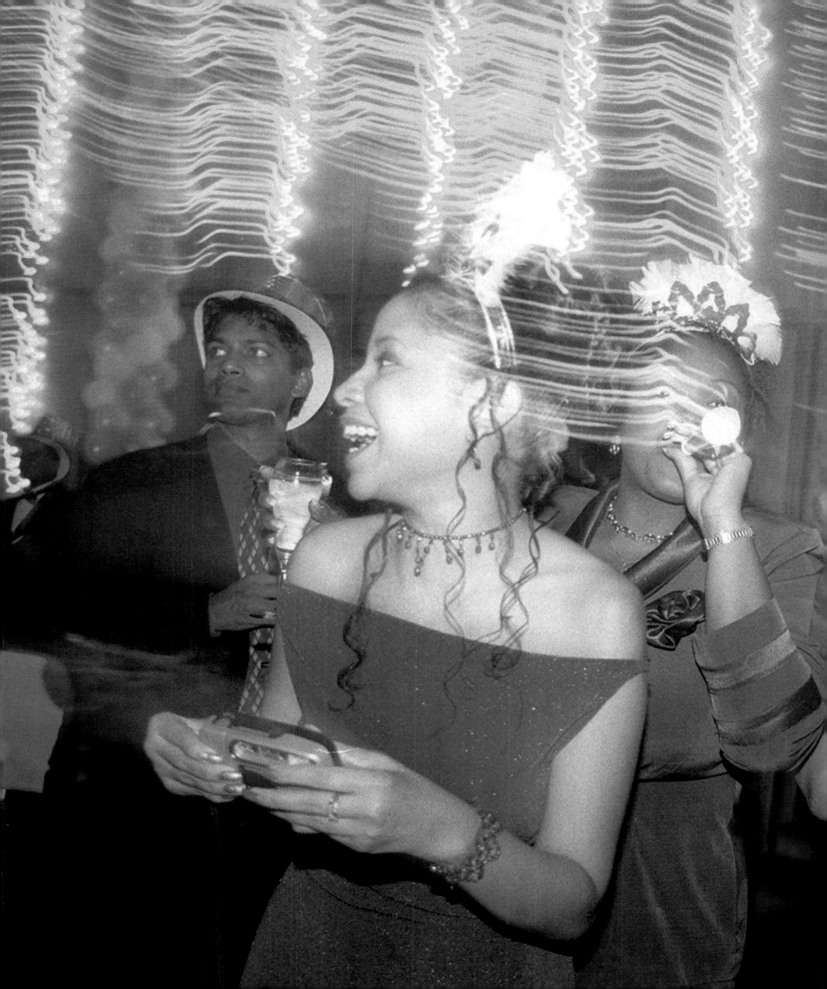

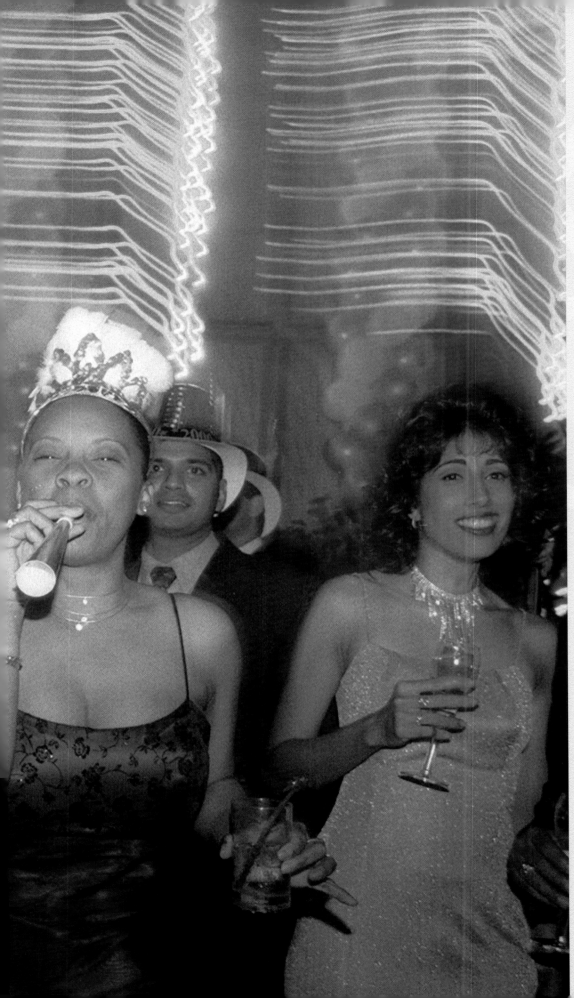

◄ **MIDNIGHT HILTON HOTEL, TRINIDAD**
Guests at a society ball on the stroke of
midnight. COLIN SHEPHERD

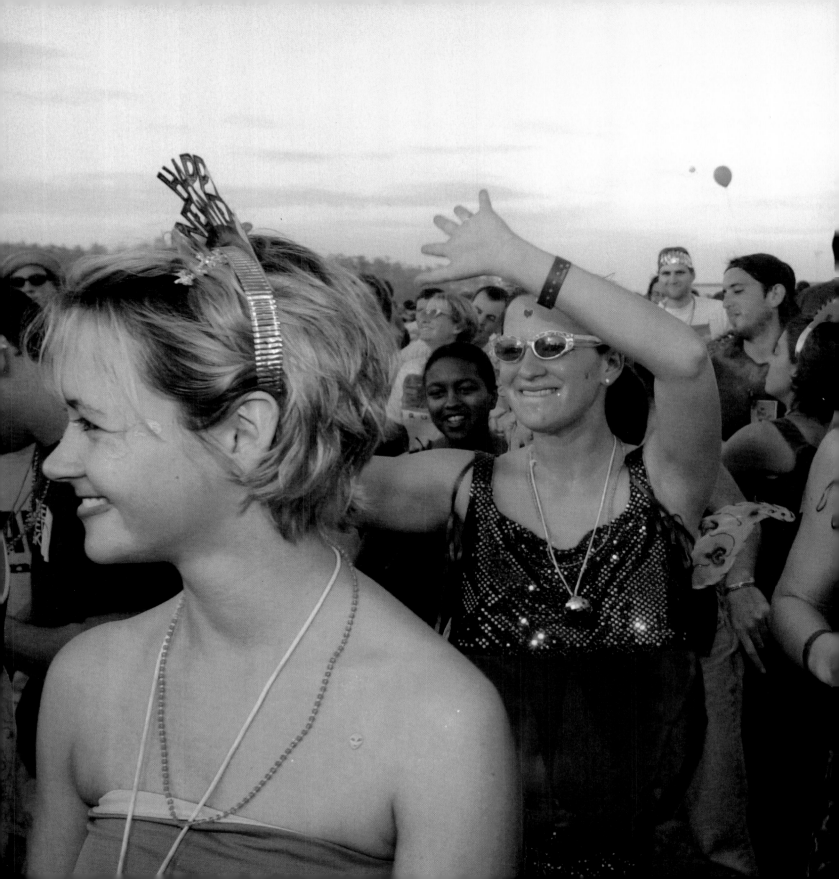

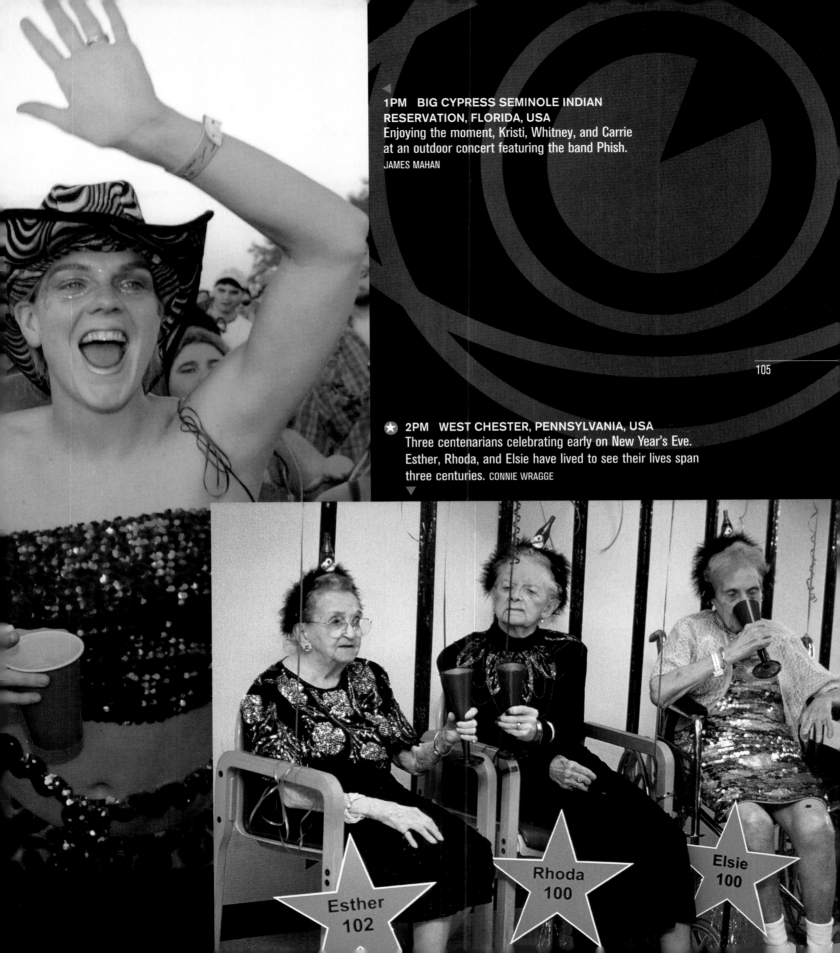

1PM BIG CYPRESS SEMINOLE INDIAN RESERVATION, FLORIDA, USA
Enjoying the moment, Kristi, Whitney, and Carrie at an outdoor concert featuring the band Phish.
JAMES MAHAN

105

★ **2PM WEST CHESTER, PENNSYLVANIA, USA**
Three centenarians celebrating early on New Year's Eve. Esther, Rhoda, and Elsie have lived to see their lives span three centuries. CONNIE WRAGGE

Esther
102

Rhoda
100

Elsie
100

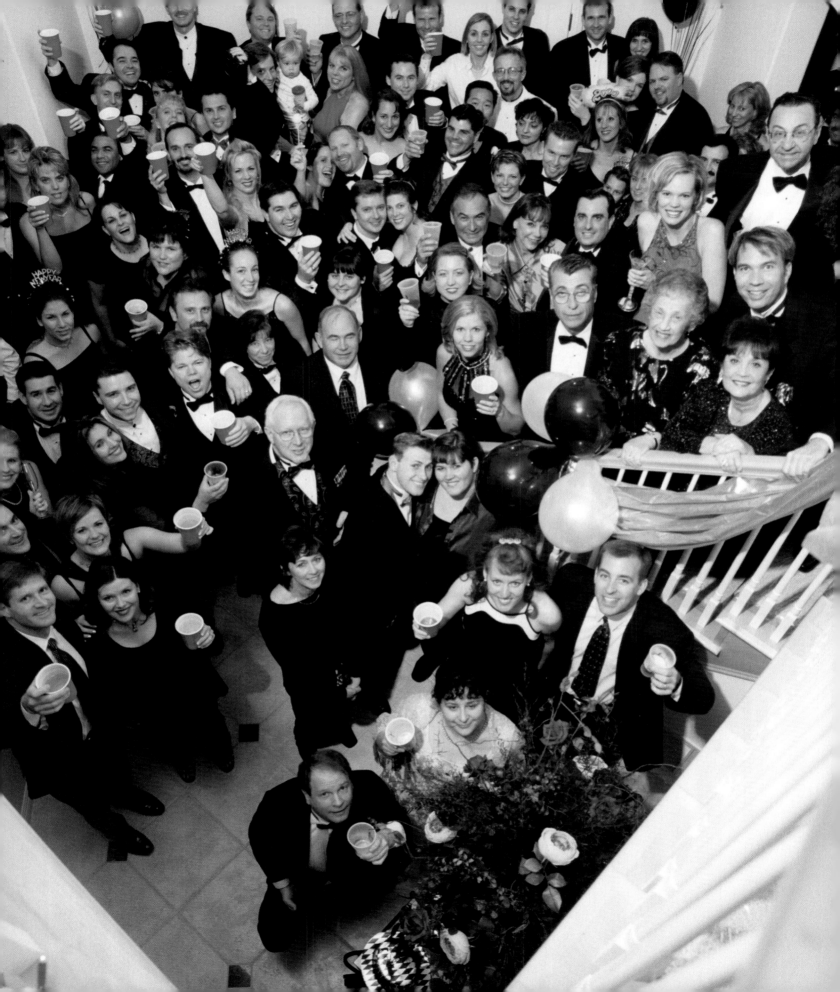

◄
11PM SAN DIEGO, CALIFORNIA, USA
A toast to the New Year in classic style.
TIM OTTO

◄
1:30PM BIG CYPRUS SEMINOLE INDIAN RESERVATION, FLORIDA, USA
Eighty thousand people gathered here for a concert to ring in the New Year.
SARA GALLUP

►
(NEXT PAGE) 11AM PHILADELPHIA, PENNSYLVANIA, USA
Revellers strut their stuff at the annual Mummers' Parade.
CONNIE WRAGGE

2PM BOLTON, ENGLAND
GARY TAYLOR

7:15PM PERTH, AUSTRALIA
TOM MCGHEE

★ **10PM CHAPEL HILL, NORTH CAROLINA, USA**
ARTHUR SAWYERS

12:30AM TORINO, ITALY ★
RENATO VALTERZA

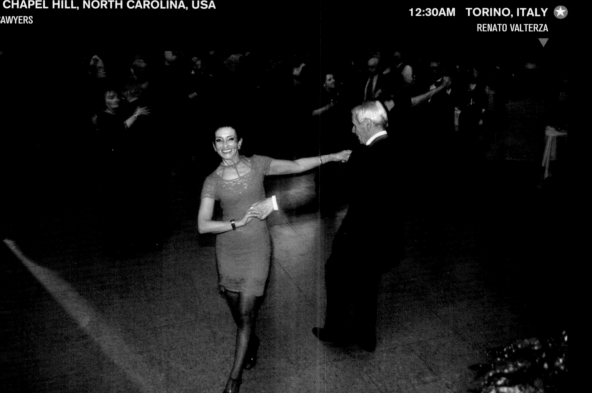

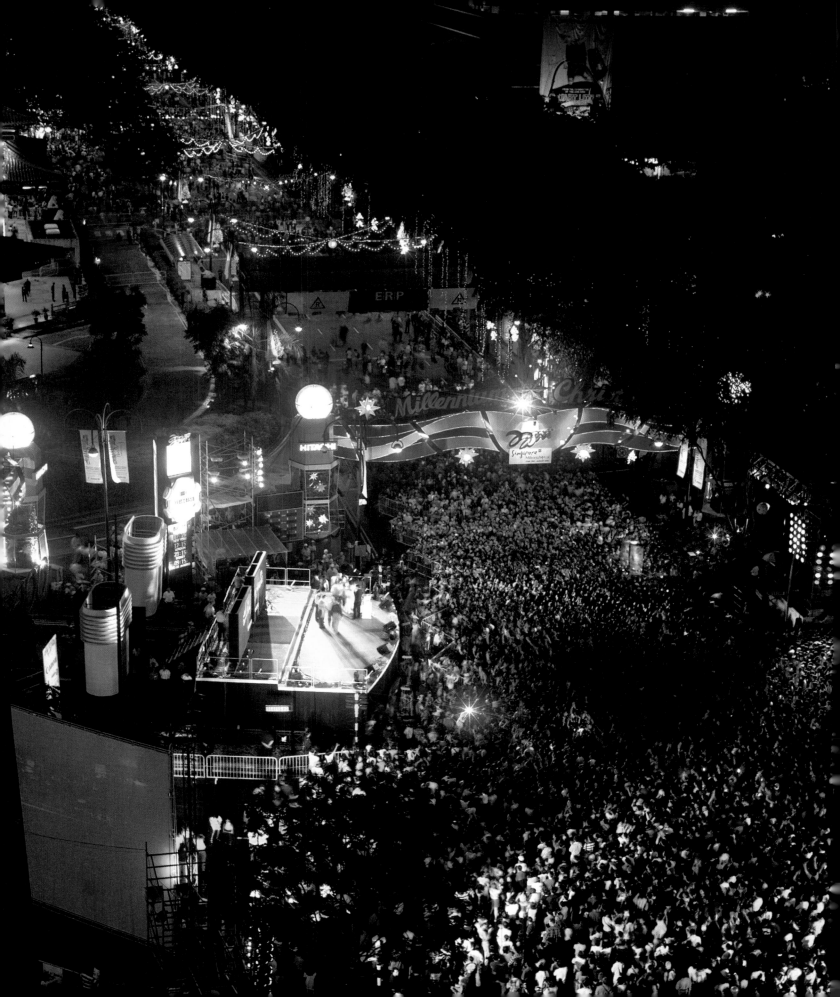

8:15PM SINGAPORE
Thousands gather in Orchard Rd. to wait for midnight.
DANIEL ZHENG FUJIA

9:30PM CALGARY, CANADA
Lisa Odjig, a well-known aboriginal
hoop dancer, performs before a
crowd of more than 20,000 people
at Olympic Plaza.
VINCENT JOACHIM

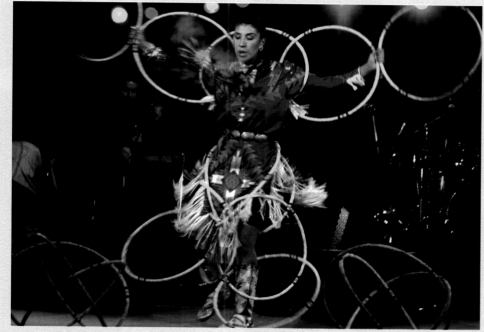

4PM BINTINSHAN, CHINA
A parade of drummers in this busy city.
HONGXUN GAO

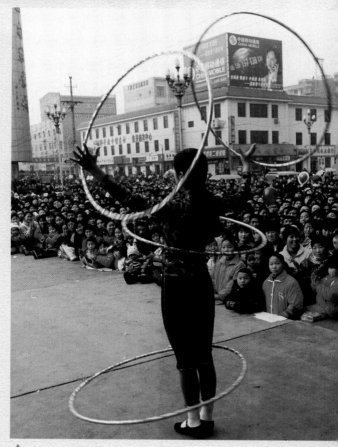

11:15AM BINTINSHAN, CHINA
Eighteen-year-old Wang Jin demonstrates her
hoop skills. HONGXUN GAO

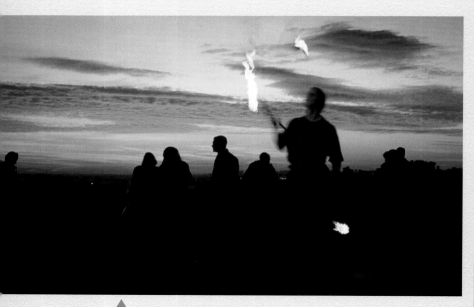

▲
6:30PM MADRID, SPAIN
Fire juggler at the Templo de Debod, where people
often gather to watch the sunset. JUAN FERRERO

▶
5:30AM BOROBUDUR, INDONESIA
A villager watches some of the doves released as
part of the local millennium celebrations. EDY PURNOMO

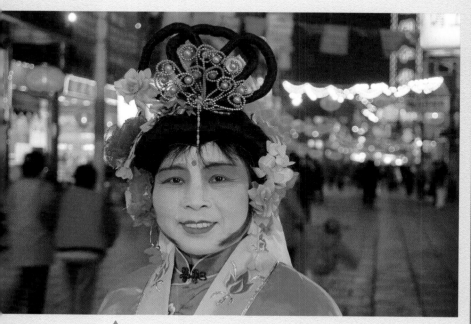

▲
7:20PM BEIJING, CHINA
Wearing traditional dress, this woman will perform a Chinese dance
on Dashalan, the oldest business street in Beijing. DONG-PING YUAN

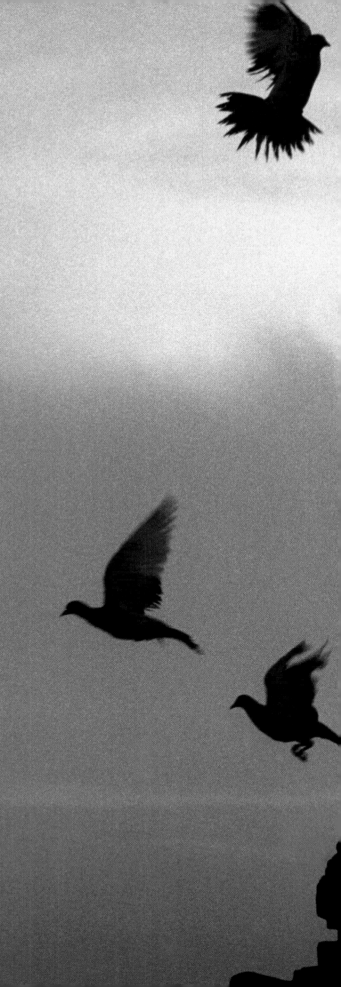

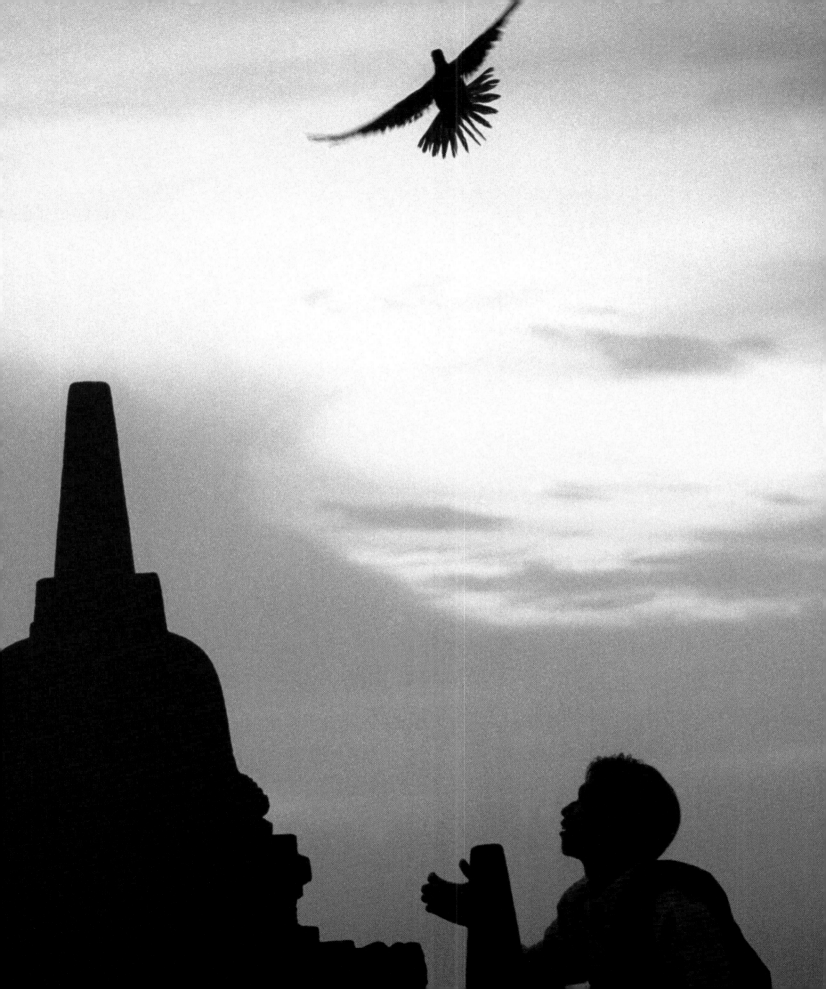

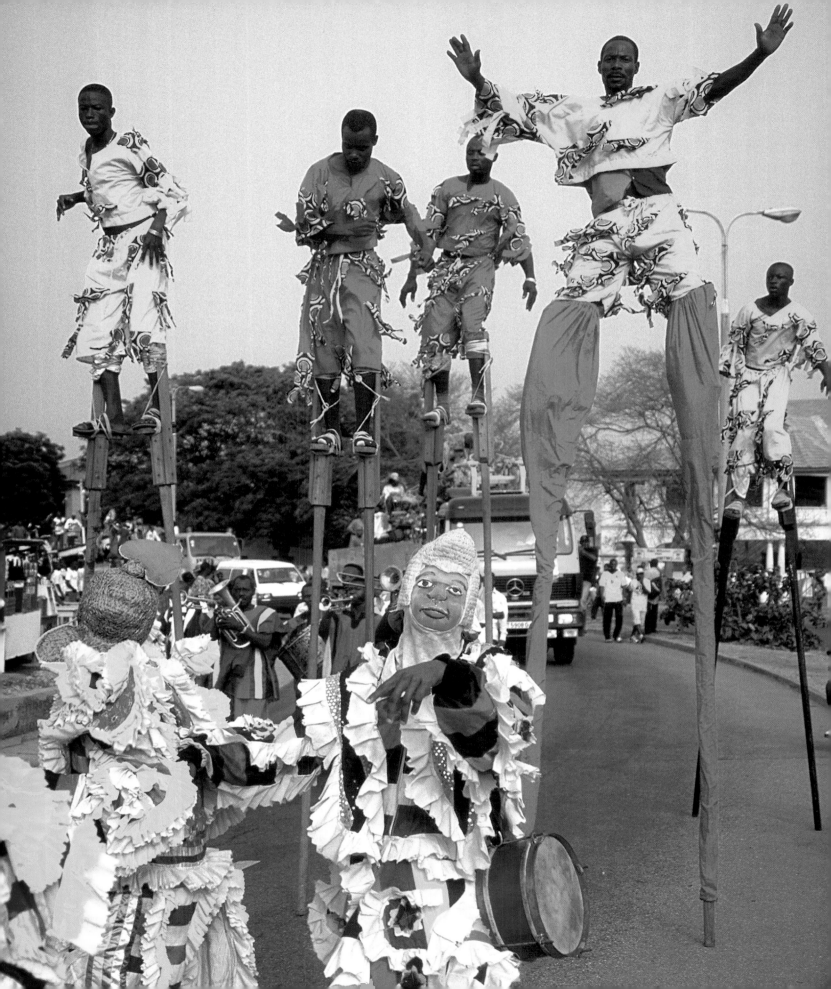

◄
3:40PM ACCRA, GHANA
In a parade through Accra, stilt walkers, a popular
attraction throughout western Africa, compete to
see who can balance on the highest stilts.
ROBERT BURCH

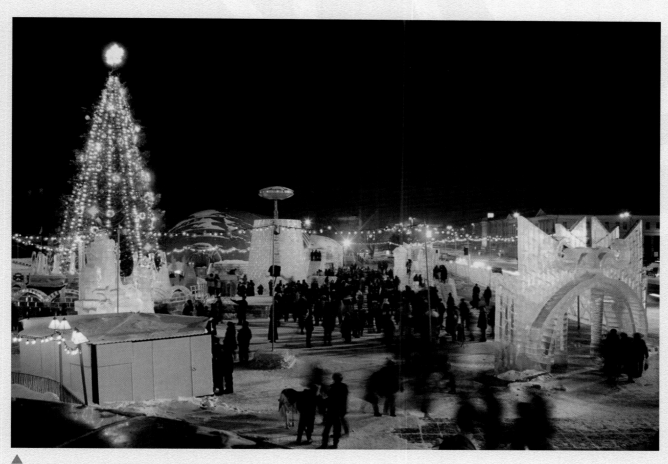

▲
6:30PM YEKATERINBURG, RUSSIA
The central square is decorated with a huge tree and a fairy-tale ice town. VLADIMIR GUDKOV

7:30PM LIVERPOOL, ENGLAND
A free spectacle set to music at the Albert
Dock in Liverpool. MARK ANTHONY WILSON

4PM NEW YORK CITY, USA
As each time zone entered the new millennium,
representatives of those countries paraded
through Times Square, wearing indigenous
clothes and bearing puppets and flags.
TOM DONADIO

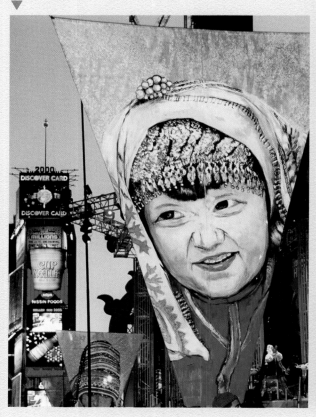

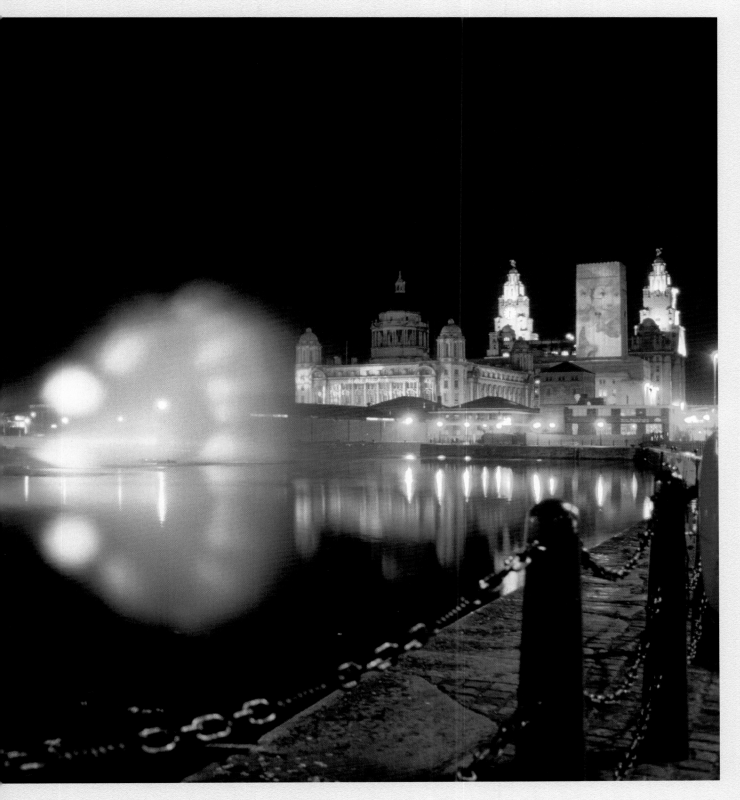

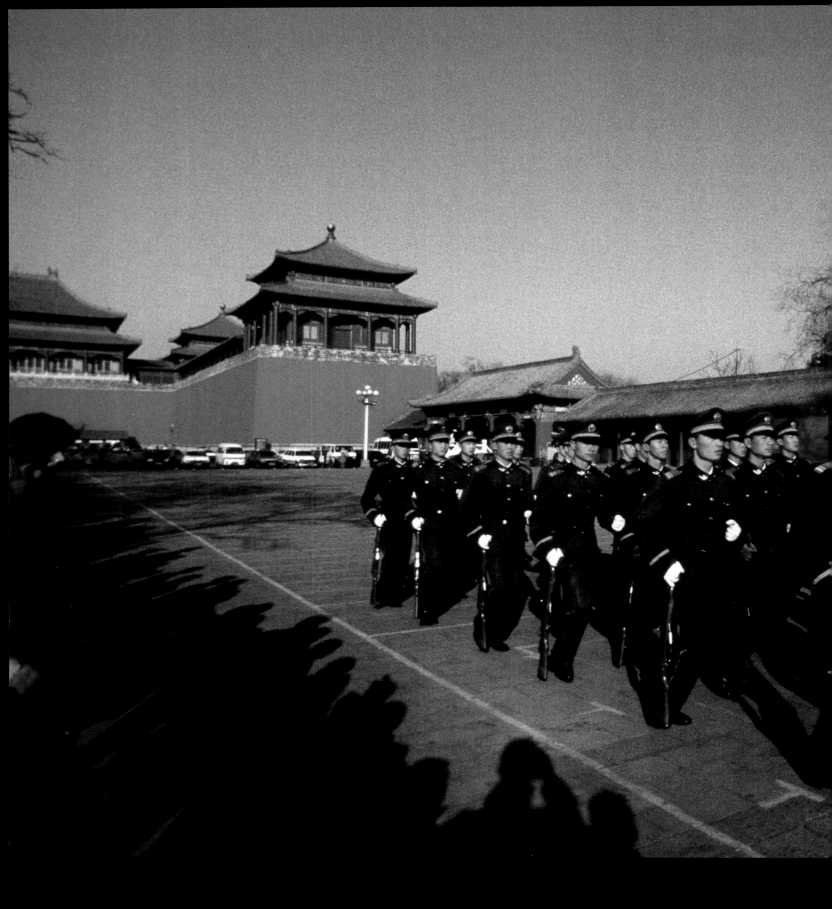

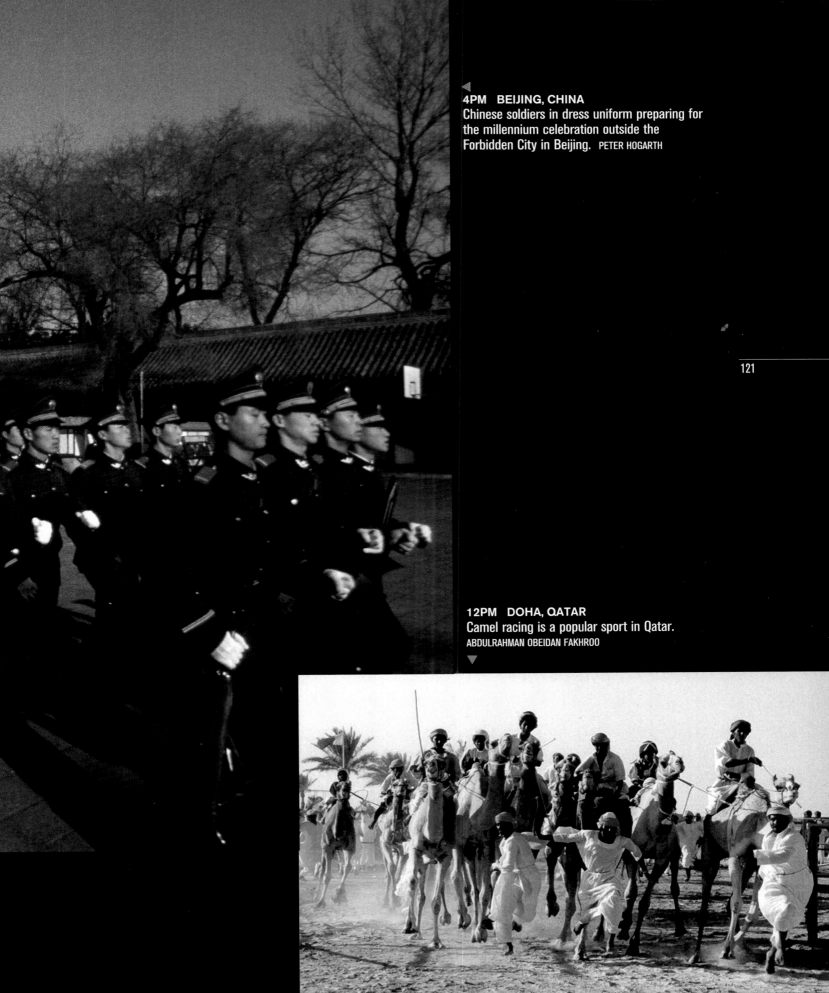

4PM BEIJING, CHINA
Chinese soldiers in dress uniform preparing for the millennium celebration outside the Forbidden City in Beijing. PETER HOGARTH

121

12PM DOHA, QATAR
Camel racing is a popular sport in Qatar.
ABDULRAHMAN OBEIDAN FAKHROO

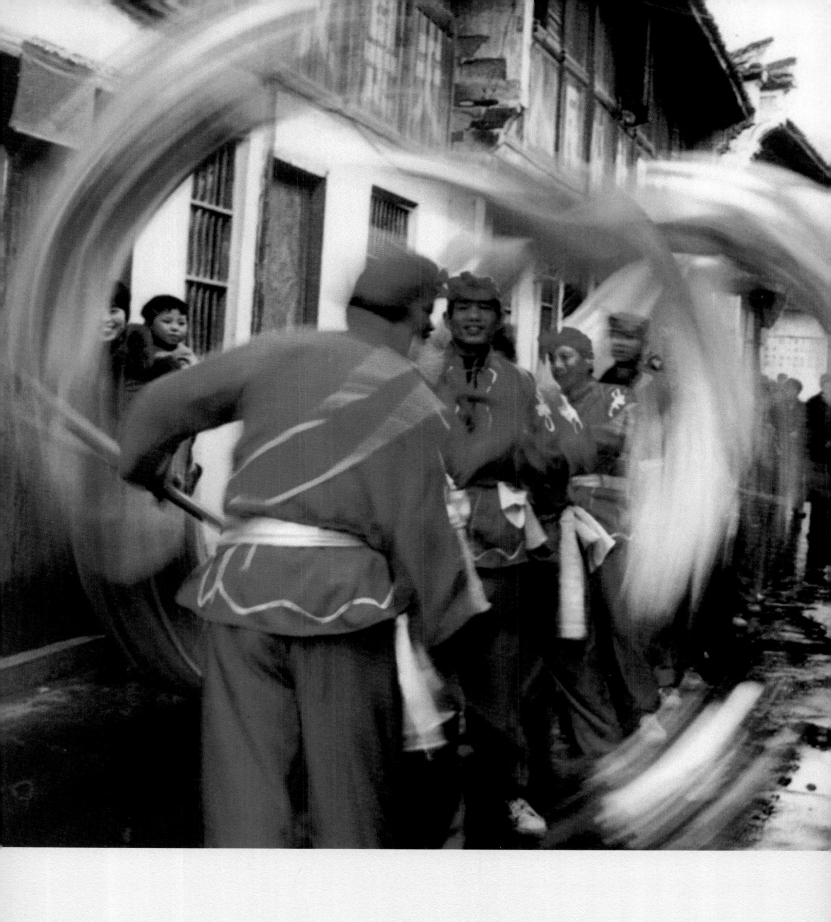

◄ **11:30AM LISHUI, CHINA**
Welcoming the new millennium
and the Year of the Dragon.
RUIKANG XU

1AM CHORONI, VENEZUELA
Dancing at the local nightclub.
ORIOL TARRIDAS MASSUET
▼

123

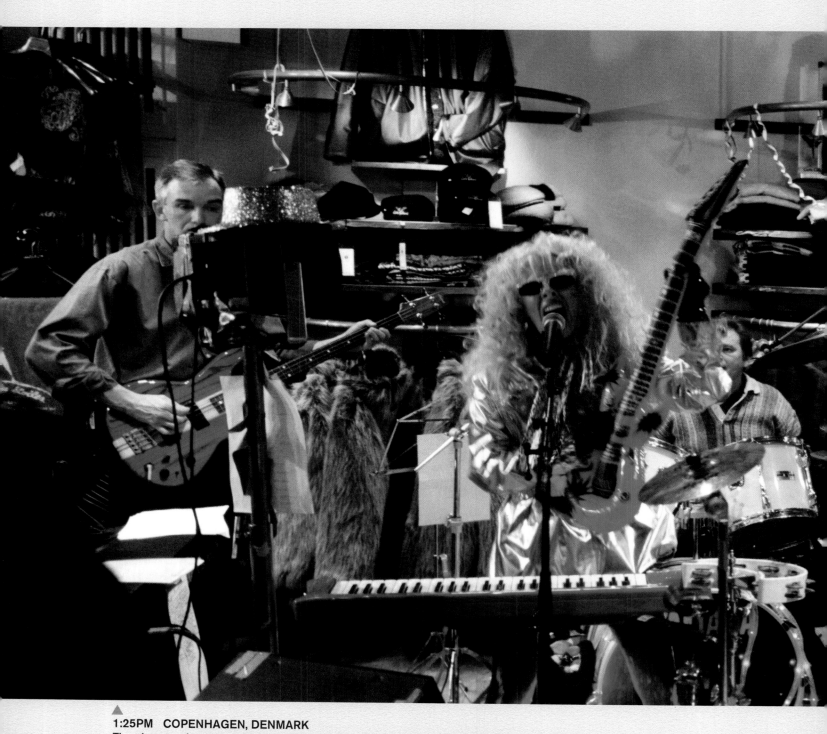

1:25PM COPENHAGEN, DENMARK
The photographer writes: "I was walking down the main shopping street when I heard loud music coming from a clothing store. To this day I have no idea what it was about or why. The man on the right, though, came in for a free cup of champagne!" THOMAS WINBLAD MERKEL

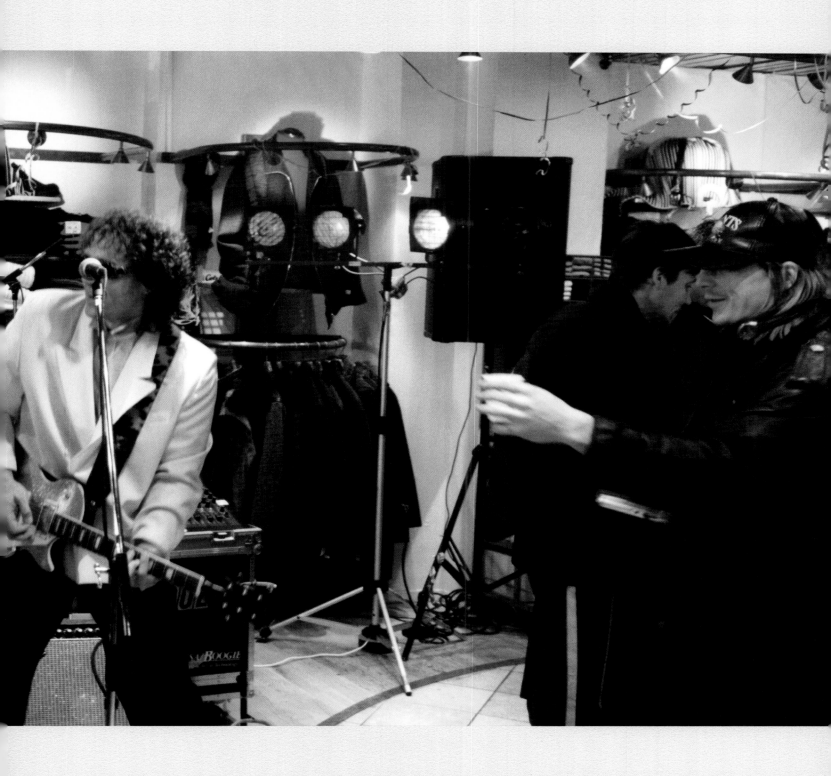

(NEXT PAGE) 2PM PHILADELPHIA, PENNSYLVANIA, USA
Confetti falls on some of the 650 couples who were married or
renewed their vows at the Philadelphia Convention Center.
WILLIAM BRETZGER

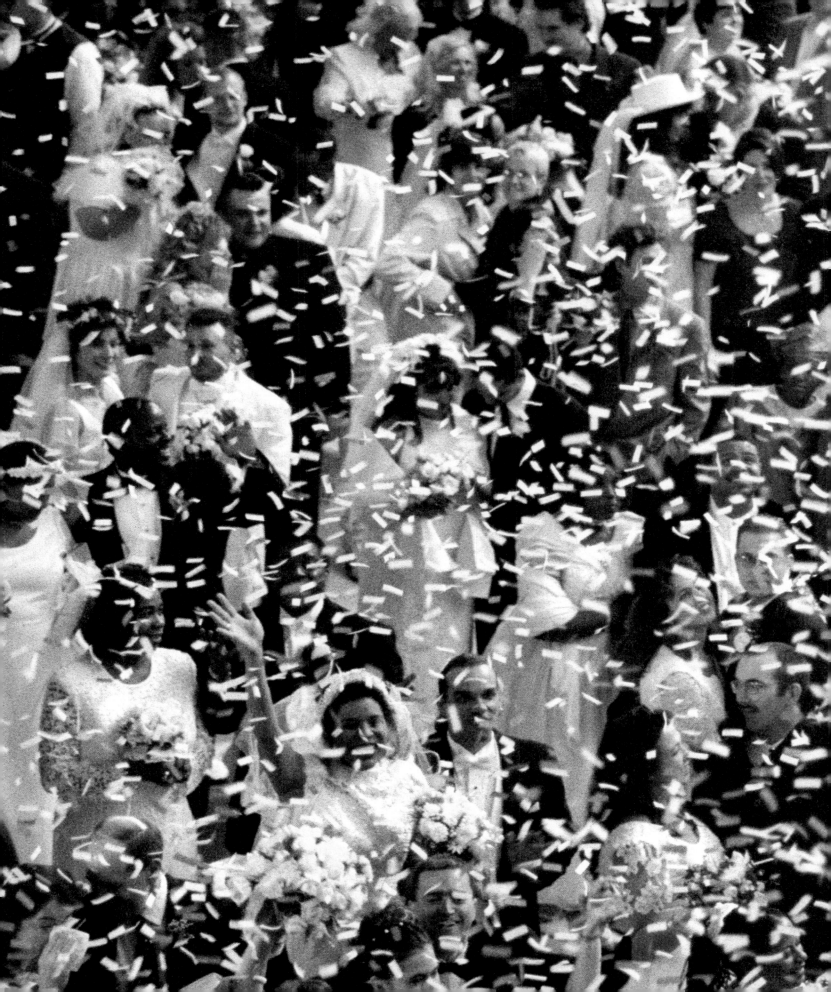

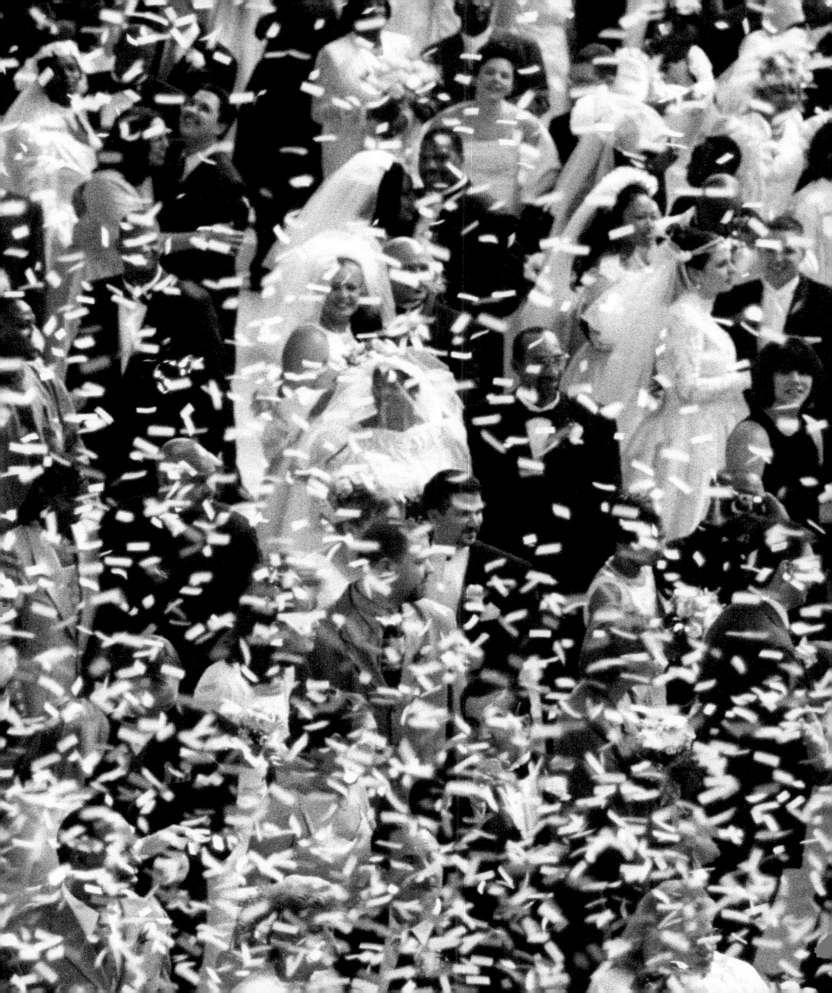

Person

Some people prefer to celebrate in smaller, more intimate gatherings. Bonfires, fireworks, and sparklers are popular.

Others choose less conventional ways to mark the turn of the millennium. In Maui, an avid deep-sea diver spends New Year's in her favourite place -- underwater. In Patagonia, Chile, five friends huddle together in a climber's shack during a rainstorm. And in Los Angeles, an enterprising couple try -- apparently successfully -- to conceive a baby.

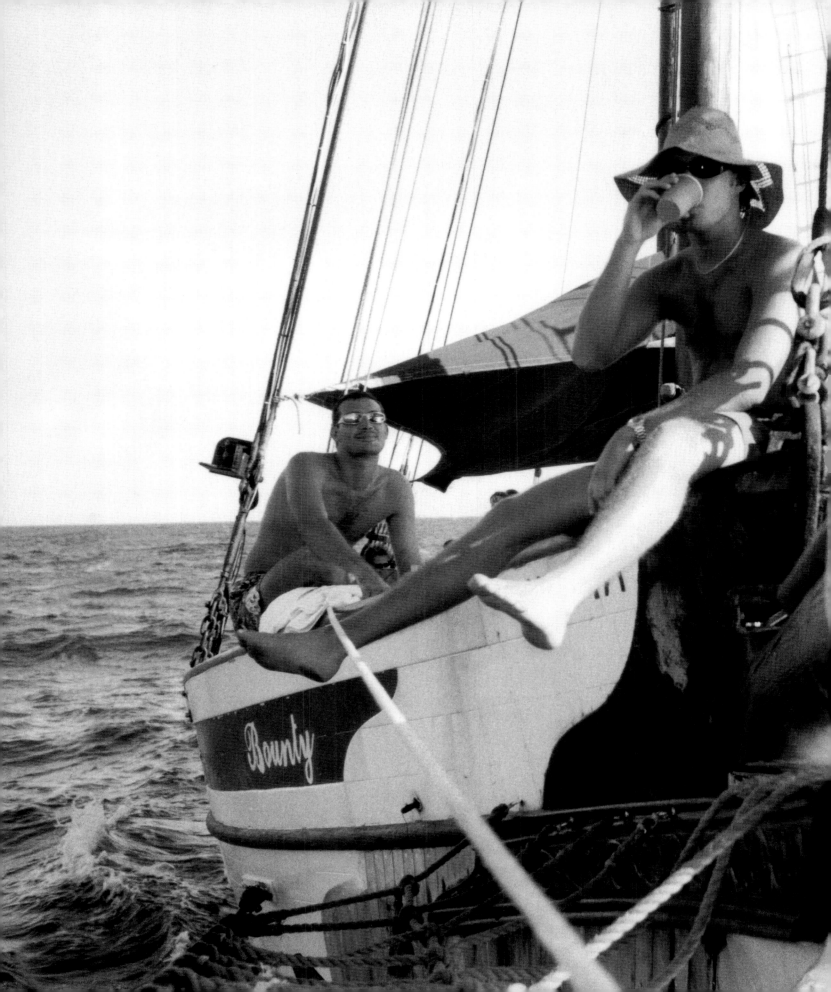

4:15PM OFF THE COAST OF
CURAÇAO, DUTCH ANTILLES
Sailing into the new millennium with
friends and family.
RICHARD VAN GINKEL

131

▶ **11PM SAFETY HARBOR, FLORIDA, USA**
The hosts of this party covered their house in mylar
for their "Shine on 2000" event for forty guests.
DAVID LUBIN

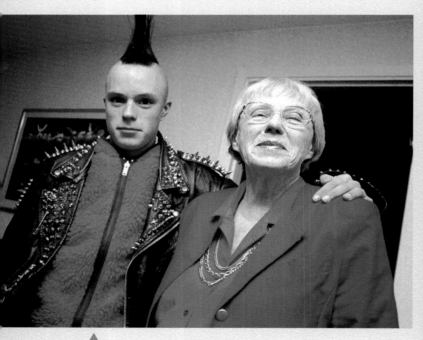

▲
⭐ **5PM UPPSALA, SWEDEN**
Johan and his grandmother Olga.
ANDRE MASLENNIKOV

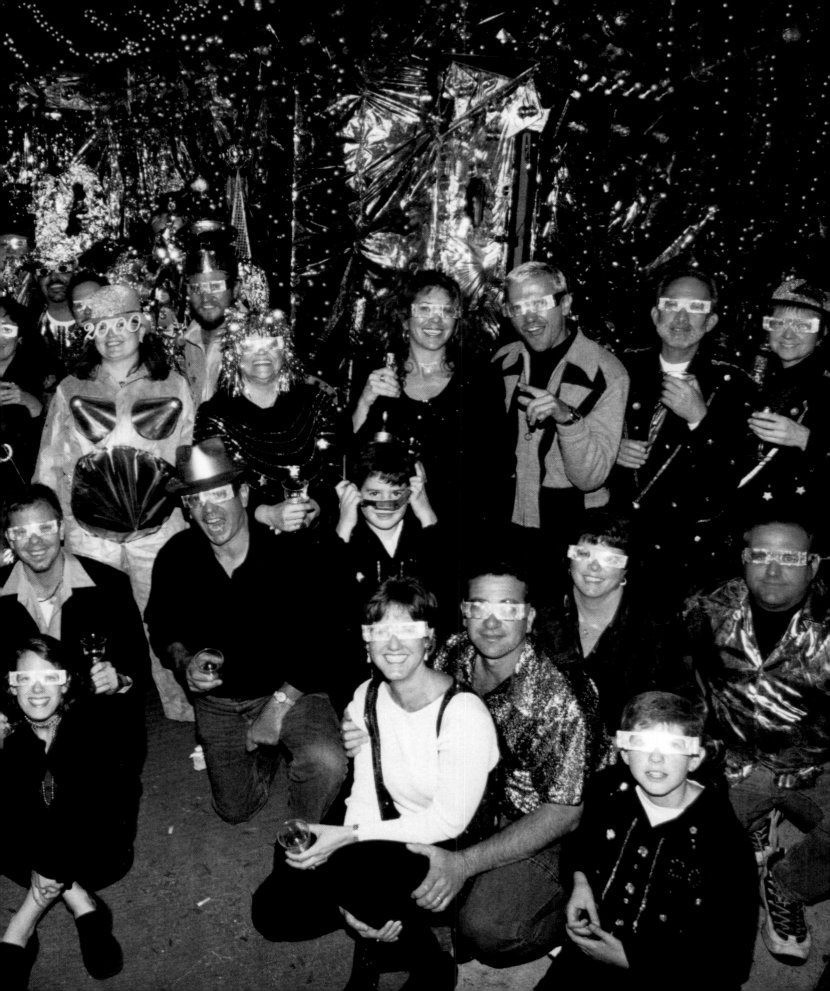

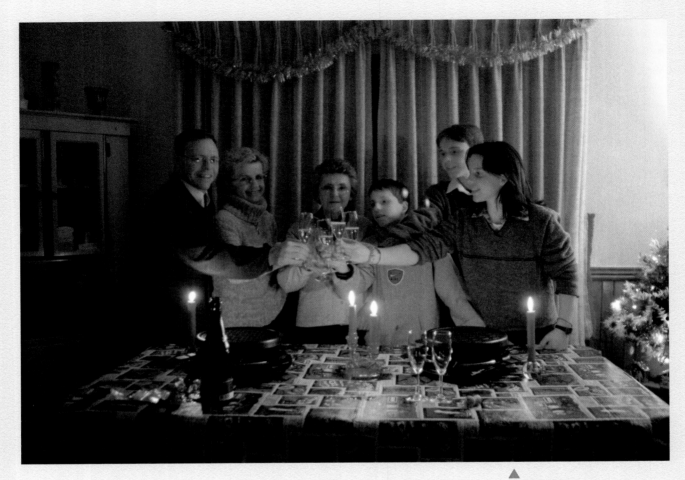

 1AM BAIE-COMEAU, QUEBEC, CANADA
Having danced all evening, this family gathers for an intimate self-portrait.
GAËTAN GAUTHIER

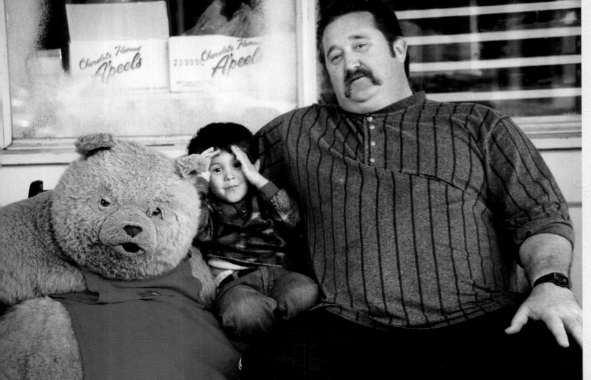

12:10PM SACRAMENTO, CALIFORNIA, USA
Father and son relax on a bench in early afternoon... with friend!
GREGORY STRINGFIELD

▲
9:30PM CARACAS, VENEZUELA
The Raventós Márquez family await
the New Year in the kitchen of their
eleventh-floor apartment.
JORGE RAVENTÓS

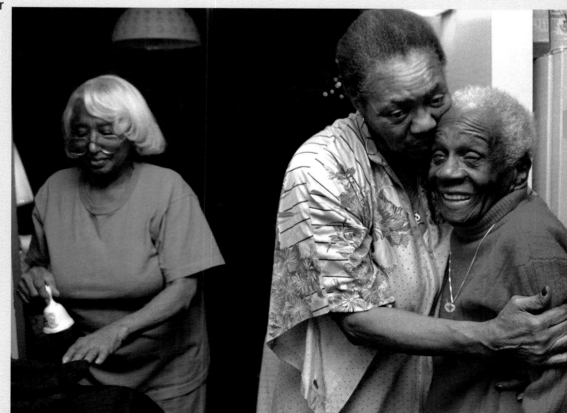

▶
1AM DETROIT, USA
Ruth Ellis, 100 years old, is
given a big New Year's hug,
by her friend and neighbour
Henrine Grubbs.
ELISABETH SILVIS

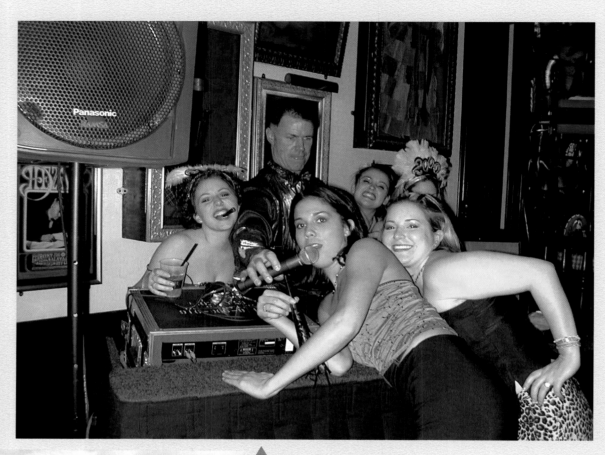

12:07AM SACRAMENTO, CALIFORNIA, USA
These young ladies joined the DJ in an inpromptu karaoke at the Hard Rock Cafe.
GREGORY STRINGFIELD

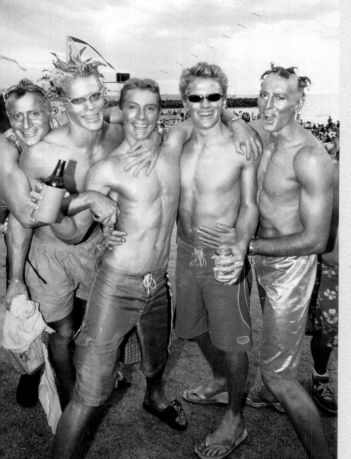

7PM PERTH, AUSTRALIA
These men painted themselves silver before partying on the beach.
TOM MCGHEE

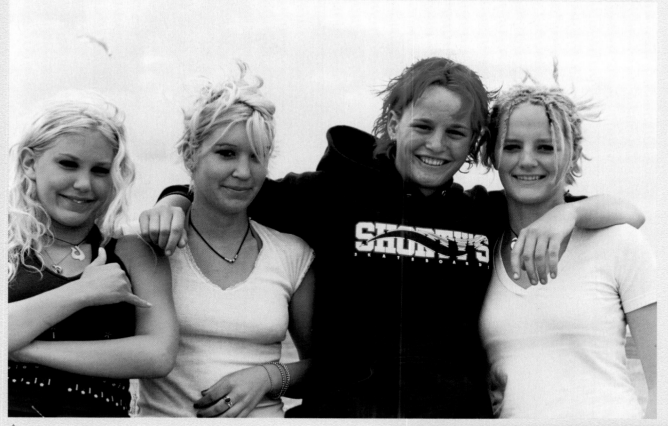

▲
3:35PM MOUNT MAUNGANUI, NEW ZEALAND
Kendyl, Angeline, Alison, and Nyssa, all from Hamilton in the North Island of New Zealand, are enjoying the happy occasion. JOHN PETERSON

◀
12:36AM DEPOT BEACH, AUSTRALIA
Sisters Anne and Sarah appear bemused by the antics of the adults, at their family party in a small south-east Australian coastal village.
JENNIFER LYNDON

▶
12:15AM NITEROI, CAMBOINHAS BEACH, BRAZIL
These women were apparently quite a hit in the Brazilian town of Niteroi on New Year's Eve.
FÁTIMA LEITE

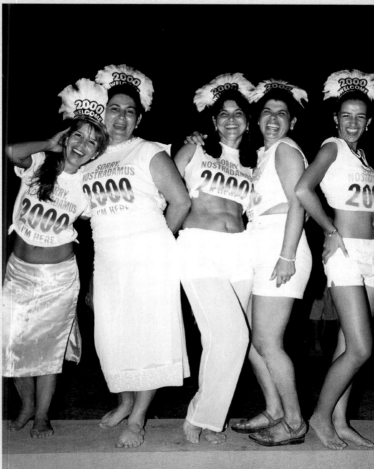

⭐ **9:50PM BELO HORIZONTE, BRAZIL** CARLOS ROBERTO

9:21AM AUCKLAND, NEW ZEALAND JOHN GERARD COSGROVE

10AM DAKHLA, MOROCCO JIMI HUGHES

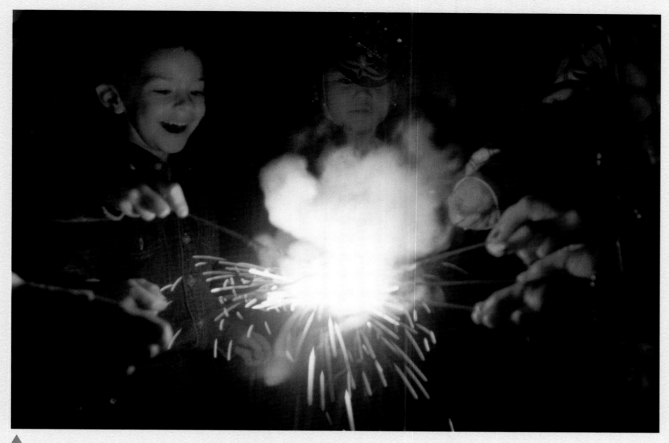

▲ 10PM HERMOSA BEACH, CALIFORNIA, USA NANCY PERONG

3:30PM LOS ANGELES, USA BETH KUKUCKA
▼

12:05PM GHANDRUNG, NEPAL RICKY WRIGHT
▼

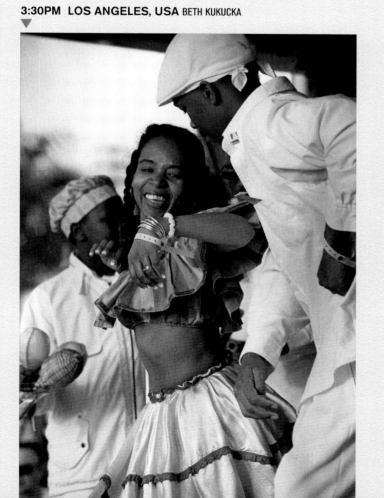

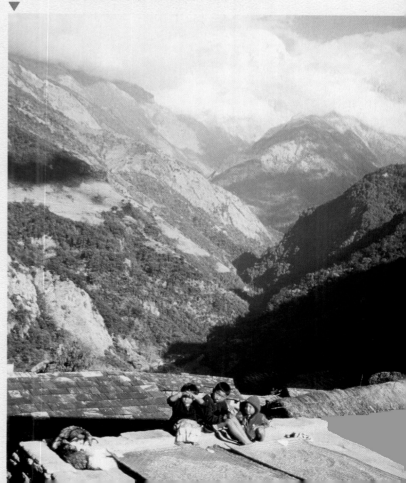

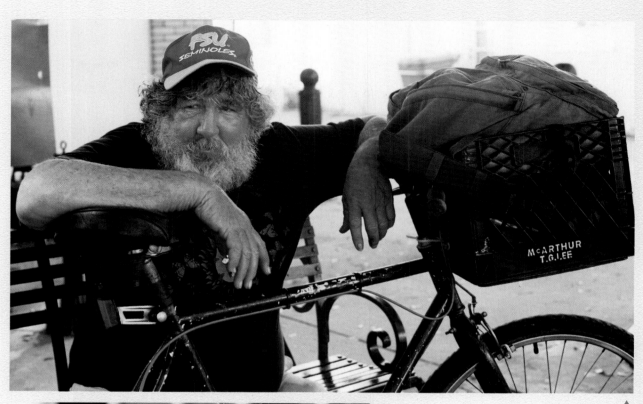

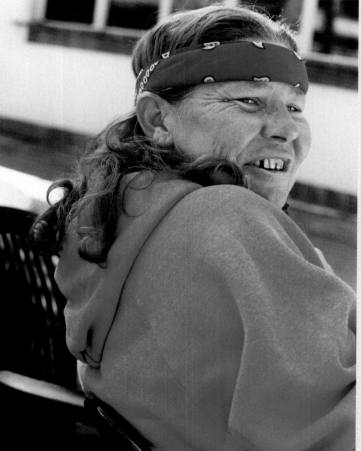

3:30PM SARASOTA, FLORIDA, USA
ELIZABETH LARRABEE

12:30PM SARASOTA, FLORIDA, USA
ELIZABETH LARRABEE

3PM WASHINGTON, DC, USA
WILLARD OVERTON

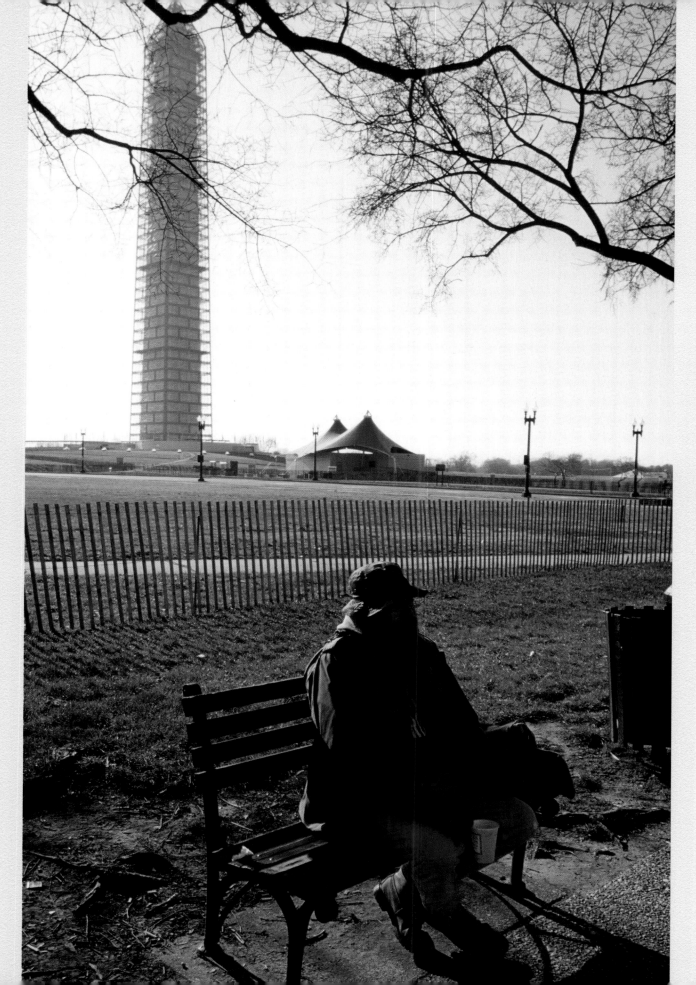

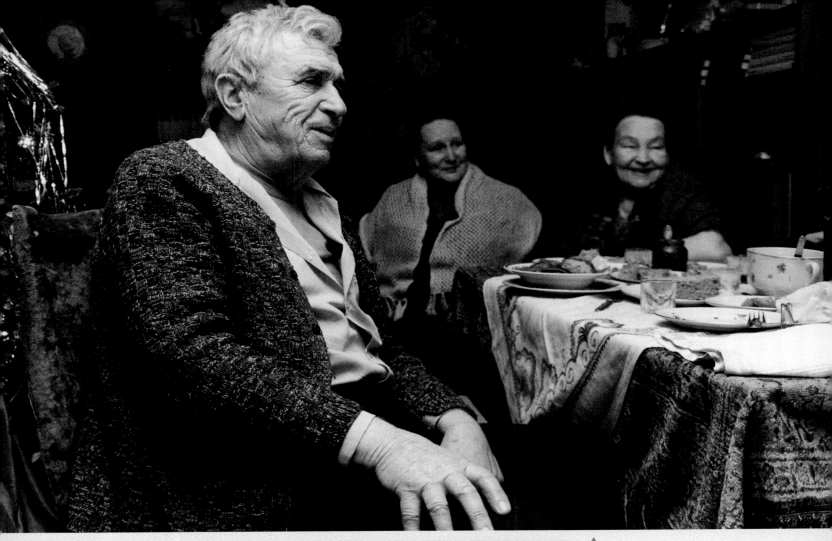

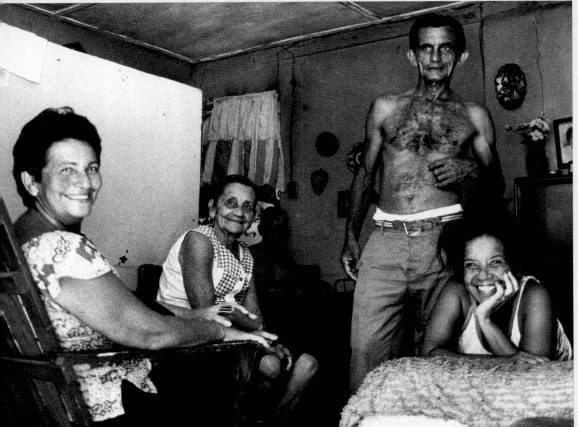

6PM SANTA FE, ARGENTINA
'La última mirada'. Rosa Aponte lived through three centuries. Regretfully she passed away less than a month after this picture was taken.
JOSÉ CETTOUR

3:30PM NEW DELHI, INDIA
Lured by dreams of Dubai, this man has spent the last five years in the parking lot of New Delhi's airport, hoping to one day get a ticket. VINAYAK PRABHU

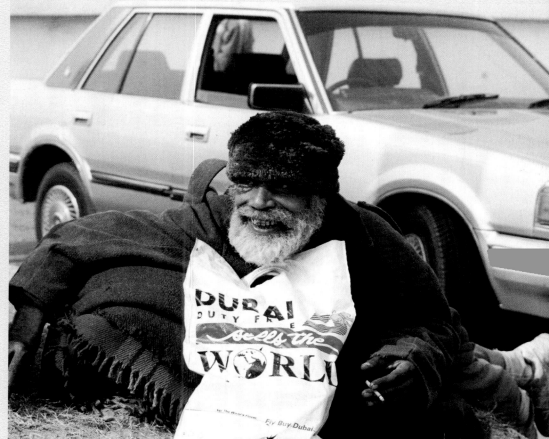

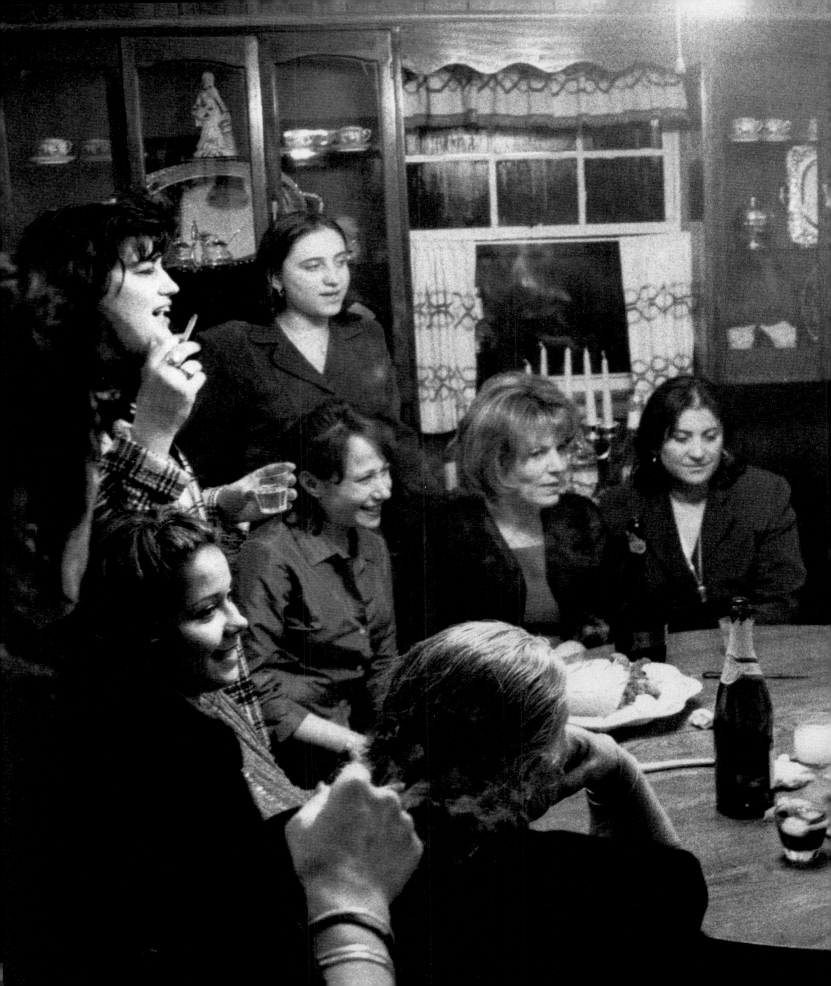

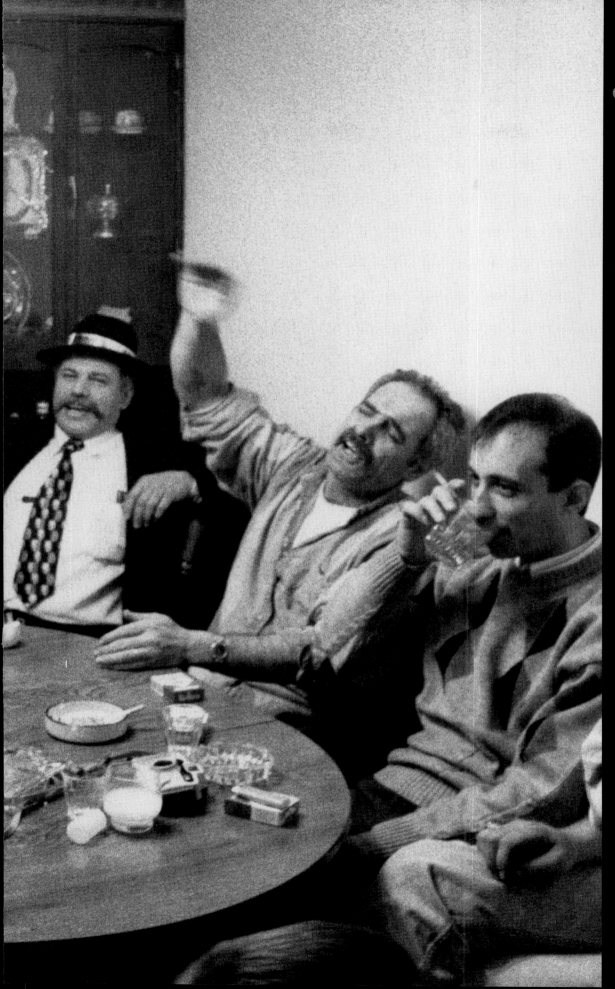

◄
★ **12:30AM ALLENTOWN, PENNSYLVANIA, USA**
Around the kitchen table, three generations of the photographer's Syrian family celebrate the New Year by drinking ouzo and singing Arabic songs.
DANNY YOUSSEF

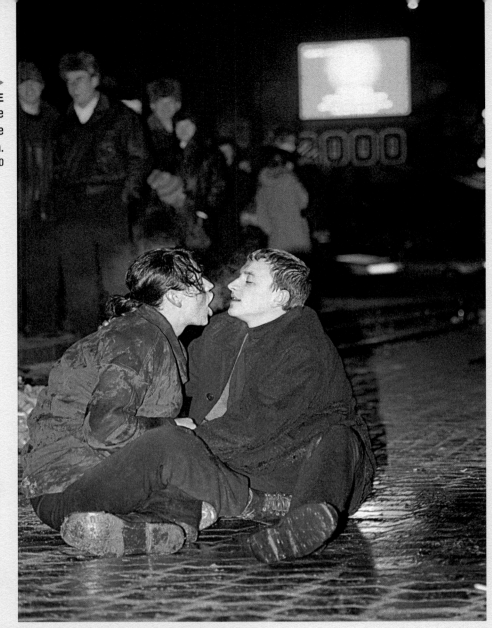

▶
2:30AM KIEV, UKRAINE
A young couple sits in a puddle
of champagne, oblivious to the
people around them.
KONSTANTIN RUDESHKO

146

11PM EDINBURGH, SCOTLAND
Will you marry me?
And the answer is...Yes! CARA MCCANN
▼

▶
1:40PM TAMPA, FLORIDA, USA
Rick and Jackie Johnston kick off
their millennium with a New Year's
Eve wedding.
MICHAEL CLARK

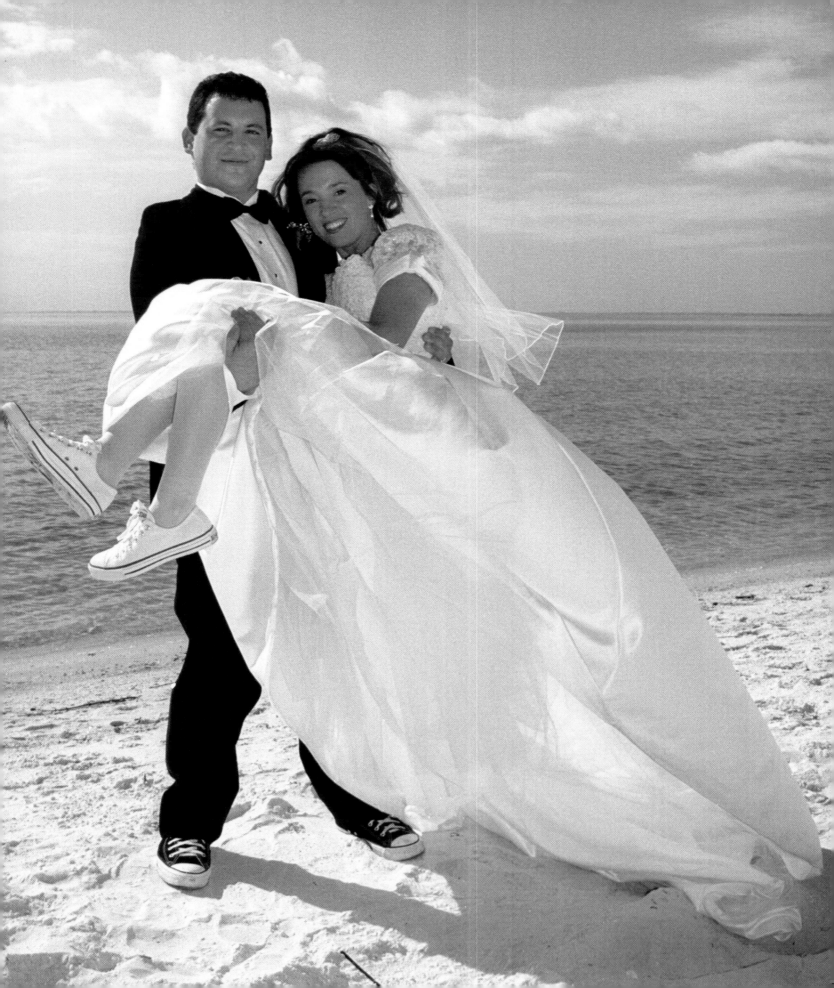

★ **5:30PM FLORIDA, USA**
JAMES MAHAN

1PM PORT OF SPAIN, TRINIDAD
DAVID WEARS

M SYDNEY, AUSTRALIA
EEN MILLER

7AM GISBORNE, NEW ZEALAND
HILLARY GREGORY

3PM HAVANA, CUBA
STEPHEN LIARD

12:01AM MOSCOW, RUSSIA
VALENTIN GLADYSHEV

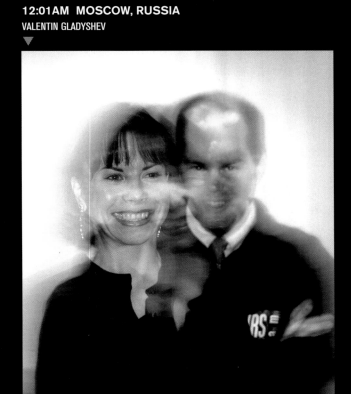

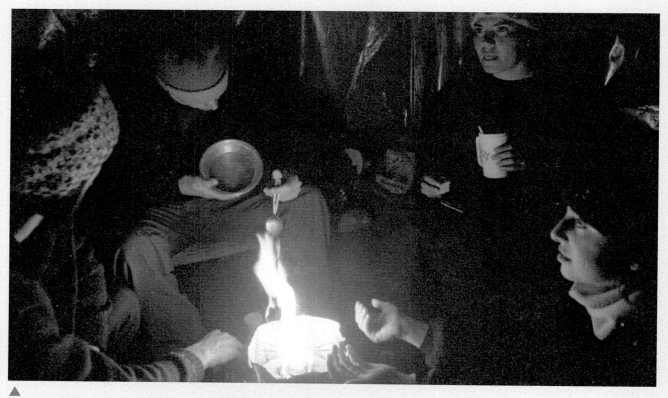

▲

10:30PM TORRES DEL PAINE NATIONAL PARK, CHILE
Five friends from the U.S. huddle together in a climber's shack, safe from the driving rains of Patagonia, and enjoy a meal of freeze-dried turkey, mashed potatoes, and gravy. LARS HOWLETT

12:15AM KIRRAMA, AUSTRALIA
Shaun unleashes fireworks at a campsite. ROB PARSONS

▼

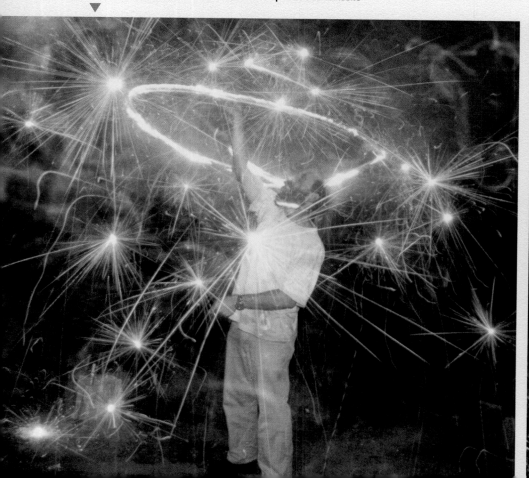

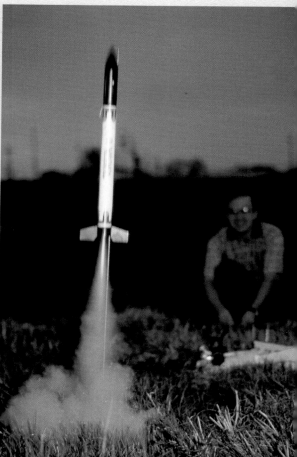

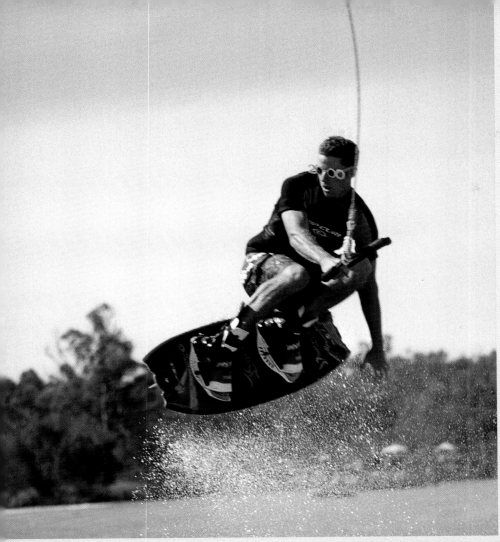

◄
5PM NANGILOC, AUSTRALIA
Nathan Gilbert spent the daylight hours
water-skiing on the Murray River.
GLENN MILNE

◄
4PM TUSCALOOSA, ALABAMA, USA
Jeffrey Sides launches a model rocket
to entertain his family. AMY LEWIS SIDES

11:45PM MAUI, HAWAII, USA ►
Angie spent the turning of the
millennium in her favourite place...
underwater! She is pictured here
at sixty feet down. DAVID FLEETHAM

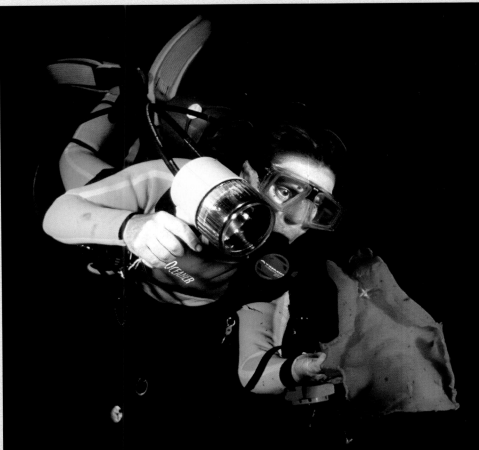

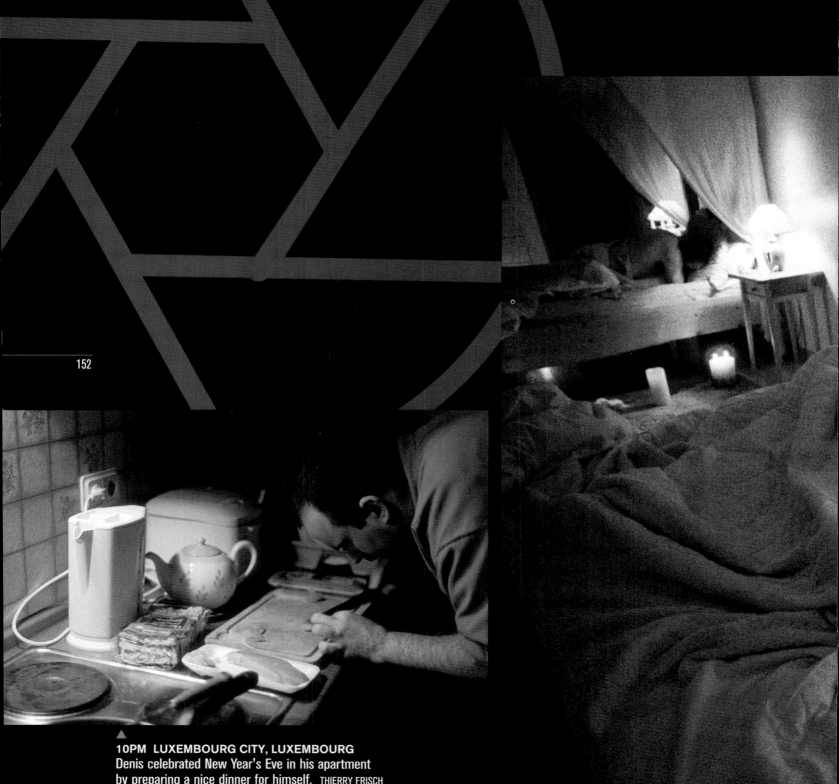

10PM LUXEMBOURG CITY, LUXEMBOURG
Denis celebrated New Year's Eve in his apartment
by preparing a nice dinner for himself. THIERRY FRISCH

▲
★ **10:30PM LOS ANGELES, USA**
The photographer's friends hope to conceive a baby on the last night of 1999.
JOAN LAUREN

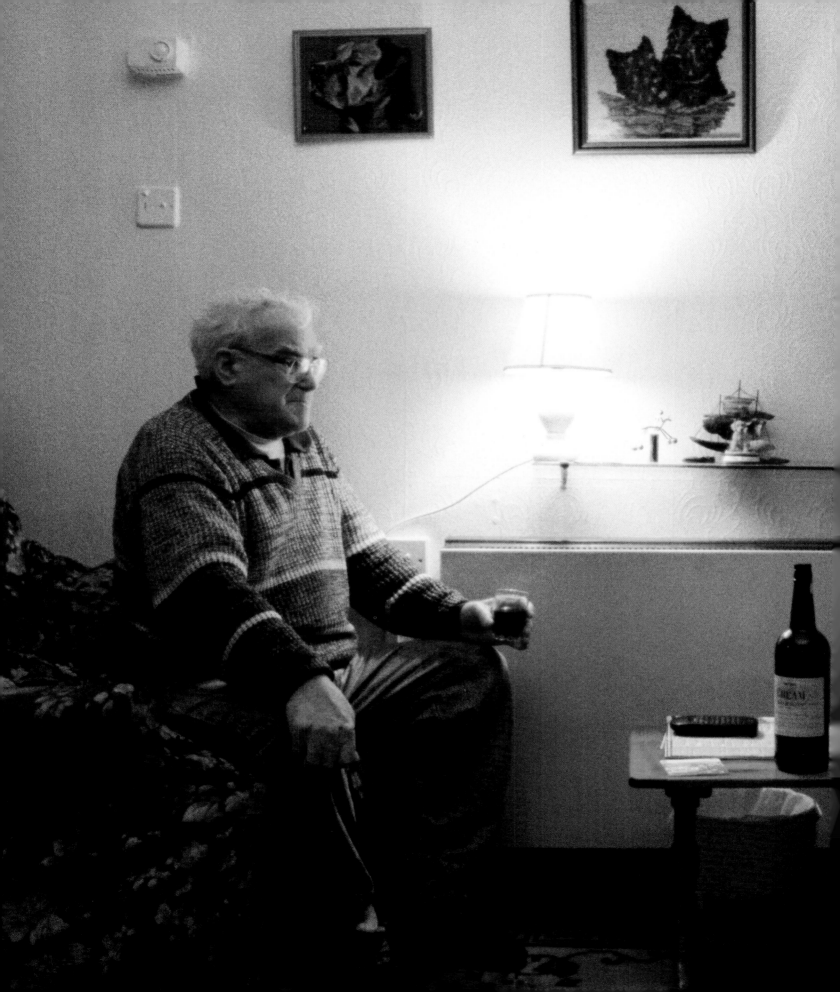

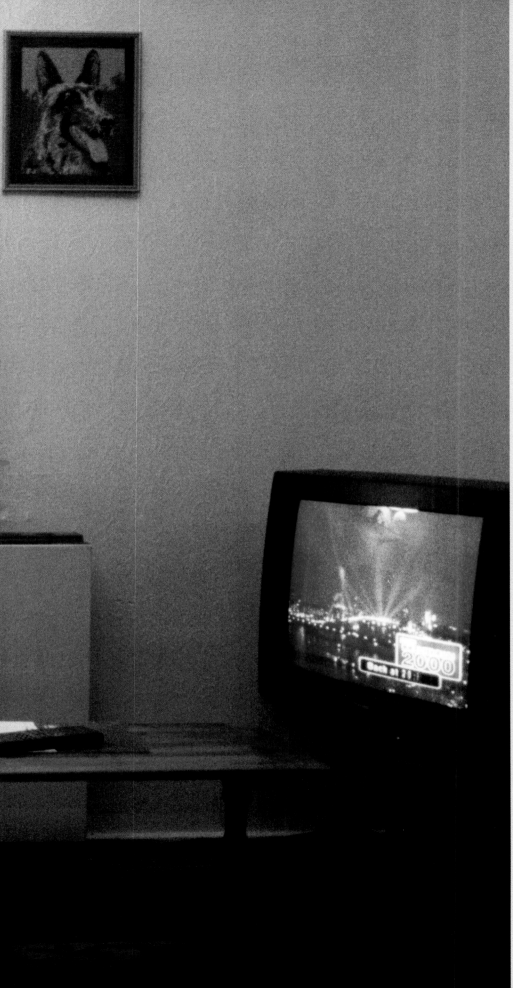

◀

✪ **8PM WAKEFIELD, YORKSHIRE, ENGLAND**
Alfred Hudson thinks about the changes he has witnessed since he was a young boy, and contemplates the future.
CAROL HUDSON

155

Every major world religion holds special services. Candles are lit, hymns are sung, solemn processions unfold.

More privately, people choose to devote themselves to personal prayer and contemplation of nature.

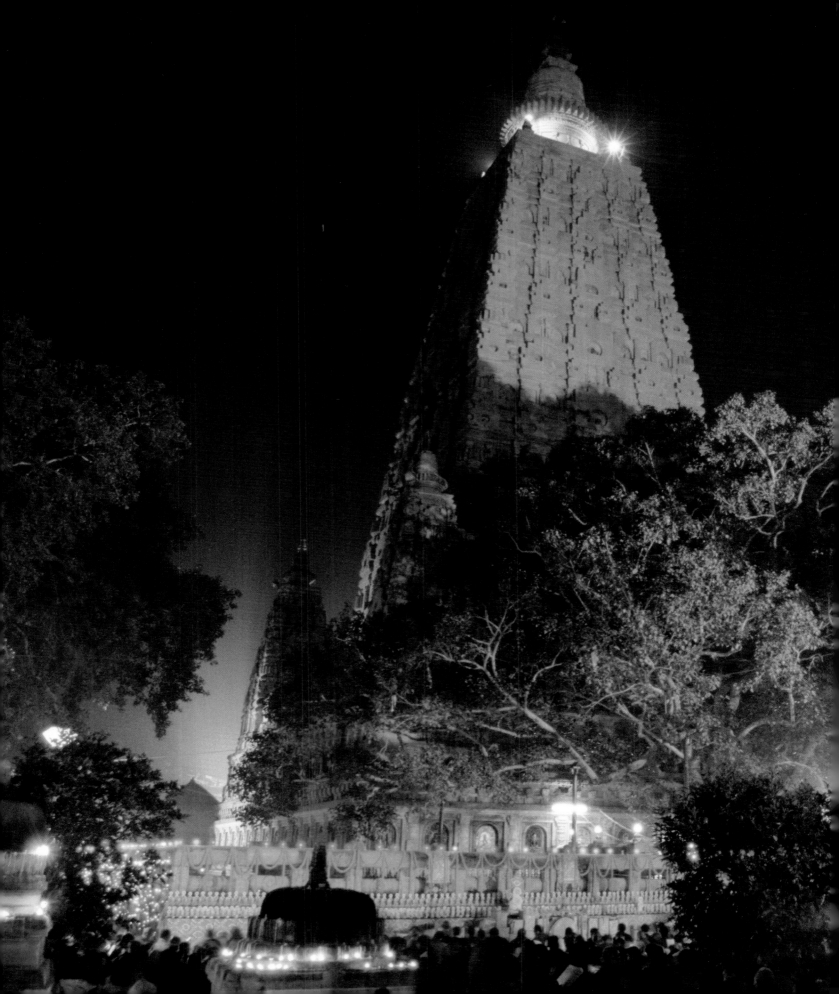

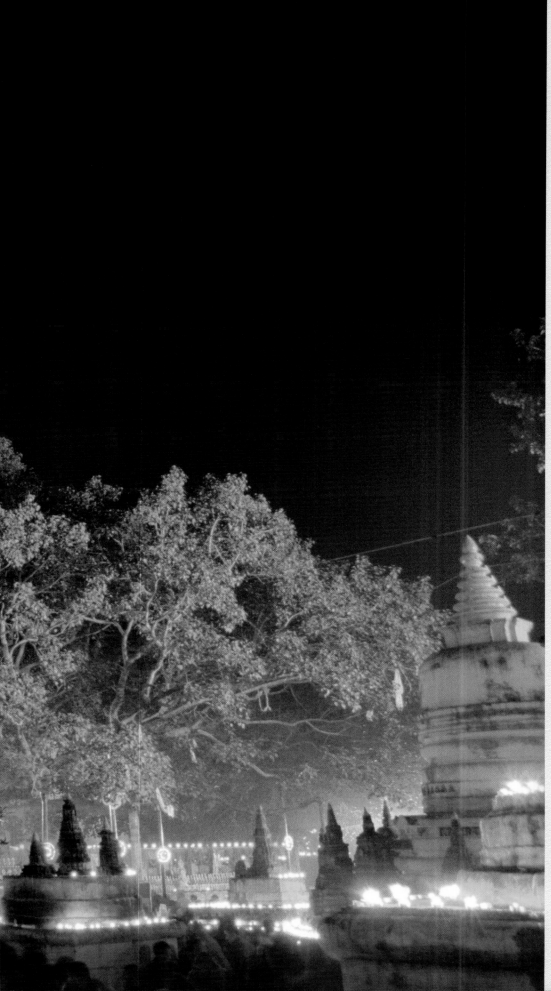

10PM BODH GAYA, INDIA
Buddhist pilgrims gather in front
of the sacred Bodhi tree at the
Temple of Mahabodhi.
NICHOLAS DAWSON

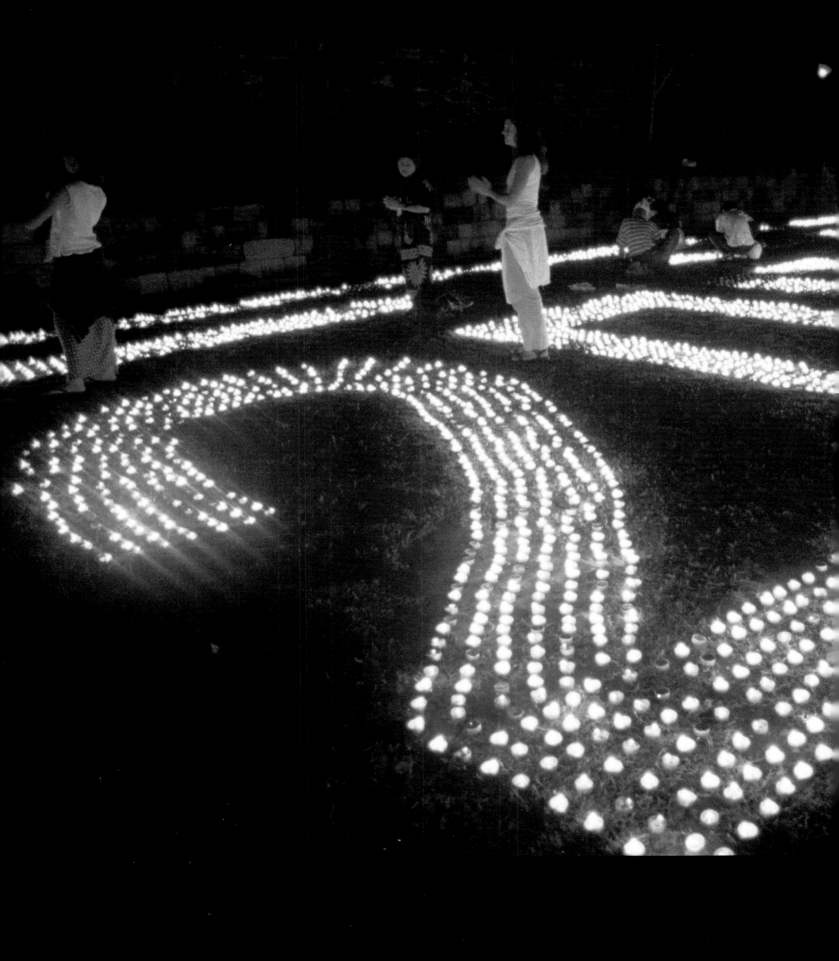

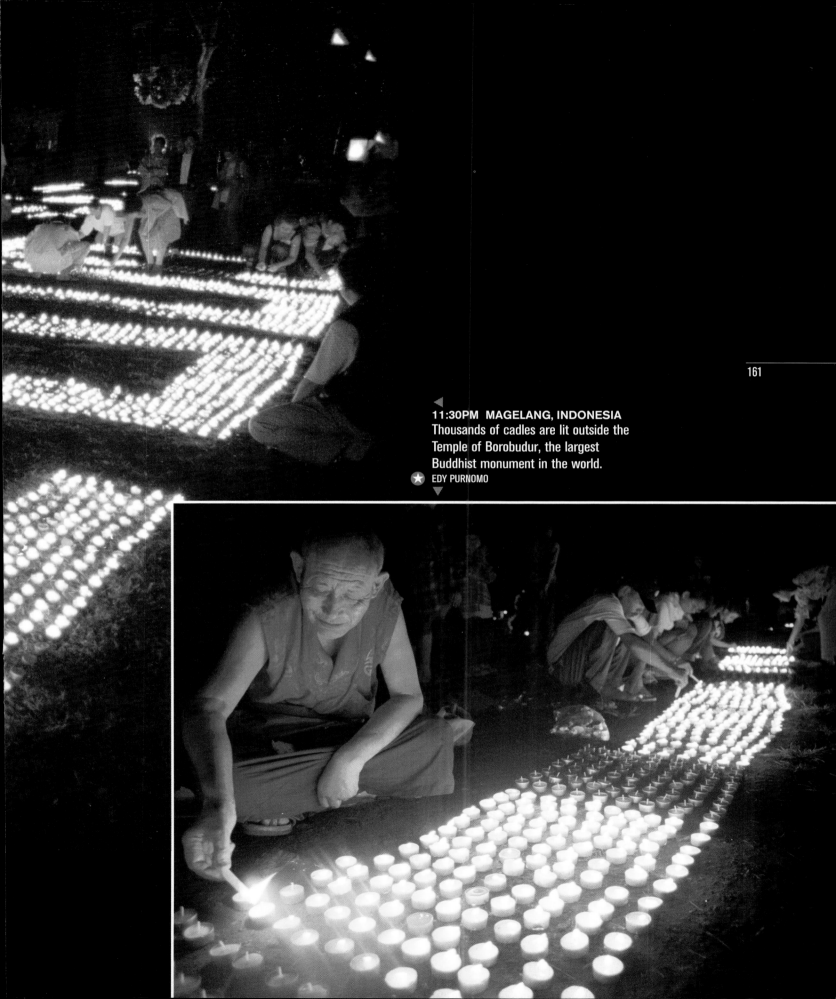

◀ **11:30PM MAGELANG, INDONESIA**
Thousands of cadles are lit outside the
Temple of Borobudur, the largest
Buddhist monument in the world.
★ EDY PURNOMO

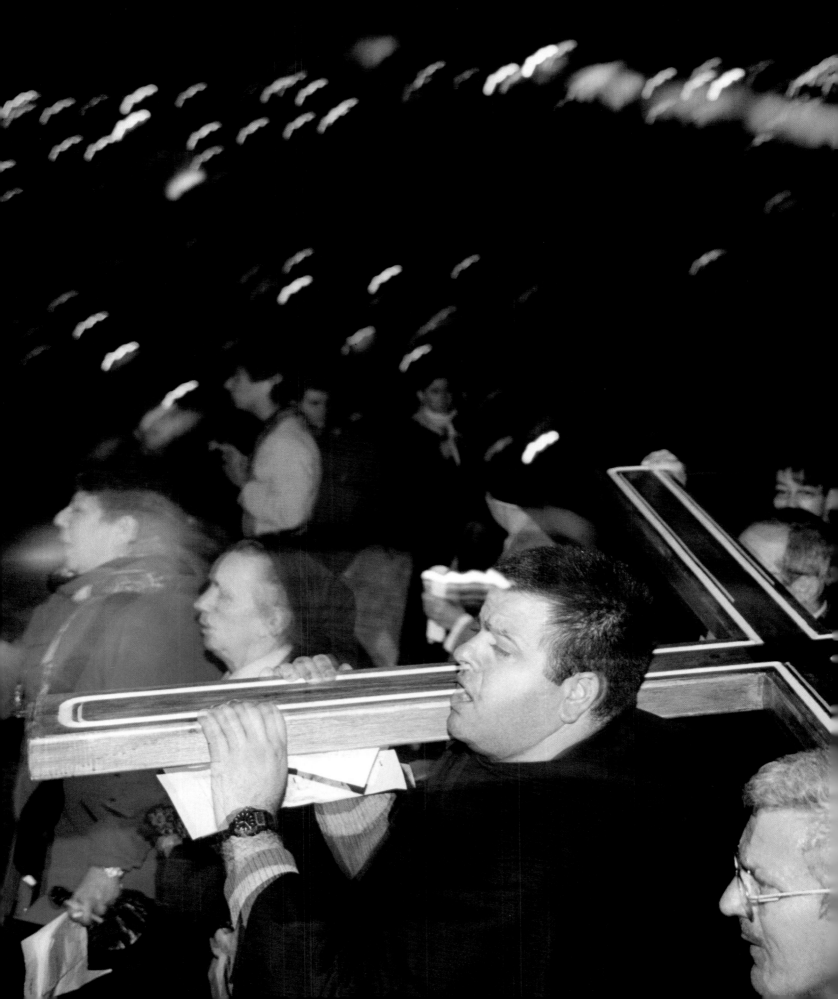

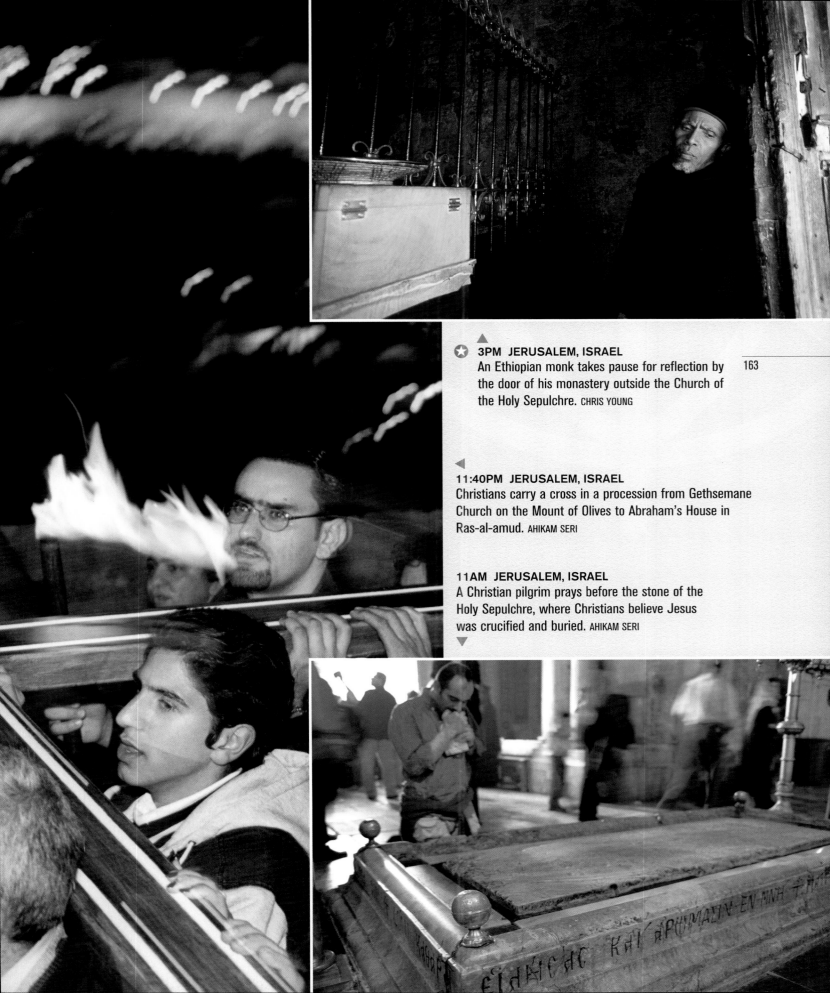

★ **3PM JERUSALEM, ISRAEL**
An Ethiopian monk takes pause for reflection by
the door of his monastery outside the Church of
the Holy Sepulchre. CHRIS YOUNG

163

◀

11:40PM JERUSALEM, ISRAEL
Christians carry a cross in a procession from Gethsemane
Church on the Mount of Olives to Abraham's House in
Ras-al-amud. AHIKAM SERI

11AM JERUSALEM, ISRAEL
A Christian pilgrim prays before the stone of the
Holy Sepulchre, where Christians believe Jesus
was crucified and buried. AHIKAM SERI
▼

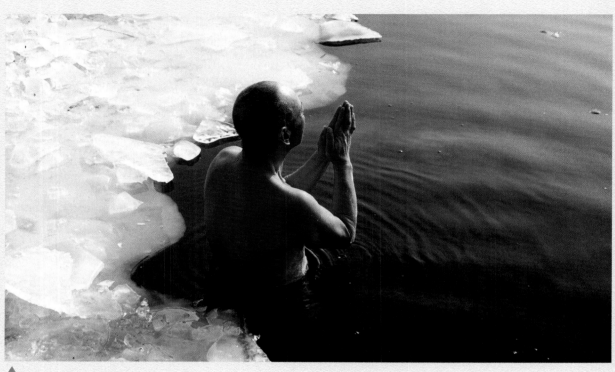

▲
7AM BEILIN PARK, BEIJING, CHINA
A seventy-six-year-old man in an icy lake at dawn, wishing for
peace on earth and happiness for humanity. BAI LENG

11AM JORDAN VALLEY, ISRAEL ★
A baptismal ceremony near the Sea of Galilee. ALON LEVITE
▼

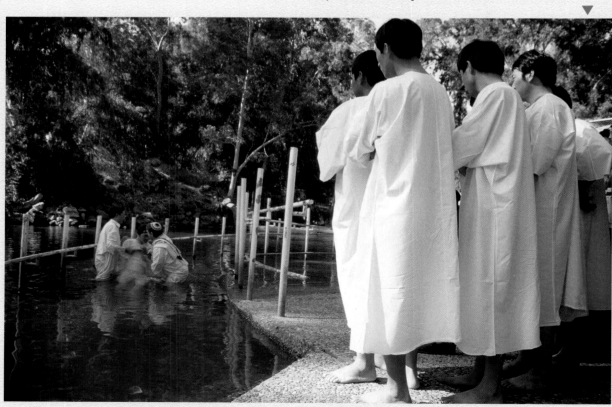

▲
3PM YAKOIN TEMPLE, TAKAOSAN, JAPAN
Traditional Japanese ritual. PETER OXLEY

5PM RIO DE JANEIRO, BRAZIL
Offering flowers to the gods at Copacabana Beach. ANE MARQUES
▼

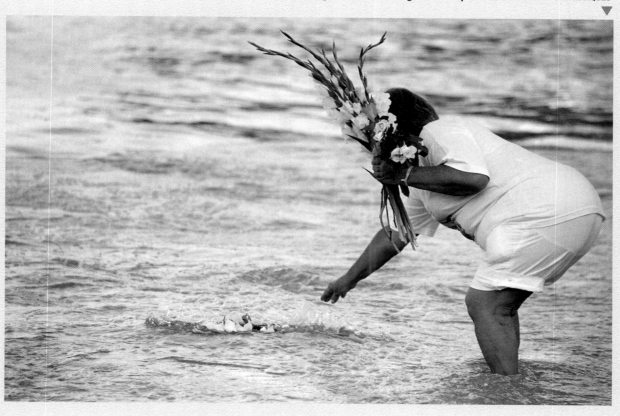

▶

6:35PM KONARAK, INDIA
This couple asks the sun god's
blessing for the coming year.
GHANI ZAMAN

166

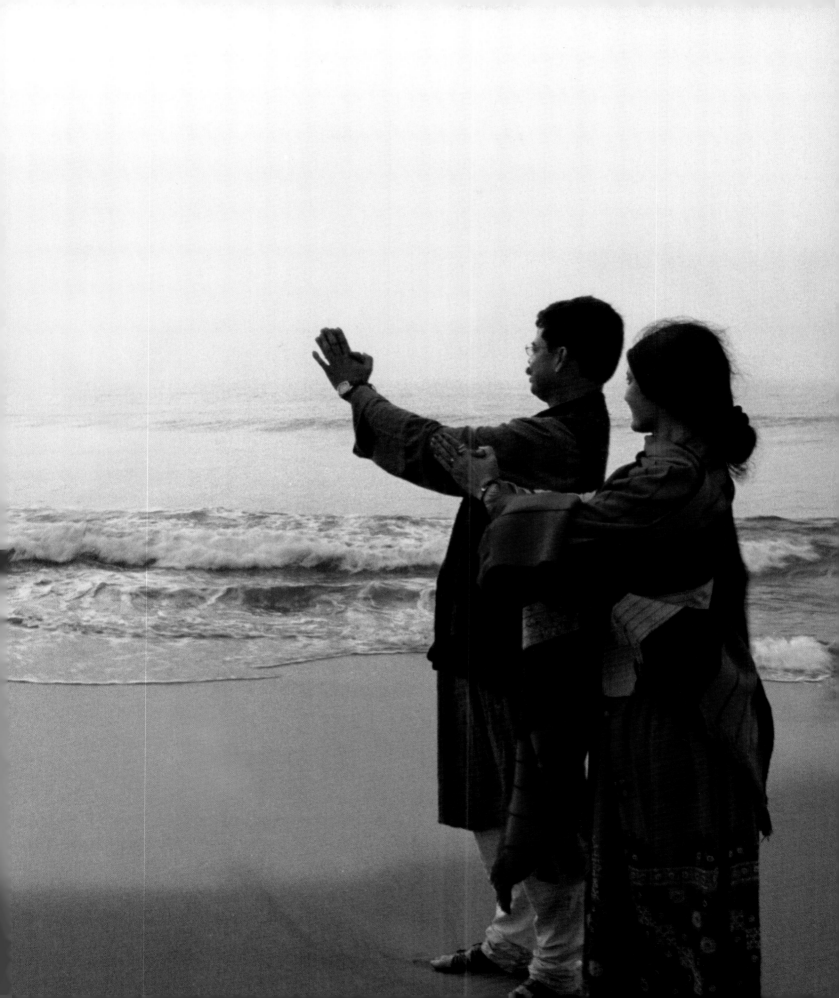

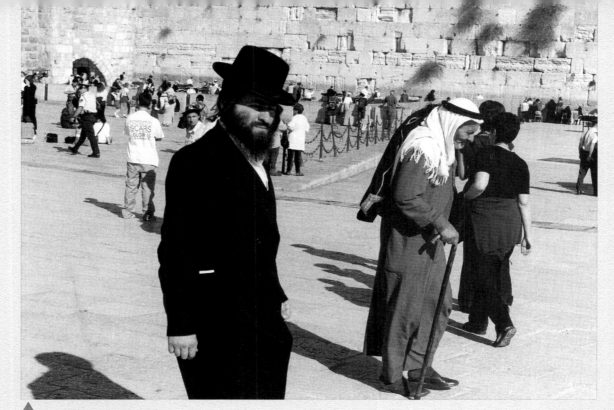

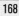 **2PM JERUSALEM, ISRAEL**
Jews and Palestinians cross each other's
paths in front of the Wailing Wall.
ALEXANDER KANTOR

11:15PM PLAYA DE ZAPALLAR, CHILE
This young woman lights a candle at the Virgin of Lourdes
cave, and gives thanks for the year that is ending.
CATALINA AGUIRRE BARROS

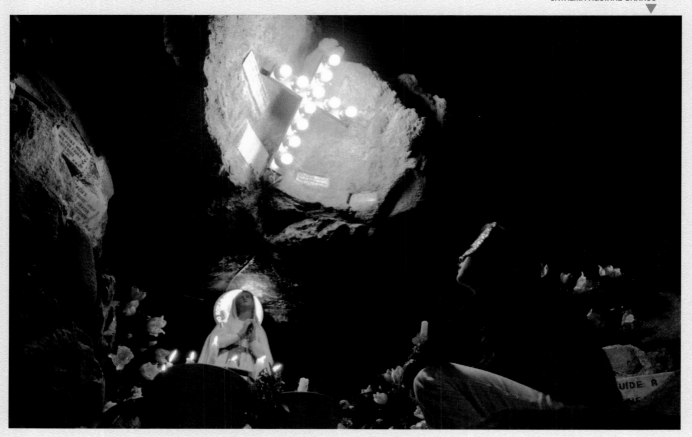

▲
2PM LONDON, ENGLAND
With the Millennium Wheel in the background, evangelists on Westminster Bridge preach about the second coming of Christ. NICK TSINOSIS

11:55PM GREAT BOWDEN, ENGLAND
George, aged seven, keeps an eye on the proceedings at a candlelight service in the town square. ED MAYNARD
▼

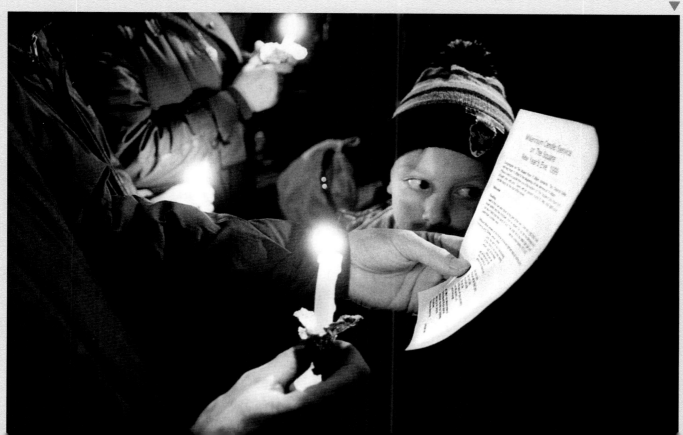

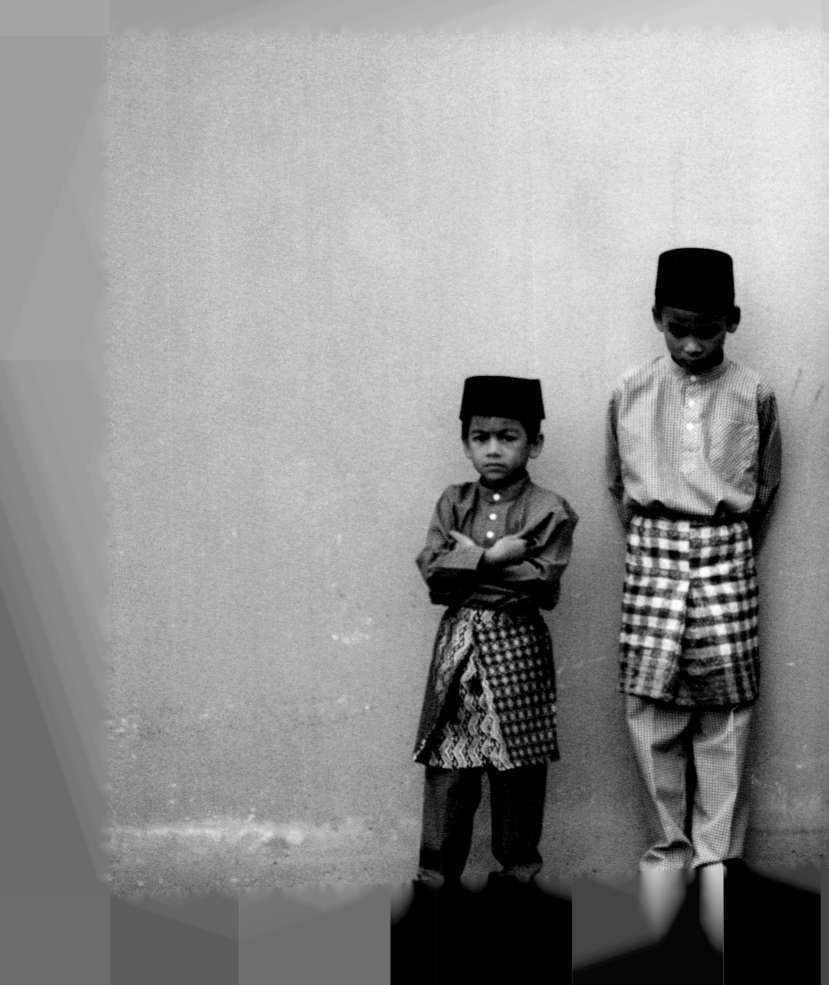

◄
★ **1:15PM KEPONG, MALAYSIA**
While others prepare to celebrate
New Year's, these Muslims wait to
attend prayers during Ramadan.
JASON ISAAC COLLAR

12:15AM MEMPHIS, TENNESSEE, USA
A crowd gathers before tall crosses in the American South, in contrast with the police car close by.
CANDACE WILLIAMS

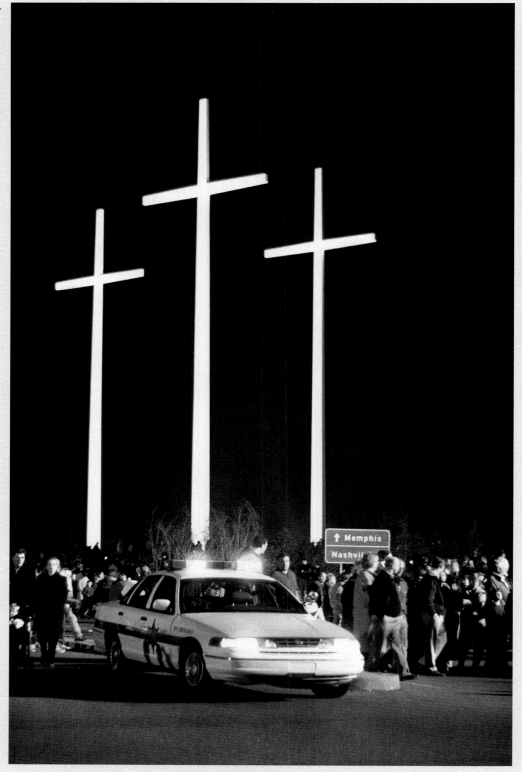

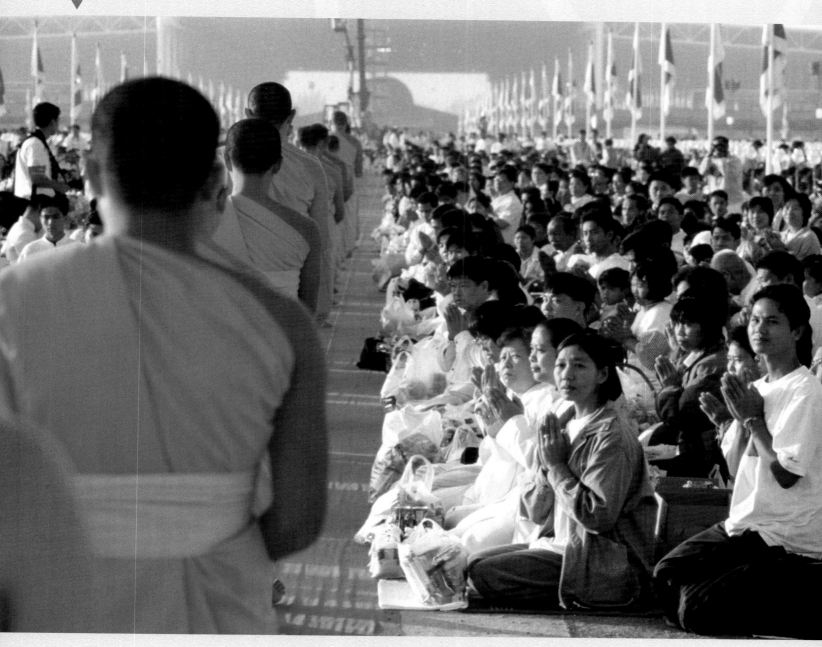

7AM PATHUMTHANI, THAILAND
Some of the quarter of a million Buddhists who gathered at the Phra Dhammakaya Temple.
PANICH CHULAVALAIVONG
▼

(NEXT PAGE) MIDNIGHT PATHUMTHANI, THAILAND ▶ ★
The Phra Dhammakaya Temple.
PANICH CHULAVALAIVONG

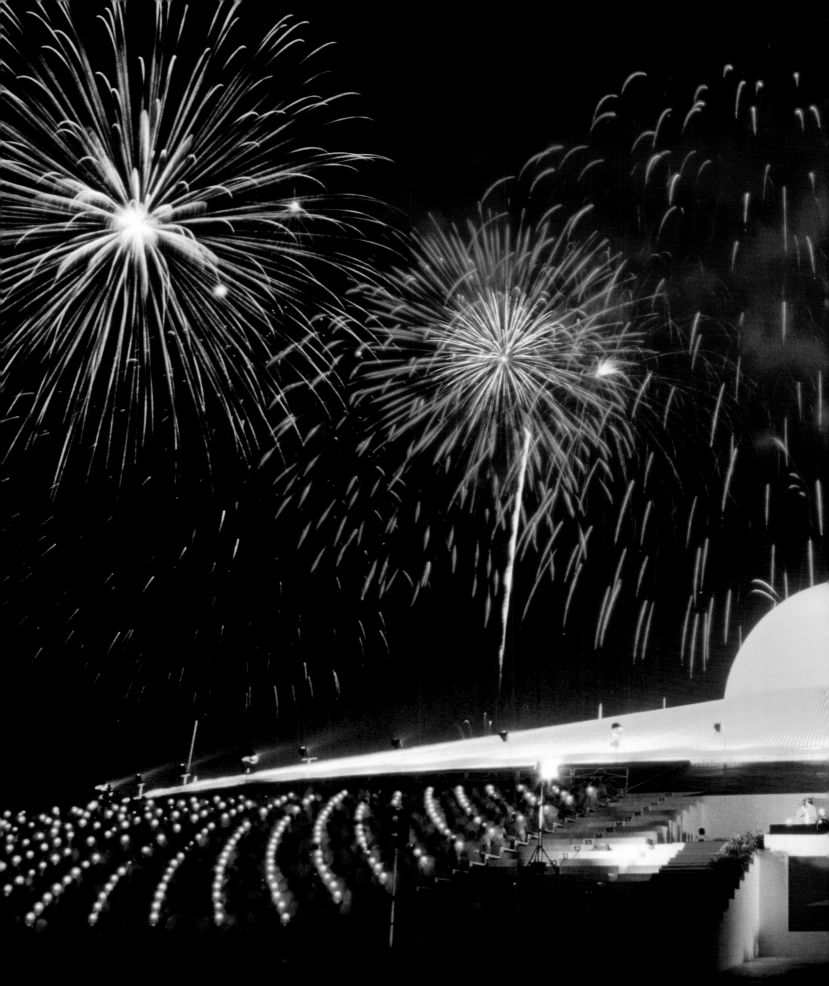

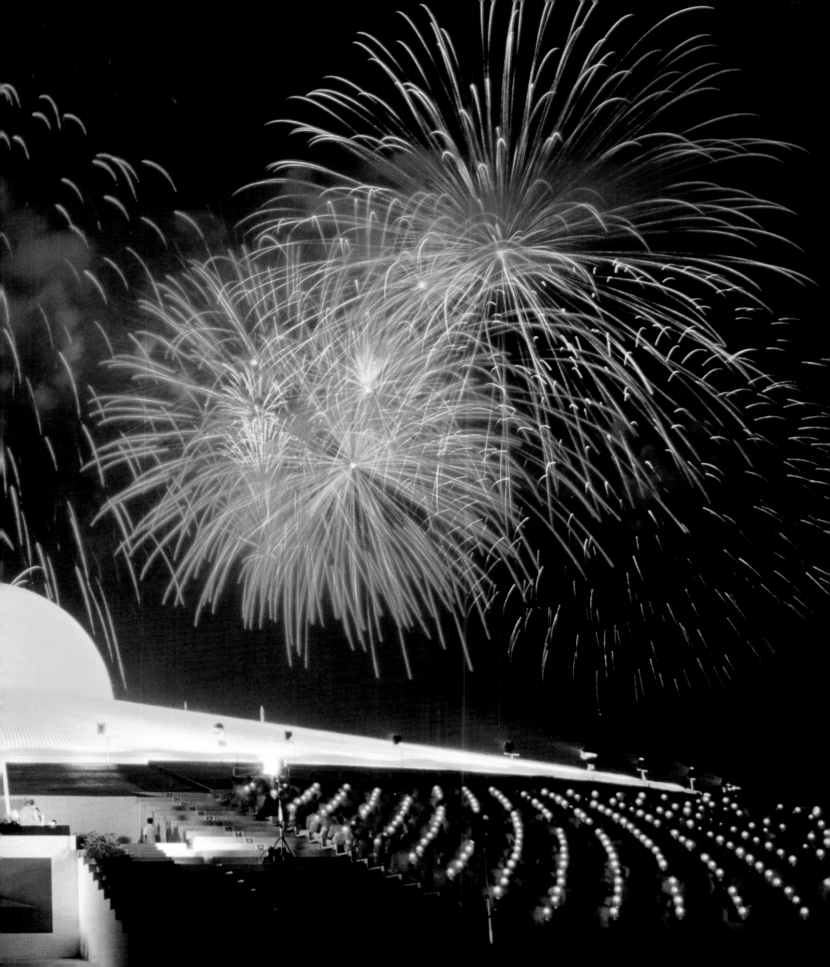

Mid

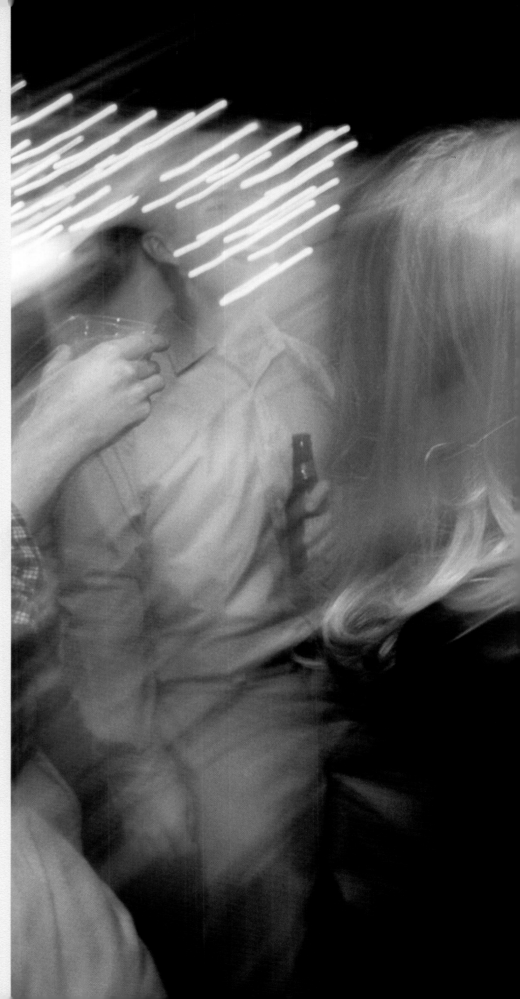

CHAPEL HILL, NORTH CAROLINA, USA
Midnight kiss at Goodfellows Bar.
JEFFREY CAMARATI

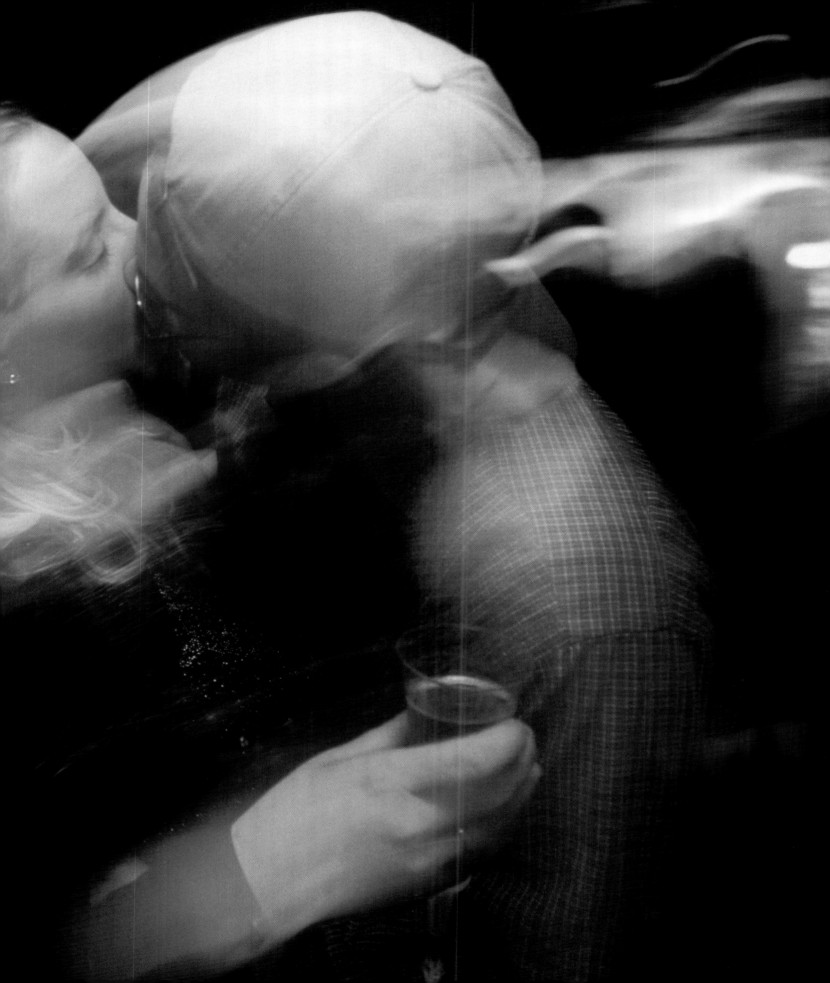

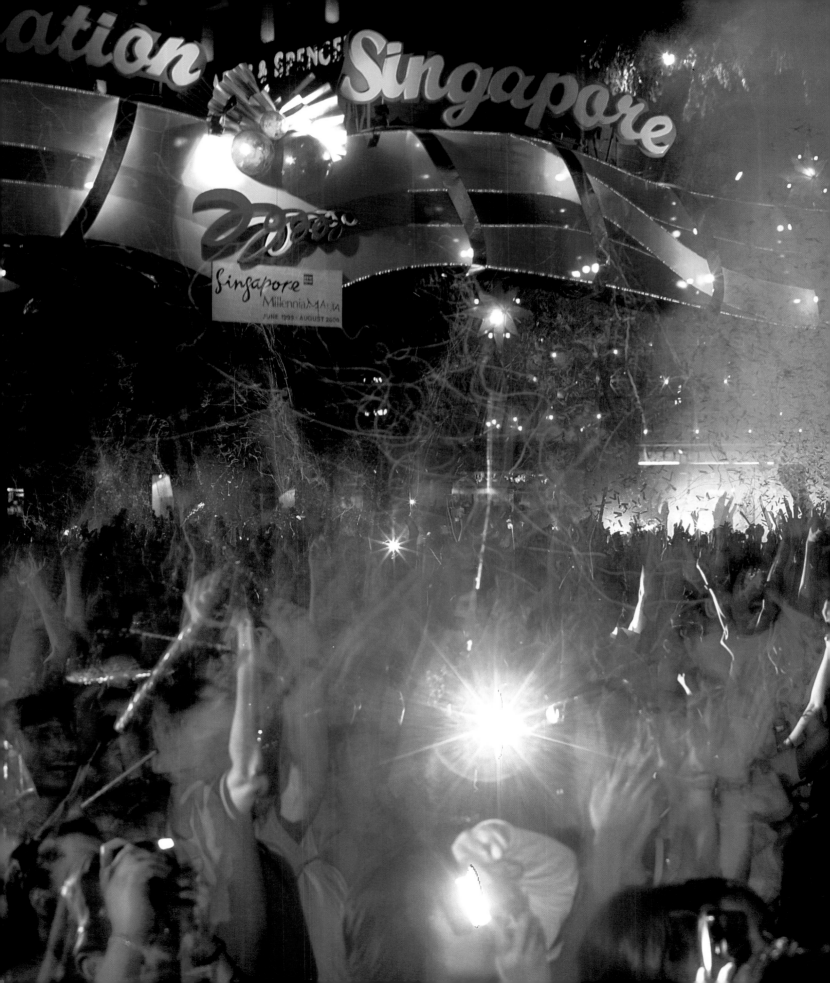

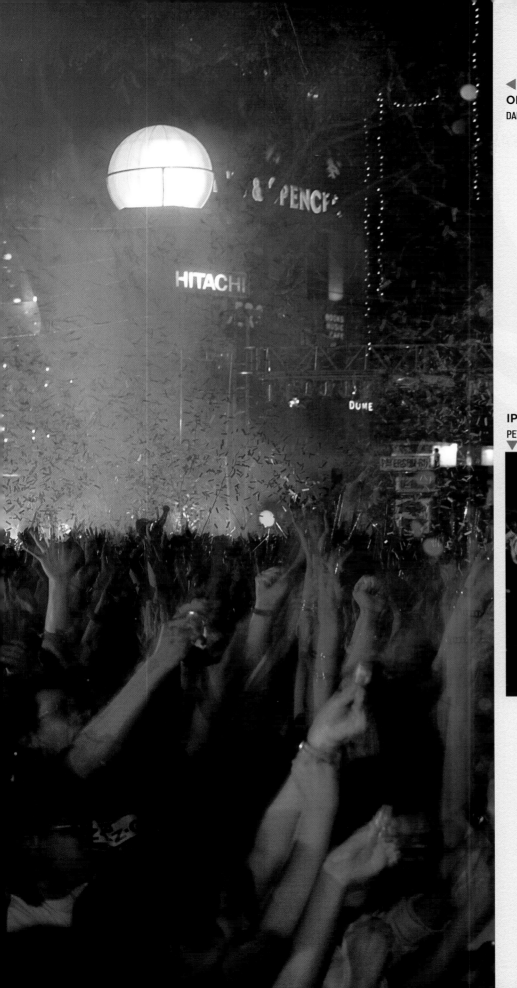

ORCHARD ROAD, SINGAPORE
DANIEL ZHENG

181

IPOH, MALYASIA
PETER LIOW CHIEN YING

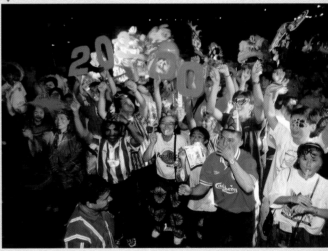

▲
VIRTU, ESTONIA
2000 is in the air!
PEETER VISSAK

▶
NEW YORK CITY, USA ★
Firefighters on standby duty
take part in the celebration
at Times Square.
KEVIN J. MCCORMICK

TORONTO, CANADA
Fireworks illuminate the CN Tower.
LAURA COMELLO
▼

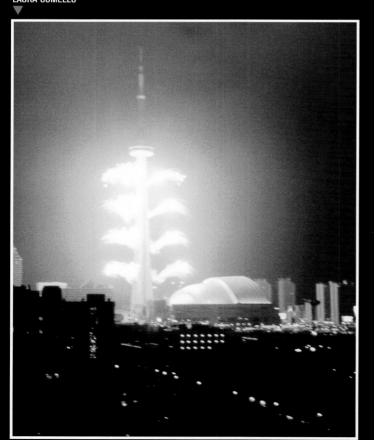

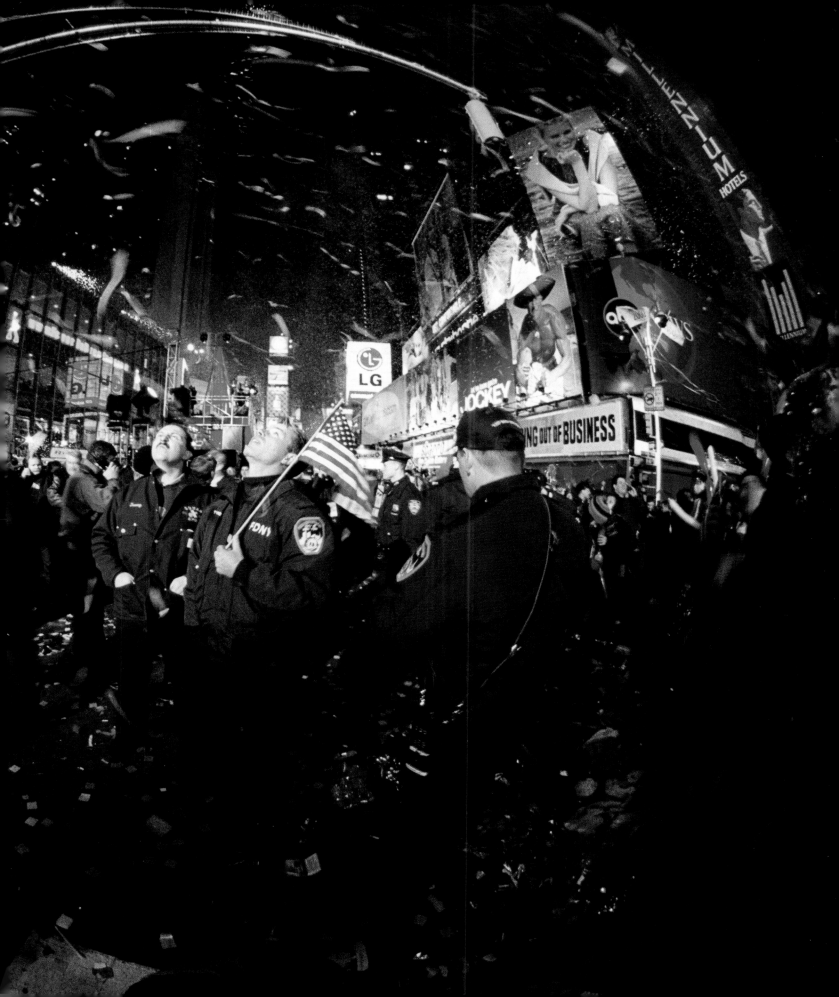

GIZA PLATEAU, EGYPT
"Man fears time, time fears the pyramids." This is their fifth millennium celebration. RICHARD SMITH

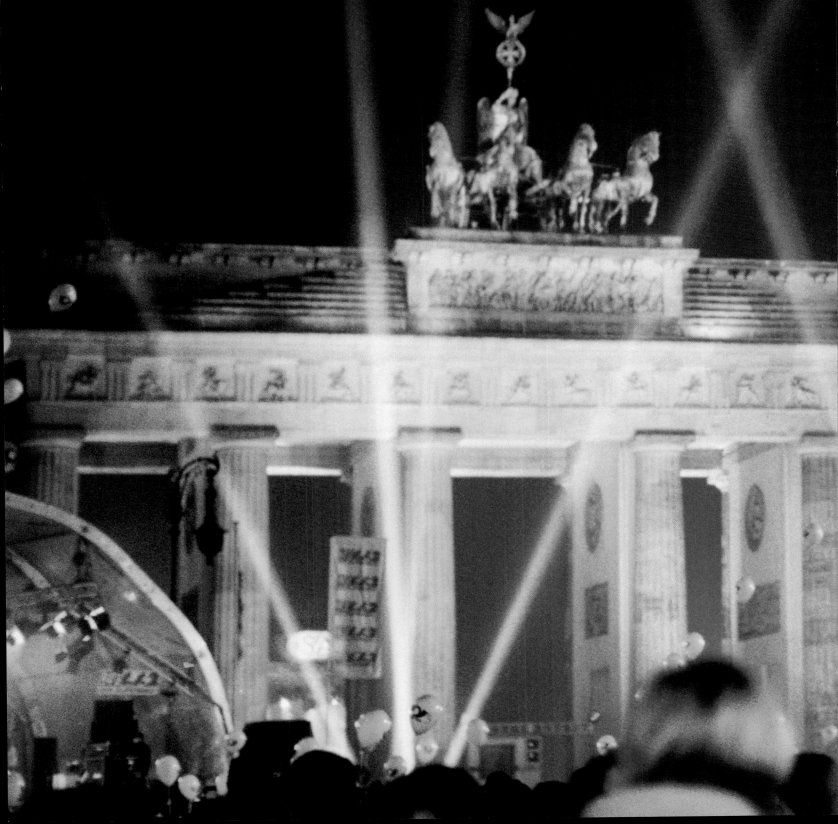

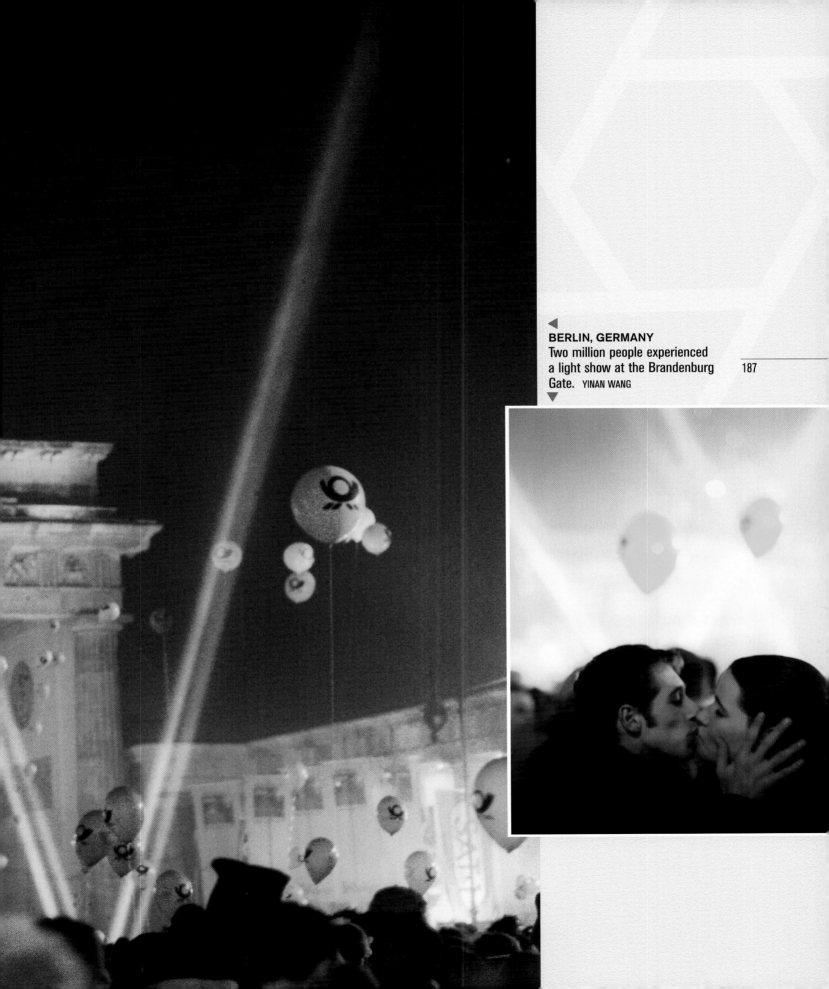

BERLIN, GERMANY
Two million people experienced
a light show at the Brandenburg
Gate. YINAN WANG

187

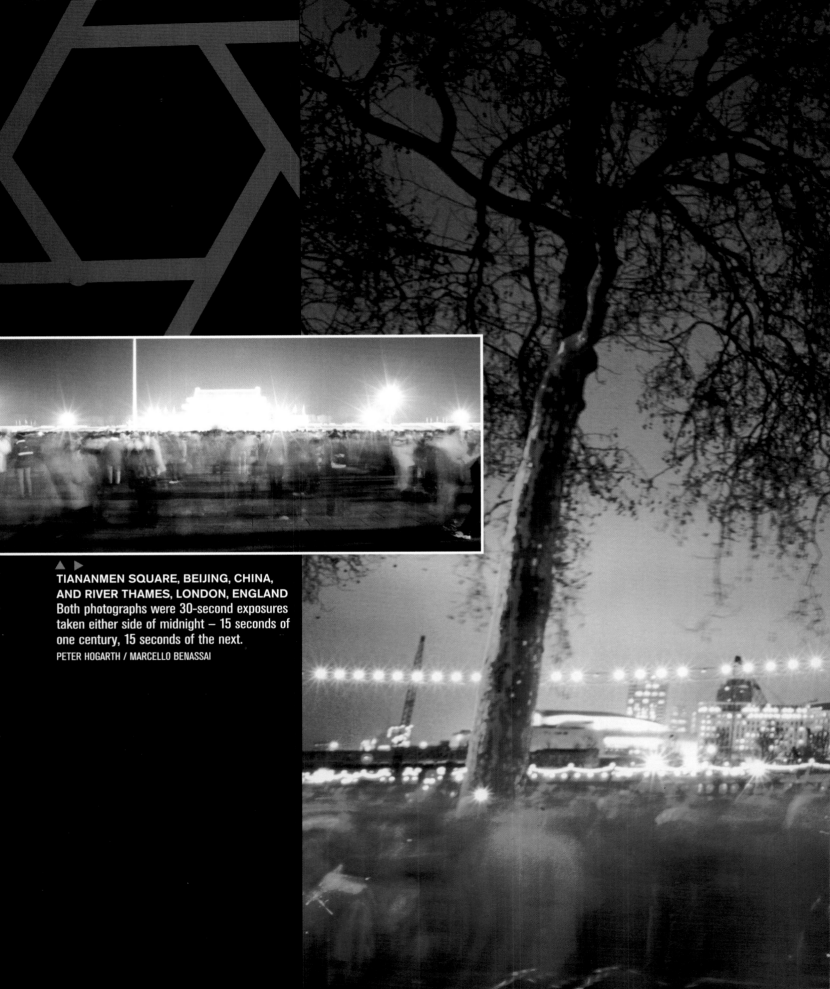

TIANANMEN SQUARE, BEIJING, CHINA, AND RIVER THAMES, LONDON, ENGLAND
Both photographs were 30-second exposures taken either side of midnight — 15 seconds of one century, 15 seconds of the next.
PETER HOGARTH / MARCELLO BENASSAI

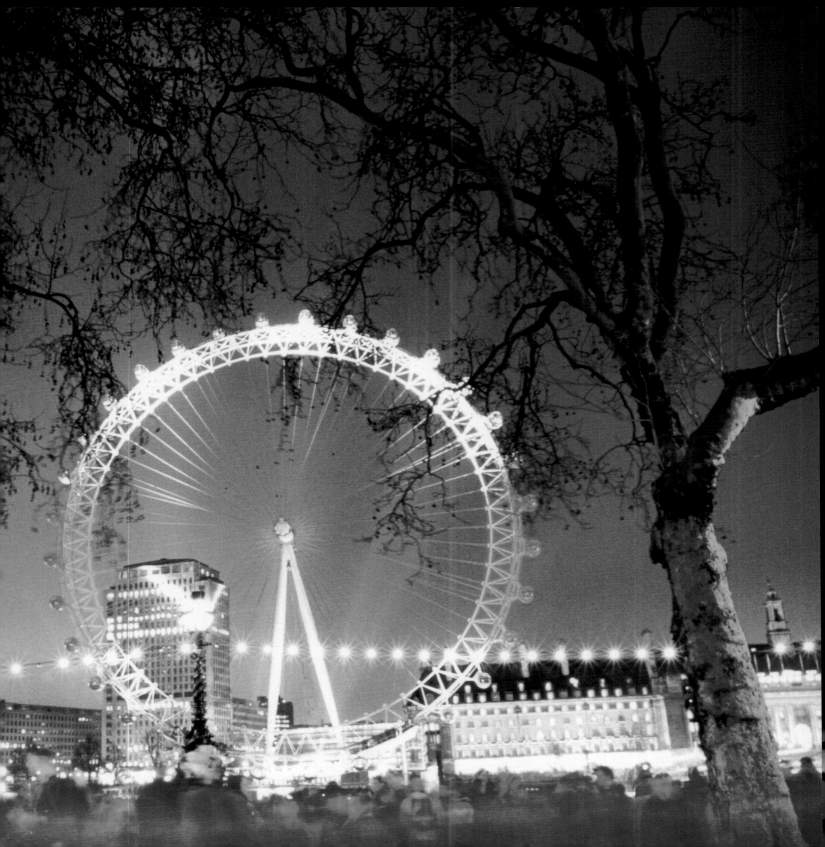

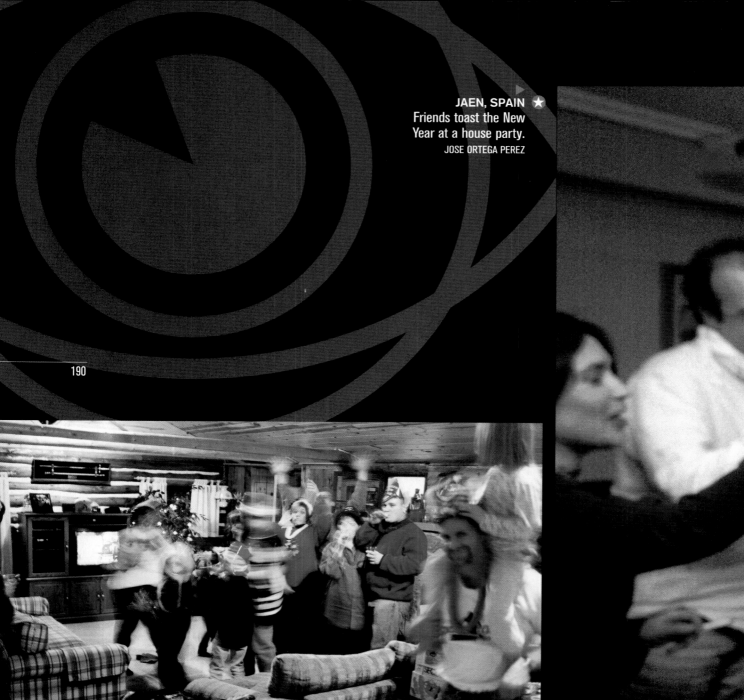

JAEN, SPAIN ★
Friends toast the New
Year at a house party.
JOSE ORTEGA PEREZ

ROSE CITY, MICHIGAN, USA
The Thompson family celebrates at midnight.
AIMEE MATTESON

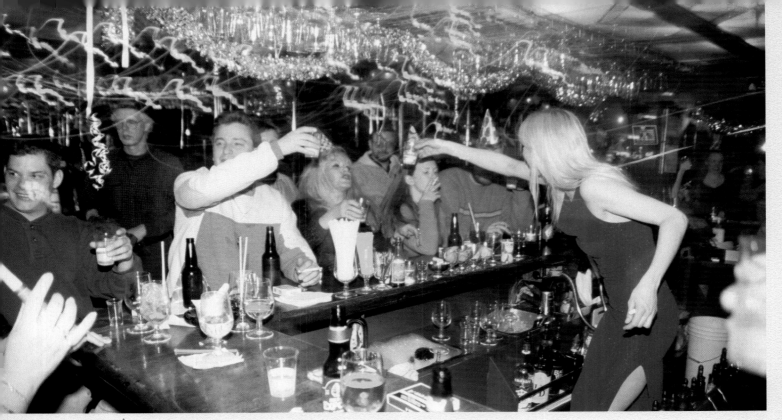

MONTREAL, CANADA
SUSAN SHEEN

TALLINN, ESTONIA
HELE-MAI VARIK

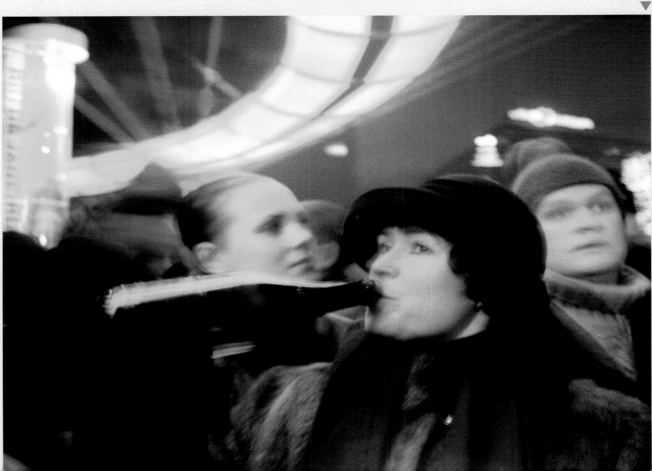

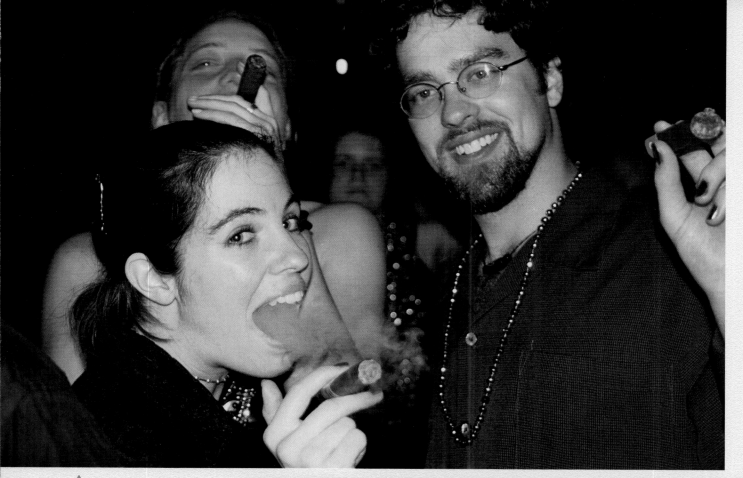

NEW ORLEANS, USA
ELLEN MERTEN

CHAPEL HILL, NORTH
CAROLINA, USA
JEFFREY CAMARATI

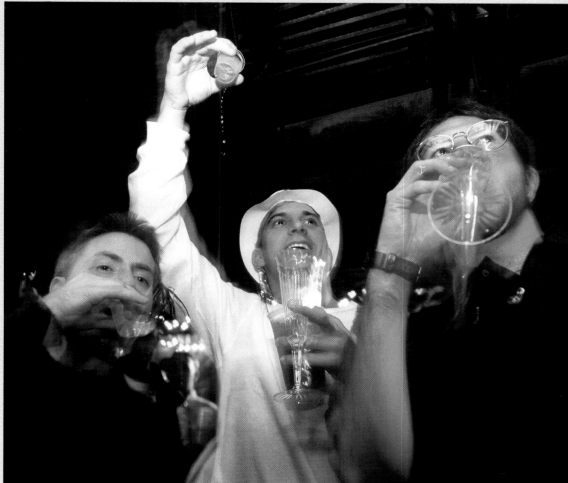

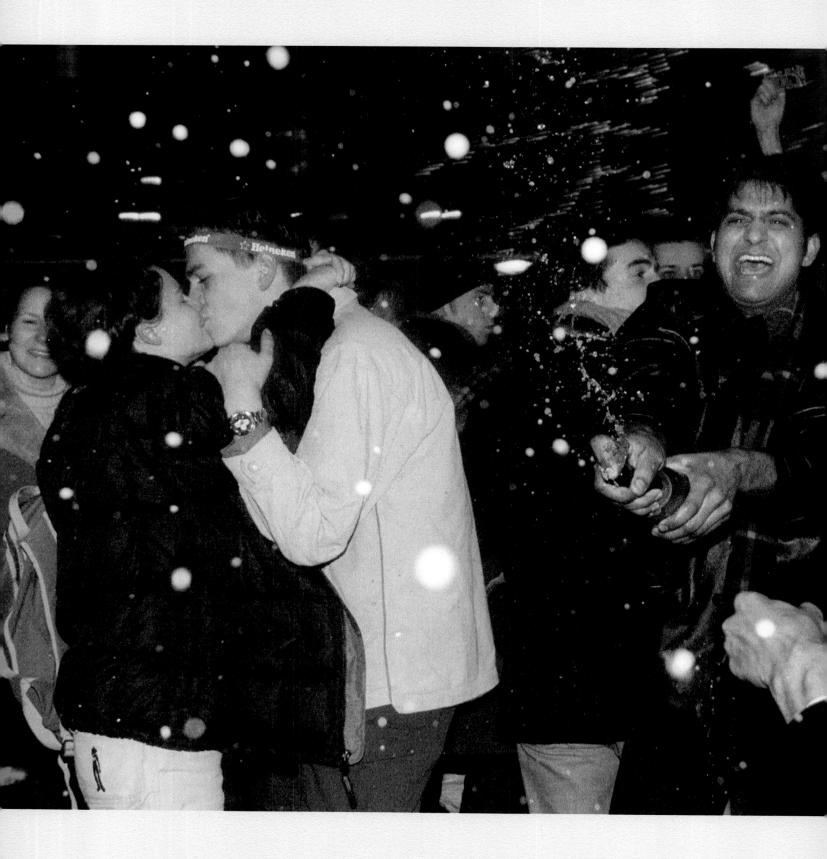

AMSTERDAM, NETHERLANDS
JOCK FISTICK

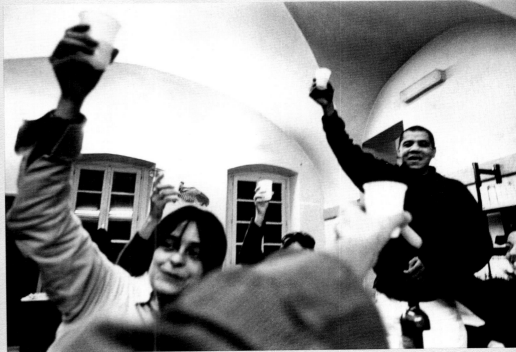

CITTA DELLA PIEVE, ITALY
DUILIO POLIDORI

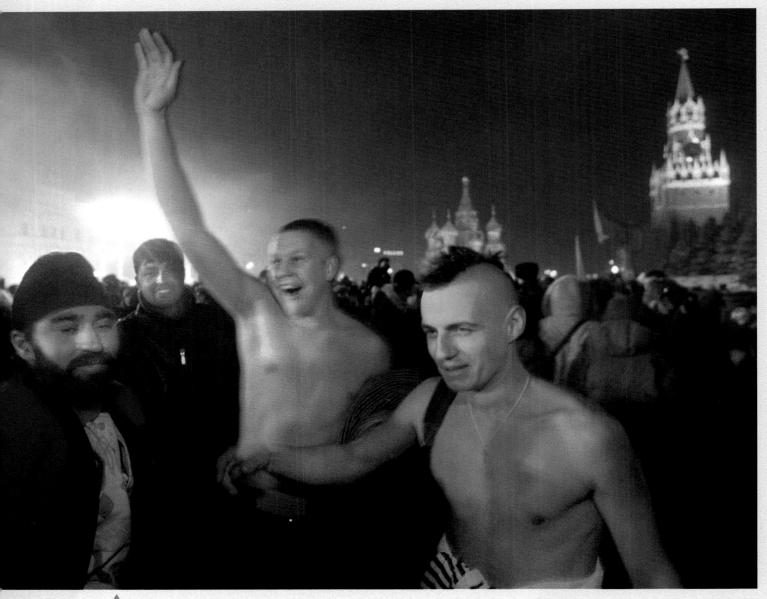

RED SQUARE, MOSCOW, RUSSIA
KONSTANTIN ZAVRAZHIN

GISBORNE, NEW ZEALAND ★
SUSAN OGROCKI

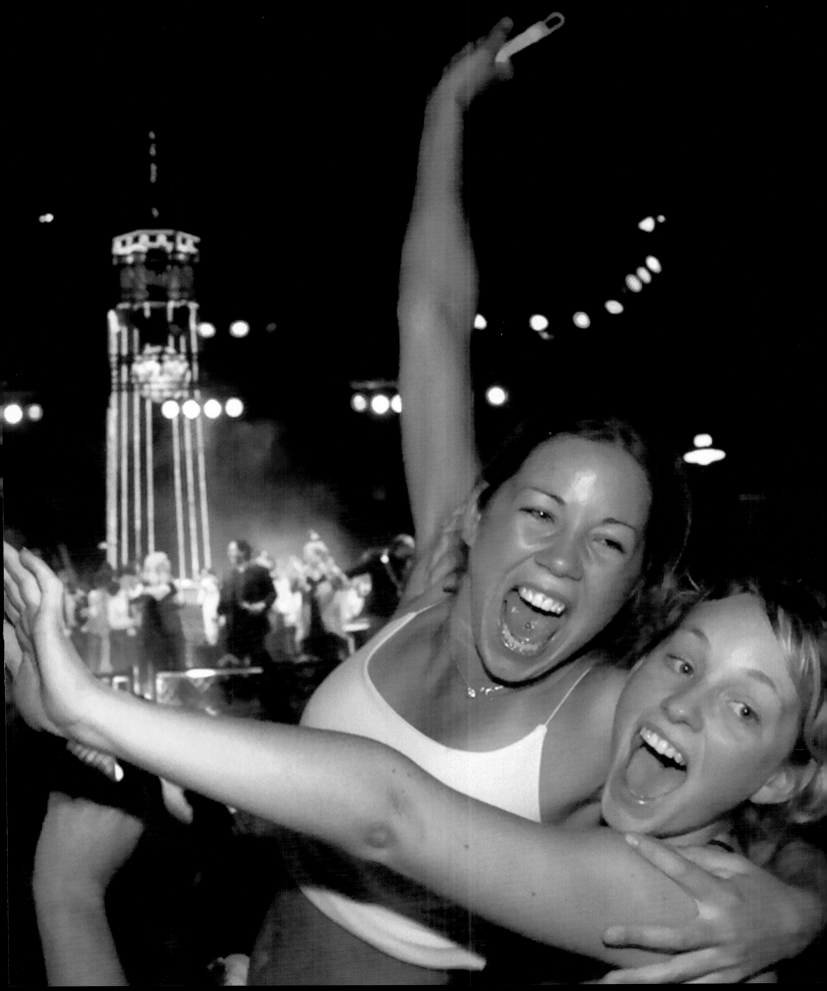

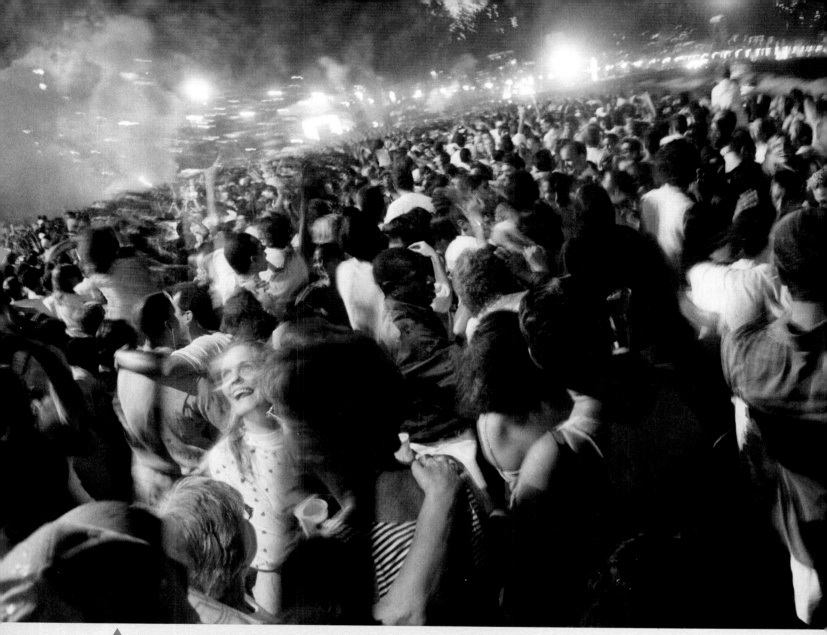

COPACABANA BEACH, RIO DE JANEIRO, BRAZIL
ROBERTO DELPIANO

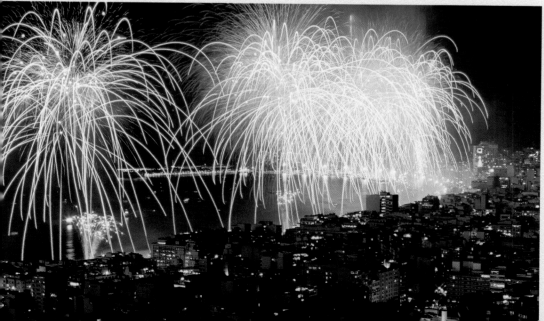

RIO DE JANEIRO, BRAZIL
It was a wet evening in Rio, but the rain stopped just five minutes before midnight, to the delight of more than 2.5 million people who watched the fireworks display at Copacabana Beach. ANDRÉ ARRUDA

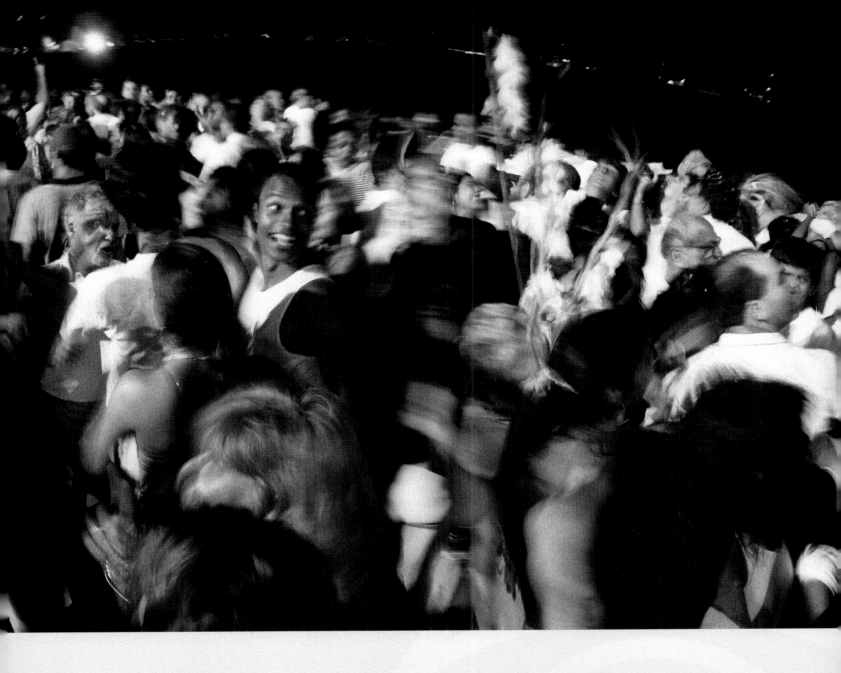

(NEXT PAGE) BARCELONA, SPAIN
A Catalan theatre group constructed "Millennium Man"
and suspended it above Barcelona's main square.
Thirty thousand people contributed ideas to the design
with the most common being a big, luminous heart!
DARIUS KOEHLI

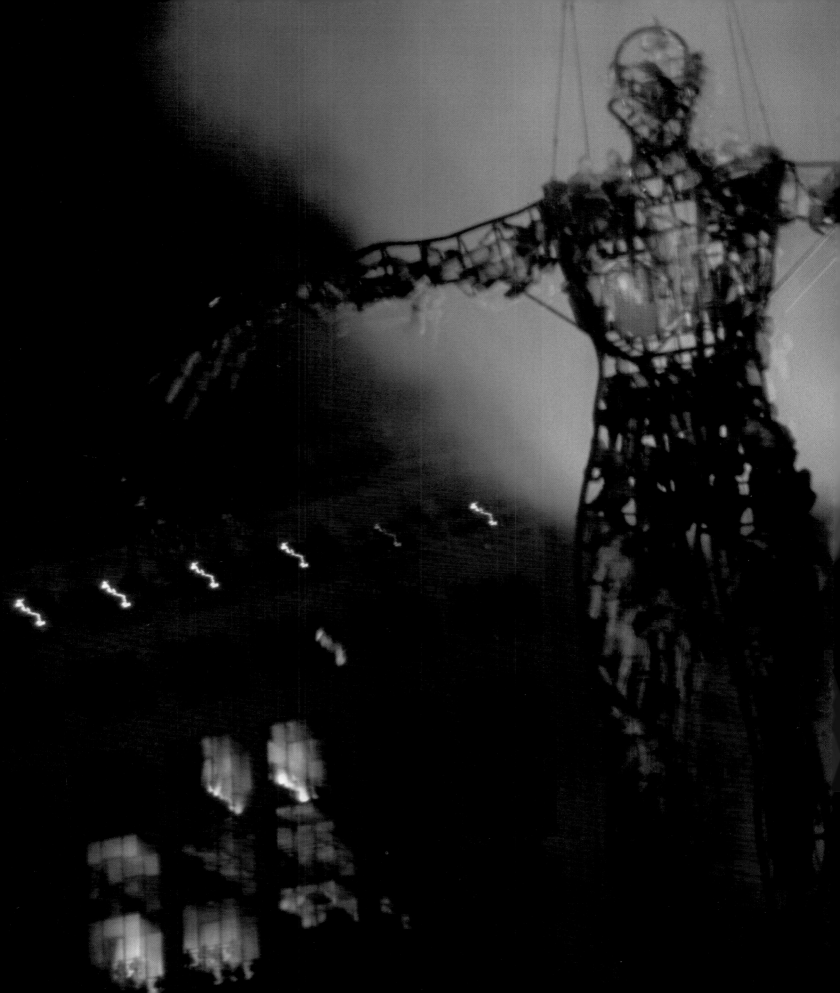

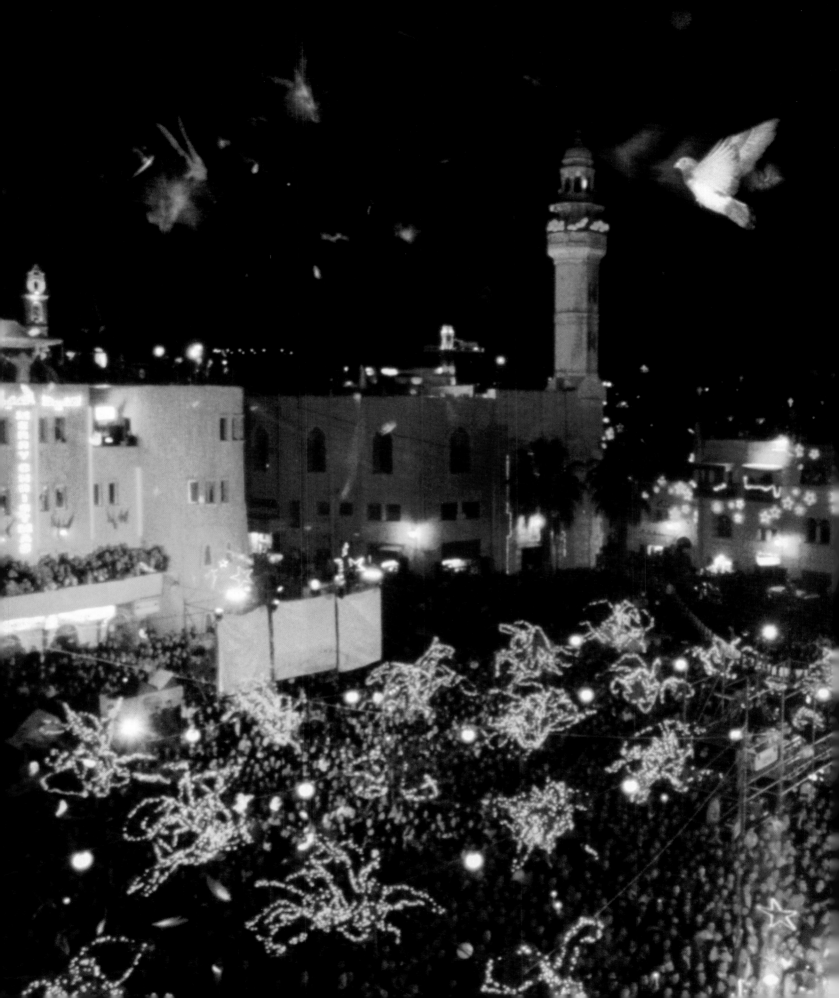

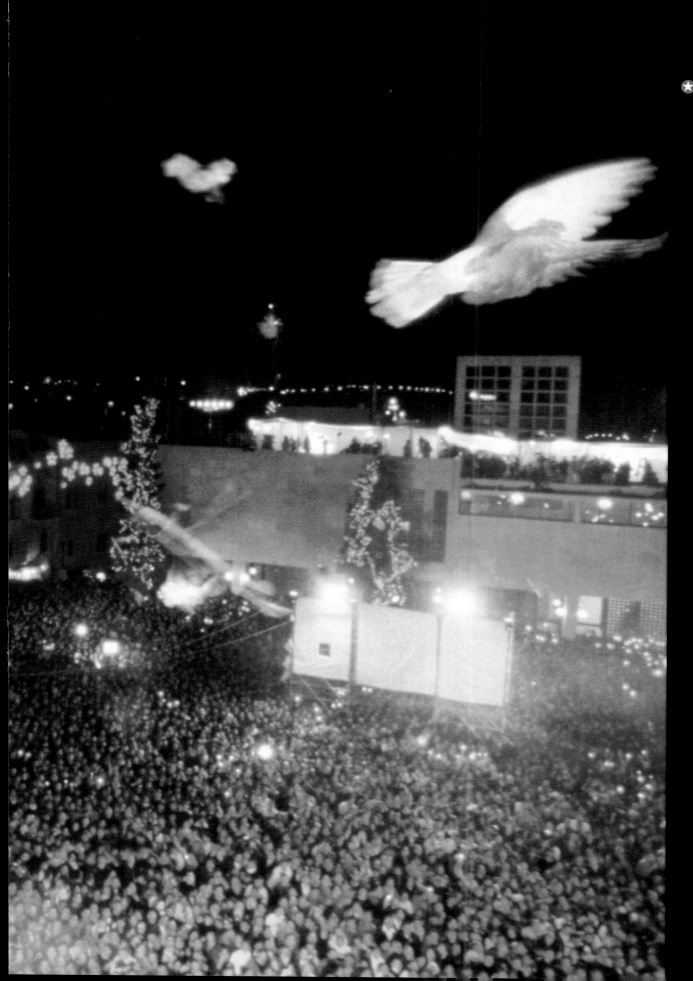

203

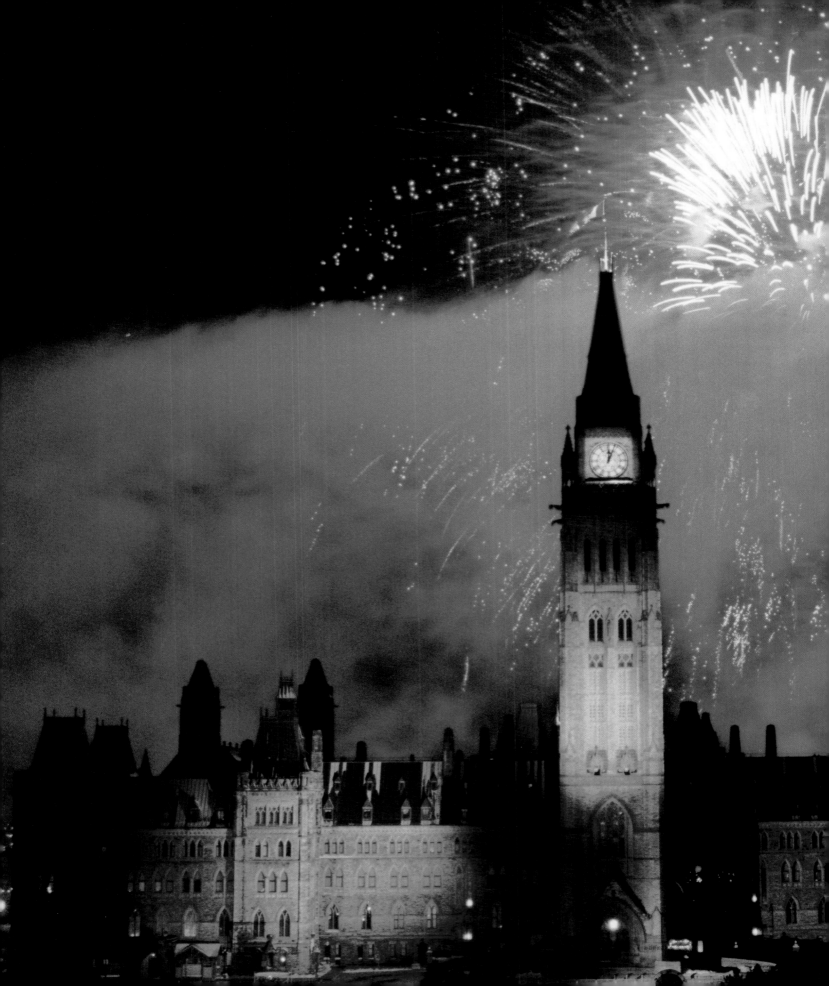

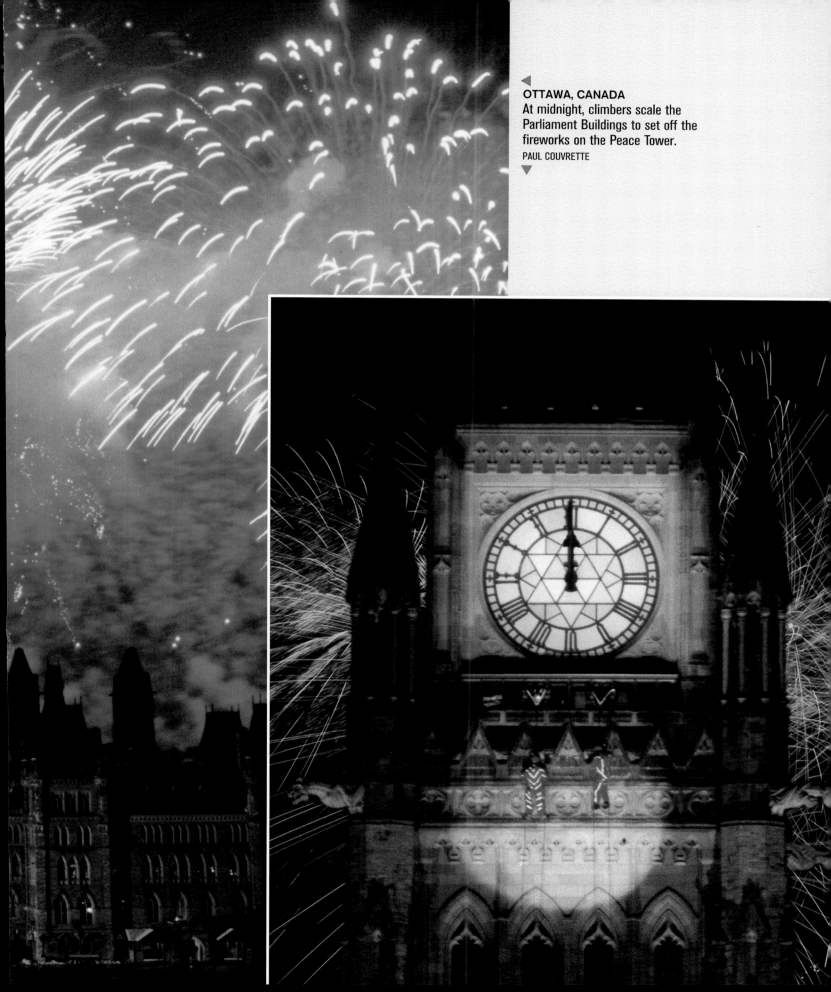

OTTAWA, CANADA
At midnight, climbers scale the
Parliament Buildings to set off the
fireworks on the Peace Tower.
PAUL COUVRETTE

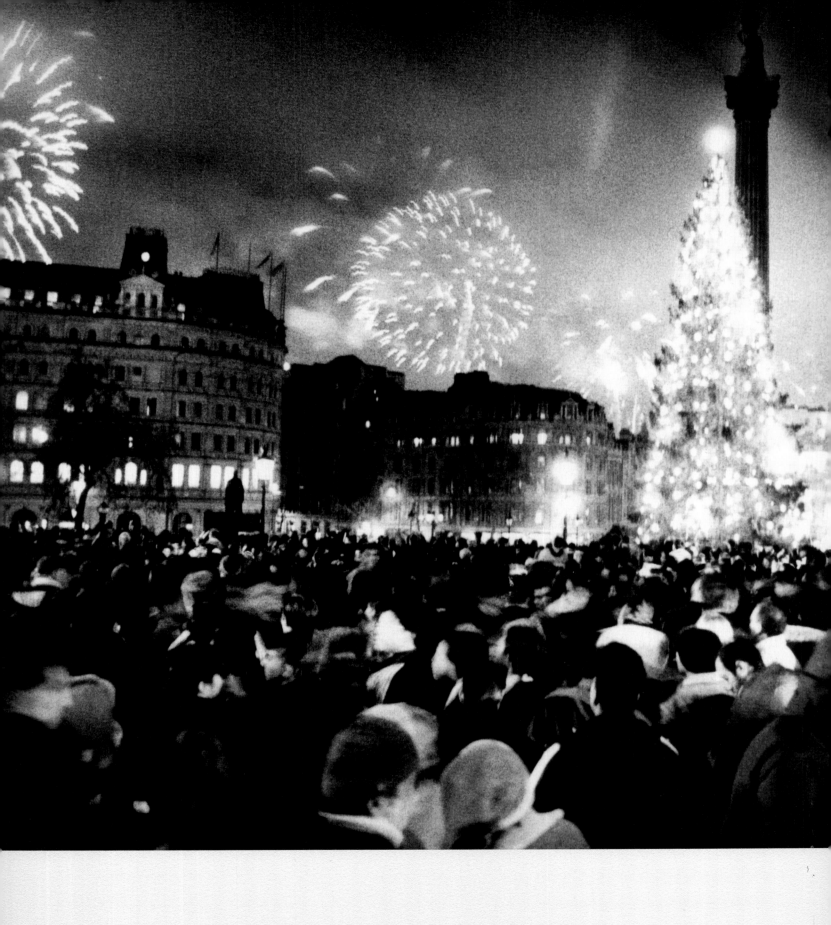

◀ ▲
TRAFALGAR SQUARE, LONDON, ENGLAND
MATTEO ALESSANDRI

207

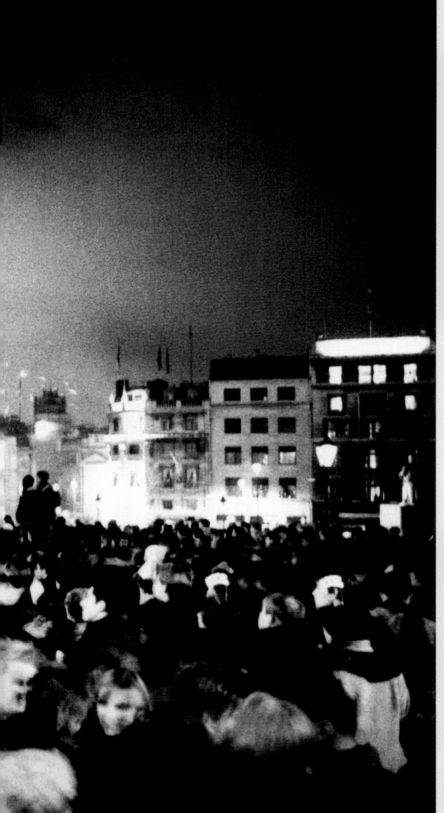

WESTMINSTER BRIDGE, LONDON, ENGLAND
ANDREA MOSSO
▼

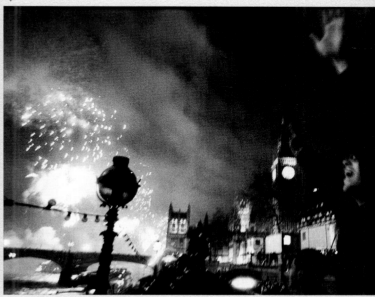

⭐ **CAPE TOWN, SOUTH AFRICA**
Twenty thousand people gather
for an all-night rave.
ANDREW OCTOBER

▶
MOSCOW, RUSSIA
Thousands gather in Red
Square to see fireworks
over the Kremlin.
KONSTANTIN ZAVRAZHIN

⭐ **ROME, ITALY**
The religious and secular worlds
join together for a benediction by
the Pope, and for a fireworks
display in St. Peter's Square.
MICHELE SORTINI

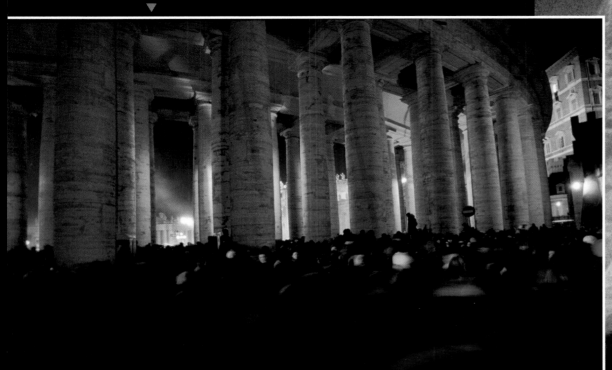

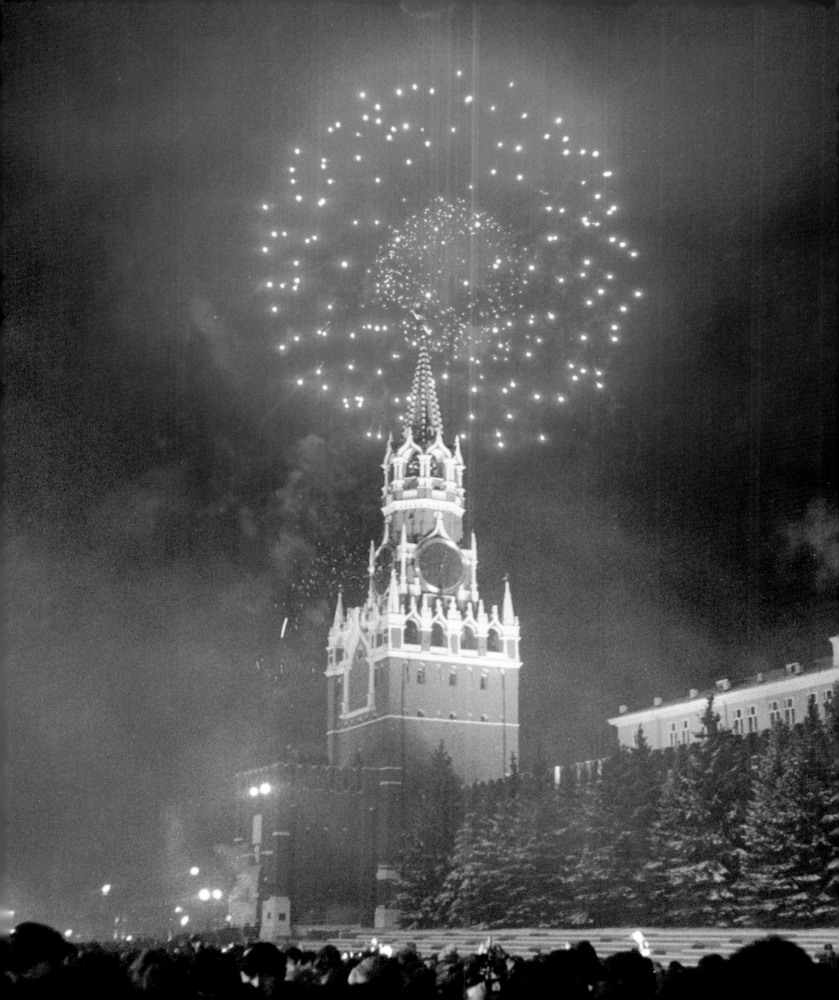

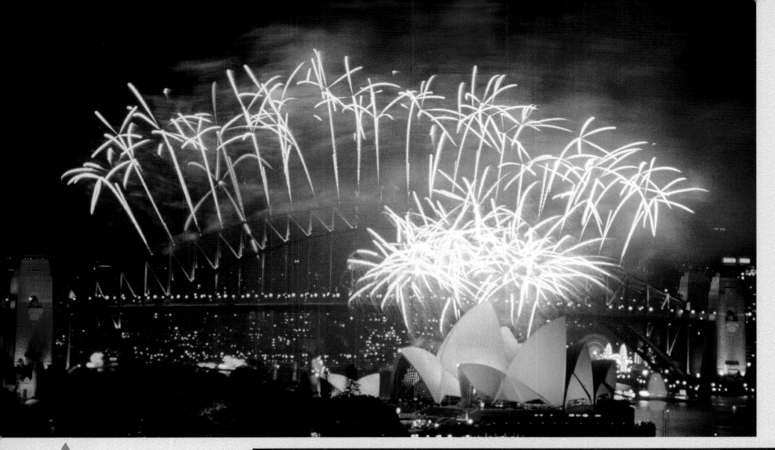

SYDNEY, AUSTRALIA
Fireworks over the Sydney
Opera House PAUL MARKHAM

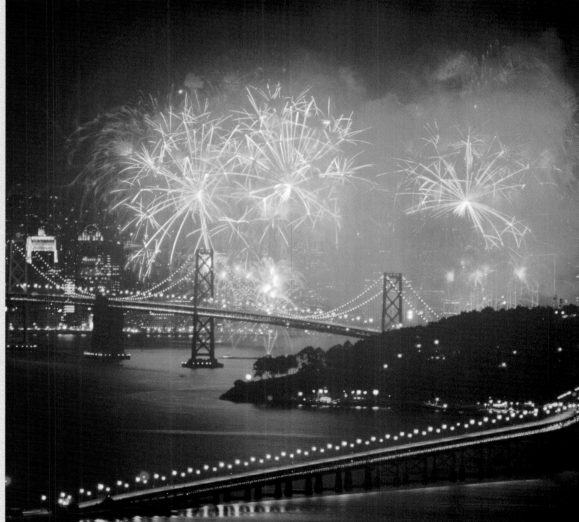

SAN FRANCISCO, USA ★
View towards the Bay Bridge.
BRAD PERKS

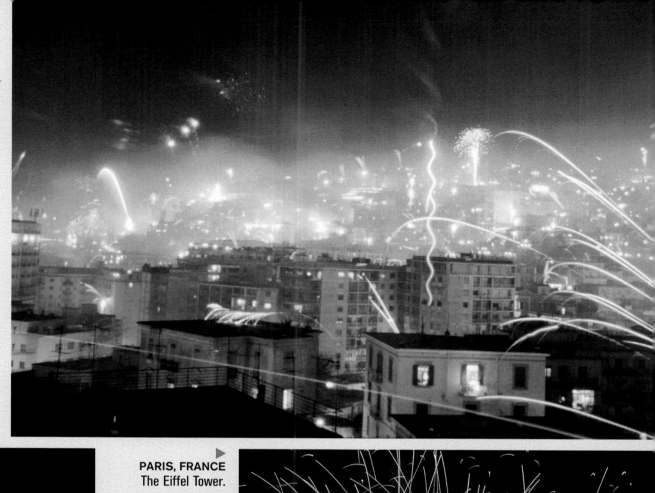

NAPLES, ITALY
A firecracker battle
between the houses.
ALDO MESCHINI

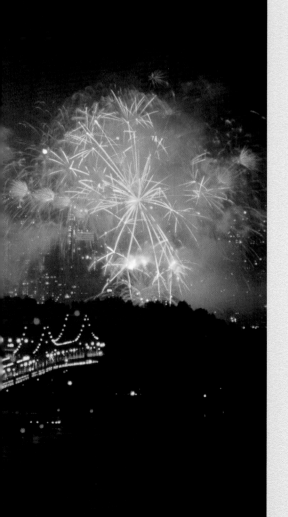

PARIS, FRANCE
The Eiffel Tower.
LUIZ EDUARDO ACHUTTI

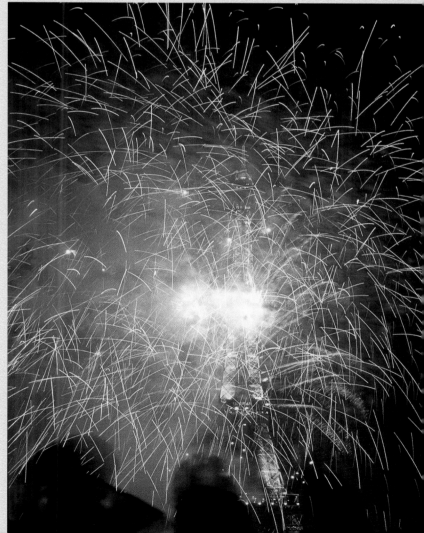

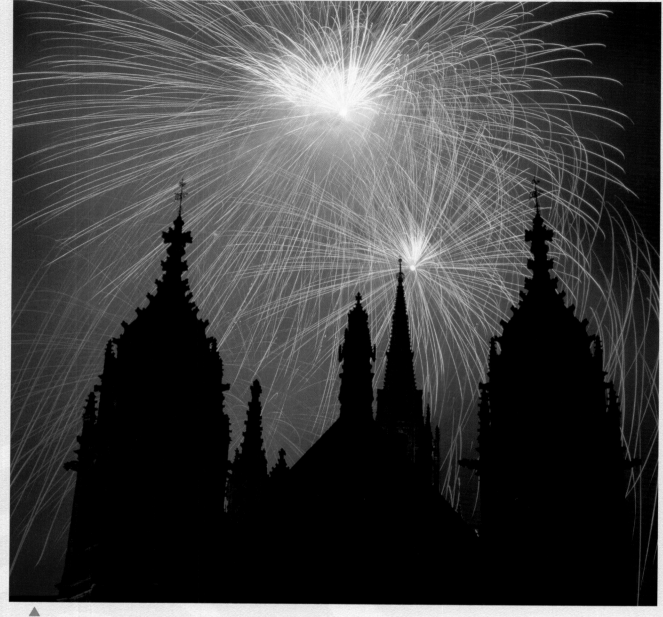

214

★ ▲ **LONDON, ENGLAND**
Fireworks light up the Houses of Parliament.
WILLIAM BOWDEN

▶ **POUND RIDGE, NEW YORK, USA** ★
Locals of this small town enjoy a
firework display before midnight.
STUART SIMONS

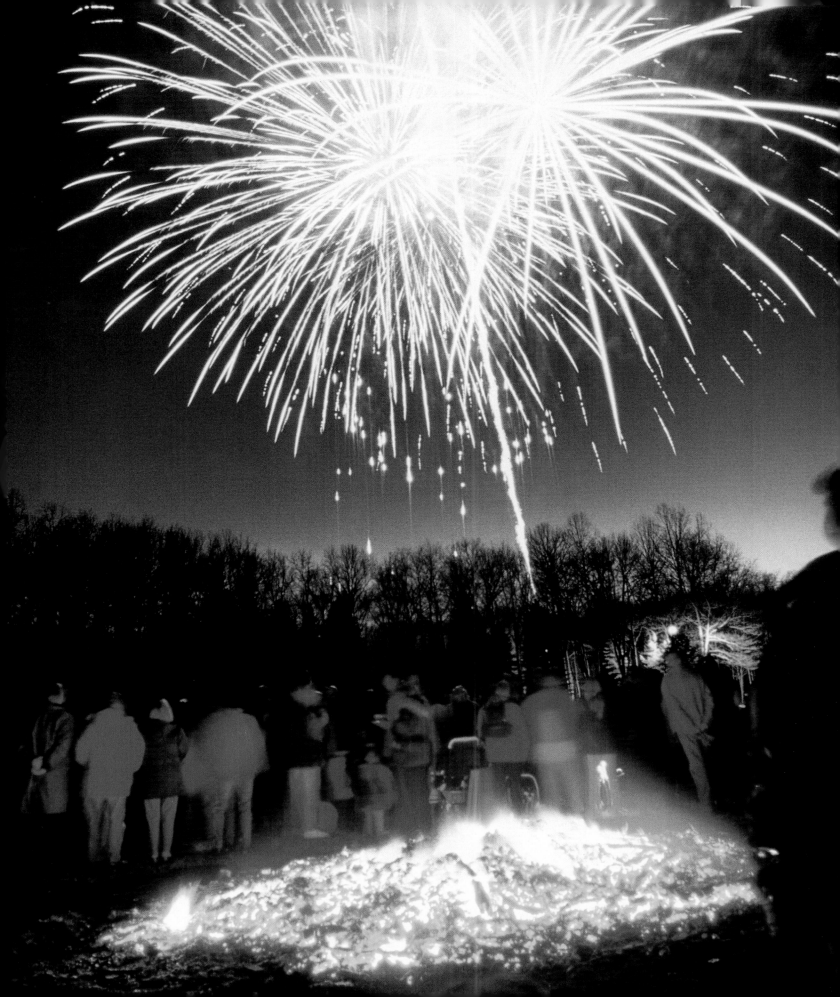

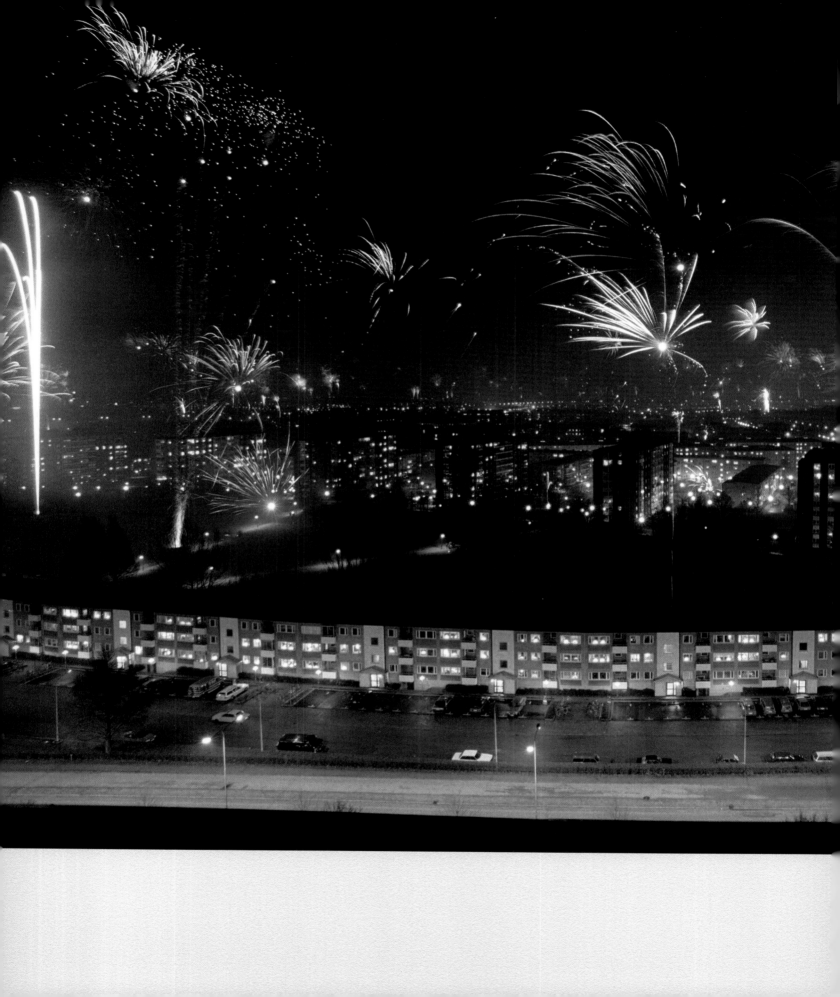

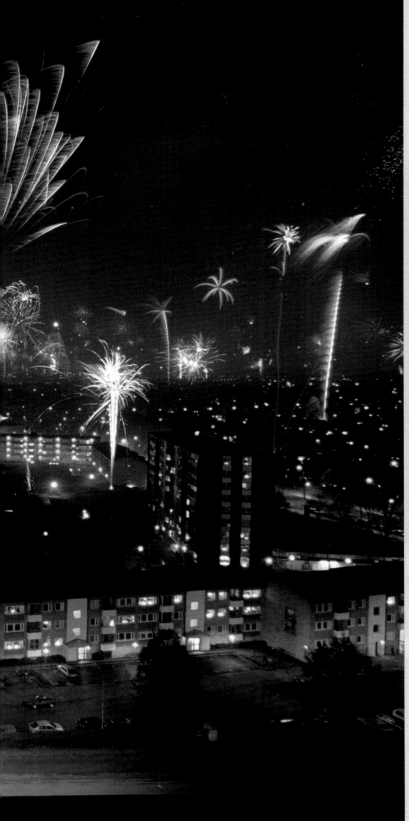

◄
MALMO, SWEDEN
A view across the town.
LARS BRUNDIN

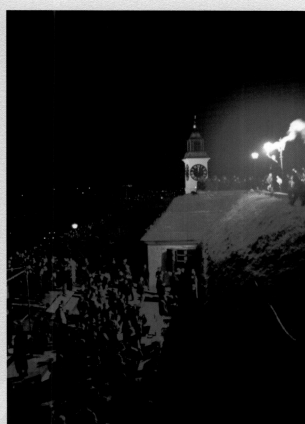

▲
NOVI SAD, YUGOSLAVIA
Something to celebrate. The war
is over and a new year begins.
DUBRAVKA LAZIC

217

▶
(NEXT PAGE) NEAR BALLENY ISLANDS, ANTARCTICA
Midnight at 66 degrees south in the Antarctic circle.
Passengers on this Russian ice breaker only have sixteen
more minutes to wait until sunrise.
JILL WHILLOCK

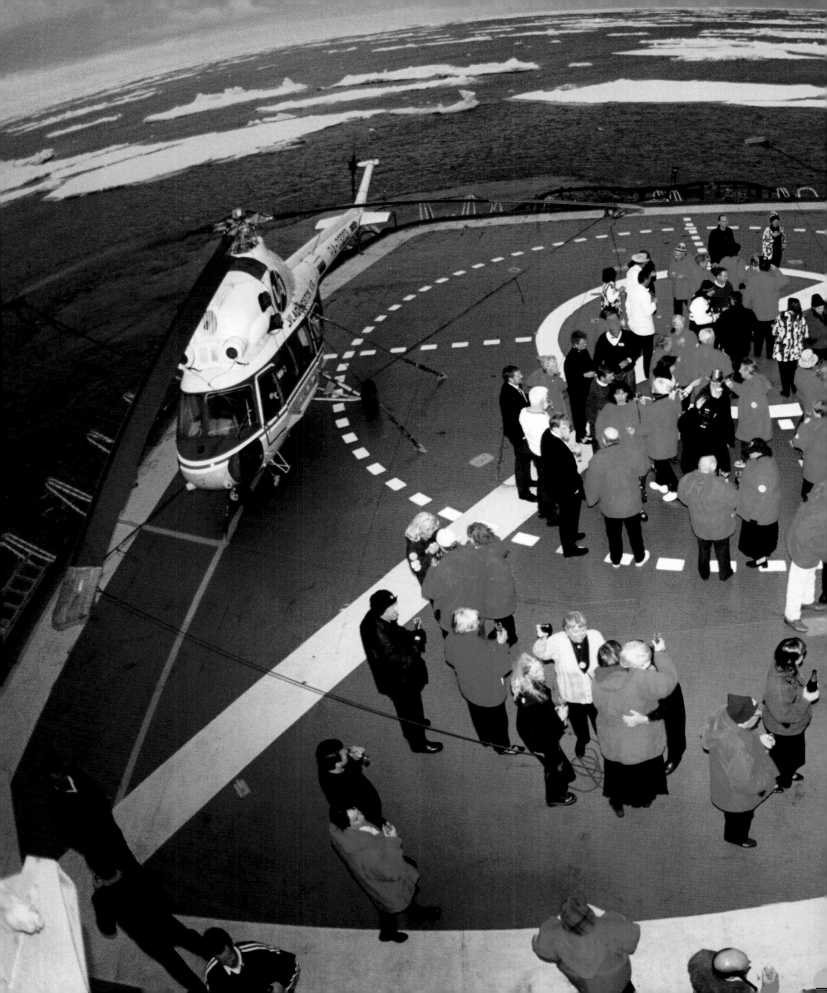

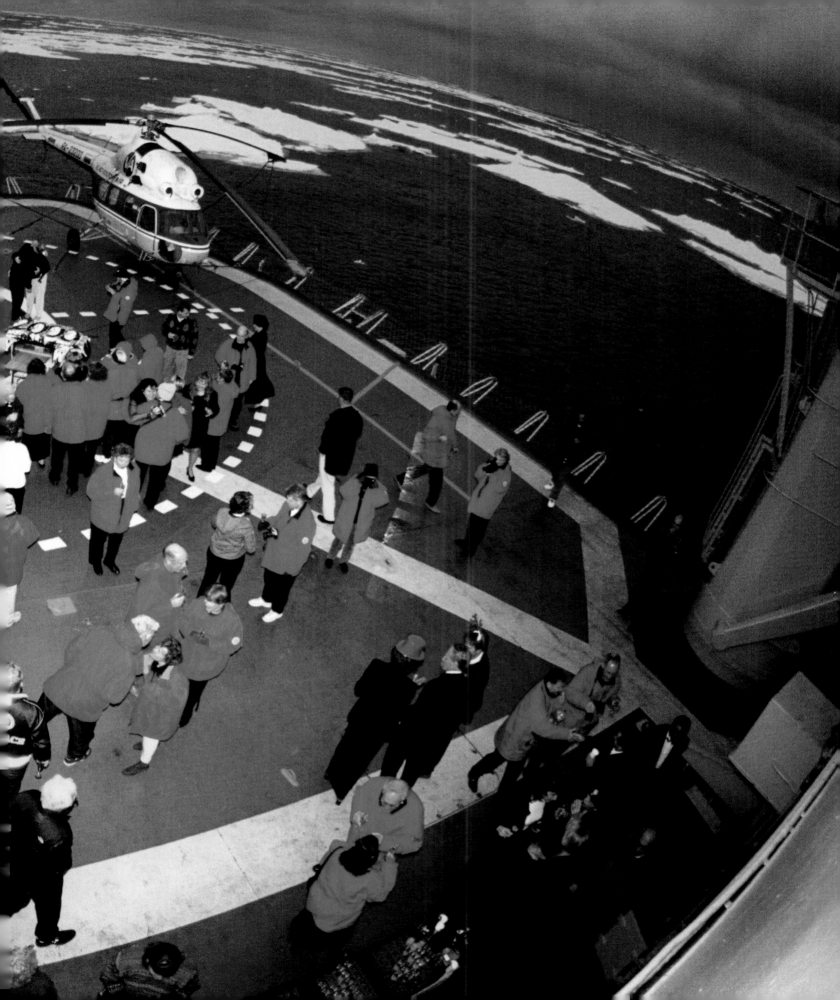

After

math

Crowds begin to disperse. Parties wind down or heat up. People gather for pre-dawn breakfasts. And everywhere clean-up crews begin to deal with the debris.

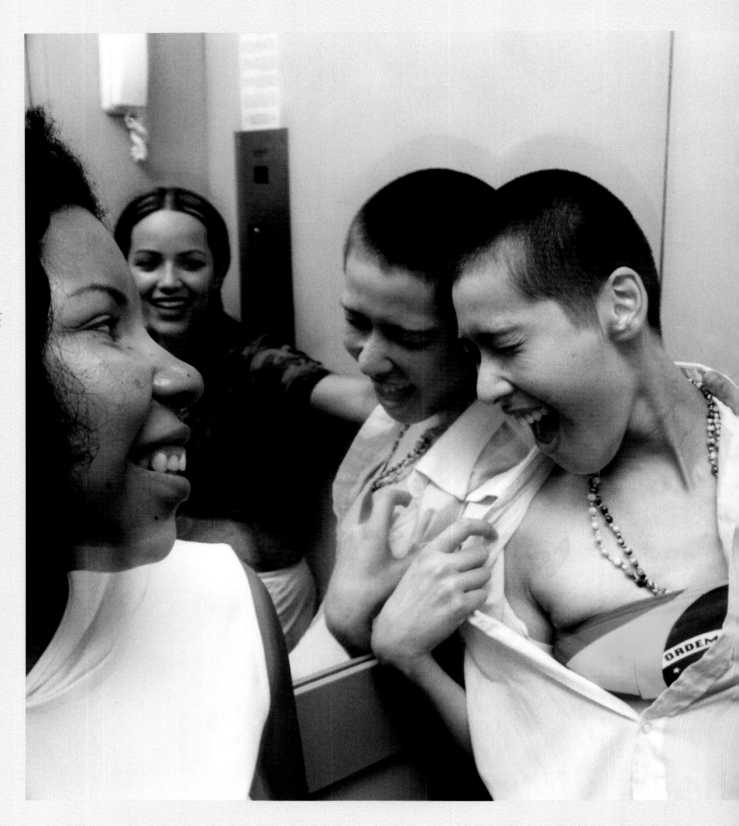

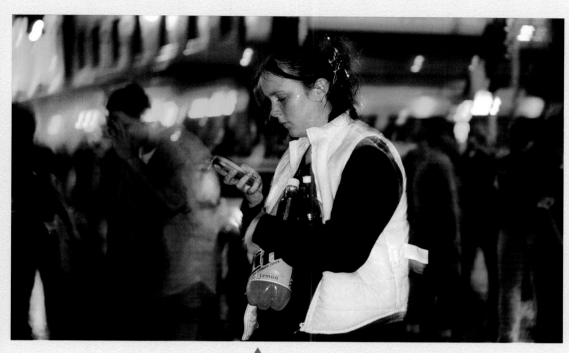

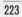

◄ **2:15AM RIO DE JANEIRO, BRAZIL**
ARTHUR LEANDRO

▲ **12:12AM AUCKLAND, NEW ZEALAND**
SHARIE PENWARDEN

3AM AMSTERDAM, NETHERLANDS
JOCK FISTICK
▼

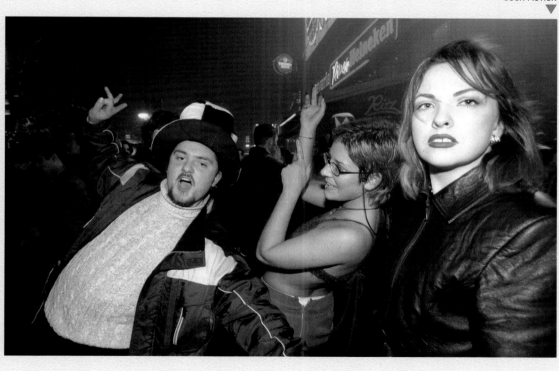

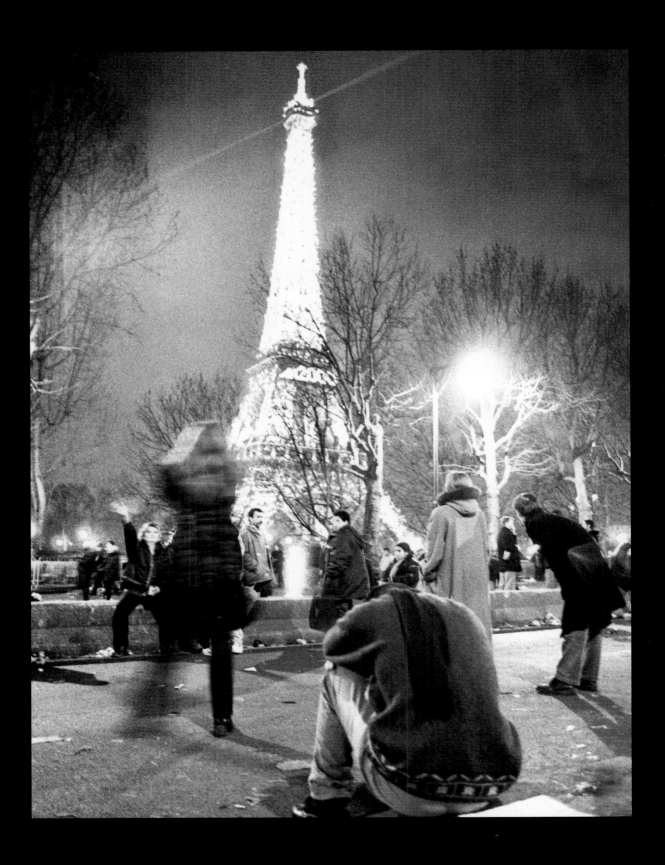

2:30AM FORT COLLINS, COLORADO, USA
All is calm at the emergency operations centre
as the last employees leave the room.
RICHARD MIODONSKI

12:30AM UPPER DARBY, PENNSYLVANIA, USA
This boy lasted until midnight before
finally succumbing to sleep.
TIFFANY RUOCCO

2:45AM PARIS, FRANCE
A few partygoers still remain
at the Eiffel Tower.
DONNA HENRY

1AM HELSINKI, FINLAND
The transit system is strained to the limit as people try to get home.
CARL-MAGNUS DUMELL

6:42AM AUCKLAND INTERNATIONAL AIRPORT, NEW ZEALAND
A journalist interviews a pilot whose flight from Los Angeles carried only sixty
brave passengers. They were treated to a full 360-degree turn over Pitt Island
to see the sun rise five minutes before the official dawn. JOHN GERARD COSGROVE

▲
3AM ST. LOUIS, MISSOURI, USA
After swing-dancing in retro clothing from the 1940s, friends stop
at the South Side Diner for an early breakfast. CHRISTINE A. OLSON

4AM NEW YORK CITY, USA
Four hours after midnight, the crowds have dispersed from Times Square.
CHRIS PERSON

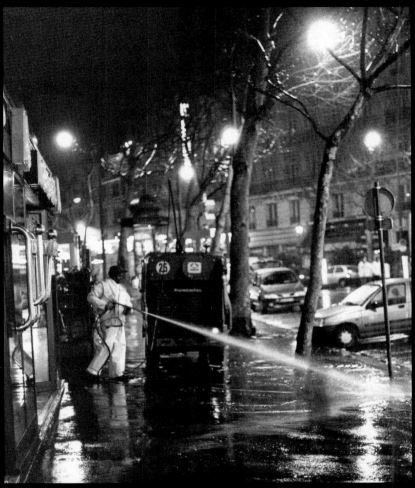

5:30AM PARIS, FRANCE
Washing down the streets near dawn.
EROL BENT

12:45AM NEW YORK CITY, USA
Empties on the subway. CHRIS PERSON

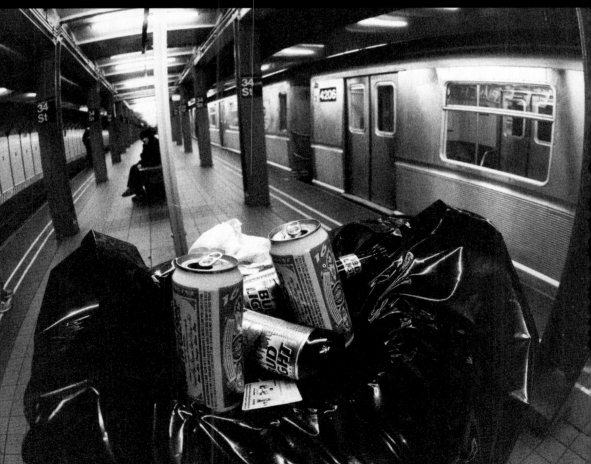

12:30AM BANGKOK, THAILAND
These men work in the notorious
Pat Pong sex district.
EVE HENRY

12:10AM BANGKOK, THAILAND
A young girl plays with discarded
party decorations. EVE HENRY

9:25AM WASHINGTON, DC, USA
A huge cleanup job awaits.
DANIEL B. MCNEILL

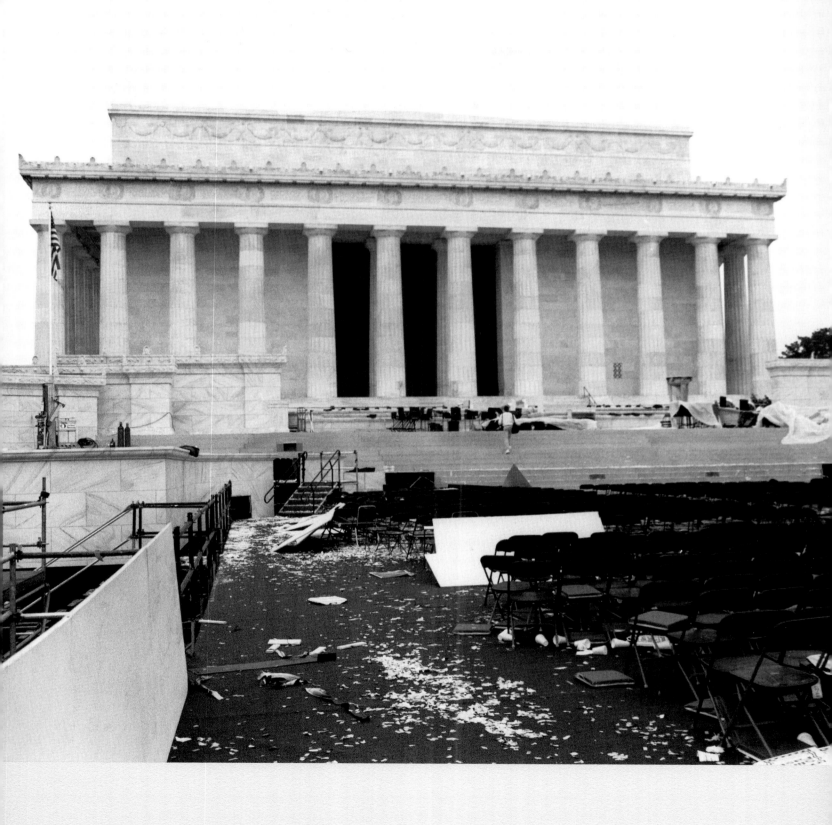

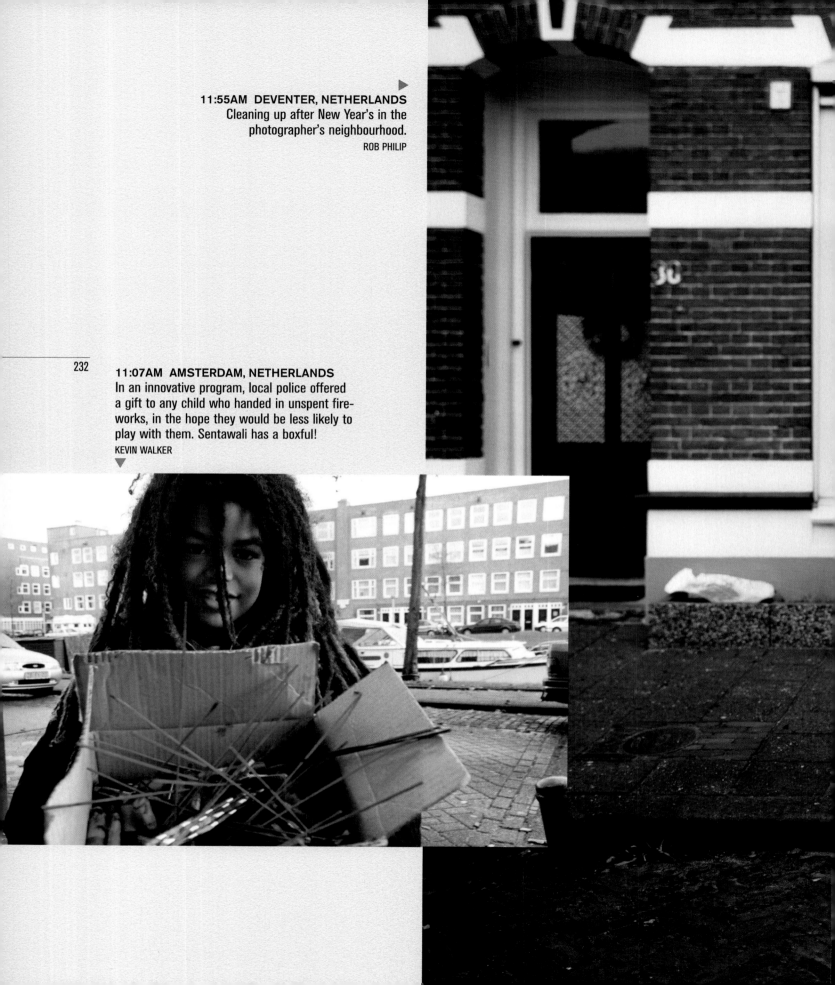

11:55AM DEVENTER, NETHERLANDS
Cleaning up after New Year's in the
photographer's neighbourhood.
ROB PHILIP

232

11:07AM AMSTERDAM, NETHERLANDS
In an innovative program, local police offered
a gift to any child who handed in unspent fire-
works, in the hope they would be less likely to
play with them. Sentawali has a boxful!
KEVIN WALKER

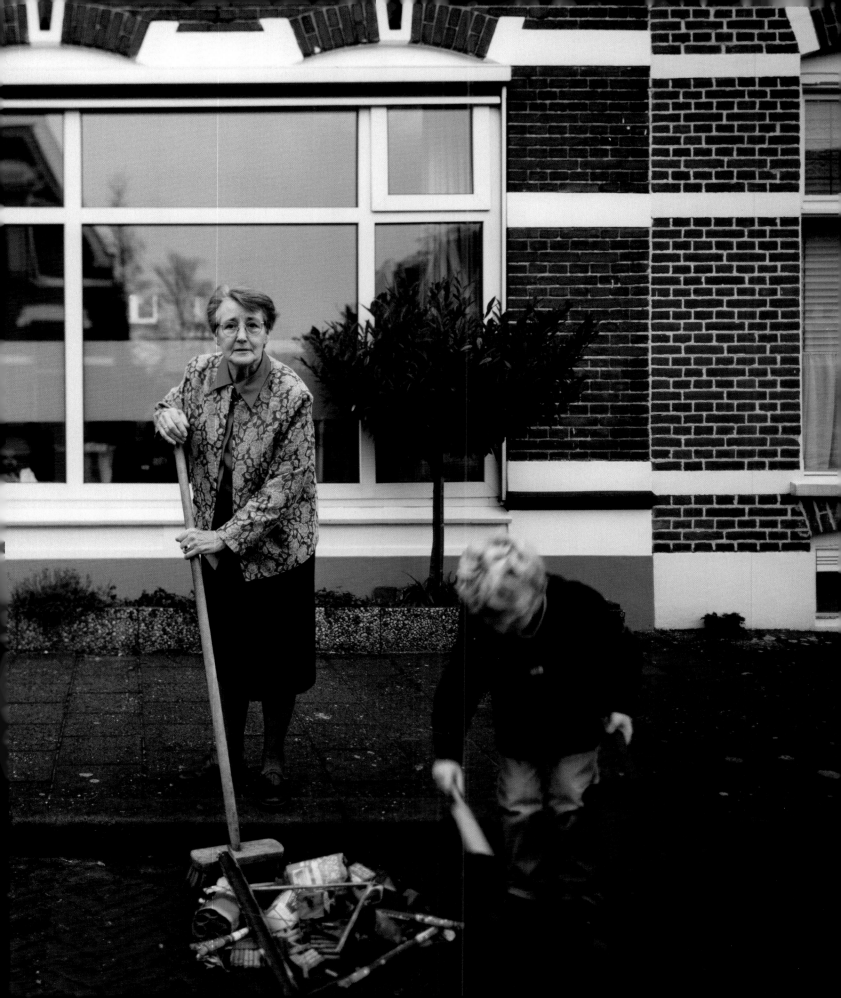

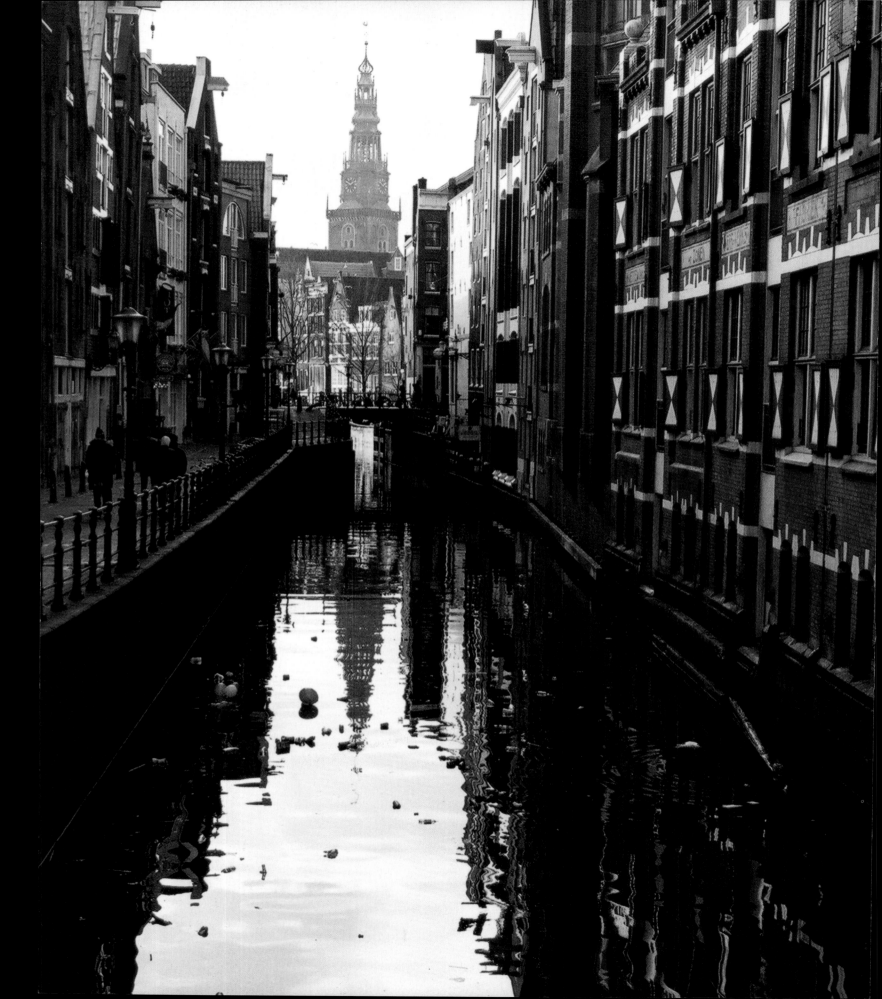

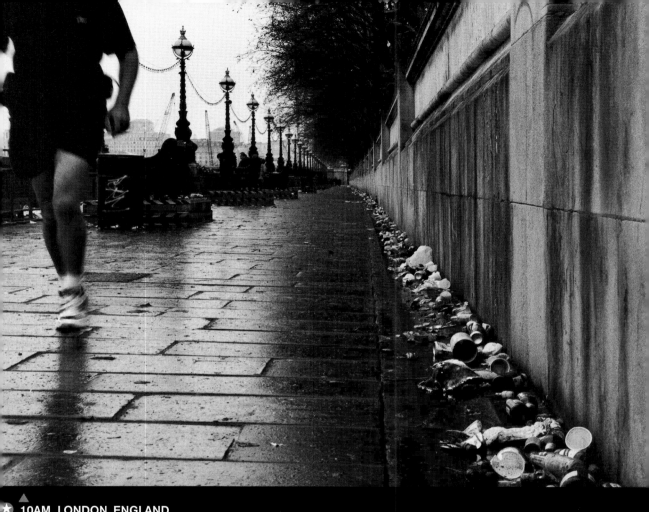

★ ▲ **10AM LONDON, ENGLAND**
A jogger runs along the Albert Embankment where hours before huge crowds gathered to watch the fireworks.

Perspe

ctives

Some photographs defy description or categorization. They represent an alternative and uniquely different perspective on the part of the photographer or their subject.

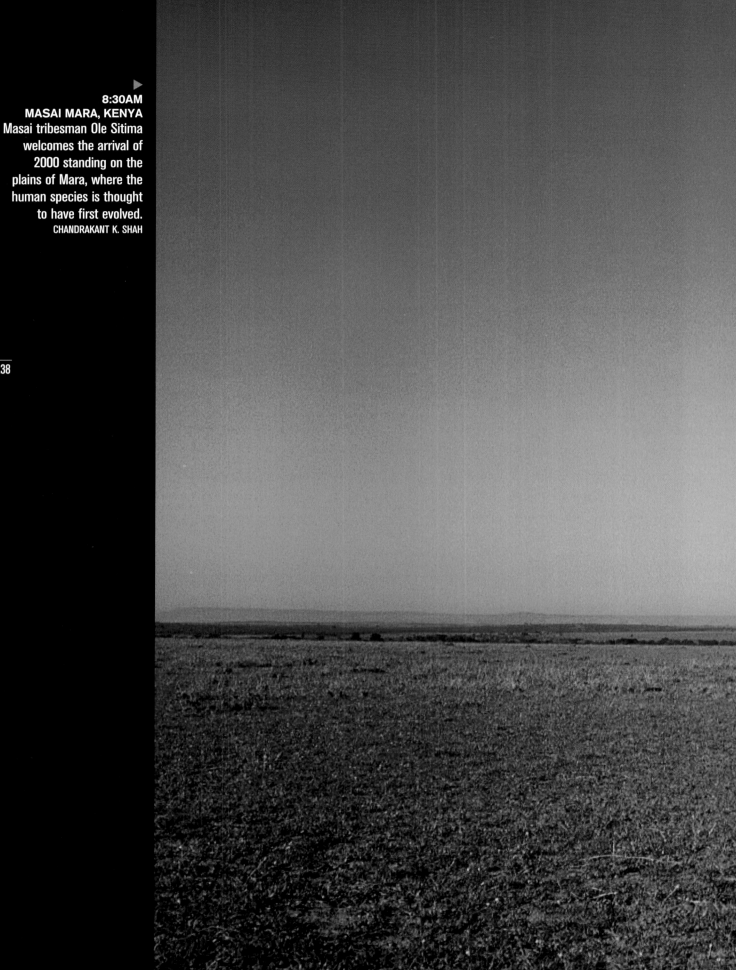

▶
8:30AM
MASAI MARA, KENYA
Masai tribesman Ole Sitima
welcomes the arrival of
2000 standing on the
plains of Mara, where the
human species is thought
to have first evolved.
CHANDRAKANT K. SHAH

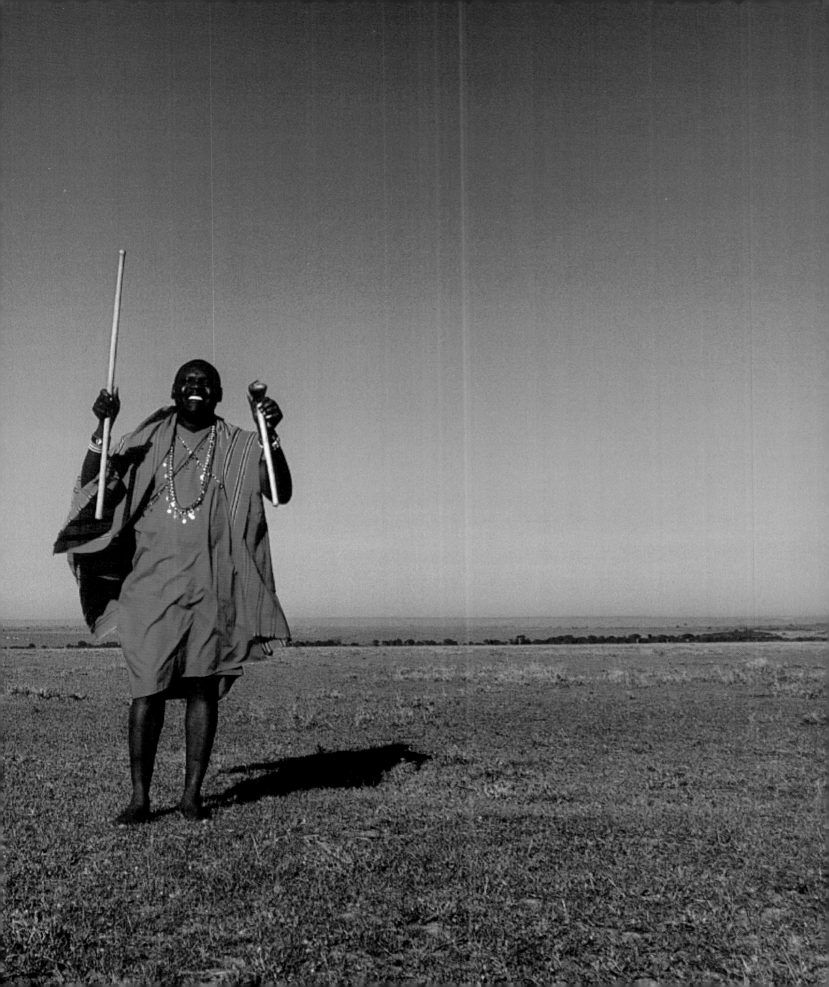

► **9:30PM BOLTON, ENGLAND** ✪
Pamela Jaymes entertains at the
Halliwell Labour Club.
GARY TAYLOR

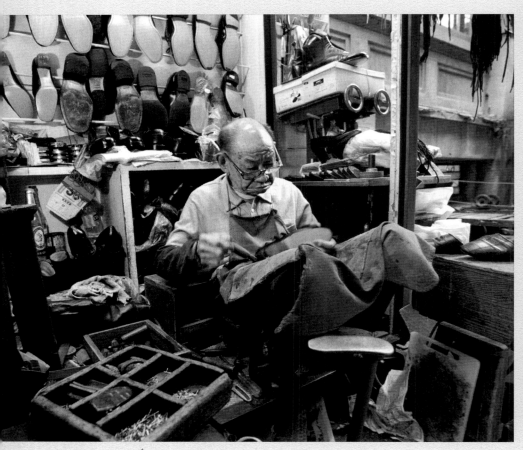

▲
✪ **5:30PM HONG KONG**
Eighty-three-year-old cobbler Chan Foo Kee has worked at
his stall in the business district for fifty years. He worked
as usual on New Year's Eve and went home to bed early.
PALANI MOHAN

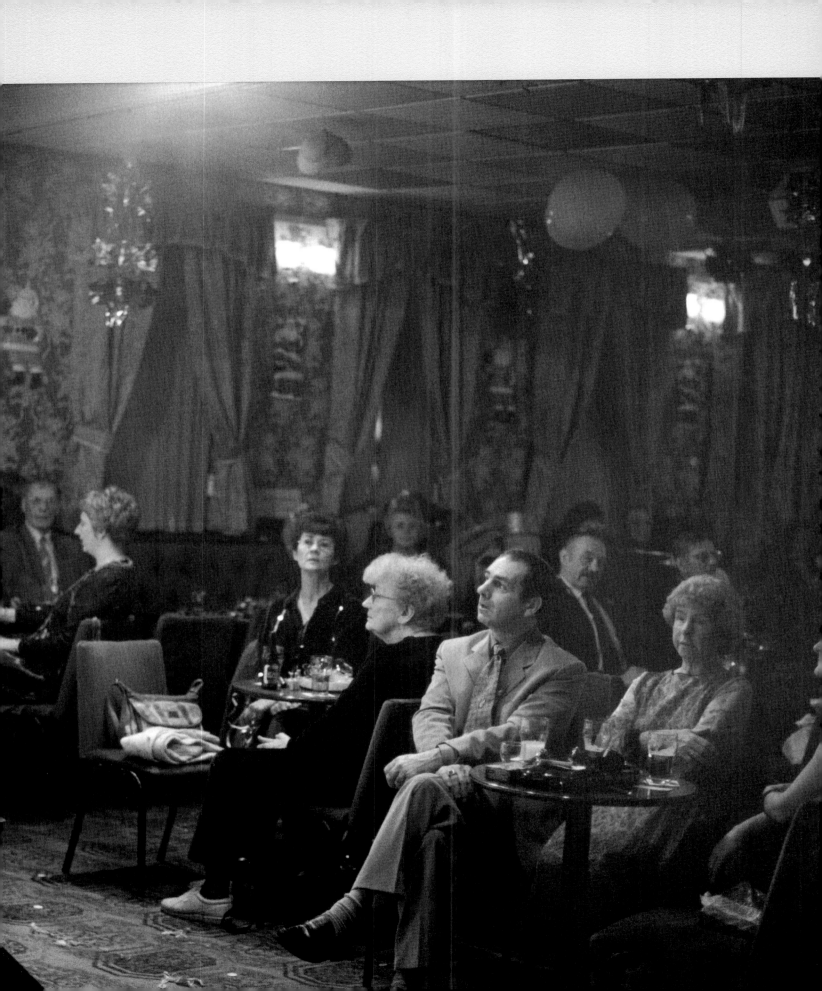

◄ **(PRECEDING PAGE) 8AM BODH GAYA, INDIA**
These Tibetan monks spent the entire night
providing tea for thousands of pilgrims.
NICHOLAS DAWSON

12:15PM BARCELONA, SPAIN ►
For the last hundred days of the
millennium, a local theatre group
performed before crowds in front
of this building designed by
Antonio Gaudi. Thousands turned
out for their final performance.
DARIUS KOEHLI

▲
10AM FLOYD COUNTY, VIRGINIA, USA
The photographer and her friends decided to spend
New Year's Day getting dressed up and taking photos.
MICHELLE ELMORE

▲
1:15AM NOVI SAD, YUGOSLAVIA
The photographer writes: "The movement of light frames the contours of the bodies, similar to the cheap New Year's streetlights in this pedestrian zone." DRAGAN ZIVANCEVIC

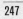

1:10PM BEIJING, CHINA
Citizens of Beijing crowd the street to buy lottery tickets for a draw in which this mini-car is the grand prize. Owning a car is still a dream for many in China.
DONG-PING YUAN

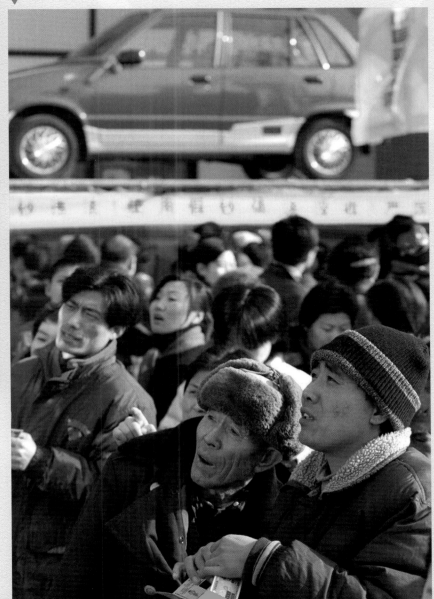

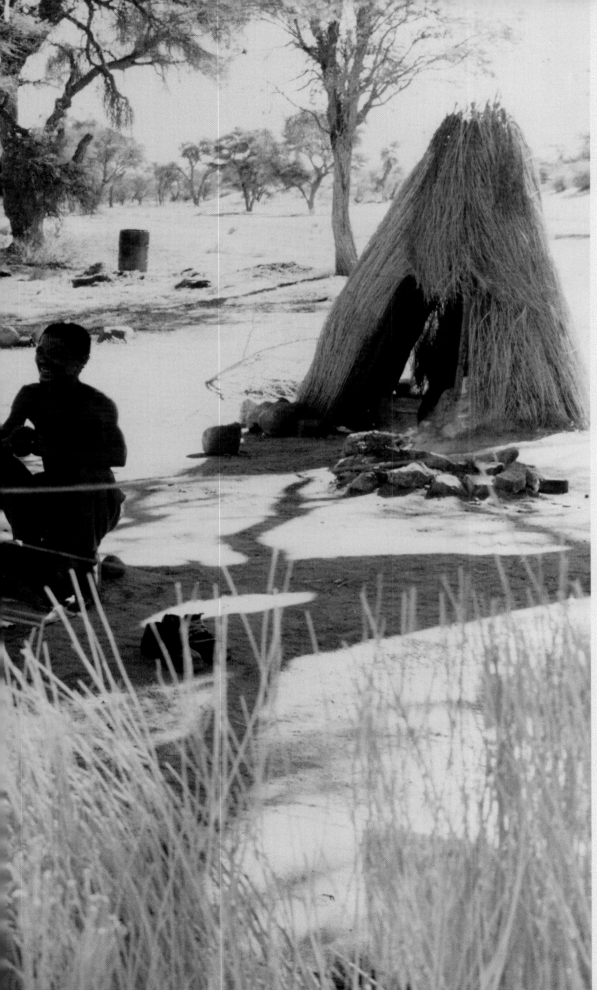

▲

4PM KALAHARI DESERT, BOTSWANA
The photographer's son entertains San tribesmen with renditions of western pop music.
RITA VAN DEN HEEVER

249

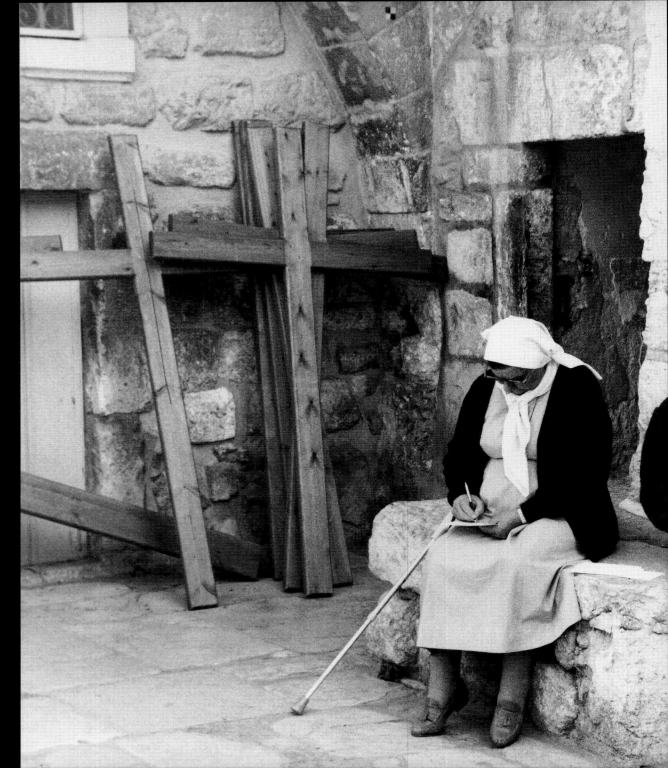

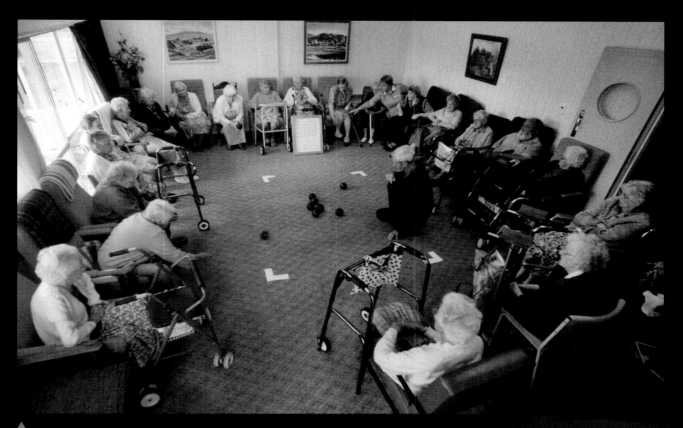

▲
10AM OTOROHANGA, NORTH ISLAND, NEW ZEALAND
Residents of the Beattie Rest Home enjoy a game of indoor bowls to start the new millennium. RICHARD WALLACE

◄
2PM JERUSALEM, ISRAEL
In the Christian quarter of the city, a woman writes down her thoughts.
ALEXANDER KANTOR

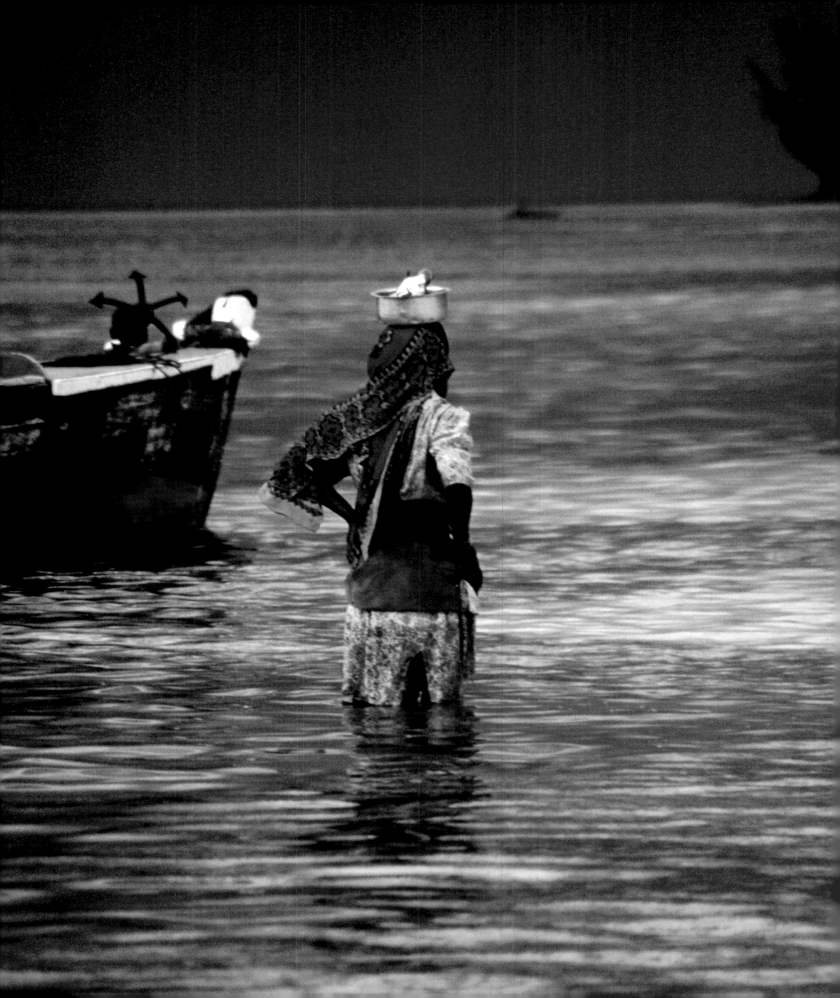

4:30PM ZANZIBAR, TANZANIA
A woman stands in the warm waters of the Indian
Ocean waiting for the fishermen to come home.
JAMES STEJSKAL

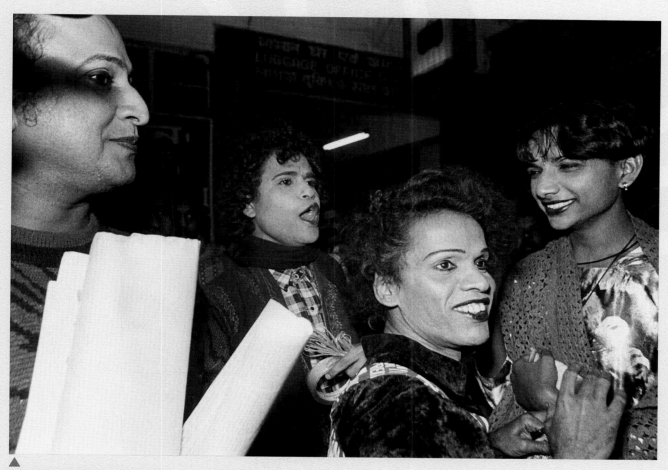

9:30PM CALCUTTA, INDIA
A group of transsexuals gather in a railway station before
joining a rally to demand civil rights. DUTTA NILAYAN

253

(NEXT PAGE) 11:50AM BARROW, ALASKA, USA
A woman looks out at the frozen Arctic Ocean
beside an arch of whale bones. At this time of the
year, the sun doesn't rise for sixty-seven days.
LUCIANA WHITAKER-AIKINS

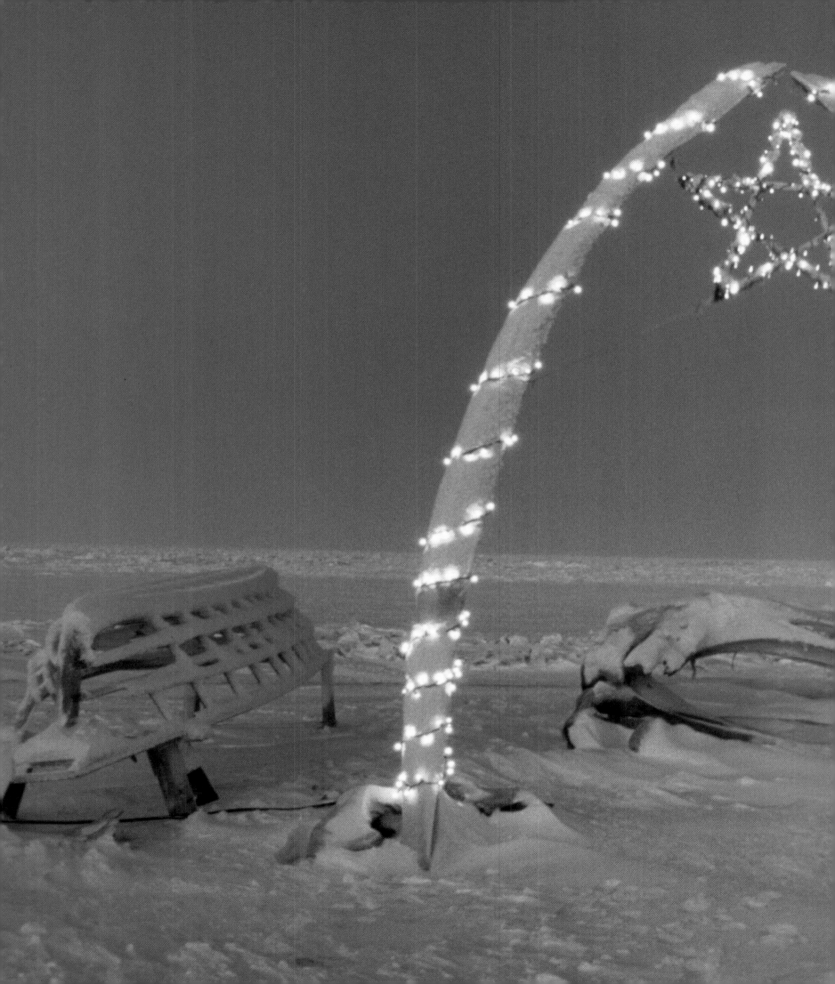

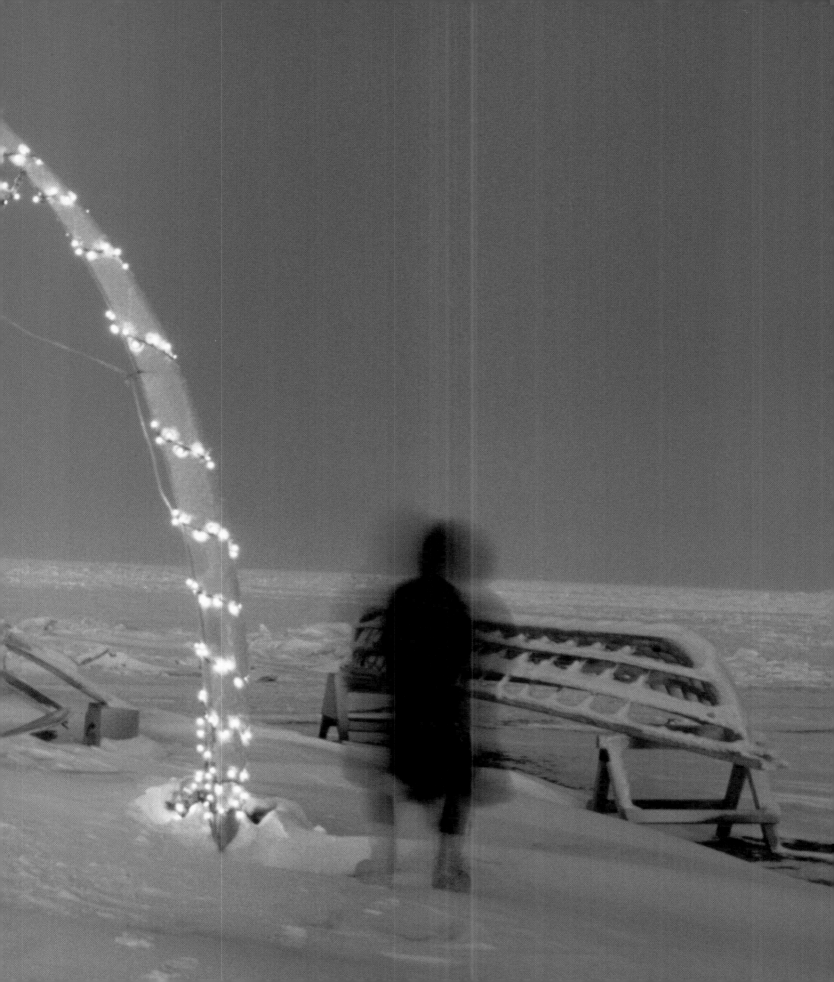

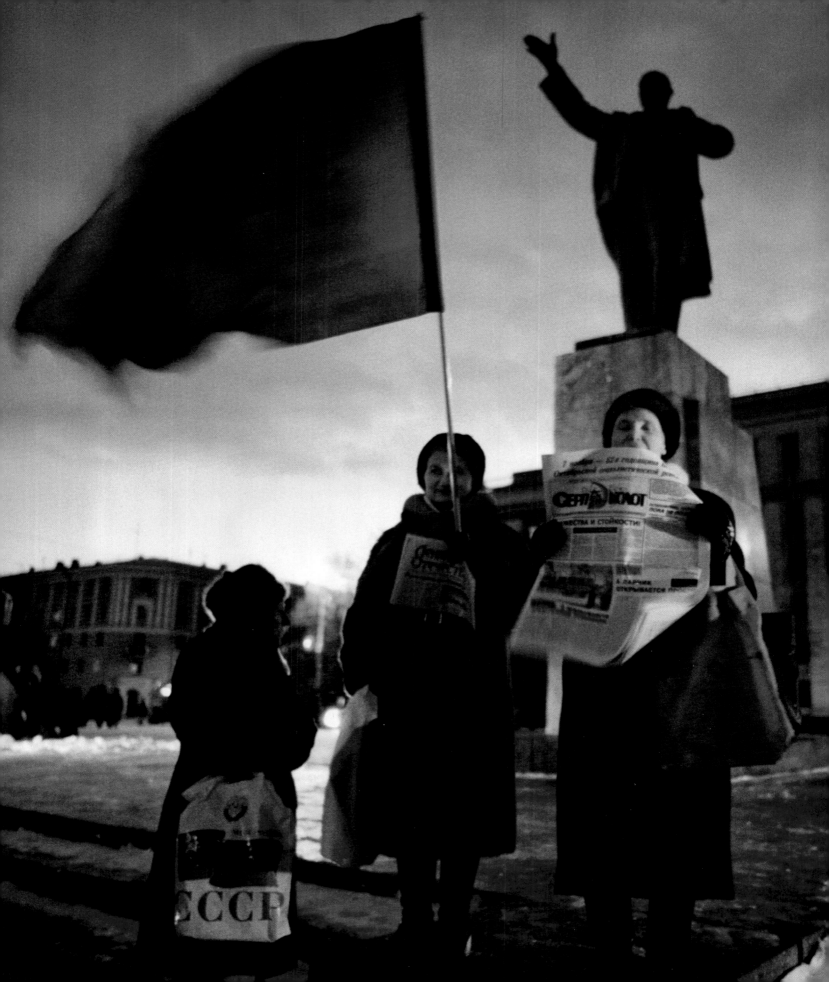

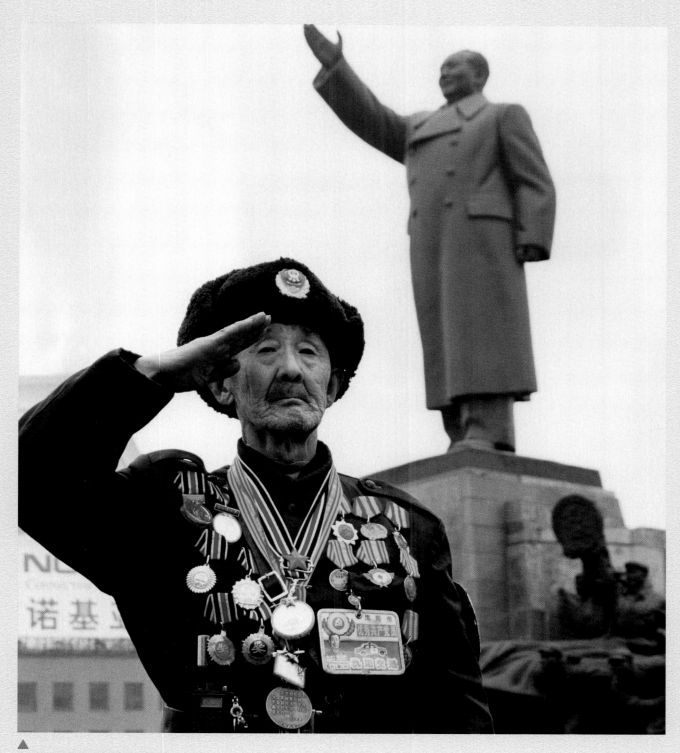

▲
11:50AM TSUMCHI, CHINA
Citizen Wu fought in the Revolution and the Korean War. He is
determined to continue to meet the standards of a 'service soldier'.
BAI LENG

◄

5:05PM VORONEZH, RUSSIA
These women are upset at Boris Yeltsin's recent resignation.
VITALY GRASS

4:30PM CENTRAL KALAHARI, BOTSWANA
Last afternoon in the central Kalahari desert.
KELVIN SCHÄFLI

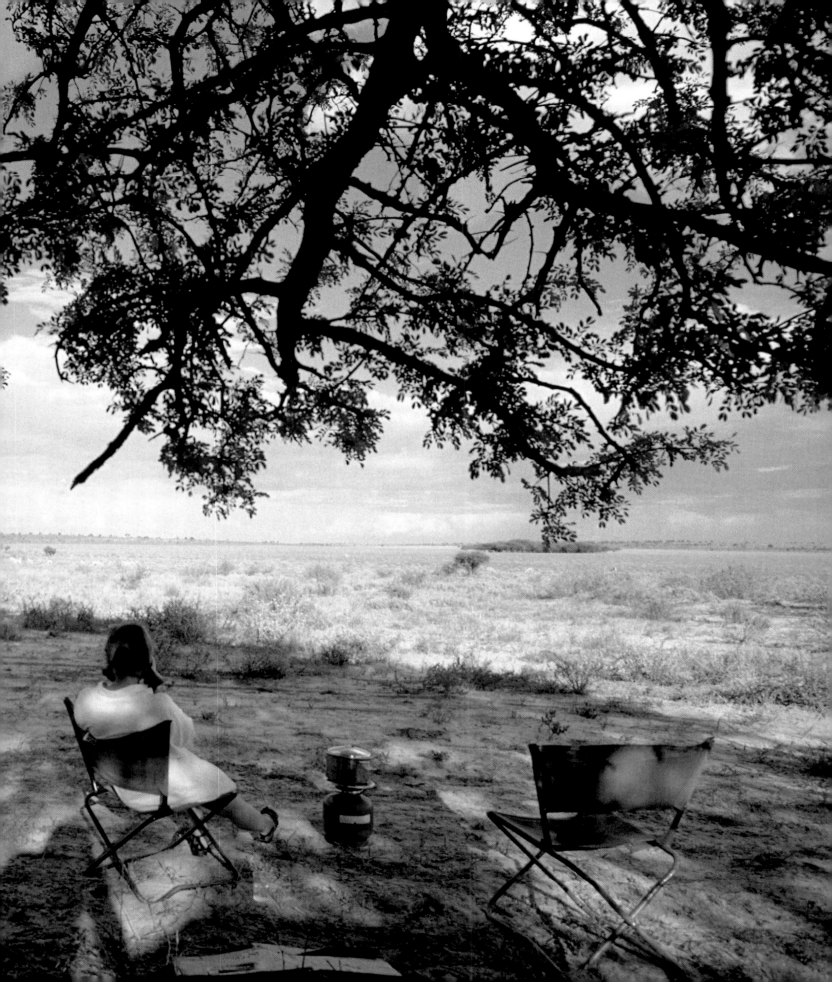

Dawn

As they did to watch the last sunset of the old millennium, people around the world gather to watch the first sunrise of the new. Many choose to be alone in nature.

Then the day begins in earnest: the morning newspaper arrives, the dog has to be walked. Cities hum to life again, farmers go about their chores, and there are still parades, celebrations, acts of devotion to come.

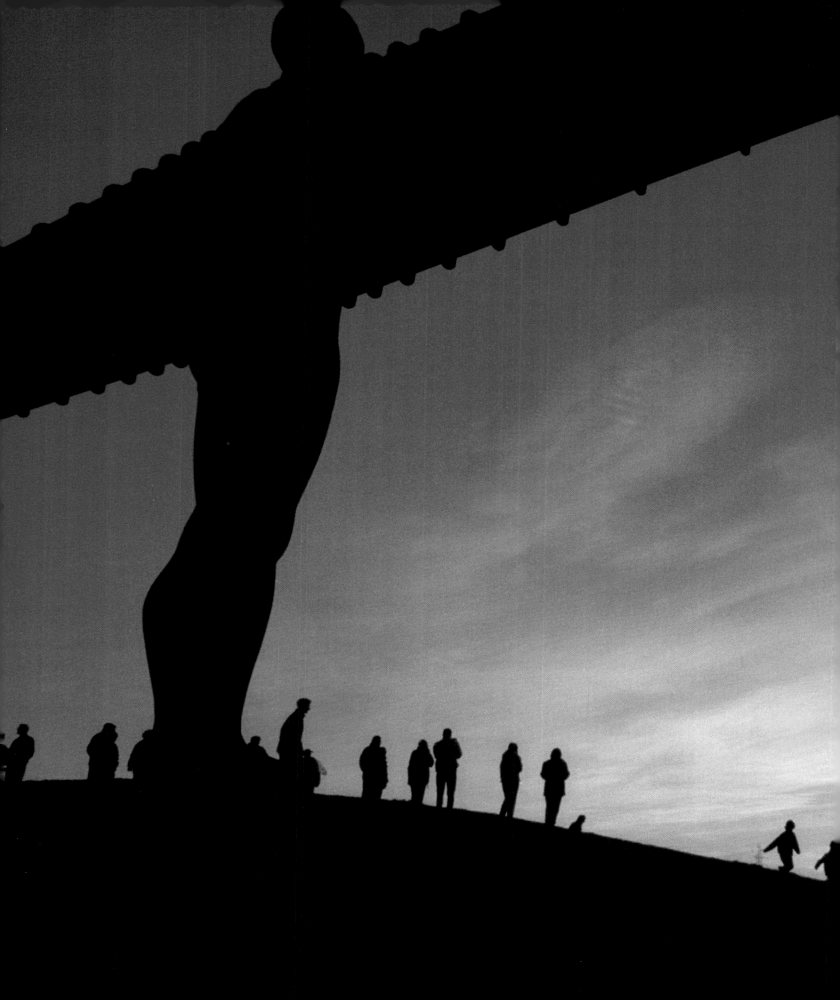

◀

⭐ **8AM GATESHEAD, ENGLAND**
A crowd gathers to watch the sunrise at the
Angel of the North statue. LYNNE OTTER

263

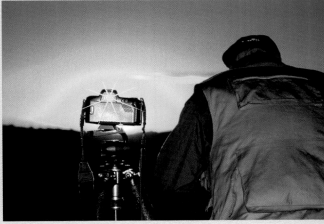

▲
6:45AM PHOENIX, ARIZONA, USA
Another photographer "crazy enough to be
out at dawn taking pictures!"
MARK J. PHILLIPS

▶

**(NEXT PAGE) 5:45AM HAVELOCK
NORTH, NEW ZEALAND** ⭐
Thousands gather at Te Mata Peak to be
among the first in the world to see the
dawn of the 21st Century. TIM WHITTAKER

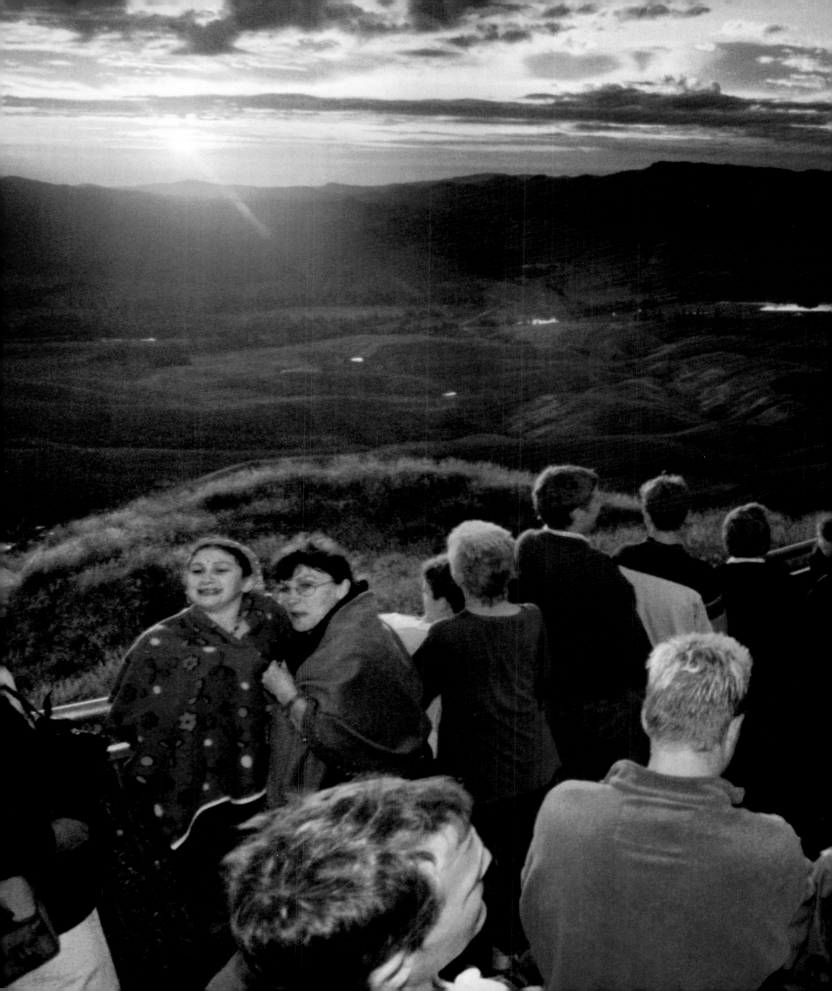

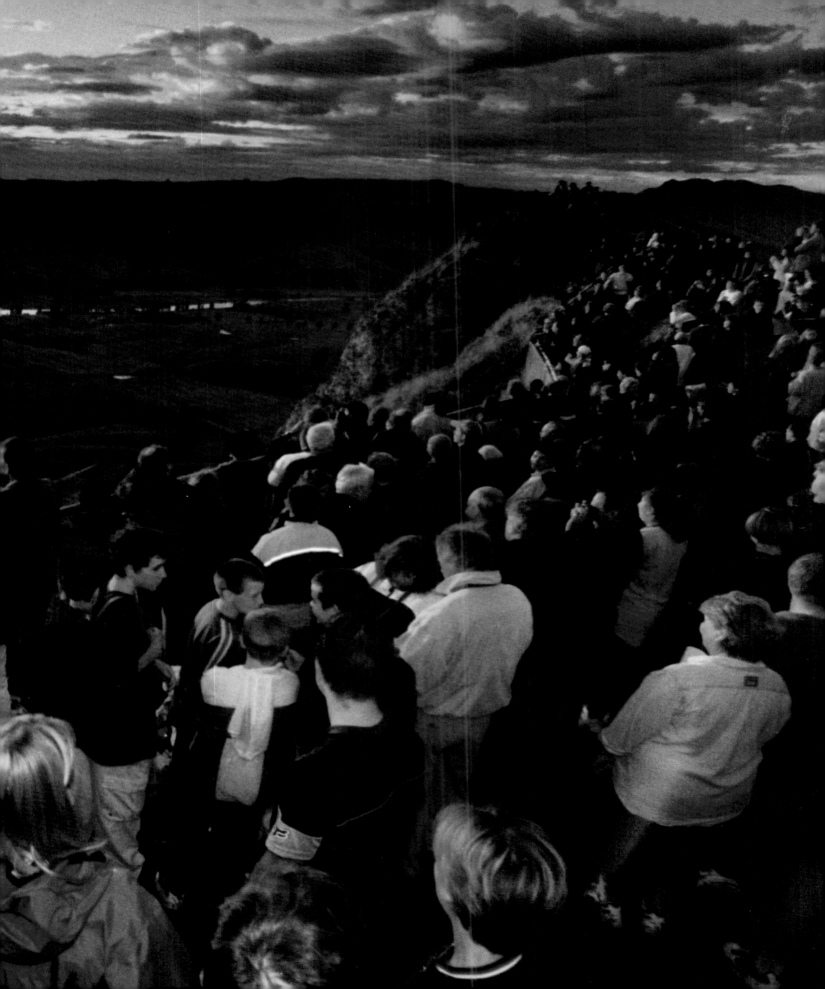

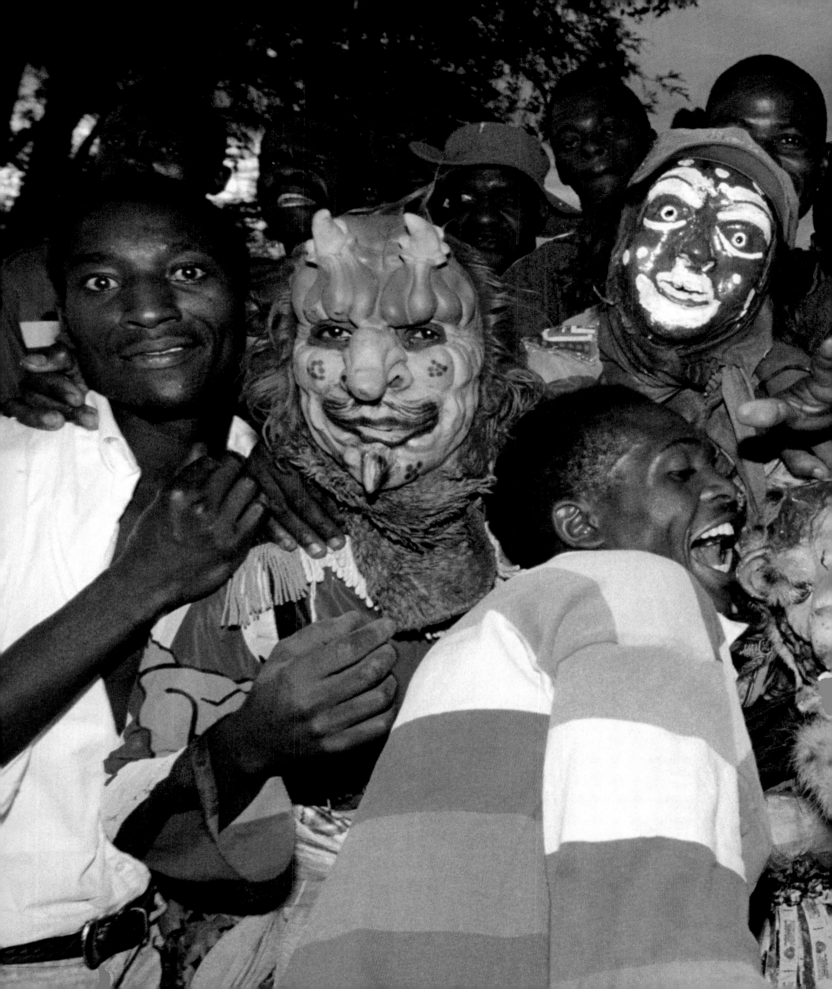

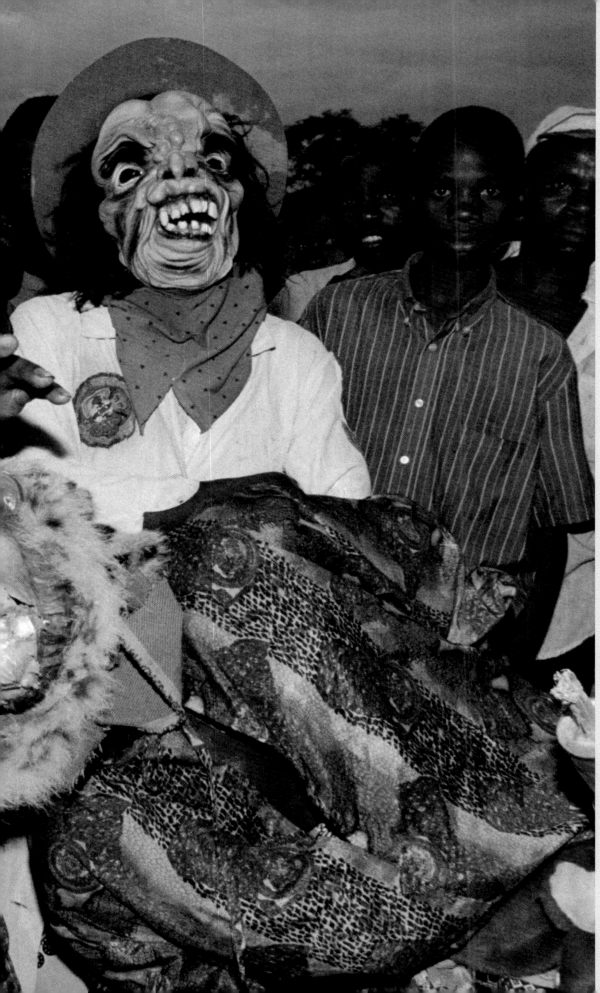

6AM NORTH OF HARARE, ZIMBABWE
Wearing masks on New Year's Day is a tradition that enables the poorest Zimbabweans to poke fun at their former colonial masters.
ROB COOPER

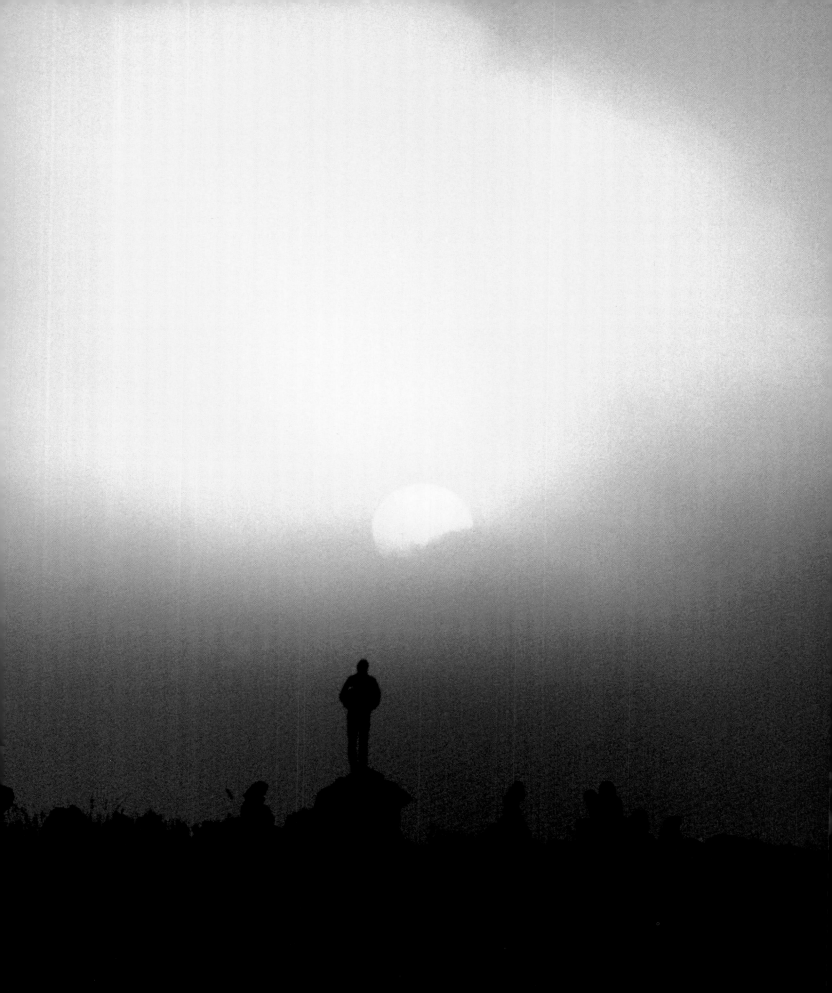

30AM ATLANTIC CITY, NEW JERSEY, USA
ter spending all night searching for the perfect
hoto opportunity, the photographer found this
ew over the Atlantic.
AYMOND CASBOURN

55AM TABLE MOUNTAIN, SOUTH AFRICA
any Cape Towners braved the cold to watch
e sunrise from the top of the mountain.
OHANN VAN TONDER

6:45AM DAYTONA BEACH, FLORIDA, USA
A mother and child drove across Florida to
watch the sunrise on the east coast.
MAUREEN HOYT

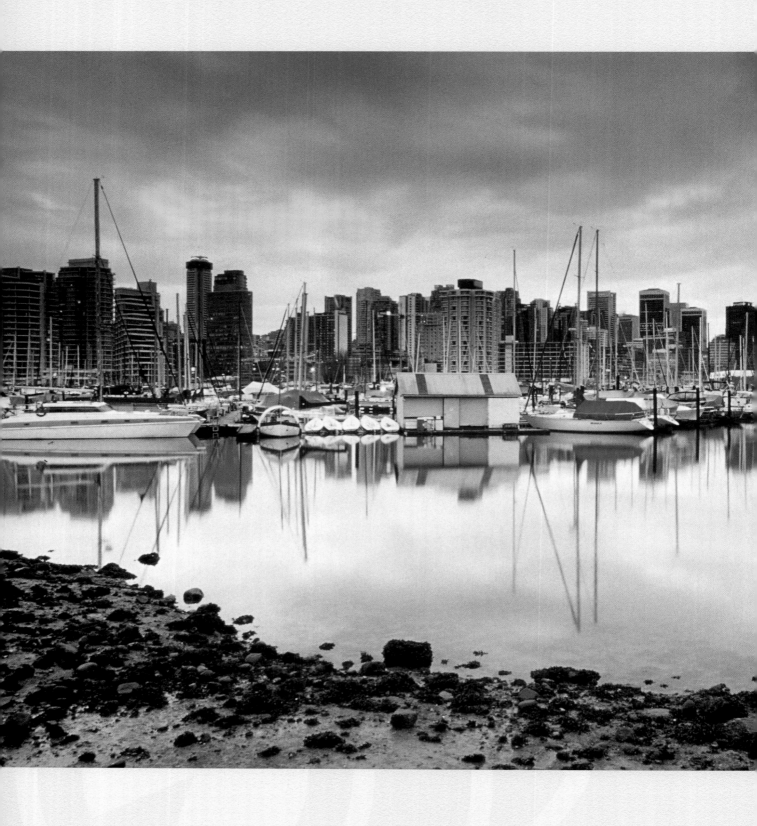

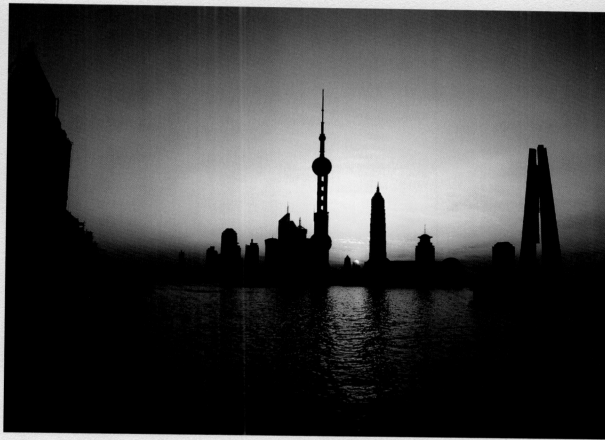

▲
6:50AM SHANGHAI, CHINA
Futuristic skyline.
GU XINZHI

◄
8:15AM VANCOUVER, CANADA
A view of the city from Stanley Park.
AGUNG TANDJUNG

►
7AM LUBEC, MAINE, USA
The West Quoddy Point lighthouse,
easternmost point of mainland USA.
EDWARD HERSOM II

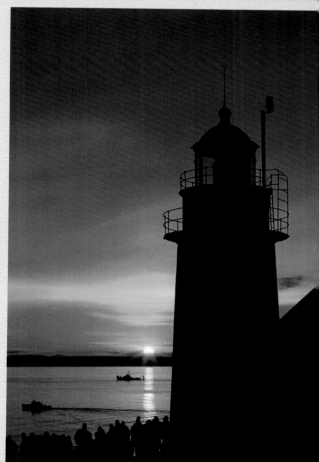

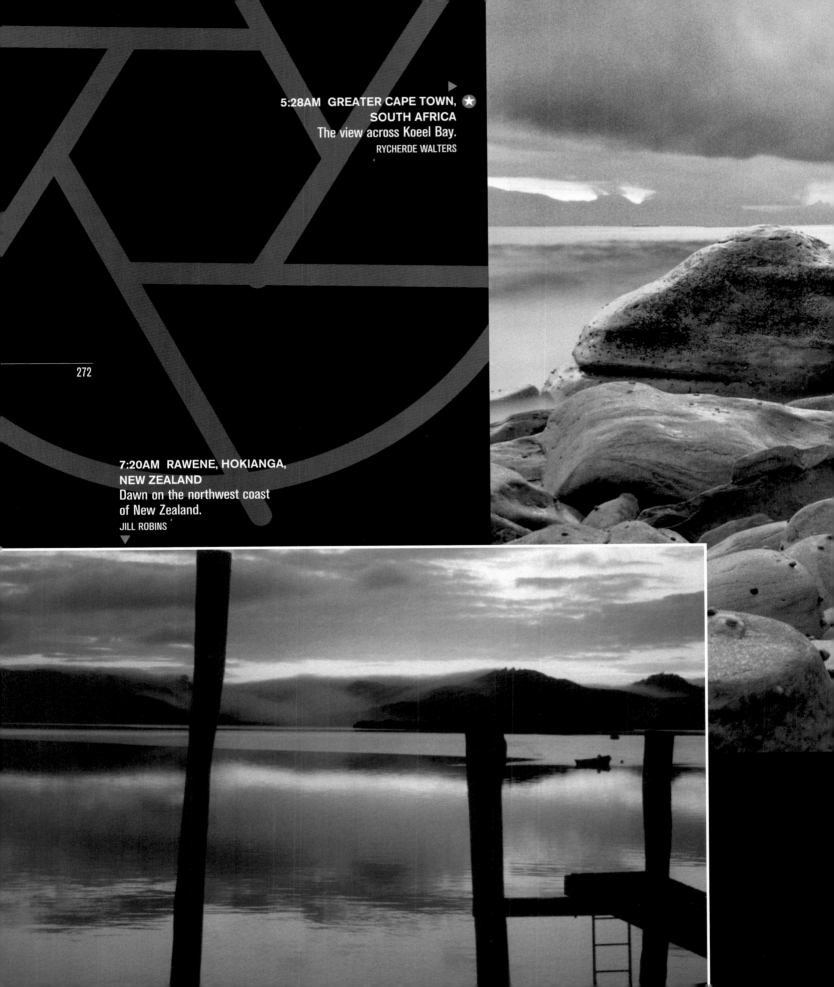

**5:28AM GREATER CAPE TOWN, ★
SOUTH AFRICA**
The view across Koeel Bay.
RYCHERDE WALTERS

**7:20AM RAWENE, HOKIANGA,
NEW ZEALAND**
Dawn on the northwest coast
of New Zealand.
JILL ROBINS

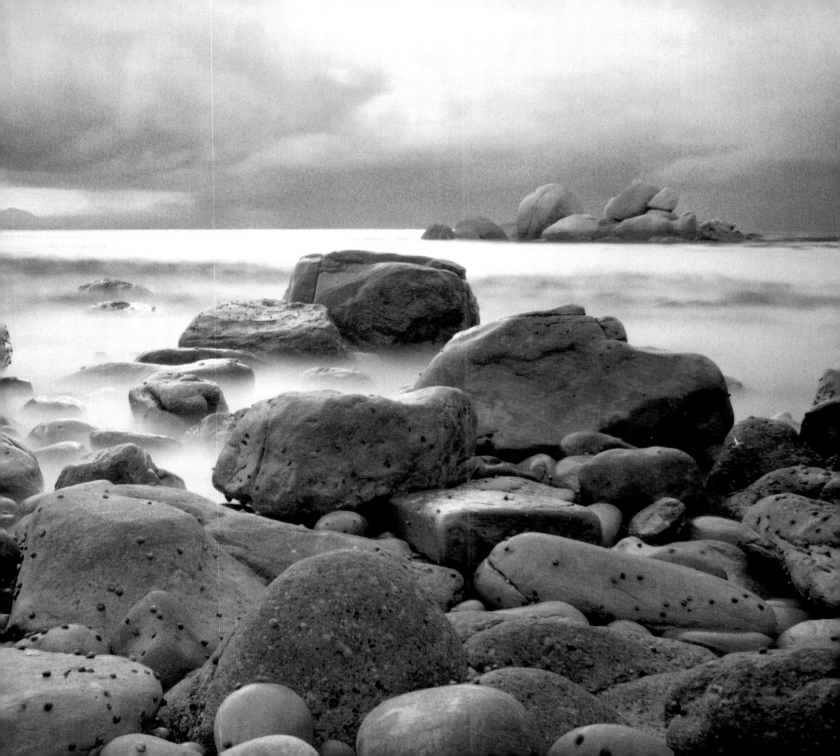

11:10AM MELTON MOWBRAY, LEICESTERSHIRE, ENGLAND
Three of the country's most famous hunts – the Quorn, the Cottesmore,
and the Belvoir – come together for a joint New Year's Day hunt.
ED MAYNARD

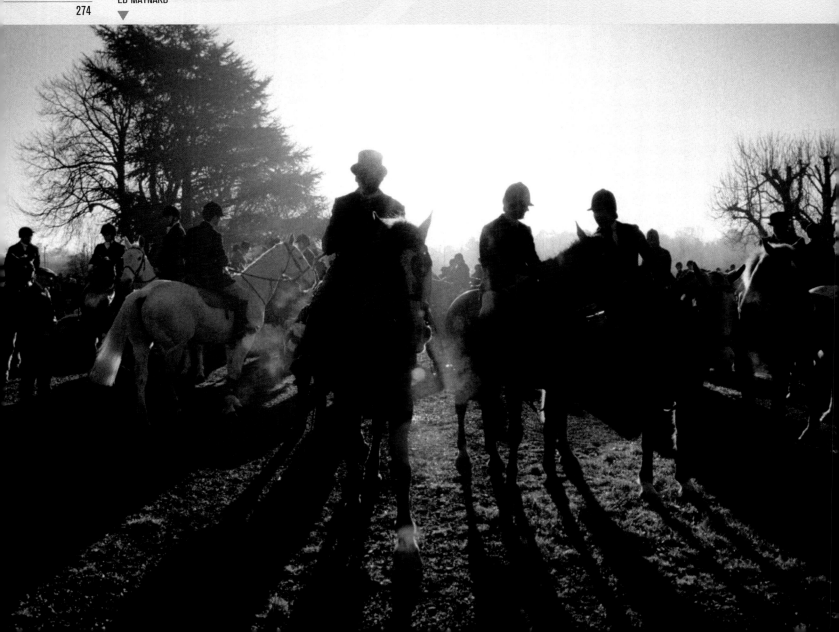

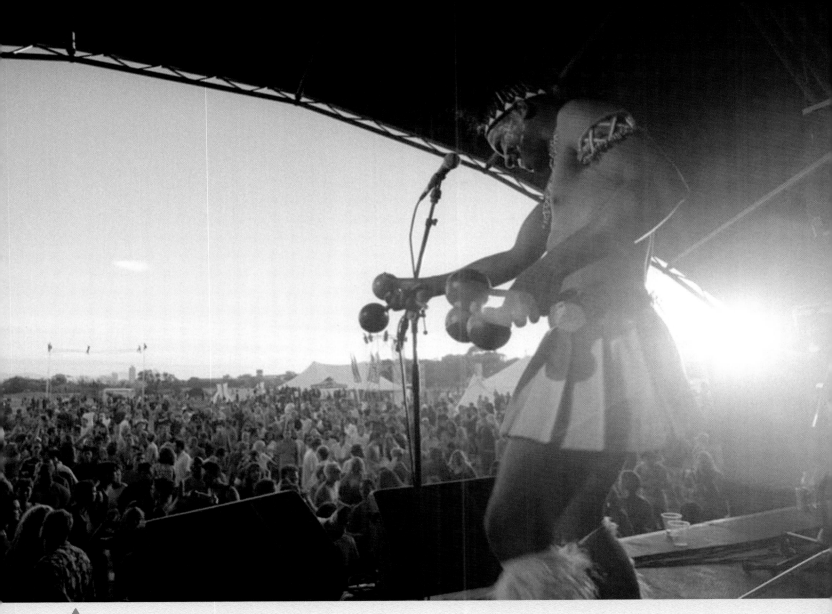

5:40AM CAPE TOWN, SOUTH AFRICA
Some twenty thousand ravers greet the sunrise to the African
rhythms of Amampondo and the techno sounds of Juno Reactor.
ANDREW OCTOBER

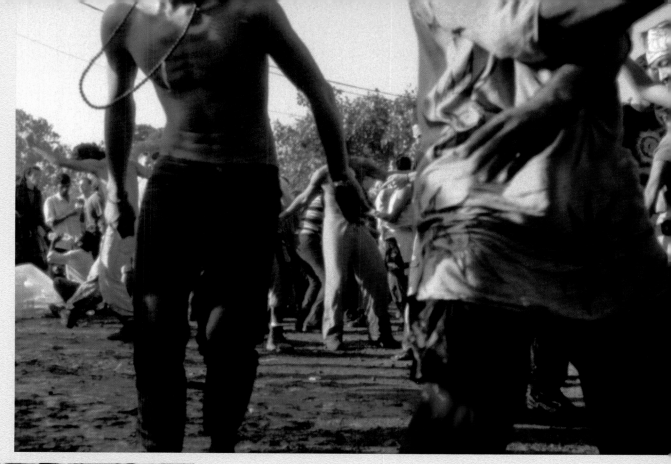

▲
10AM GOA, INDIA
Still dancing at this outdoor rave. IVAN KURIMOY

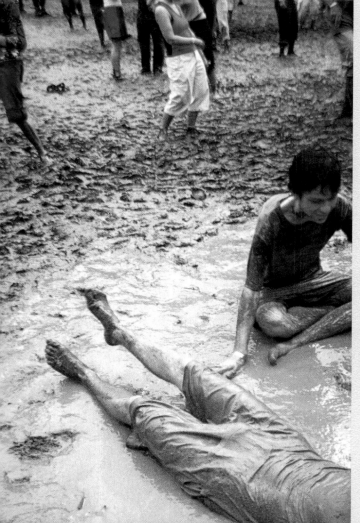

◄
11:30AM TAKAKA HILL, NEW ZEALAND
Bathing in the mud at 'The Gathering', a dance music
festival held on a hill "in the middle of nowhere."
MATTHEW NAGEL

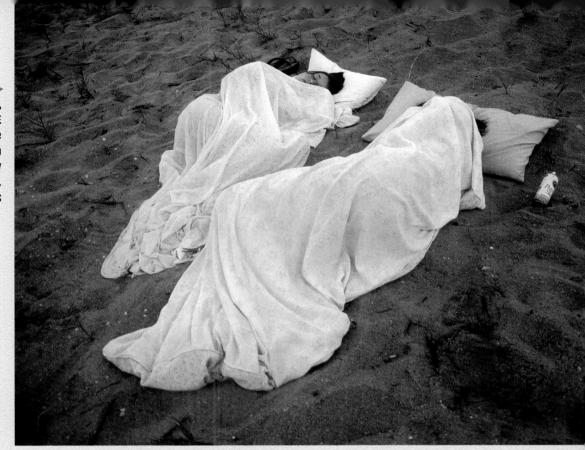

5:50AM XAI-XAI BEACH, MOZAMBIQUE
These students trekked all the way from South Africa to watch the sunrise, but fell asleep shortly before it happened.
SAM REINDERS

 8AM WHANANAKI, NEW ZEALAND
Having stayed up all night, friends enjoy the early morning light.
JASON BURGESS

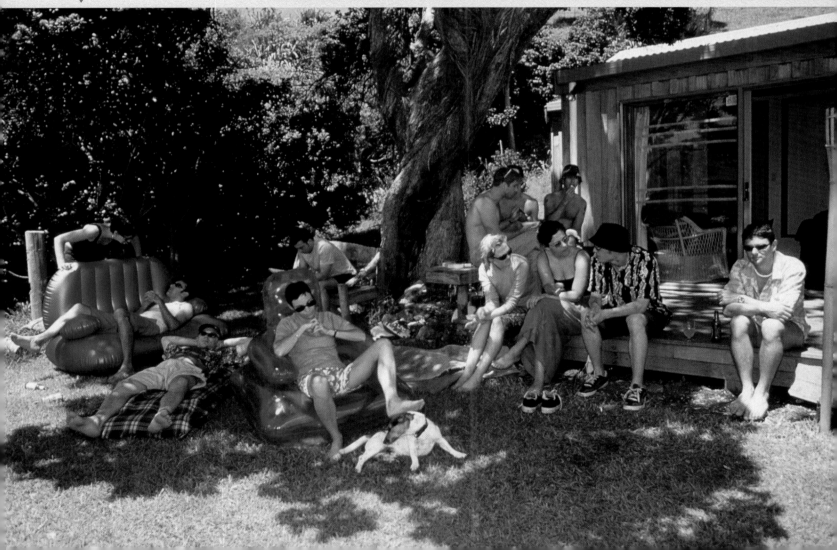

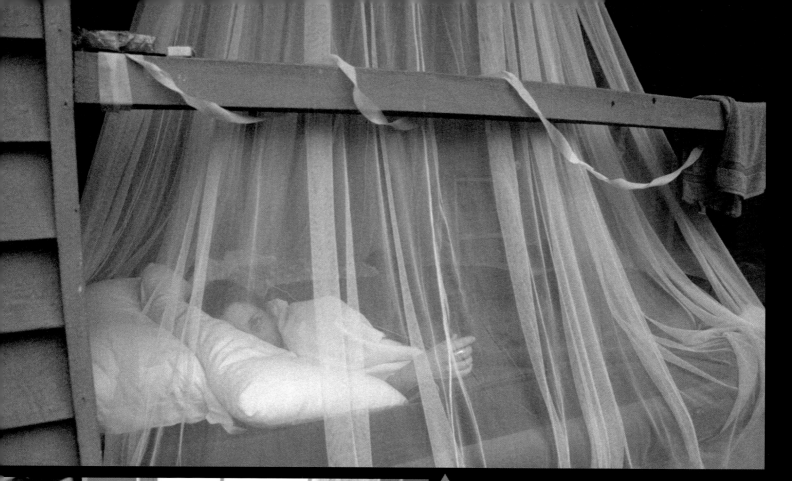

▲
6AM KIRRAMA, AUSTRALIA
In the far north of Queensland, Lucy awakes under the safety of her mosquito net.
ROB PARSONS

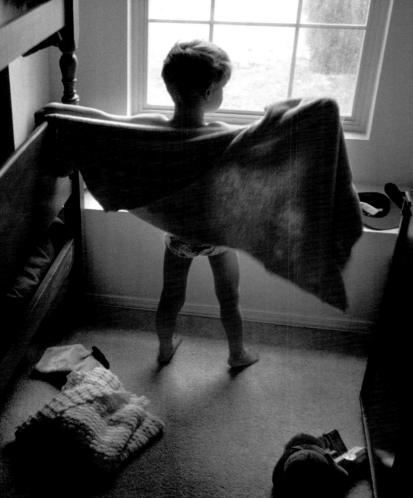

◄
8:30AM ALBUQUERQUE, NEW MEXICO, USA
Cole, four years old, will be able to say he lived in some of the 20th century.
STEVEN SMITH

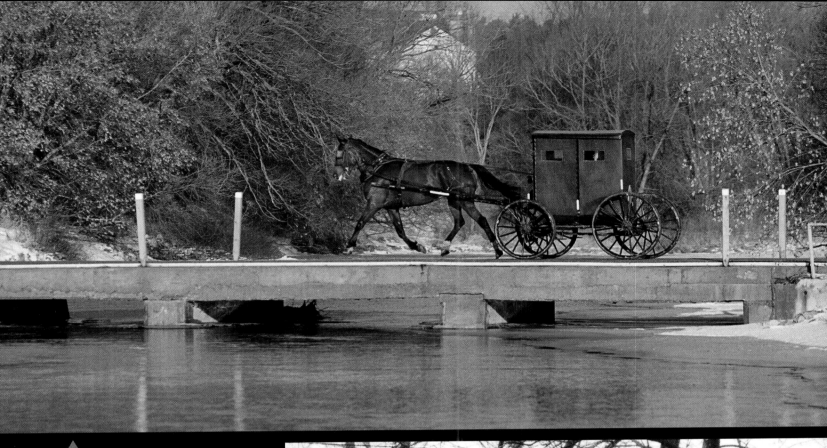

11AM NEAR ST. JACOBS, ONTARIO, CANADA
Mennonites on their way to worship.
MONIQUE CAMPBELL

10AM MAGNOLIA, NEW JERSEY, USA
A solitary walk in a light fog.
RAY RODA

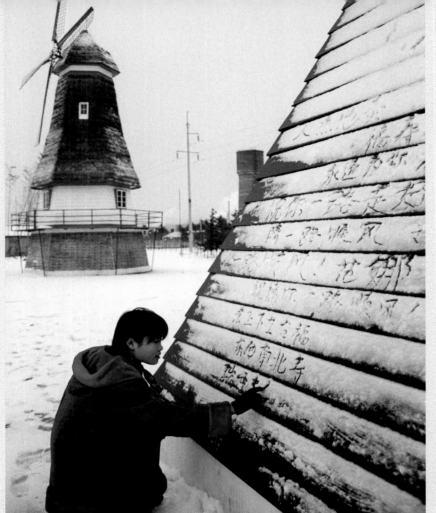

8:10AM SUNSHINE CITY, CHINA
A student at the local art institute writes good wishes for her friends in the snow.
XINGJIAN GAO

9:30AM HANGZHOU, CHINA
Two thousand children were given the chance to paint one metre each of a 2km long banner, commemorating the turn of the millennium. XU JIAN

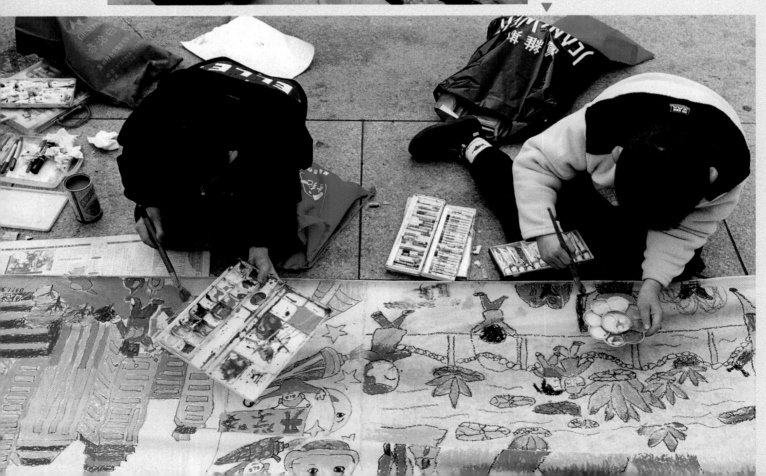

▲
7:20AM SACRAMENTO, CALIFORNIA, USA
Catching up on the news over morning coffee.
GREGORY STRINGFIELD

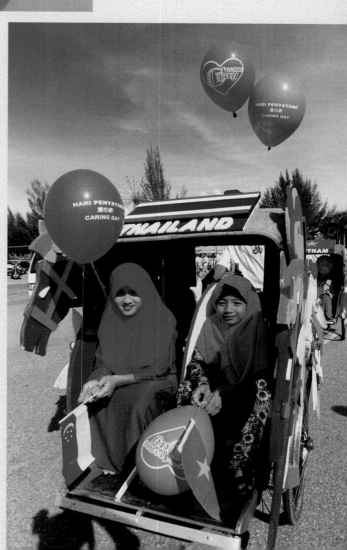

▶
11:33AM IPOH, MALAYSIA
Each trishaw represents a country participating in
this parade to declare January 1st "Caring Day."
PETER LIOW CHIEN YING

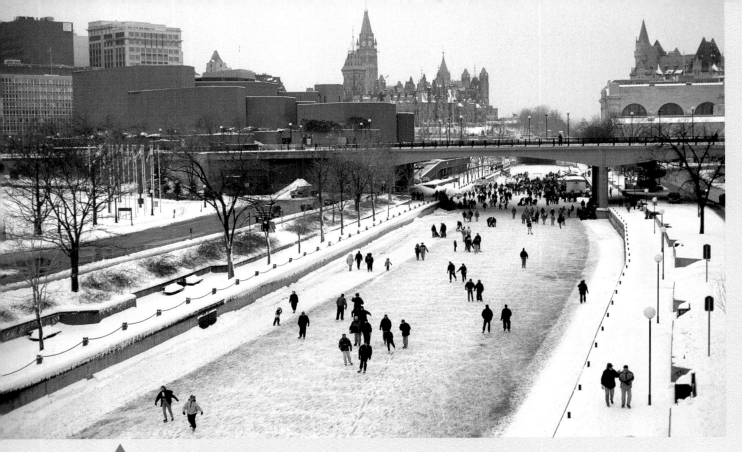

11:30AM OTTAWA, CANADA
A popular tradition on New Year's Day –
skating on the Rideau Canal.
DOUG DROUILLARD

11AM PORT ELIZABETH, BEQUIA, ST. VINCENT & THE GRENADINES
These children are among the six thousand inhabitants of this small island
in the Caribbean. PAUL MARSIK

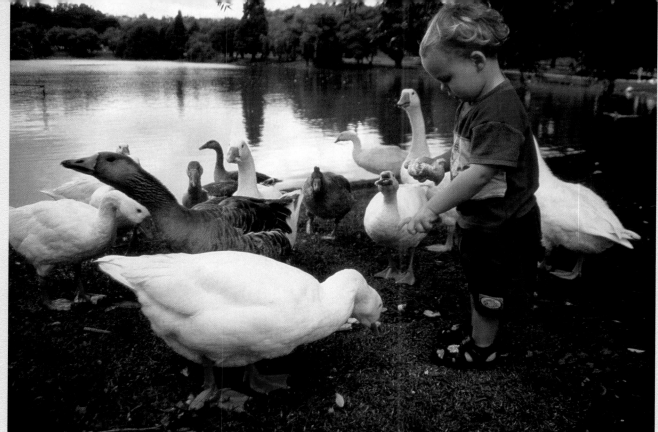

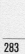

9AM JOHANNESBURG, SOUTH AFRICA
Martin feeds the ducks at Zoo Lake on New Year's Day.
JANET CURRIN

283

11:54AM SAN ANTONIO, TEXAS, USA
Tourists and locals alike enjoy trips along
this popular stretch of river. MICHELE DARIEN

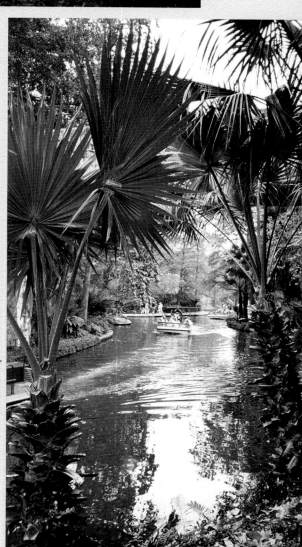

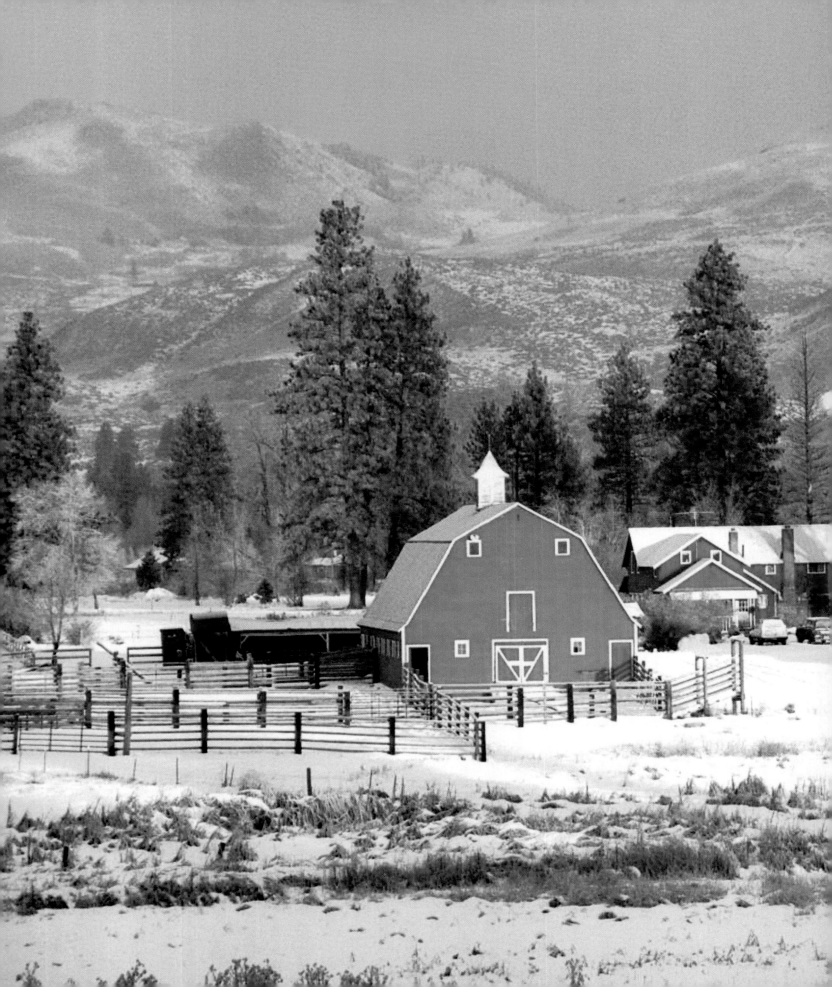

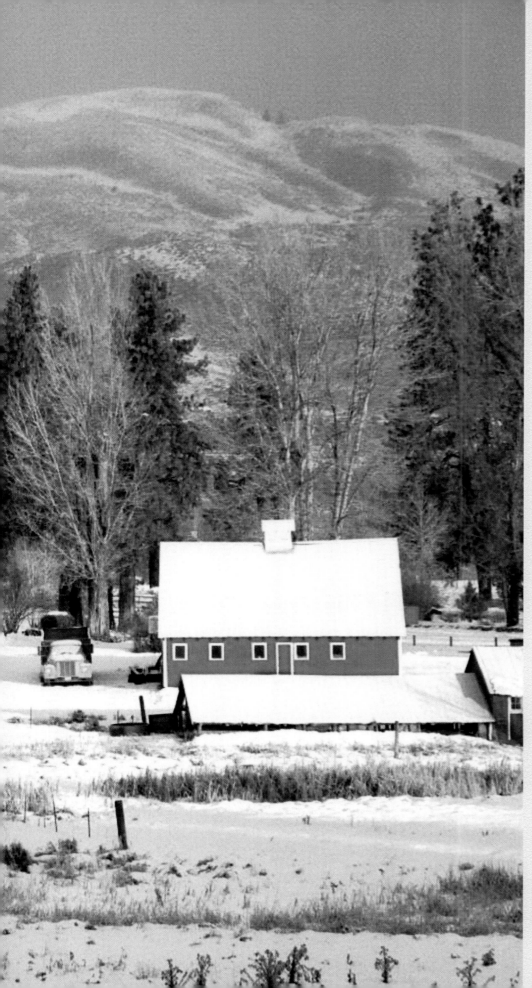

7AM METHOW VALLEY, WASHINGTON, USA
A farm in northern Washington state.
JOHN SWENSON

285

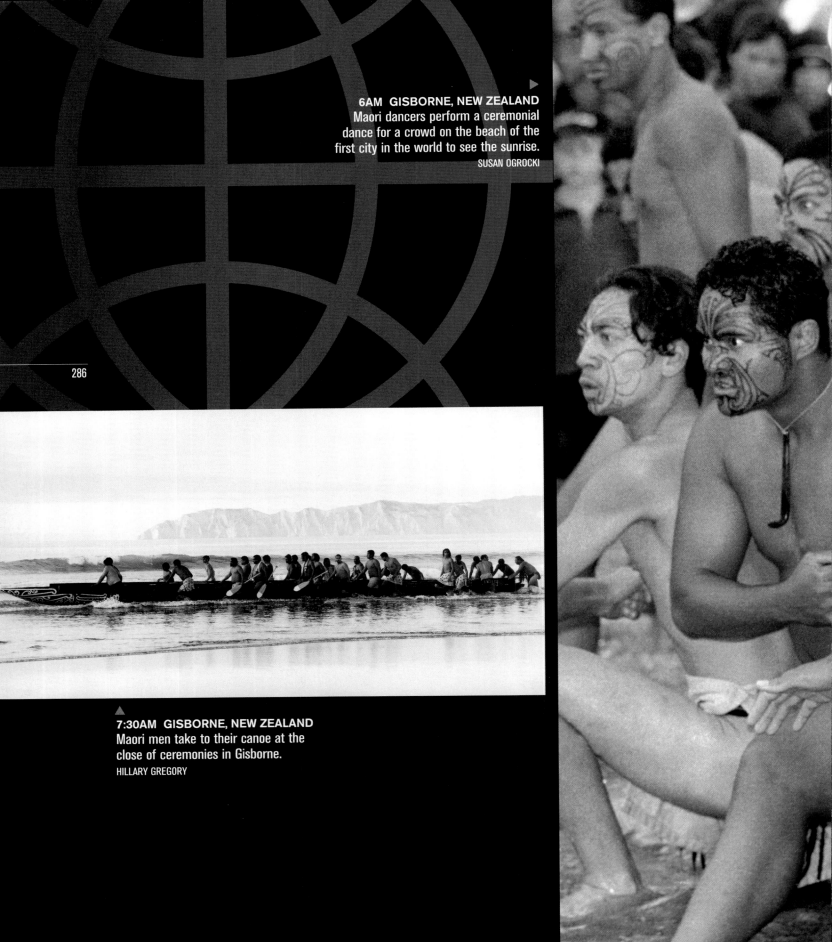

6AM GISBORNE, NEW ZEALAND
Maori dancers perform a ceremonial
dance for a crowd on the beach of the
first city in the world to see the sunrise.
SUSAN OGROCKI

7:30AM GISBORNE, NEW ZEALAND
Maori men take to their canoe at the
close of ceremonies in Gisborne.
HILLARY GREGORY

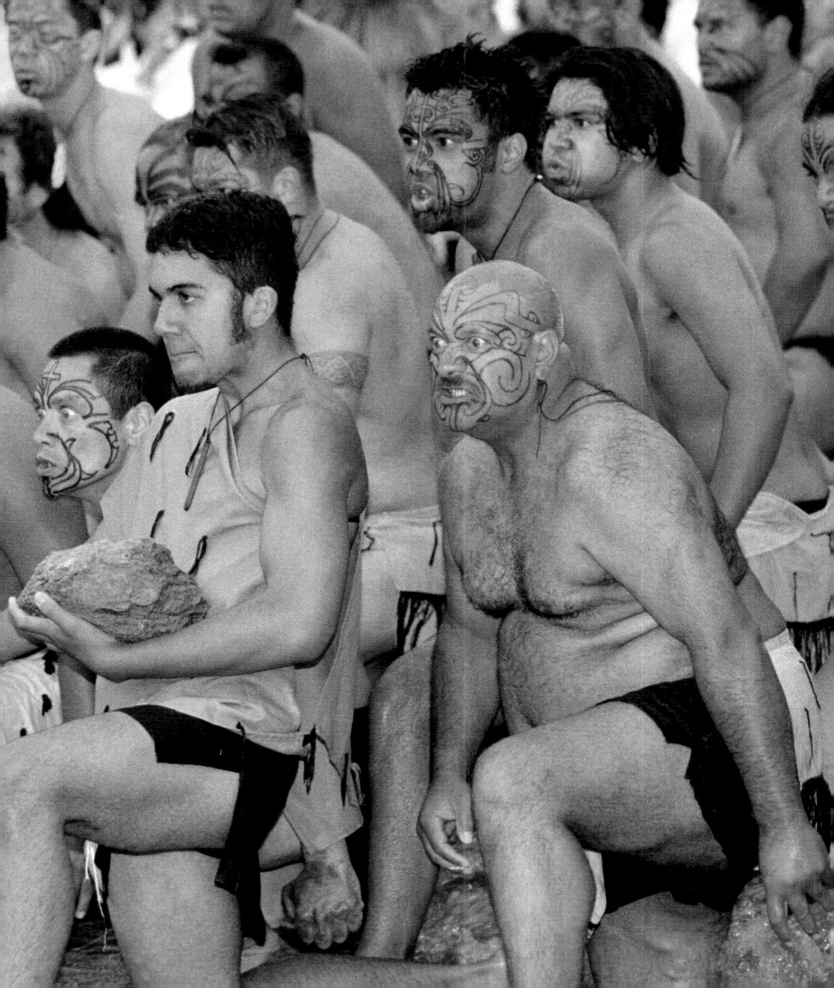

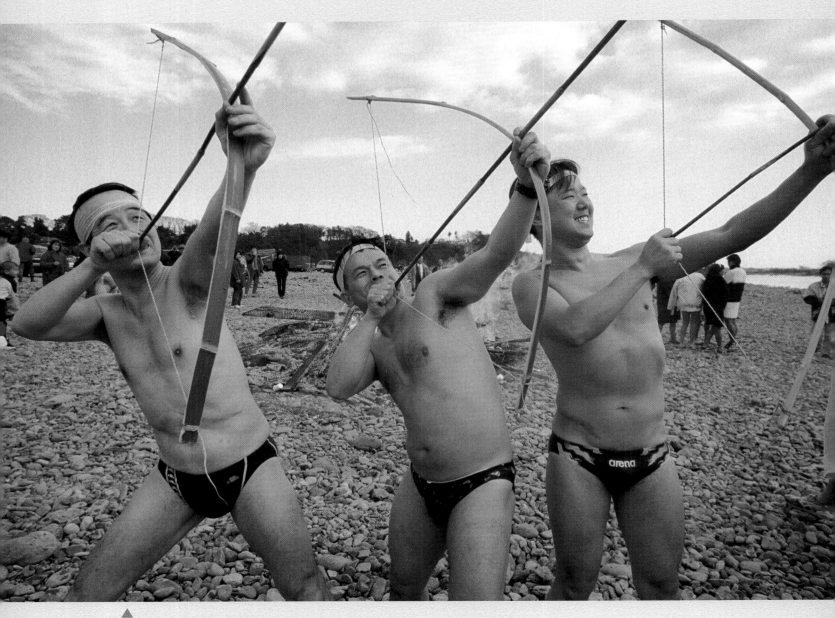

⭐ **NOON SAGAMIHARA, JAPAN**
Legend has it that when the arrows hit their target, the people will have a healthy and happy life.
MIYATA HIRONORI

▲ **10AM MILWAUKEE, WISCONSIN, USA**
The New Year's Day swim at Bradford Beach draws warmly dressed onlookers. SUZANNE KRULL

NOON BARCELONA, SPAIN
A photo opportunity in the Mediterranean. DARIUS KOEHLI
▼

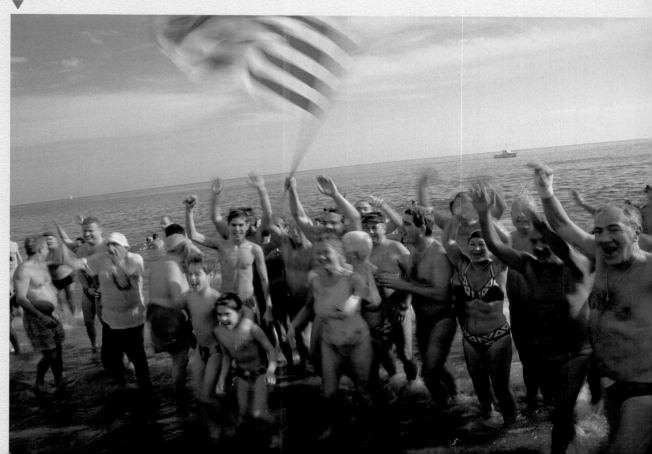

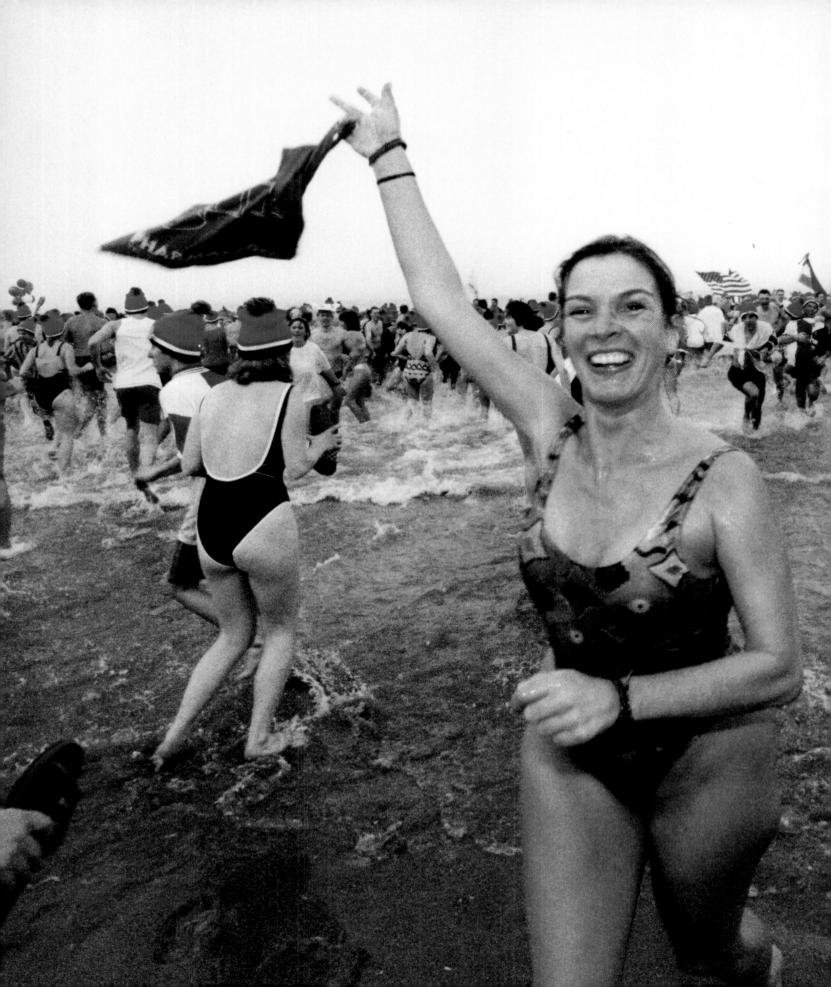

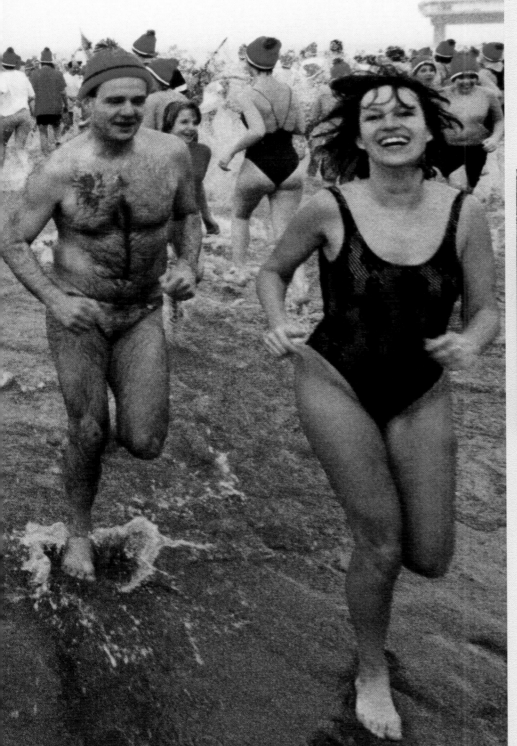

NOON SCHEVENINGEN, NEAR THE HAGUE, NETHERLANDS
Around 10,000 hardy souls dived into the icy waters of the North Sea.
WALTER SANS

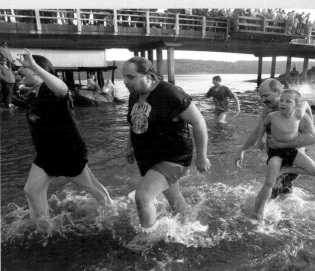

11AM OLALLA, WASHINGTON, USA
More than 150 people participate in the annual Olalla Polar Bear bridge jump into freezing water.
JIM BRYANT

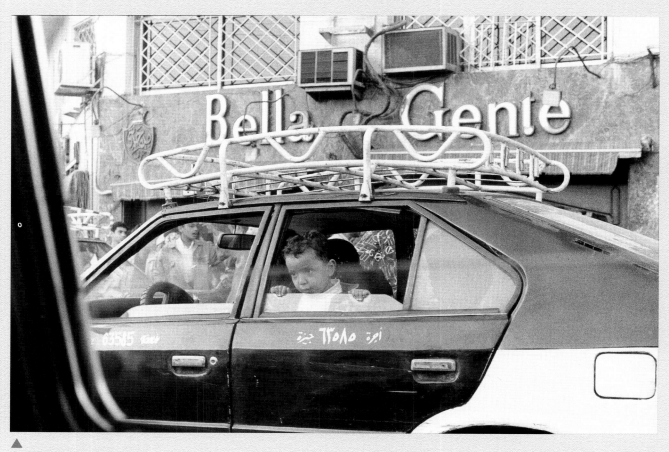

11AM CAIRO, EGYPT
After spectacular fireworks at the pyramids the night before, the city returns to normal.
SUSMITA DE

11AM VERACRUZ, MEXICO
Children play at the historic San Juan de Ulua Fort,
where Spanish rule of Mexico both began and ended.
ARTURO PIERA

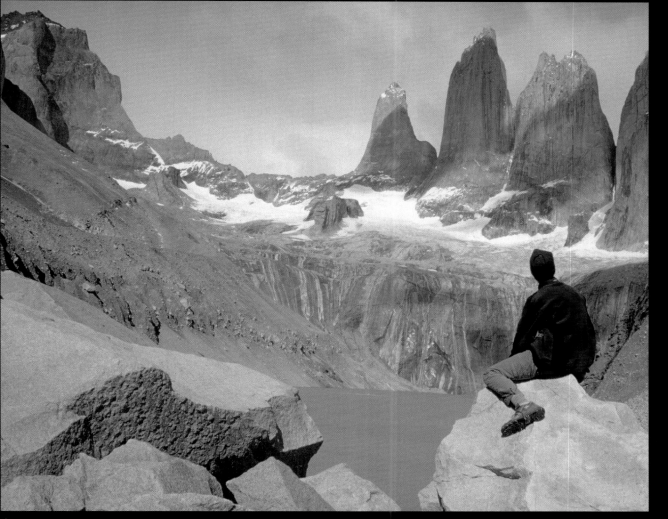

8AM TORRES DEL PAINE NATIONAL PARK, CHILE
The culmination of a two-week backpacking trip through Patagonia.
A chance to reflect on what changes a new century might bring.
LARS HOWLETT

7AM JAMAICA, QUEENS, NEW YORK CITY, USA
Hexel says: "Every day while riding the subway I see this view. I decided on this day I would capture it forever."
HEXEL HERNANDO

Chronology

One last glance. An opportunity to bring to you an added selection of photos in the form of a chronological tour around our planet.

At noon on December 31st, in Allegan, Michigan - Travis, Tracy, and Tommy Lee toast the millennium with grape juice. Their mother will later be out taking photos at midnight. By noon the following day, the village of Millennium, North Carolina -- population 750 and the object of media attention for months -- has returned to its usual, quiet existence.

In between these two, an entire world of cultures, and a celebration of the glorious diversity of humanity...

DECEMBER 31, 1999

12:03PM
ALLEGAN, MICHIGAN
USA
DIANE SUMNER

12:05PM
PALMAS, TOCANTINS
BRAZIL
JOÃO NORONHA

**12:20PM
ZHANGJIANG
CHINA**

FAJIAN WANG

**12:30PM
FLORENCE
ITALY**

CHRIS MCDOWELL

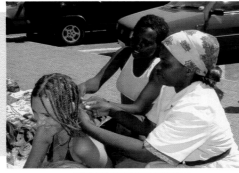

**1PM
DURBAN
SOUTH AFRICA**

EMANUEL MARIA

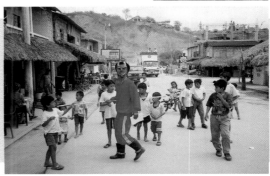

**1PM
MONTANITA
EQUADOR**

SAMUEL HENRIQUE BERGER

**1PM
LA CROSSE, WISCONSIN
USA**

GERALD BONSACK

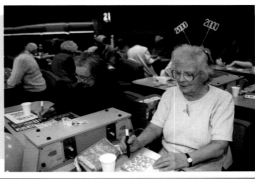

**1:30PM
BOLTON
ENGLAND**

GARY TAYLOR

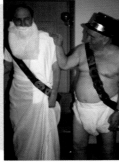

**1:45PM
BENSALEM, PENNSYLVANIA
USA**

LIZ MURPHY

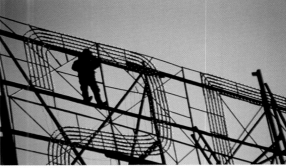

**2PM
NAPOLI
ITALY**

ALDO MESCHINI

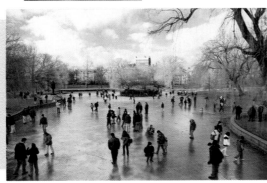

**2PM
BOSTON
USA**

PATRICIA DESMARAIS

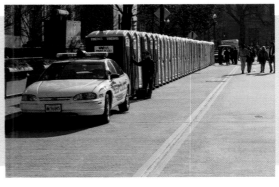

**2PM
WASHINGTON, DC
USA**

WILLARD OVERTON

297

2PM
ORANJESTAD
ARUBA
NADINE SALAS

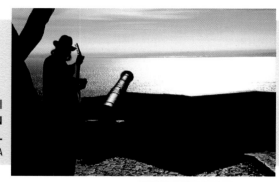

2PM
LISBON
PORTUGAL
ANDREAS BUSCHA

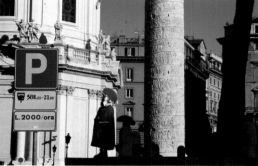

2PM
ROME
ITALY
MAURO OGGIONI

298

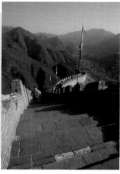

2PM
GREAT WALL, NR. BEIJING
CHINA
LAN YIN

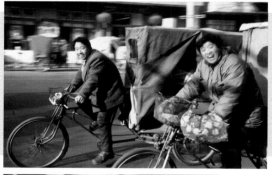

2PM
BEIJING
CHINA
JOE BROCK

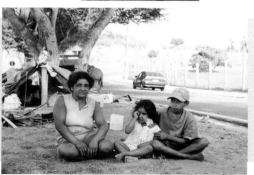

2:20PM
NATAL
BRAZIL
MARCOS GALVÃO

2:30PM
GERMANTOWN, TENNESSEE
USA
LINDA PHILLIPS

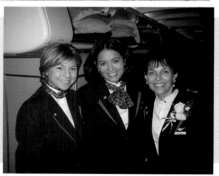

2:30PM
BLOOMINGTON, MINNEAPOLIS
USA
BRYAN JENSEN

2:30PM
FLORENCE
ITALY
CHRIS MCDOWELL

2:30PM
ALTAMONTE, FLORIDA
USA
SALLY MCCRAE KUYPER

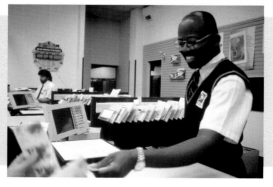

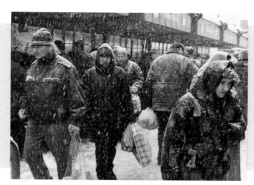

**3PM
SOFIA
BULGARIA**
NIKOLAY GEORGIEV

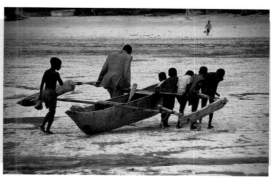

**3PM
ZANZIBAR
TANZANIA**
JAMES STEJSKAL

**3PM
ISLA MUJERES
MEXICO**
STANLEY PATZ

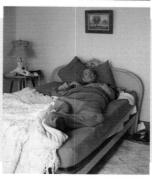

**3PM
ALEXANDRIA, LOUISIANA
USA**
ELIZABETH BRAZELTON

299

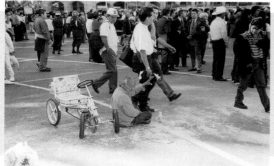

**3:20PM
MEXICO CITY
MEXICO**
RODRIGO BENAVENTE SANCHEZ

**3:30PM
GEIRSNEF, REYKJAVÍK
ICELAND**
EINAR ÓLI EINARSSON

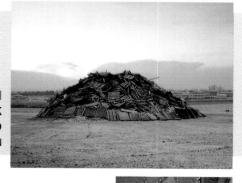

**3:30PM
SUZHOU
CHINA**
XIAOJUN YANG

**3:30PM
ACCRA
GHANA**
ROBERT BURCH

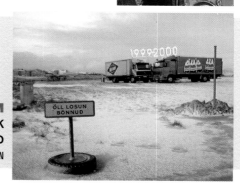

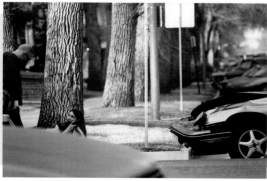

**3:30PM
FORT COLLINS,
COLORADO
USA**
BEA TAYLOR

**3:40PM
GEIRSNEF, REYKJAVÍK
ICELAND**
EINAR ÓLI EINARSSON

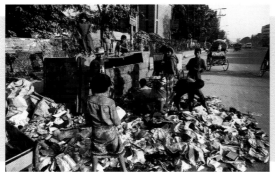

**3:45PM
DHAKA
BANGLADESH**
DIRK R. FRANS

**3:45PM
SOMEWHERE ABOVE
NEW MEXICO
USA**
BRIAN MARR

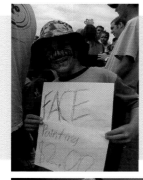

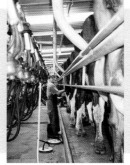

**3:45PM
SYDNEY HARBOUR
AUSTRALIA**
COLLEEN MILLER

300

**4PM
CENTRAL HAWKES BAY
NEW ZEALAND**
VERONICA LOUSLEY

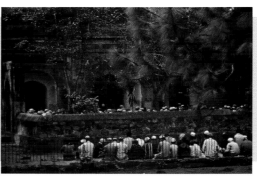

**4PM
NEW YORK
USA**
MADS IZMODENOV ESKESEN

**4PM
DELHI
INDIA**
MYRON W. LUSTIG

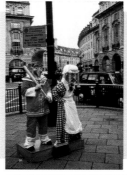

**4PM
LONDON
ENGLAND**
NICK TSINONIS

**4PM
PARIS
FRANCE**
LUIZ EDUARDO ACHUTTI

**4:10PM
HAWKES BAY
NEW ZEALAND**
JESSE BYWATER

**4:15PM
SEATTLE
USA**
JOHN CHARLES SCHLESSELMAN

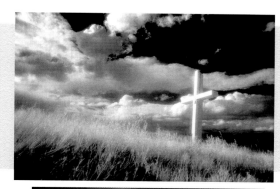

4:15PM
LITTLETON, COLORADO
USA
JEFF JOHNSON

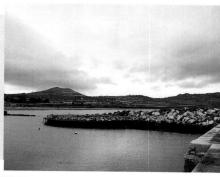

4:30PM
GREYSTONES, CO. WICKLOW
IRELAND
KEVIN BUTTERLY

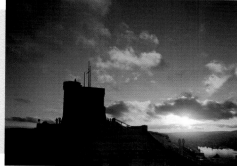

4:30PM
ST. JOHN'S,
NEWFOUNDLAND
CANADA
CHARLES DUFOUR

4:30PM
FRANKFURT
GERMANY
BERTHOLD ROSENBERG

301

4:35PM
DEPOT BEACH
AUSTRALIA
JENNIFER LYNDON

4:50PM
NEW ORLEANS
USA
ZACHARY FOURNET SMITH

5PM
ALEXANDRIA, LOUISIANA
USA
ELIZABETH BRAZELTON

5PM
PLAYA DE ZAPALLAR
CHILE
CATALINA AGUIRRE BARROS

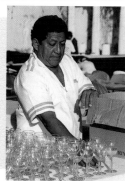

5:30PM
ACAPULCO
MEXICO
ALBERTO HOCHKOEPPLER

5:30PM
SYDNEY
AUSTRALIA
ANNEMAREE PAYNE

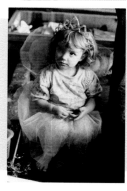

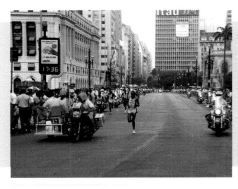

5:36PM
SAO PAULO
BRAZIL
EDUARDO CASTANHO

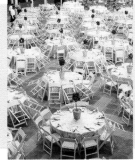

5:40PM
LA ROMANA COUNTRY CLUB
DOMINICAN REPUBLIC
ANNE FRANCO RUCKENSTEIN

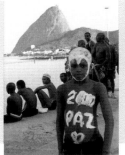

5:40PM
RIO DE JANEIRO
BRAZIL
VANESSA POITENA

5:45PM
BOSSIER CITY, LOUISIANA
USA
GARY MACKEY

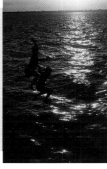

5:50PM
AMAZONIA
BRAZIL
RAFAEL BOULHOSA

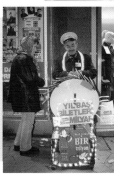

6PM
ISTANBUL
TURKEY
ALI KABAS

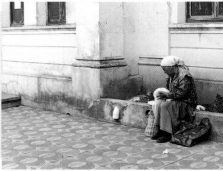

6PM
BARBACENA
BRAZIL
CLÁUDIA MÔNICA VIOL

6PM
SUGAR GROVE, ILLINOIS
USA
MATT DORAN

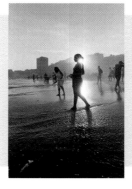

6PM
RIO DE JANEIRO
BRAZIL
PEDRO REY

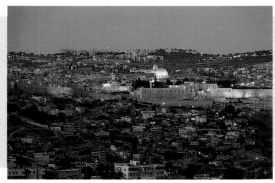

6PM
JERUSALEM
ISRAEL
DOUGLAS GUTHRIE

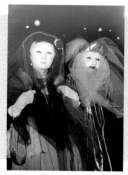

6:30PM
BOSTON
USA

ROBERT A. EDSALL

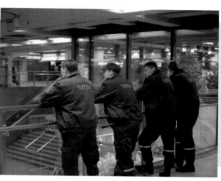

7PM
HELSINKI
FINLAND

CARL-MAGNUS DUMELL

7PM
ISTANBUL
TURKEY

ALI KABAS

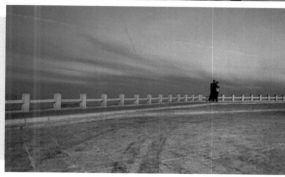

7:10PM
DALIAN CITY
CHINA

QIANG KANG

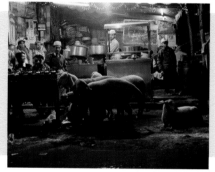

8:30PM
DELHI
INDIA

OSCAR DE MELLO

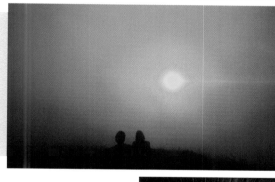

8:42PM
CAPE REINGA
NEW ZEALAND

DAN MCGRATH

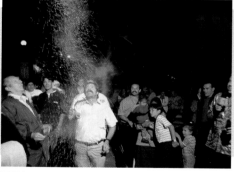

8:50PM
HEREDIA
COSTA RICA

MARCO SABORIO

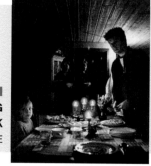

9PM
MALLING
DENMARK

SYLVY VAN BOCHOVE

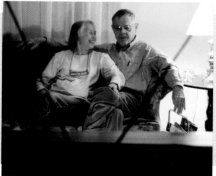

9PM
NASHVILLE, TENNESSEE
USA

CHRIS HOLLO

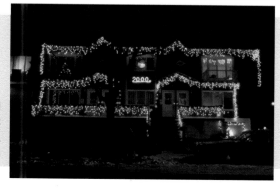

9:30PM
LASALLE, QUEBEC
CANADA

SUSAN SHEEN

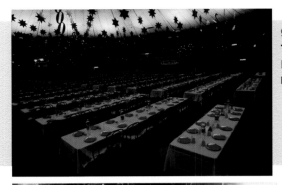

9:30PM
TORINO
ITALY
RENATO VALTERZA

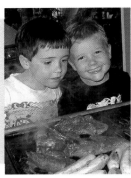

9:30PM
AUCKLAND
NEW ZEALAND
JACK SPROSEN

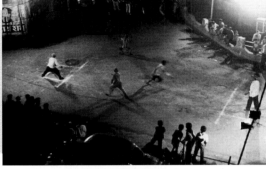

9:30PM
CALCUTTA
INDIA
SUGATO CHATTOPADHYAY

10PM
NR. BUCKINGHAM PALACE, LONDON
ENGLAND
MICHELLE STORM

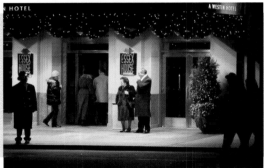

10PM
NEW YORK
USA
JOHN BOWEN

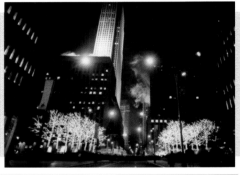

10PM
NEW YORK
USA
ATTILA LUKATS

10PM
CHORONI, EDO ARAGUA
VENEZUELA
AMALIA CAPUTO DODGE

10PM
VANCOUVER, BRITISH COLOMBIA
CANADA
CHAW SHIN PUI

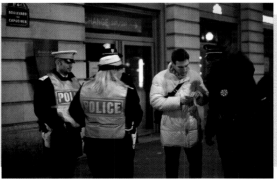

10PM
PARIS
FRANCE
EROL RECARDO BENT

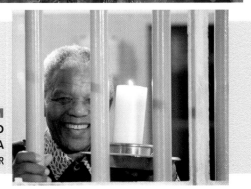

10PM
ROBBEN ISLAND
SOUTH AFRICA
JOHANN VAN TONDER

**10:20PM
KUALA LUMPUR
MALAYSIA**
ZI XIONG YANG

**10:30PM
RIO DE JANEIRO
BRAZIL**
ANDRE MARCO GOMES

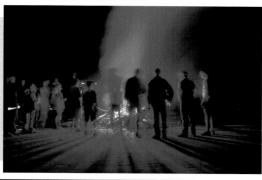

**10:30PM
GOLDEN BAY
NEW ZEALAND**
LAUREL MACDONALD

**10:30PM
NEW YORK
USA**
JOHN BOWEN

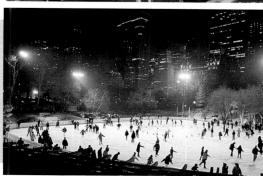

**10:30PM
TANJONG KLING,
MALACCA
MALAYSIA**
FARIDA SHAH

**10:43PM
ANAHEIM, CALIFORNIA
USA**
JEANNE BARKEMEIJER DE WIT

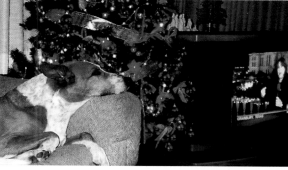

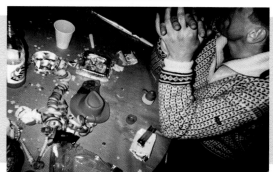

**11PM
COPENHAGEN
DENMARK**
SIGNE VAD

**11PM
NEW DELHI
INDIA**
ANUPAMA VINAYAK

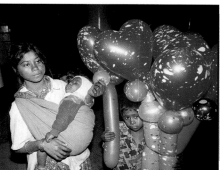

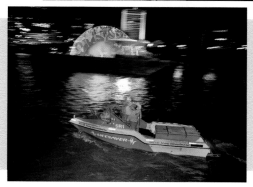

**11PM
BRISBANE
AUSTRALIA**
DARRIN J. ZAMMIT LUPI

**11PM
TIMES SQUARE,
NEW YORK
USA**
DAVIDE ROLANDO

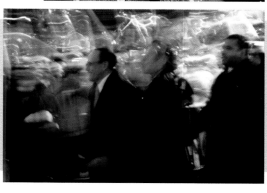

11PM
LONGWOOD, FLORIDA
USA
SALLY MCCRAE KUYPER

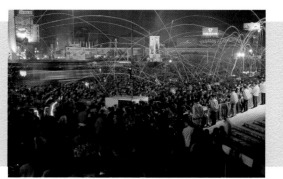

11PM
ISTANBUL
TURKEY
ALI KABAS

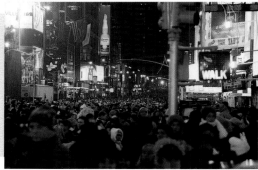

11PM
TIMES SQUARE, NEW YORK
USA
GREGORY CONROY

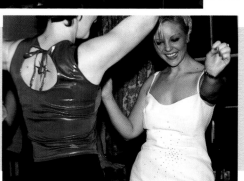

11PM
BATH
ENGLAND
ERICA HASENJAGER

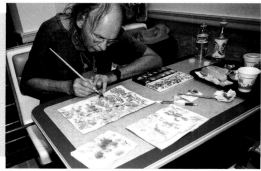

11:30PM
PLAYA DE LAS AMERICAS
TENERIFFE
PAULINA HOLMGREN

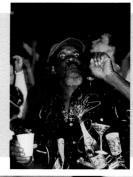

11:30PM
JOST VAN DYKE
BRITISH VIRGIN ISLANDS
KYMBERLY BARNETT

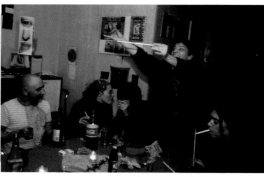

11:30PM
LIEGE
BELGIUM
RUSS OSTERWEIL

11:30PM
MOUNT MANGANUI
NEW ZEALAND
JOHN PETERSON

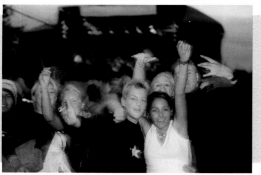

11:35PM
SEATONVILLE, ILLINOIS
USA
RANDALL SIMONE

11:45PM
LIVERPOOL
ENGLAND
MARK ANTHONY WILSON

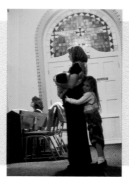

11:45PM
BRYAN, TEXAS
USA
SHAWNA MANNING MARCONTELL

11:45PM
NEW ORLEANS
USA
ELLEN MERTEN

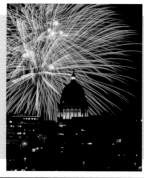

11:50PM
MADISON, WISCONSIN
USA
STEVEN MAERZ

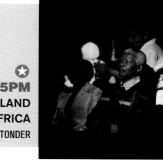

★
11:55PM
ROBBEN ISLAND
SOUTH AFRICA
JOHANN VAN TONDER

307

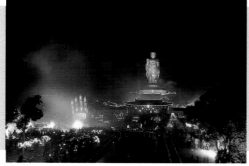

11:55PM
WUXI
CHINA
JUN JI

11:58PM
SUNNYVALE, CALIFORNIA
USA
KEITH BETTINGER

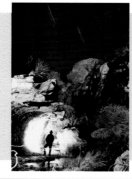

11:58PM
SITTING BULL CANYON, NEW MEXICO
USA
TERRY EDWARD BALLONE

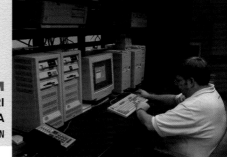

11:59PM
JEFFERSON CITY, MISSOURI
USA
SHAUN T. ZIMMERMAN

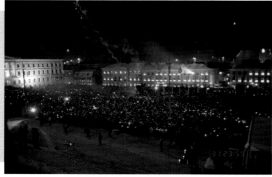

11:59PM
HELSINKI
FINLAND
CARL-MAGNUS DUMELL

11:59PM
JINTAN
CHINA
ZHANG JIANLIN

Midnight

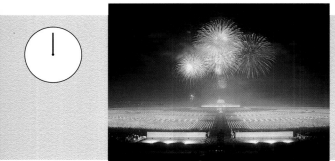

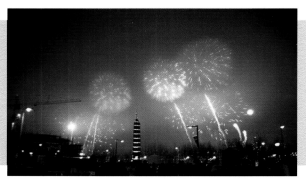

**PATHUMTHANI
THAILAND**
SUWAN OUNRASAMEEWONA

**PHILADELPHIA
USA**
PATRICK BOYLE

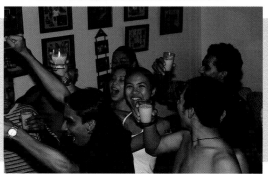

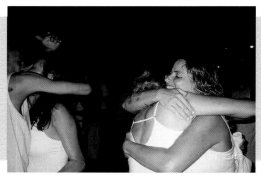

**KUALA LUMPUR
MALAYSIA**
ZABRINA FERNANDEZ

**MONGAGUA
BRAZIL**
SINVAL GARCIA

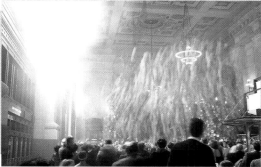

**UNION STATION,
KANSAS CITY
USA**
JEFF KNIGHTS

**BEIRUT
LEBANON**
THOMAS CROWN

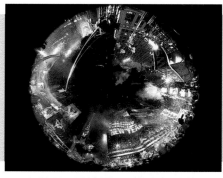

**NEW YORK
USA**
KEVIN J MCCORMICK

**KUALA LUMPUR
MALAYSIA**
TANG AH TONG

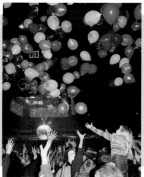

**BENNEKOM
NETHERLANDS**
JAN W. DIMMENDAAL

**RAPID CITY, SOUTH DAKOTA
USA**
BOBBI JO BEAVER

**OCEAN PINES, MARYLAND
USA**
SCOTT WOLPIN

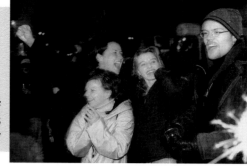

**CARDIFF
WALES**
SIMON RIDGWAY

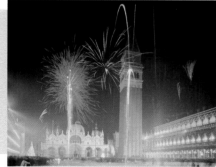

**TELLURIDE,
COLORADO
USA**
AMANI WILLETT

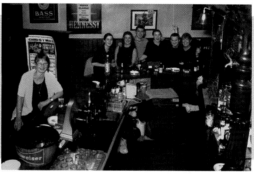

**CARRICK-ON-SHANNON,
CO. LEITRIM
IRELAND**
KEITH NOLAN

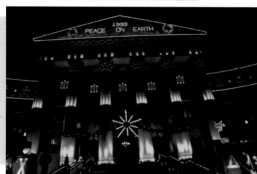

**VENICE
ITALY**
RICHARD WALL

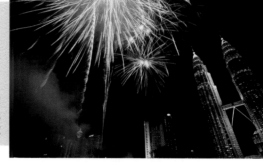

**KUALA LUMPUR
MALAYSIA**
TONY WONG THIAM HOCK

**DENVER, COLORADO
USA**
KATHY J. KUNCE

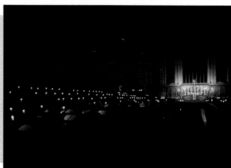

**ST. PAULS CATHEDRAL,
CALCUTTA
INDIA**
SHUVAM BISWAS

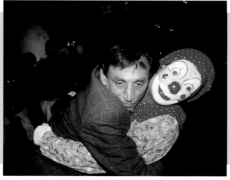

**NEW DELHI
INDIA**
ANUPAMA VINAYAK

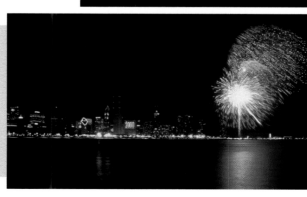

**CHICAGO
USA**
ALEX HALVORSEN

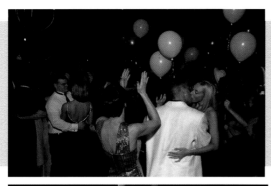

12:01AM
UPPER DARBY,
PENNSYLVANIA, USA
TIFFANY RUOCCO

12:01AM
MANGONUI
NEW ZEALAND
DAN MCGRATH

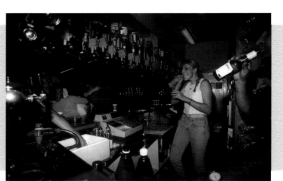

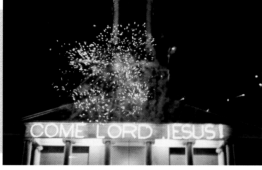

12:02AM
BOSSIER CITY, LOUISIANA
USA
GARY MACKEY

12:02AM
LONDON
ENGLAND
LOUISE ABBIATI

12:02AM
MADRID
SPAIN
JUAN FERRERO

12:02AM
BOISE, IDAHO
USA
DIANNE BUCHTA HUMBLE

12:02AM
PLOVDIV
BULGARIA
PLAMEN ANTONOV

12:03AM
FUNCHAL, MADEIRA
PORTUGAL
JONAS ALMEIDA DE ANDRADE

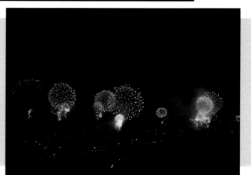

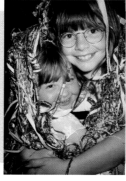

12:04AM
AUCKLAND
NEW ZEALAND
LYNN WILLIAMS

12:04AM
DAYTON
USA
PAMELA THIMMES

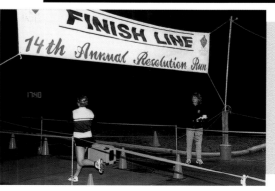

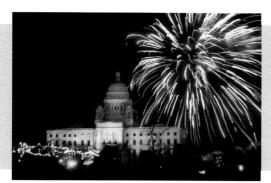

12:05AM
PROVIDENCE, RHODE ISLAND
USA
RICK SILVESTRO

12:05AM
KRANJ
SLOVENIA
BOSTJAN GUNCAR

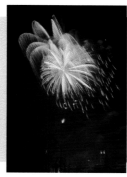

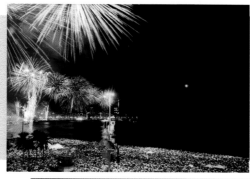

12:05AM
RIO DE JANEIRO
BRAZIL
RICARDO SERPA

12:05AM
ACAPULCO
MEXICO
JOSE DALMA

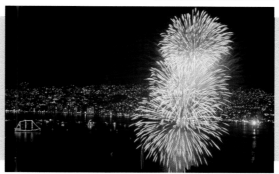

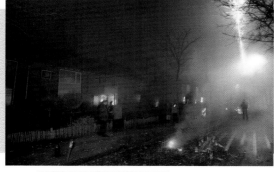

12:05AM
BENNEKOM
NETHERLANDS
JAN W. DIMMENDAAL

12:05AM
LONDON
ENGLAND
WILLIAM BOWDEN

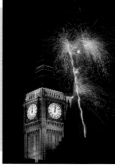

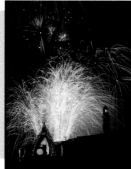

12:10AM
SALVADOR CITY
BRAZIL
VERA LÚCIA AQUINO

12:10AM
RIO DE JANEIRO
BRAZIL
MARCELO CORRÊA

12:10AM
RUJIENA
LATVIA
KARLIS ZIKMANIS

12:13AM
BEIRUT
LEBANON
THOMAS CROWN

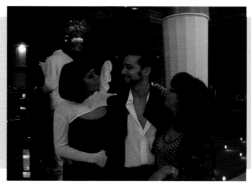

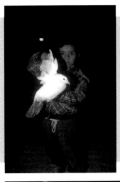

12:15AM
BETHLEHEM
PALESTINE
KOBI ISRAEL

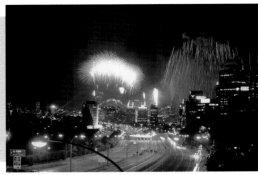

12:15AM
SYDNEY
AUSTRALIA
CLIFFORD WHITE

12:19AM
RIO DE JANEIRO
BRAZIL
AGUINALDO RAMOS

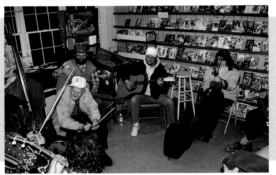

12:30AM
BRASSTOWN, NORTH
CAROLINA
USA
RUTH M. HARRIS

312

12:30AM
TARTU
ESTONIA
AIGAR LUSTI

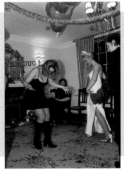

12:30AM
BATH
ENGLAND
ERICA HASENJAGER

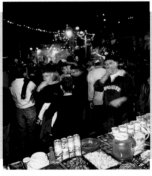

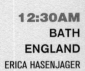

12:50AM
HAIFA, WADI-NISNAS
ISRAEL
PINI VOLLACH

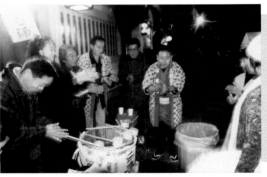

1:30AM
TOKYO
JAPAN
AKIRA TOMITA

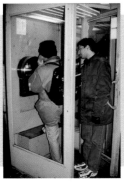

1:30AM
KARLSRUHE
GERMANY
LALIT BHATT

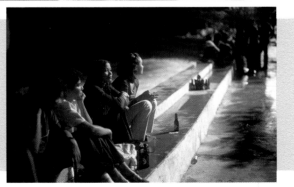

1:30AM
CHORONI
VENEZUELA
ORIOL TARRIDAS MASSUET

2AM
ROME
ITALY
CLAUDIO MARCOZZI

3AM
UNION HOSPITAL
ELKTON, MARYLAND
USA
HENRY FARKAS

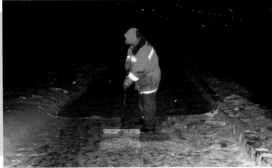

3AM
MOSCOW
RUSSIA
ANTON PROKOFIEV

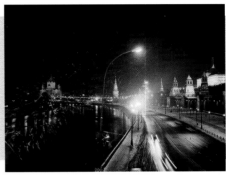

3AM
MOSCOW
RUSSIA
VALENTIN GLADYSHEV

313

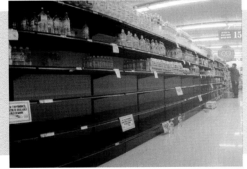

3:30AM
FORT COLLINS, COLORADO
USA
MARIAN RICHARD MIODONSKI

5AM
ARLINGTON, VIRGINIA
USA
DAVID MOSS

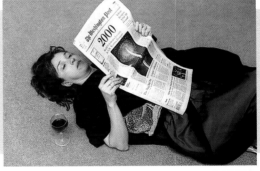

6AM
CALCUTTA
INDIA
AMIT BASU

6AM
HARDY'S BAY
AUSTRALIA
ANDY MCCOURT

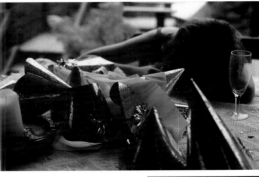

6AM
PARIS
FRANCE
BARBARA PASTRANA

6AM
POKHARA
NEPAL
ANDY SMALL

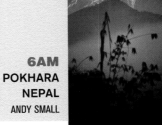

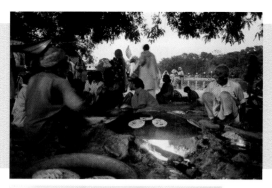

6:30AM
NEW DELHI
INDIA
ANAMITRA CHAKLADAR

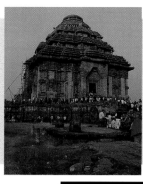

7AM
KONARK, ORISSA
INDIA
GHANI ZAMAN

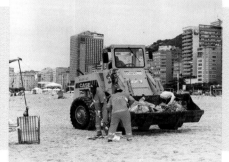

7AM
RIO DE JANEIRO
BRAZIL
VITOR HUGO MOREAU

7AM
VENICE
ITALY
RICHARD WALL

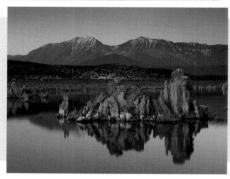

7:05AM
MONO LAKE, CALIFORNIA
USA
LEPING ZHA

7:30AM
HILTON HEAD, SOUTH CAROLINA
USA
SCOTT ANDERSON

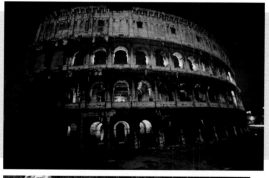

7:45AM
ROME
ITALY
MICHELE SORTINI

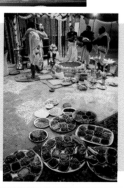

8AM
NEW DELHI
INDIA
RONALD ALEX LEO

8AM
RIO DE JANEIRO
BRAZIL
CAROL BAPTISTA

8AM
CAPE SPEAR,
NEWFOUNDLAND
CANADA
DUNCAN MAJOR

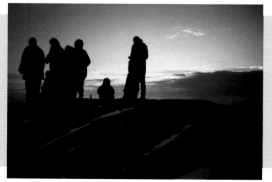

8AM
CARAIVA, BAHIA
BRAZIL
FELIPE MOROZINI

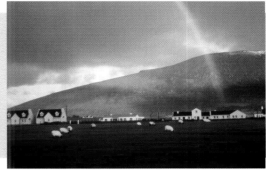

9AM
ACHILL ISLAND, CO. MAYO
IRELAND
MAURICE LONDON

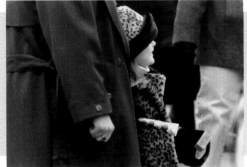

9:15AM
PHILADELPHIA
USA
ANDREA RICHBURG

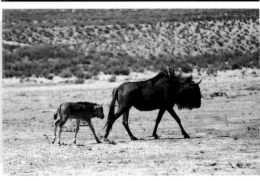

9:30AM
KALAHARI DESERT
BOTSWANA
ANDRÉ VAN DEN HEEVER

315

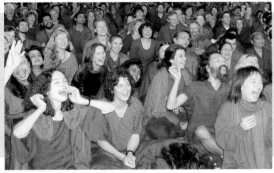

9:45AM
PUNE
INDIA
AHMNO TRACY

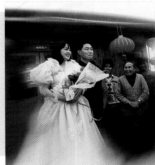

9:58AM
JINTAN
CHINA
ZHANG JIANLIN

10AM
FRANKFURT
GERMANY
BERTHOLD ROSENBERG

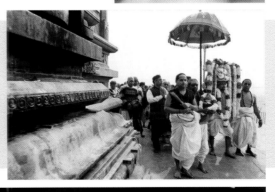

10AM
NEW DELHI
INDIA
RONALD ALEX LEO

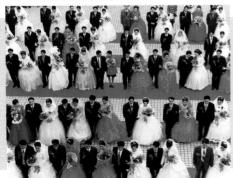

☆
10AM
BINTINSHAN
CHINA
HONGXUN GAO

10AM
ST.LOUIS, MISSOURI
USA
CHRISTINE A. OLSON

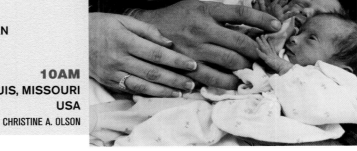

10AM
EDSON, ALBERTA
CANADA
KRISTA LOGAN

10:25AM
PASADENA, CALIFORNIA
USA
SANDRA SPARR

10:30AM
MUMBAI (BOMBAY)
INDIA
ISHIKA MOHAN

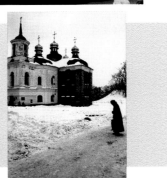

10:30AM
KIEV
UKRAINE
ALFRED SUPIK

10:30AM
ALTO TIQUIRRISI
COSTA RICA
MARCO SABORIO

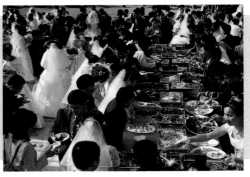

11AM
JIANGMEN
CHINA
SHANJI ZHAO

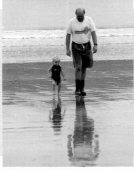

11AM
KENNEDY BAY
NEW ZEALAND
SHARON VOSCHEZANG

11:15AM
BOHINJ
SLOVENIA
MIKLAVZ HVASTIJA

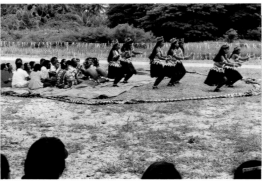

11:30AM
RABI ISLAND
FIJI ISLAND
TOKIRETI TEKERAU

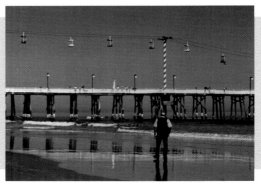

11:32AM
DAYTONA BEACH
USA
KAREN ANN DONNELLY

NOON
DAYTONA BEACH
USA
KAREN ANN DONNELLY

NOON
SCHEVENINGEN (NEAR THE HAGUE)
NETHERLANDS
WALTER SANS

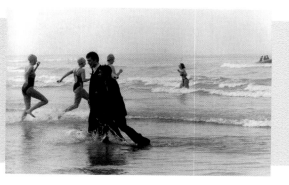

NOON
MILLENNIUM, NORTH CAROLINA
USA
DEBBIE KLINGENDER

317

Credits

Project Director - Alx Klive

Art Director - Andrew Smith
Editor - David Kilgour

Design Team - Andrew Smith, Alx Klive, Joseph Gisini, Kevin Cockburn

For Moveable Type - Joe Kotler, James Li, Jennifer Malloy

Director of Sales and Marketing - Salman Nensi
Assistant Director of Sales and Marketing - David Leonard

Head of E-Mail and Database Administration - Wesley Young
Judging Event Co-Ordinator - Steve Alvey
Assistants to Project Director - Elvis Prusic and Connie Wragge
Senior Web Designer - Terra Jung
Additional Web Design - Digby Norris, Alx Klive
Digital Submissions - Andrew Cermak
Production Assistants - Amanda Elliston and Michele Arthur

Judges - John Gunn, Michael McLuhan, Jill Waterman, Peter Anderson, Sue Brisk, Lee Corkran, Alx Klive, Dan Diamond

Judging Equipment and Systems - Richard Bell & Associates
Hotel Sponsor – Le Royal Meridien King Edward Hotel, Toronto
Digital Printing Sponsor - Epson Canada

Media Kit and Logo Design - Jane Kosstrin, Barbara Zuckerman
Media Kit Photography - Michele Arthur

Regional Co-Ordinators / Translators
China - James Zeng-Huang, Liu Jie, Pu Ruarua
Russia - Valentin Gladishev
Brazil - Orlando Discacciati, João Noronha, Luis Fernando Marcomini
South Africa - Andrew October, Richard van der Spuy
Germany - Claudia Klepser
Italy - Renato Valterza
India - Phiroze Dalal, Sahir Raza, Suhas Dutta, Ghani Zaman, Valappil Radhakrishnan
France - Luiz Achutti
Spain - Txiki Guillén, Bruno De La Mata
Netherlands/Belgium - Richard van Ginkel
Australia - Andy McCourt, Glenn Milne, Zoe Wolfendale, Denise Goff
New Zealand - Bill Patterson

Project Ambassadors: Amy Sides, Mark Phillips, Patricia Desmarais, Kevin Butterly, Lalit Bhatt, Gordon Barber, Jeff Johnson, William Ferguson, Kelly Brezee, Lorraine Goldych, Michel Cenac, Jim Potosky, Tina Petersen, Larry Furnace, Lisa Kerr, Shaun Zimmerman, Alfonso Rodriguez, Bill Patterson, Brad Perks, Andrea Richburg, Krista Logan, Thomas Crown, Henry Farkas, Richard Cass, Bruce Reiter, Bea Taylor, Carlos Silva, Diane Humble, Thomas Cronshaw, David Lubin, Rebecca

Doremus, Sally McCrae Kuyper, Ed Maynard, James Wakefield, Felipe Huicochea, Jeanne Barkemeijer de Wit, Keith Nolan, Karen Maynard, Palani Mohan, Molly McDonald, Plamen Antonov, Rommel Feria, Rebecca Garges, Richard Smith, Rodney Tregale, Stephen Liard, Agung Tandjung, Johann Van Tonder, Ward McGaughrin, Douglas Tesner, Diane Pyburn, John Lee, Brittney Moraski, James Fijalkovich, Victoria Vancek, Jason Burgess, Tom Donadio, John Swenson, John Pearce, Clare Bourke, Sharie Penwarden, David Fitzgerald-Irons, John Gerard Cosgrove, Sean Sisk, Elizabeth Silvis, Anastasia Steinbrunner, Jesse Bywater, Arthur Sawyers, Montserrat Sau, Philippe Mémeteau, Mariano Aparicio, Darrin J. Zammit Lupi, Russell Johnson, Jane Johnson, Danny Youssef, Pedro Rey, Arthur Leandro, Phillip Adams, Connie J. Stone, Serzh Zhdanov, Chris Ainslie, Raymond Casbourn, Eddie Chuah, Mark Barley, Blaine Ducote, Ali Kabas, Eddie Gerald, Clive Warren, Charles Dufour, Darius Koehli, Jock Fistick, Mike Valentine, Nick Tsinonis, Ralph I. Miller, Paul Gapper, Dirk R. Frans, Dennis Capper, Colleen Miller, Susan Sheen, Jennifer Lyndon, C.Elizabeth Vest, Tom Merchant, Christel Dhuit, Mario Squarotti, Pini Vollach, Alfred Supik, Charlie F. Kohn, Theo Vorster, Deborah Ray, Luciana Whitaker-Aikins, Morten Bendiksen, Arfan Amaluddin, Reuben Reynoso, Reshma Kamat, Rosey Goodman, Russ Osterweil, José Alysson Dehon Moraes Medeiros, José Ortega "Sitoh", Gerry Normand, Carlos Roberto, Jonas Almeida de Andrade, Jill Whillock, Ishika Mohan, Mark Sadan, Elio Lombardo, Shuvam Biswas, Brent Price, Candace Williams, Chaw Shin Pui, Diane Sumner, Joan Lauren, John Rupe, Karen I. Hirsch, Elizabeth Larrabee, Edward Hersom II, John Peterson, Darren O'Shannassy, Jim Bryant, Duncan Major, Christine A. Olson, John Karsten Moran, Michele Darien, Robert A. Edsall, Jackqueline H. Diaz, William Bowden, Paul Couvrette.

Our thanks to the following companies: The Artshouse, Bayview Photo, Enterprise Rent-a-Car, Brant Press, Lionheart Printing, Viveka Printers, GR Technologies, Peerless Travel, BGM Imaging.

Special thanks to: Brian Monrad, Kevin Hanson, Morty Mint, Dan Diamond, Michael Schwarz, Charlotte Chahrvin, Patrick Smyth, Connie Wragge, Stephen Williams, Nick Tsinonis, John Gunn, Jill Waterman, Rozanne Gribble, Laura Tachini, Ann Medina, Lyn Staley, Michael Levine, Karen Curry, Shirley Chan, Tom Heitzman, Dara Rowland, Rob Firing, Maryann Palumbo, Jack Stoddart, Paul Davidson, Mike Wallace, David Kent, Laura Comello, Amy Sides, Melleny Melody, David Giddens, Ted Snell, John Williams, Terence Leung, Connie Fitzpatrick, Nathon Gunn, Tina Botterill, Jon de la Mothe, Aaron Milrad, Ben Manzo, Debbie Bailey, Michael Morrison, Rita Dickson, Keith Schaefer, Stephen Hanks, Chris Cheeseman, Walter Downes, Victor Caffarena, Marjan Savli, John Bright, Michael Marzolini, Doug Sheridan, Andrew Bauer, Rahul Vaid, Andrew Kines, Phill Snel, Natasha Eloi, Gavin Bryan, Nicholas Reichenbach, Howie Bell, Greg Hermanovic, Jane Millichip, John Thornton, Joan Spence, Mum & Dad, Hannah, K. Tony Matharu, Joy Branford, Burt Davidson, Chris Divita, Kristen & Davide, Kendra Francis, Meredith Nickie, Andrew Sutton, Lisa Barnes, Mark Phillips, Gregory Wright, Lisa Pitt, Dave Maman, Nicole Triplett, Jonelle Moore, Sean Hurlburt, Christina LaFlamme, Lou Nigro.

Crew Photographers

Abdulrahman Obeidan
 Fakhroo
Abigail Linné
Abraham Jacobus
 Andre van Zyl
Adam Beckerman
Adele Wikner
Adonai Teles
Adriel Chan
Aguinaldo Ramos
Agung Tandjung
Ahikam Seri
Ahmno Tracy
Aigar Lusti
Aimee Matteson
Akira Tomita
Alberto Hochkoeppler
Aldo Meschini
Alessandro Bravetti
Alex Halvorsen
Alex Foong
Alexander Sandev
Alexander Kantor
Alexander Svetlovsky
Alexandre De Souza
 Martins
Alf Goran Lyback
Alfred Supik
Ali Kabas
Allan Hart
Allan Porter
Allan J Faid
Alon Levite
Amalia Caputo Dodge
Amanda Dalgleish
Amani Willett
Amarnath Chandra
Amber Guessford
Amber-Lee Farmer
Ami Chakrabarti
Amit Basu
Amy Lewis Sides
Anamitra Chakladar
Anastasia Malovanaia-
 Brouns
Anastasia Steinbrunner
Andre Marco Gomes
Andrea Gowland-
 Douglas
Andrea Richburg
Andrea Mosso
Andreas Buscha
Andrew October
André van den Heever
André Maslennikov
André Arruda
Andrzej Michalowski
Andy McCourt
Andy Small
Andy Gaffney
Ane Marques
Angela Lawson
Anita Clancy
Anne Franco
 Ruckenstein
Annemaree Payne
Annette Brown
Anton Prokofiev
Antonio Paso
 de la Torre
Anupama Vinayak
April Warn
April
Arfan Amaluddin
Armando Martinez
Armands Sausins
Arthur Antonio Chagas
 Pisani
Arthur Leandro
Arthur Sawyers
Arturo Piera
Attila Lukats
Attila Keszei
Audrey Miller
Avi Sabavala
Avinash Jindal
Bai Leng
Barbara Lee
Barbara Pastrana
Barbara Lueck
Barbara Adams
Barbara Rishel
Barbara Nagy
Barr Gilmore
Bea Taylor
Becky Hunt
Bernard Lee
Berthold Rosenberg
Beth Kukucka
Beth Anderson

Beth Wolff
Betty Anne Moore
Bill Forbis
Bill Wallace
Bin Teng
Bob Alosi
Bob Franklyn
Bob Ecker
Bobbi Jo Beaver
Bobby Bank
Boon Lee Lim
Bostjan Guncar
Brad Perks
Brenda M. Combs
Brent Price
Brian Marr
Brittney Moraski
Bruce Reiter
Bruno De La Mata
Bryan Jensen
Burt Hesselson
C.Venkat Raman
Candace Williams
Canindé Soares
Cara McCann
Carl-Magnus Dumell
Carlos Garcia
Carlos Cerqueira Silva
Carlos Roberto
Carol Hudson
Carol Ann Coward
Carol Baptista
Catalina Aguirre Barros
Cecilia M. Orsi
Chandrakant K Shah
Chao Pang
Charles Bagnall
Charles Philip
 Cangialosi
Charles Kosina
Charles Dufour
Charlie F. Kohn
Charter Taylor
Chaw Shin Pui
Cheok Yong Peng
Chico Carneiro
Chris Barnard
Chris McDowell
Chris Hollo
Chris Young
Chris Person
Chris Vaughan
Christiane Bullis
Christina Toth
Christine A. Olson
Christopher Leather
Ciara O'Shea
Claire Bown
Clare Bourke
Clarence Chan
Claude Banta
Claudio Capucho
Claudio Marcozzi
Claudio Perrone
Clifford White
Clinton White
Cláudia Mônica Viol
Colin Shepherd
Colleen Miller
Connie Spyker
Connie Wragge
Constantino Lopez
Craig Merrick
Cristian Baitg
 Schreiweis
D. Jean Taylor
Daisuke Tomiyasu
Daixing Huang
Damian Alex Buttle
Dan McGrath
Dan Stoica
Dan McCormack
Dan Koeck
Dana Smillie
Daniel B. McNeill
Daniel Koch
Daniel Belet
Daniel Zheng
Danny Youssef
Dante Staciokas
Darius Koehli
Darren O'Shannassy
Darrin J. Zammit Lupi
Darwin Wiggett
David Lubin
David Miller
David Hands
David Phelps
David Choo
David Wears
David Fleetham
David Allan Slater

David Alosi
David Moss
Davide Rolando
Dean Kara
Debbie Kowalewycz
Debbie Klingender
Debbie Pacheco
Deborah Brower
Dee Bond
Dee Laughlin
Deng Gang
Denise Ward
Derek Wojcik
Derk Kuyper
Diana Franczek
Diana Martin
Diane Pyburn
Diane Sumner
Dianne Buchta Humble
Dirk R. Frans
Dmitry Sirotkin
Don Johnson
Dona Rehome
Dong-Ping Yuan
Donna Henry
Donna Krueger
Donna Bertrand
Doug Drouillard
Douglas Mahoney
Douglas Guthrie
Douglas Hook
Dragan Zivancevic
Dubravka Lazic
Duilio Polidori
Duncan Major
Earl Echelberry
Ed Maynard
Eddie Chuah
Eduardo Castanho
Edward Hersom II
Edwin Story
Edy Purnomo
Einar Óli Einarsson
Elaine Hodgkinson
Eleonora Saldanha
Elio Lombardo
Elisabeth Silvis
Elizabeth Lee
Elizabeth Brazelton
Elizabeth Larrabee
Elizabeth Stehno
Ellen Merten
Eloy Esteban
Elsbeth Vernon
Elsie Jones
Emanuel Maria
Enric Vives
Enrique Gutièrrez San
 Miguel
Eric Cheung
Erica Hasenjager
Erin Riley
Ernest Welthagen
Erol Recardo Bent
Eve Henry
Fabio Rizzo
Fajian Wang
Farida Shah
Felipe Morozini
Fernanda Casari
Fernando Manuel Pires
 Ferreira
Fernando Elimelek
Fiona May Roland
Fátima Leite
Fran Feldman
Frances Boyd
Francisca Schweitzer
Frankie Jim
Frauke Scholz
Fred Lowery
Frederico Roldao
Fredrick Martin
Freed Schmitter
Gail Chapin
Gaëtan Gauthier
Gary Mackey
Gary Taylor
Gene Gerbasi
Gerald Bonsack
Gerald Chew
Gerry Normand
Ghani Zaman
Gideon Fisher
Gilad Katz
Gilad Pomerantz
Giulio Di Mauro
Glen Jensen
Glenn Powers
Glenn Milne
Gordon Barber
Gregory Conroy

Gregory Stringfield
Gregory S. Churchill
Gu Xinzhi
Hal Rosenthal
Hanoch Grizitzky
Heather Gibbs-Burtner
Heather Owens
Heidi Schumann
Hele-Mai Varik
Helene Svensson
Henry Farkas
Hexel Hernando
Hilary Browder
Hillary Gregory
HongXun Gao
Howard Bell
HuiLing Shi
Ian Thomson
Ian Homer
Irving Johnson III
Isaac Ferreira da Silva
Isaac Buxeda Aliu
Ishika Mohan
Ivan Kurinnoy
Ivan Ramsey
Ivan Vtorov
J. Allen Hansley
Jack Sprosen
Jackie Cytrynbaum
Jacqueline Crump
Jacqueline H. Diaz
James Mourgos
James Wakefield
James Williamson
James Radvan
James Huang Zeng
James DeBoer
James Dikaios
James Raviola
James Stejskal
James Mahan
James Falsken
Jamie Krishnan
Jamie Christensen
Jan W. Dimmendaal
Jan Polverini
Jane Johnson
Janet Currin
Janet Ramsey
Janez Zorman
Janice Cranch
Janko Belaj
Jason Isaac Collar
Jason Burgess
Jay Greenbaum
Jeanne Barkemeijer
 de Wit
Jeff Hartzer
Jeff Johnson
Jeff Benham
Jeff Knights
Jeff Wasson
Jeff Mamola
Jeff Griffith
Jeffrey Camarati
Jeffrey Blake Long
Jennifer Lyndon
Jennifer Stanley
Jesper Hallen
Jesper Andersen
Jesse Bywater
Jian Ming Chen
Jill Whillock
Jill Robins
Jim Byrne
Jim Bryant
Jimi Hughes
Jingjun Zhang
João Noronha
João Loureiro
 Fernandes
Joan Tomas
Joan Lauren
Joanna Artiss
Joanne Konstantopoulos
Jocelyn Chester
Jock Fistick
Joe Brock
Joey Chau Pham
Johanan Toth
Johann Van Tonder
Johanna Rosenbohm
Johannes Howstein
John Winters
John Pearce
John Peterson
John Swenson
John Charles
 Schlesselman
John Rupe
John Bowen
John Allen

John Gostomski
John Starkey
John Apostol
John Gerard Cosgrove
John Karsten Moran
John Valentine
Johnny deJesus
Jonas Almeida
 de Andrade
Jonathan Masullo
Jonathan Sabin
Jorge Raventós
Jose Dalma
Joseph Smith
Joseph Sudol
Josh Gitlitz
José Alysson Dehon
 Moraes Medeiros
José Cettour
José Ortega "Sitoh"
Juan Ferrero
Judi Schiff
Judy Cheung
Judy Cline
Julie Sprott
Julie Lopez
Jun Ji
Junie Miles
Junlei Xu
Karen Molloy
Karen Ann Donnelly
Karen I. Hirsch
Karen Roberts-Lynch
Karen Maynard
Karlis Zikmanis
Katharine Schäfli
Kathleen Ramonda
Kathy J. Kunce
Kathy McElwain
Kedson Kede
Keith Nolan
Keith Bettinger
Keith Hall
Kelly Fulton
Kelvin Schäfli
Ken Martin
Ken Johnson
Keren Elizabeth
 Prosser
Kerry Dexter
Kerry Griffiths
Kevin Butterly
Kevin Watkins
Kevin Walker
Kevin White
Kevin J McCormick
Kim Forster
Kim Cooper
Kim Rich
Kim Allen
Kimberly Wadsworth
Kobi Israel
Konstantin Zavrazhin
Konstantin Rudeshko
Konstantin Chvilyov
Krista Logan
Kristin Sawyer
Kristo Rihm
Kuan Sng
Kwok Yoong Lee
Kymberly Barnett
LaDonna Powell
Lalit Bhatt
Lan Yin
Lance Drill
Lara Wear
Larry Furnace
Larry Madrigal Alvarez
Lars Howlett
Lars Brundin
Laura Comello
Laurel MacDonald
Lawrence Worcester
Lee Gin Ling
Lee Pullen
Leo Riedel
Leoric Woon
Leping Zha
Lester Vincent
 Ledesma
Liana Bittencourt
Liina Anier
Lily Sampson
Linda Hilberdink
Linda Reeves
Linda Montoya
Linda Phillips
Linda Viggers
Lisa Bianchi
Lisa Sherry
Lisa Kerr
Lisa Marie Dutra

Lisbeth Atkinson
Lissette Solórzano
Liz Murphy
Nawfal Nur
John Rosenthal
Lorraine Goldych
Louis Lobsinger
Louise Lucas
Louise Abbiati
Luciana Whitaker-
 Aikins
Luis Alonso Pagoada
Luis Fernando
 Marcomini
Luiz Eduardo Achutti
Luke Chen
Lyman Rudolph
Lyn Webster
Lynda Lagerwey
Lynn Williams
Lynne Otter
Lynnette Chiles
Madeleine Zagni
Mads Izmodenov
 Eskesen
Malachi Toth
Marcela García
 Miranda
Marcello Benassai
Marcelo Corrêa
Marcelo Kauffmann
 Abud
Marco Saborio
Marcos Galvão
Marcus Christian
Marg Wood
Maria Elena Romero
Maria Cecilia
 Guilherme Siffert
Maria Ferrenti
Maria Madalena Rosa
 Marangoni
Marian Richard
 Miodonski
Marian Starosta
Marina Ionni
Marischka Klinkhamer
Marius Jones
Mark Barley
Mark Anthony Wilson
Mark Sadan
Mark J. Phillips
Marla Cohen-Theodoro
Marsha Polier
 Grossman
Marshall Glenn Wylie
Martha Dugger
Martin Bravo Aguirre
Mary Ann Davis
Mary Mulford
Mary Whisenant
Marzia Cosenza
Massimo Ottaviani
Matheus Rocha
Matt Doran
Matteo Alessandri
Matthew Bowen
Matthew Nagel
Matthew Lea
Maureen Hoyt
Maurice London
Mauro Oggioni
Megan Kimber
Meredith Barcham
Michael Clark
Michael Martin
Michael Fenichel
Michael Zahn
Michael Young
Michele Sortini
Michele August
Michele Darien
Michelle Loret
Michelle Storm
Michelle Holland
Michelle Lane
Michelle Elmore
Michelle Graham
Michelle Sparr
Mick Greenbank
Miguel Hijjar
Mike Hochachka
Mike D'Onofrio
Mike Hudson
Miklavz Hvastija
Mitsuo Yamamoto
Miyata Hironori
Molly McDonald
Monique Campbell
Monique Weijers
Morten Bendiksen
Mylah Mateo
Myron W. Lustig
Nadine Salas

Nancy Perong
Nancy McMahan
Nawfal Nur
Nei Vieira de Souza
Neil Bradfield
Nicholas Dawson
Nicholas Bright
Nicholas Dragon
Nick Tsinonis
Nicki Marie Western
Nicole Hulet
Nikolay Georgiev
Nilayan Dutta
Ningqiao Wang
Noeline Cutts
Ola Karlsson
Oleg Lapshinov
Olivia Davis
Oriol Tarridas Massuet
Orlando Discacciati
Orlando Maneschy
Oscar De Mello
Palani Mohan
Pamela Thimmes
Pamela Montague
Panich Chulavalaivong
Pat Larke
Patricia Desmarais
Patricia Leroy
Patricia Trent
Patrick Boyle
Patrick Lavery
Paul Couvrette
Paul Griffin
Paul Markham
Paul Marsik
Paul Godin
Paul Kuldkepp
Paul Gapper
Pauleitta Phillips
Paulina Holmgren
Pauline Prior
Paulo Octavio Almeida
Paulus Susilo Tjahjadi
Pedro Rey
Pedro Marques
Peeter Vissak
Peter Liow Chien Ying
Peter Vogeli
Peter Oxley
Peter Ginn
Peter Hogarth
Peter McMurtrie
Phiroze Dalal
Piet Van Der Meer
Pini Vollach
Plamen Antonov
Qiang Kang
Rachel Wolf
Rafael Boulhosa
Raffaele Calafiore
Rainer Ehlert
Raj Janek
Rajmohan V Pai
Ramiro Verissimo
Randall M Gunning
Randall Simone
Rande Rash
Randie Spencer
Randy Romano
Raul Acevedo
Ray Roda
Raymond Casbourn
Rebeca Barroso
Rebecca Cate
Rebecca Garges
Regis Martin
René R. Jensen
Renae Ivany
Renata Johnson
Renato Valterza
Rene Joseph
Renee Liang
Reshma Kamat
Rhonda Woodell
Ricardo Martius
Ricardo Serpa
Richard Yell
Richard van Ginkel
Richard Wall
Richard Cass
Richard Wallace
Richard Smith
Richard Steinberg
Richard Van der Spuy
Richard Wilson
Rick Dirk
Rick Silvestro
Ricky Wright
Rink Somerday
Rita van den Heever
Rob Parsons

Rob Cooper
Rob Philip
Robert A. Edsall
Robert Doak
Robert DeSanto
Robert Burch
Roberto Delpiano
Robyn Whittaker
Rodney Tregale
Rodrigo Benavente
 Sanchez
Roger Gagnon
Rolf Jentzsch
Ronald Knapp
Ronald Alex Leo
Rosey Goodman
Roxanne Savage Hook
Roy Pope
Roy Al. Rendahl
Roy Smith
Ruikang Xu
Russ Osterweil
Russell Johnson
Ruth M. Harris
Ruth Herron
Rycherde Walters
Sabira Daredia
Sahir Raza
Sally McCrae Kuyper
Salvijs Bilinskis
Sam Reinders
Samuel Veta
Samuel Henrique
 Berger
Sandi Terry
Sandra Sparr
Sandra Gleeson
Sandra Hixson-
 Matthews
Sandy Vannasse
Sandy Sacki
Sara C. Gallup
Sara Dick
Sara Irina Sallehudin
 Sara Porle
Sara Cross
Scott Wolpin
Scott Barthelmes
Scott Anderson
Sereena Burton
Seth Hooper
Shanji Zhao
Shannon Hobbs
Sharie Penwarden
Sharon Gordon
Sharon Voschezang
Shaun T. Zimmerman
Shawna Manning
 Marcontell
Sheryl Green
Shuvam Biswas
Signe Vad
Signe Galschioet
Silpachai Chongpra-
 Sobtham
Silvia Carranza
Simon Ridgway
Simone O'Callaghan
Sinval Garcia
Sirikul Venakul
Sérgio R. Ranalli
Sérgio Luiz Gomes
 Cardoso
Sonia Spence
Srecko Rijetkovic
Stanley Patz
Stephanie Wood
Stephen O'Connell
Stephen Liard
Stephen Muchiri Gathii
Steven Maerz
Steven Smith
Stuart Simons
Subhadip Choudhury
Sugato Chattopadhyay
Susan Toth
Susan Rudolph
Susan Sheen
Susan Ogrocki
Susana Cardoso
 Fernandez
Susanna Thornton
Susmita De
Suwan
 Ounrasameewoona
Suzanne Olsen
Suzanne Marchese
Suzanne Krull
Suzanne Risley
Suzi Richards
Sydney Lee
Syed Husain Mahmud

Syed Rizvi
Sylvy van Bochove
T.J. Zambrano
Tammy Hall
Tang Ah Tong
Tania Cristofari
Teo Khay Boon
Terence Annas
Teresa Phillips
Teri Trent
Terry Edward Ballone
Terry Noske
Thierry Frisch
Thomas Forsberg
Thomas Albert Roberts
Thomas Crown
Thomas Cannon
Thomas Winblad
 Merkel
Tian Wang
Tiffany Ruocco
Tim Otto
Tim Whittaker
Timothy Fisher
Tisha Brown
Tokireti Tekerau
Tom Donadio
Tom Merchant
Tom McGhee
Tong Wang
Tony Wong Thiam
 Hock
Tony Adamson
Toshihiro Hayashi
Tracy Kimber
Valappil
Valentin Gladyshev
Valeria Castro
Valerie Tiffany
Van Wilson
Vanessa Poitena
Vera Lúcia Aquino
Veronica Abrahamsson
Veronica Lousley
Victor Sedillo
Victoria Vancek
Vinayak Prabhu
Vincent Joachim
Vitaly Grass
Vitor Amati
Vitor Hugo Moreau
Vivian Adelene Adram
Viviana Leija
Vivianne Ward
Vladimir Gudkov
Wai Hong Ho
Walt Malone
Walter Sans
Ward McGaughrin
Wayne Klick
Wayne Shinbara
Wei Yee Chong
Wenbao Gong
Wendelin Hasner
Wendy Dahle
Willard Overton
William Bowden
William Tootill
William F. Saavedra
William Bretzger
William Ferguson
Winfried Scheidges
Winifred Meiser
Wolfgang Grulke
Wong Wai Ming
Xiaojun Yang
Xin Wa
Xingjian Gao
Xu Jian
Yehuda Broshi
Yesenia Tuckwiller
Yihuang Huang
Yinan Wang
Zabrina Fernandez
Zachary Fournet Smith
Zhang Jianlin
Zhihang Wang
Zi Xiong Yang

Plus our sincere thanks to
the approximately 2,800
photographers who also
participated in the project
and our sincere apologies
to anyone whose name
we neglected to include.
Thank you to everyone for
taking part in this crazy
and wonderful adventure!

319

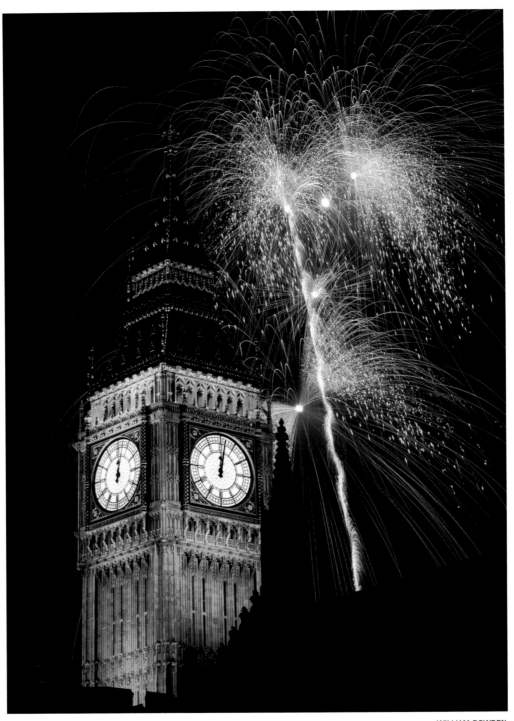

WILLIAM BOWDEN